ART DIRECTORS CLUB

M.F. Agha

Lester Beall

Alexey Brodovitch

Paul Rand

A.M. Cassandre

Charles Coiner

Jack Tinker

Seymour Chwast

Gordon Aymar

Herbert Bayer

L. Moholy-nagy

Herbert Matter

Stephen Frankfurt

Bradbury Thompson

Lou Dorfsman

George Lois

W.A. Dwiggins

Walt Disney

Massimo Vignelli

Helmut Krone

Willem Sandberg

Ladislav Sutnar

Jan Tschichold

Gene Federico

Otto Storch

Henry Wolf

Lucian Bernhard

Ivan Chermayeff

Gyorgy Kepes

George Krikorian

William Taubin

Richard Avedon

Amil Gargano

Bob Giraldi

Len Sirowitz

Jerome Snyder

Tom Geismar

Arthur Paul

Eiko Ishioka

Louis Silverstein

Leo Lionni

Art Kane

Stan Richards

Alan Fletcher

Charles Eames

Milton Glaser

Ben Shahn

Charles W. Tudor

Roy Grace

Howard Zieff

Richard Levine

Reba Sochis

Bert Steinhauser

Frank Zachary

Aaron Burns

Richard Hess

George Giusti

Onofrio Paccione

Rochelle Udell

Gordon Parks

Leo Burnett

Bob Gill

Robert Wilvers

Wallace Elton

Norman Rockwell

Paula Scher

Andy Warhol

Giorgio Soavi

Chuck Jones

Herb Lubalin

Alex Steinweiss

R.O. Blechman

Annie Leibovitz

Willy Fleckhaus

Edward Benguiat

Joe Sedelmaier

Pablo Ferro

Tandanori Yokoo

Rich Silverstein

Alvin Lustig

Edward Sorel

Andre Francois

David Kennedy

Name

N.º 84

THE
BIG BOOK

As the longest-running, widest-ranging,
best-selling publication of its kind, the
Art Directors Annual is more than a yearly
showcase: it is the industry's running his-
tory of innovative creativity in advertising,
photography, graphic design, illustration,
interactive, and student work. From the
very first hardcover book in 1921 to now,
the Art Directors Annual has honored
and archived the best in commercial com-
munication. Year after year, legends are
made when outstanding new work takes
its place in the Art Directors Annual.

Editorial Director	MYRNA DAVIS
Editor	EMILY WARREN
Designer	LOUIS HESS
Book Concept	TAXI, NEW YORK
Art Direction, Editorial Page Design & Illustration	STEPHANIE YUNG, TAXI
Judges' Photography	KEN THURLBECK
Judges' Photo Retouching	BRAD KUMARASWAMY, TAXI
Contributing Writers	NORA FUSSNER, ADC JASON McCANN, TAXI
DVD Design	MATT SUNG KAREN HORTON
Copy Editor	LISA PASQUARIELLO
Publisher	ROTOVISION SA Route Suisse 9 Ch–1295 Mies Switzerland
Sales and Editorial Office	SHERIDAN HOUSE 112-116a Western Rd. Hove, East Sussex BN3 1DD United Kingdom T: +44 (0) 1273 727268 F: +44 (0) 1273 727269 sales@rotovision.com www.rotovision.com
Production and Color Separation	PROVISION PTE. LTD., SINGAPORE
Printing	SNP LEEFUNG HONG KONG, CHINA
Design Software	ADOBE INDESIGN CREATIVE SUITE
Typography	DIN CLEARVIEW BEMBO
ADC	THE ART DIRECTORS CLUB 106 West 29th Street New York, NY 10001 United States of America

N⁰ 84

THE
CONTENTS

President ... 4

Executive Director 5

Judging Chairs & Juries........................ 6

THE 84TH ANNUAL AWARDS

Hybrid .. 28

Advertising .. 50

Photography & Illustration 176

Graphic Design 218

Interactive ... 346

Student .. 386

ADC NOW ...418

APPENDIX

Administration &
Acknowledgements 444

ADC Membership 446

Index .. 451

ROBERT
GREENBERG

PRESIDENT

As my term as President comes to a close, I am happy to report that the ADC is focused on achieving more integrated communications, and it is worth outlining some of our accomplishments in this direction.

To reflect the changes in advertising media, the Annual Awards added Multi-Channel as a major category last year, and incorporated it into the exciting new Hybrid category this year. With ADC Young Guns 4, this biennial show moved from being New York-centric to international in scope. The website, adcglobal.org, relaunched to critical acclaim last year, has a reconfigured calendar section to more accurately reflect our broad spectrum of offerings. The ADC portfolio reviews, outreach programs, and lecture series all have moved ADC forward as the leading organization addressing the entire creative community. The ADC Hall of Fame honors industry leaders from all the disciplines, and the new bylaws, rewritten last year with the support of Frankfurt Kurnit Klein & Selz, cleared the way for composing a diverse board of directors that cuts across advertising, design, interactive media, production, and education.

We are committed to keeping the Annual Awards program aligned with the evolving needs of the industry as a whole. Marketing, communications, design and production are all influenced by the massive changes being wrought by new technologies, from broadband to wireless to DVR's. The ADC show and the organization point to the future, as this vision is converted into an even more substantial reality.

MYRNA
DAVIS

EXECUTIVE DIRECTOR

The ADC exists to honor and inspire creative innovation and leadership.
Our continuing mission, begun in 1920, is expressed first and foremost through our
matchless industry archive, The Art Directors Annual. Here, in the 84th edition, we
present the year's great new work in advertising, design, interactive media, illustration,
photography, and other means of visual communication worldwide.

The 84th Annual Competition drew 10,360 entries from 47 countries. This year saw the
introduction of the HYBRID category, encompassing works that transcend traditional
media. We also introduced "Playground" in the hope of eliciting inspiring unproduced work,
but the judges deemed no entries in this new category to be worthy of inclusion this year.

Gold and silver medalists earn THE BIG CUBE—elegant, solid, weighty, and polished—
perfectly reflective in every way of the work which it honors. Their work, with that of
Distinctive Merit winners, is featured in ADC's 84th Traveling Exhibition, which will be
presented in cities around the world in the coming year with generous sponsorship
from Adobe Systems. Please check www.adcglobal.org for updates.

The Annual Awards supports ADC's vital educational programs, including national
scholarships for college-level art school juniors, the ADC Hall of Fame, speaker events
and symposia, exhibitions, and Saturday workshops which introduce talented high school
juniors to careers in these fields. Highlights from this year's programs and events are
featured in the section "ADC Now."

This is your show, and your way of giving to the next generation. We are proud to bring you
the most innovative work of the year across the board from around the world.

JUDGES

EMILY
OBERMAN

**JUDGING CHAIR: GRAPHIC DESIGN +
JURY: HYBRID**

PAUL
LAVOIE

**JUDGING CHAIR: ADVERTISING +
JURY: HYBRID**

Chairman and CCO of TAXI, co-founded with Jane Hope to integrate advertising and design. Clients include Mini, Nike, Viagra, and The Movie Network. TAXI was named Agency of the Year in Canada for 4 consecutive years. In 2004, Paul launched TAXI-NYC, and was inducted into Canada's Marketing Hall of Legends. Paul sits on the board of the VCU AdCenter and ADC.

"Chairing the ADC's 84th advertising jury was an honor and a rare opportunity to bring together a remarkable group of talented world-class communicators. Their scope of vision cut across disciplines and spanned the globe, but they shared a common purpose: to assemble the body of work in this book. The jury rose to this purpose with the passion of their individual visions, but also in a spirit of cross-disciplinary collaboration that places them in the forefront of the evolution of our industry. The result is a body of work that acts as a standard for our industry, and an inspiration for future practitioners."

Co-founder, Number Seventeen, a multi-disciplinary design firm working in TV, film, print, products, and web. Current clients include Colors Magazine, Air America Radio, and Logo. Before Number Seventeen, Emily was senior designer at M&Co, and until recently, President of AIGA NY. She received the Agustus St. Gaudens Award for Alumni of the Year from Cooper Union in 2004.

"Putting together this jury was a delight. I got to assemble a crack team of brilliant designers, thinkers, and talkers, many of whom I knew, and some of whom I had always wanted to know. They brought humor and passion to two days of intense judging. We saw an incredible range of work (as is always the case), from the bad to the crazy, to the so insanely good it makes you jealous and humble at the same time. There were impassioned speeches, heated arguments, and lots of laughs—all of which are needed to put together a truly great show. I was honored and pleased to be a part of it all (and if they'd have us back we'd do it all over again)."

KEVIN
WASSONG

JUDGING CHAIR: INTERACTIVE

President, Minyanville Publishing and Multimedia. Kevin's previous job as CEO of connect@jwt was to innovate ways to strengthen customers' bonds with clients, products, and services. Kevin launched JWT's digital marketing arm, digital@jwt, in the NY office in 1998. Prior to JWT, he ran the Sun Microsystems account at Lowe Worldwide, helping to establish their first West Coast office.

"Being a judge this year was not just predicated on 'the work,' but on what each judge contributed towards developing the interactive community. This year showed us that the marketplace is embracing interactive media as a core element of the marketing mix and embracing interactive creatives as main stream. Today, creativity is being redefined. It's no longer about the latest work in Flash or an aesthetic. It's about the ability of the work to connect on a visceral level, engage the audience, and leave an indelible mark. The jury this year had a real passion for where communications is headed. It included people from all sides of the spectrum: digital, general, strategic, and technical. Today, we're at a crossroads in innovation and the next five years are going to be much more dynamic than before when it comes to engaging consumers and building brands."

EMILY OBERMAN
Graphic Design

PAUL LAVOIE
Advertising

KEVIN WASSONG
Interactive

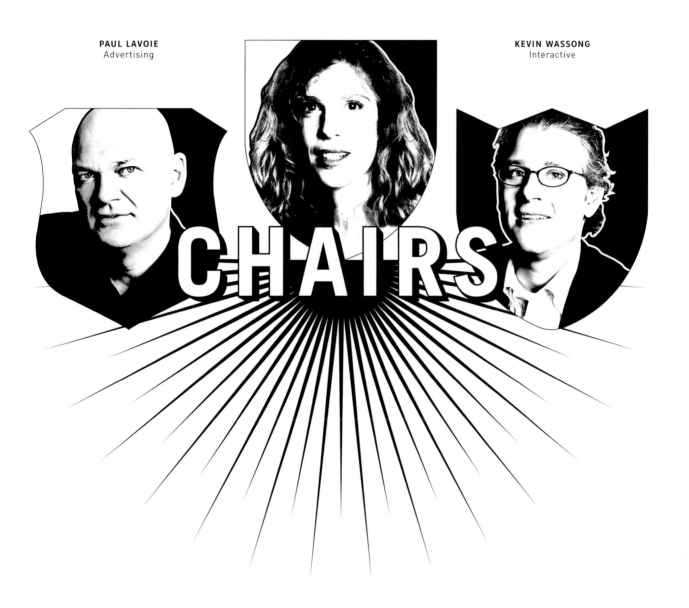

CHAIRS

KEIRA
ALEXANDRA

JURY: GRAPHIC DESIGN + HYBRID

Creative Director, Sundance Channel. Keira oversees the on-air look and marketing campaigns. Previously a graphic designer at M&Co., Bureau, Number 17, and MTV. She worked on projects of every scale and scope, from flyers, identities, and ad campaigns to film titles, video installations, and network broadcast design. Her work has been included in the 100 Show, ADC Young Guns, Creativity 30, and BDA.

KEITH
ANDERSON

JURY: INTERACTIVE

Keith started his design career in Los Angeles at Hill, Holliday and Rubin Postaer & Associates, then moved to Goodby, Silverstein & Partners working on HP, Nike, and Porsche. In 2000, Keith was named Director of Design and now heads up a team responsible for branding communication, from design to interactive to promotions. In 2003, Keith added Associate Partner to his title.

RUTH
ANSEL

JURY: GRAPHIC DESIGN

Founder, Ruth Ansel Design. Presently, she's designing a Taschen superbook (Fall 2006), and the first published book of Bob Richardson's photographs. Ruth was an Art Director at Harpers Bazaar, The NYT Magazine, House & Garden, Vanity Fair, Vogue, and Mirabella. She received a Lifetime Achievement Award from SPD, and was a guest lecturer at Cranbrook Academy.

MATHIAS
APPELBLAD

JURY: INTERACTIVE

At Forsman & Bodenfors, Mathias develops interactive advertising for many clients, primarily Volvo. He works hard to find new ways of putting traditional methods of advertising into practice for online communication. His international advertising awards include Cannes Lions, NY Festivals, One Show, Cresta, D&AD, Epica, and the Swedish advertising award "Guldägget."

ANDREW
ASHTON

JURY: GRAPHIC DESIGN

Andrew works at an independent graphic media studio in Prahran, Melbourne. He helps the big, the small, the cashed-up, the not-so-cashed-up, the great, and the people happy to keep it simple and connect with their audience. He makes posters, websites, identities, books, events, way-finding systems, shopping bags, and apparel. Andrew can laugh about something silly for days.

BOB
BARRIE

JURY: ADVERTISING

Art Director, Fallon/Minneapolis for 21 years. Bob's successful campaigns include TIME Magazine, United Airlines, and BMW. Bob is most proud of his 44 One Show pencils. As President of the One Club for Art and Copy in NY from 1998-2001, he oversaw a period of great transformation for the organization. Bob is married to a nice lady named Kris and has four kids.

GREG
BELL

JURY: INTERACTIVE

Co-Founder and Co-Creative Director of Venables Bell & Partners, San Francisco. A Texan and graduate of the UT Advertising Program, Greg began at Cliff Freeman on Little Caesars, work which was named one of the Top 10 Campaigns of the 90s by NYT, USA Today, and Adweek. He joined Goodby in 1997 on Isuzu and HP. His most recent award was a double-Gold Cannes Lion for Napster.

JEFFREY
BENJAMIN

JURY: INTERACTIVE

At Crispin Porter + Bogusky, Jeff works on Burger King, MINI, and Virgin Atlantic Airways. Prior to CP+B, Jeff worked at Goodby on HP, Saturn, and Goodyear. He's won One Show Pencils, Clios, and Cannes Lions, and his work has been showcased in the Wall Street Journal, NYT, TIME Magazine, Comm Arts, Graphis, and ADC. Jeff is also a national champion debater and certified pilates instructor.

RICK
BOYKO

JURY: ADVERTISING + HYBRID

Managing Director, VCU Adcenter. Rick began at Leo Burnett and Chiat/Day, then joined Ogilvy NY, where he was named CCO and co-president of the office in 1997. He was honored when Ogilvy was inducted into VCU's Founders' Society. Rick is on the Steering Committee for Art Center College of Design, and the boards of Roxio/Napster, Martha Stewart Living Omnimedia, ADC, and the One Club.

KEIRA ALEXANDRA

KEITH ANDERSON

RUTH ANSEL

MATHIAS APPELBLAD

ANDREW ASHTON

BOB BARRIE

GREG BELL

JEFFREY BENJAMIN

RICK BOYKO

TSIA
CARSON
JURY: GRAPHIC DESIGN + HYBRID

Partner at Flat, a multi-disciplinary design firm that works with clients including the NYC Marathon, Reuters, and Knoll. She was profiled in "ID's 40 under 30" in 2000, and has taught at Yale's Graduate Program for Graphic Design, University of the Arts, Parsons, and Hunter. Tsia is currently on the board of the Church of Craft. She has an M.A. from Ohio State University and an B.A. from Nova Scotia College of Art and Design.

JEREMY
CRAIGEN
JURY: ADVERTISING

Creative Director, DDB London. He was previously a copywriter at Bates Dorland, winning awards for VW, Budweiser, Sony, and American Airlines. He was promoted Director of Creativity on Volkswagen, propelling the agency to the top of the Gunn Report in its inaugural year. DDB London has been the most successful agency at Campaign Press Awards 2003/2004, Campaign Poster Awards 2003/2004, and Creative Circle 2004.

ARTHUR
CERIA
JURY: INTERACTIVE

Arthur's been at OgilvyOne San Francisco since 2004. Formerly, he was Executive Creative Director at Euro RSCG Worldwide, NY, on Volvo, MCI, and Evian. Previously he worked at Agency.com as Creative Director, at architecture firm Gwathmey Siegel, and built his own studio in his native France. He holds an M.F.A. from Yale in Graphic Design and an M.F.A. from Ecole National Supérieure des Arts Décoratifs, Paris.

STEVEN
COULSON
JURY: INTERACTIVE

Steve joined JWT/RMG in 2000 as their first digital Creative Director. Since then he has led projects for Lipton Brisk, Merrill Lynch, and De Beers. Prior to JWT, Steve was Senior Creative Director at iXL and the founding Creative Director of Thunder House, McCann's original digital arm (now Zentropy Partners). Steve earned a B.A. with honors in Film and Video from University of Westminster, UK.

BRIAN
COLLINS
JURY: ADVERTISING + HYBRID

Brian Collins is the Executive Creative Director of the Brand Integration Group, a maverick design division within Ogilvy & Mather Wolrldwide. Brian oversees a team of writers, designers, architects, photographers, videographers, and artists in NY and L.A. He also teaches in the graduate program for design at the SVA in New York and has lectured on design and storytelling around the world.

EMMA
COOKSON
JURY: ADVERTISING

"I started my advertising career in 1988 in the UK and worked at a variety of agencies—big and small, good and bad—before finding my spiritual home at BBH in 1994. They've put up with me ever since—first in the London office and since 1999 in New York—and have given me the chance to work on accounts including Unilever (Axe/Lynx) and Levi's. My official title is now Global Head of Strategic Planning. I have two fantastic daughters."

TSIA CARSON

JEREMY CRAIGEN

ARTHUR CERIA

STEVEN COULSON

BRIAN COLLINS

EMMA COOKSON

MATT
D'ERCOLE
JURY: INTERACTIVE

Since joining Digitas as Creative Director, Matt has spearheaded its interactive advertising capability with award-winning campaigns for clients such as American Express and the New York Times. Under his leadership, the agency has reinvented the way brands work, focusing on what they can do rather than what they can say. Matt's vices include karaoke and Pabst Blue Ribbon, preferably together.

SOPHIE
DEISS
JURY: ADVERTISING

Co-founder, Soandsau. Previously an AD at BETC Euro RSCG, Sophie was awarded for Paris Underground and Evian campaigns. In 2000, Soandsau created characters first-published in comics and then exhibited in Paris galleries. They produced two 3-D animation series of commercials for Kiss Cool mints and Munsters. In 2004, their We Will Rock You animation for Evian received international recognition.

LAURA
FEGLEY
JURY: ADVERTISING

Laura Fegley is an Associate Creative Director at Cliff Freeman and Partners, where she is inspired (and taunted) every day by a long hallway full of awards. Over the years she has worked at many New York shops on accounts such as Mercedes-Benz, DSW, Fox Sports, Citigroup, TBS, and way too many telecoms. Laura also writes and is a mediocre pool player. She has won a few ADC awards in her day.

ED
FELLA
JURY: GRAPHIC DESIGN

Ed was a commercial artist for 30 years before receiving an M.F.A. from Cranbrook Academy of Art. In 1997 he received the Chrysler Award, and in 1999 an Honorary Doctorate from CSS in Detroit. His work is in the National Design Museum and MoMA, NY. His book, Letters on America, was published in 2000. A finalist for the National Design Award in 2001, Ed has taught graphic design at CalArts since 1987.

14

TOBIAS
FRERE-JONES
JURY: GRAPHIC DESIGN

After receiving a B.F.A. from RISD, Tobias joined Font Bureau, Inc. Boston as Senior Designer, creating typefaces such as Interstate and Poynter Oldstyle & Gothic. Then in 1999, he began work with Jonathan Hoefler in NY, with whom he has collaborated on projects for The Wall Street Journal, Martha Stewart Living, Nike, Pentagram, GQ, Esquire, Business 2.0, and the NYT Magazine.

JOHN
FULBROOK
JURY: GRAPHIC DESIGN

Art Director at Scribner, board member of AIGA NY, and teacher at SVA. Previously, he was a designer for NYT Sunday Magazine and Little, Brown. Awards include AIGA 50 Books 50 Covers, Print Magazine, ADC, Type Director's Club, and I.D. He was included in Print's New Visual Artists Profile (20 under 30), ADC Young Guns 2001, and was published in Next: The New Generation in Graphic Design.

ANGELA
FUNG
JURY: INTERACTIVE

As a Senior Producer at IconNicholson, Angela develops solutions for clients such as a multinational business services company and a major financial services firm. Angela previously developed interactive projects for clients such as Nike, IBM George Harrison, and Sotheby's at @radical.media. Angela holds a B.A. in English from Dartmouth and an M.F.A. in Painting from Parsons.

MATT D'ERCOLE

SOPHIE DEISS

LAURA FEGLY

ED FELLA

TOBIAS FRERE-JONES

JOHN FULBROOK

ANGELA FUNG

ANDREAS GEYER

JURY: ADVERTISING

Creative Director, Kolle Rebbe, Hamburg, on Gauloises, Frankfurter Rundschau, Bisley, and T-Online. He began at KNSK Hamburg, on Hennessy, Lucky Strike, Expo 2000, and the German Social Democratic Party. Andreas was then Creative Director for Springer & Jacoby on Daimler-Chrysler and German Telekom. Awards include a Clio, New York Festivals, Epica, ADC Europe, ADC, Cannes Lions, and Effies.

LUKE HAYMAN

JURY: GRAPHIC DESIGN

Design Director, New York Magazine. Prior, he was CD at Travel + Leisure and Media Central and Brill Media Holdings, where he redesigned Brill's content magazine, Folio. Prior, he was Senior Partner and ACD in the Brand Integration Group at Ogilvy. Luke served as design director for I.D. and as senior designer at Design Writing Research. Awards include ASME, SPD, AIGA, and ADC Young Guns II.

ADRIAN HILTON

JURY: GRAPHIC DESIGN

Art Director for the last 7 years for clients such as Nike, ESPN, Brand Jordan and USA Networks. Adrian has spent most of his career at Wieden+Kennedy, where he had the pleasure to learn from and work with some of the greatest minds in advertising. Adrian's life mission is to create and produce the most compelling and thought-provoking communication known to man.

SALLY HOGSHEAD

JURY: ADVERTISING

Creative Director, Author. By her second year in advertising she won 6 One Show Medals. Her work has been covered by the New York Times, NBC, CNN, and Entertainment Tonight, as well as honored by The Smithsonian, Best Ads on TV, and the $100,000 Grand Kelly. In Fall 2005 Penguin released her book, RADICAL CAREERING: 100 Radical Truths for Jumpstarting Your Job, Your Career, and Your Life.

BRIAN LEE HUGHES

JURY: ADVERTISING

Director, Reginald Pike, Toronto. Brian has called agencies and production companies in New York, London, Tokyo, Mexico City, Boston, Copenhagen, San Francisco, Toronto, and Los Angeles home. Last year 'boards magazine named him the world's #1 Art Director. In his spare time, Brian makes books and films with the art collective he founded, www.publicincorporated.com.

DAVID ISRAEL

JURY: GRAPHIC DESIGN

Executive Creative Director, Desgrippes Gobé, NY. Previously, he was Creative Director, Senior Partner in the Brand Integration Group at Ogilvy, on clients such as Kodak and Amex. Recognized for General Excellence at The National Magazine Awards for work on I.D., and featured in ADC Young Guns and Mixing Messages at the Cooper-Hewitt National Design Museum.

DOUG JAEGER

JURY: INTERACTIVE + HYBRID

By 25, Doug established two award-winning interative/digital design departments for JWT and TBWA\Chiat\Day. He launched DeBeers' "design your own engagement ring" website and TV campaign, Orbitz.com and Absolut Vodka's online campaign. Doug left in 2003 to pursue his vision, thehappycorp global, a company designed to help good companies gain a larger share of the future.

JOERG JAHN

JURY: GRAPHIC DESIGN

Creative Director, HEYE & Partners, Munich. Starting as assistant director for MARKENFILM Hamburg, he was then a copywriter at RG Wiesmeier Werbeagentur. He was Creative Director at .start, Munich and Scholz & Friends Berlin, returning to RG Wiesmeier as management director/creative head. Awards include Cannes Lions, Clios, ADC Germany, and Type Directors Club NY.

BETHANY JOHNS

JURY: GRAPHIC DESIGN

Program Coordinator for Graduate Studies in Graphic Design, RISD. She has taught at SUNY Purchase, RISD, Hartford Art School, and Yale. Her clients include MoMA New York and San Francisco, and Museum of Contemporary Art in LA. Her work has appeared at the National Design Museum and in I.D. and Eye magazines. She was elected in 2004 to the AIGA NY Board of Directors.

16

ANDREAS GEYER

LUKE HAYMAN

ADRIAN HILTON

SALLY HOGSHEAD

BRIAN LEE HUGHES

DAVID ISRAEL

DOUG JAEGER

JOERG JAHN

BETHANY JOHNS

NICK
LAW

JURY: INTERACTIVE

At R/GA, Nick defines and delivers creative projects, and is especially focused on new business, spearheading interactive work on IBM and Levi's. Formerly a Creative Director at FGI, Nick was responsible for creative vision, advertising, design, and interactive projects. Before FGI, he was Senior Designer at Deifenbach Elkins (now FutureBrand), and Senior Designer at D'Arcy Masius Benton & Bowles, London.

ALAN
MADILL

JURY: ADVERTISING

Alan Madill is a Partner, Creative at Grip Limited in Toronto. A graduate of the Ontario College of Art and Design, Alan worked at Ranscombe and Co., TAXI, and BBDO before joining Grip. He has won Cannes Lions, One Show Pencils, Clios, and ADC awards for MINI, Honda, Viagra, Pepsi, and Nike, and his work has also appeared in Communication Arts, Archive, and D&AD publications.

JAN
LETH

JURY: INTERACTIVE + HYBRID

Since 1996, Jan has overseen all creative development at OgilvyInteractive for IBM, Ameritrade, American Express, Coke and Cisco. He has won the Grand Prix at Cannes and the LIAA, the Grand Clio, Caples, Adtech, One Show, and Effies. He's chaired the OneShow and Clios, and judged Cannes, Andy Awards, Adtech, Caples, and the Echoes. Currently, he is Chairman of the OgilvyOne Worldwide Creative Council.

ELSPETH
LYNN

JURY: ADVERTISING

Elspeth Lynn is a partner and co-creative director at ZiG, Toronto. A graduate of McMaster University and O.C.A.D., she has worked on Fruit of the Loom, Kellogg's, Labatt Breweries of Canada, W Network, and IKEA. Elspeth and partner Lorraine Tao have earned a place on Maclean's list of "100 Canadians to Watch," and "Who's Who in Canada." ZiG was named Marketing Magazine's Agency of the Year 2002.

SCOTT
LEWIS

JURY: INTERACTIVE + HYBRID

Creative Director of integration at JWT, Scott works on Merrill Lynch, Jenny Craig, and US Marines, putting his 15 years of experience to good use. "Whether we plan it or not, integration happens. Customers interact with the brands we represent—and the combined experience they get from all the channels they touch is what drives their behavior. It's our responsibility to make sure all of those touch points work together."

PASSAPOL
LIMPISIRISAN

JURY: ADVERTISING

Passapol began his career at Lintas in Thailand. Now he is a Creative Director at the Euro RSCG Flagship, Thailand. He's worked at Lintas, FCB, Dentsu, and Young & Rubicam. He's been awarded by B.A.D., TACT, Mobius, and Ad Fest for work on Hitachi, Thai Airways, and Fuji Film. In 2004, his Soken DVD campaigns won "Best of the Best" Media Asian Awards, a Bronze Clio, and a Gold Cannes Lion.

NICK LAW

ALAN MADILL

JAN LETH

ELSPETH LYNN

SCOTT LEWIS

PASSAPOL LIMPISIRISAN

ANDY
MCKEON

JURY: ADVERTISING

Considered one of the up-and-coming great creative minds in advertising, he is now ECD of StrawberryFrog, NY. Originally from Melbourne, Andy joined Wieden+Kennedy, Portland on campaigns for Nike, then moved to Goodby for several years. Before joining StrawberryFrog as Senior Creative Director on Mitsubishi Europe, Andy developed the US MSN campaign that's currently running.

G. ANDREW
MEYER

JURY: ADVERTISING

Starting as a designer and art director, Andrew morphed into a copywriter and Executive Creative Director at Leo Burnett in Chicago, currently working on Altoids. His work has been recognized by the Kelly Awards, the Andys, ADC, Communication Arts , One Show, D&AD, Clios, and OBIES. Andrew holds a journalism degree from the University of Wisconsin, Madison.

NAGI
NODA

JURY: GRAPHIC DESIGN

Nagi Noda is a Japanese designer, multi-disciplinary art and film director, and underground fashionista. Nagi won 2 golds, 1 silver, and 1 distinctive merit from the ADC in 2004. Nagi spent her formative years in NY before returning to her native Japan in 1987. She launched her own company, uchu-country ltd., in 2003. Nagi's recent creations are Han-Panda, and the Horror Cafe in Tokyo.

BEN
PALMER

JURY: ADVERTISING + HYBRID

Ben serves as the President and CEO of The Barbarian Group. He got into inter-active advertising by way of studying physics, working as a dj, and designing record covers. He decided to focus entirely on interactive advertising, and started The Barbarian Group. There are now 20 Barbarians in the Boston office and 5 in New York, with 30 active clients and a host of awards.

JUDGES

20

EDUARD
POU

JURY: INTERACTIVE

With a degree in advertising and PR from the Universitat Autònoma, Barcelona, he began as a copywriter for Briefing on Nestlé and La Caixa. In 2000 he joined DoubleYou Madrid as Concept Director, and then DoubleYou Barcelona as Creative Director, in charge of projects for Nike, Audi, Dodot, San Miguel Beers, and Mitsubishi Japan. His numerous awards include a Grand Prix in Cannes 2004.

KEVIN
PROUDFOOT

JURY: ADVERTISING

Co-Executive CD at Wieden+Kennedy NY, on Nike, Jordan, Timberland, SEGA, and ESPN. His work has been featured in the NYT Magazine, Newsweek, and Wall Street Journal, on the Tonight Show, CBS News Sunday Morning, Late Night with Conan O'Brien; and is in permanent collection at the MoMA. His awards include Cannes, ADC, One Show, CA, D&AD, Clios, Andys, and AICP.

BRIAN
REA

JURY: GRAPHIC DESIGN

Art Director, Op-Ed Page for the NYT. His illustrations have appeared in Playboy, the NYT, Ray Gun, Outside Magazine, Fast Company, Sports Illustrated, and Time. After his work on the music video Danger! High Voltage (Electric six/ Kuntz and Magure) he was recognized by Comm Arts, and since, his paintings, posters, drawings, and T-shirt designs have been shown in Toronto, San Francisco, NY, and Tokyo.

ANDY MCKEON

G. ANDREW MEYER

NAGI NODA

BEN PALMER

EDUARD POU

KEVIN PROUDFOOT

BRIAN REA

BRAD
REILLY
JURY: ADVERTISING

Net#work BBDO, South Africa. Awards include Loerie Grand Prix's, Golds, the Chairman's Award, Clios, Cannes, and One Show. Brad was part of the team that launched Cell C — SA's 3rd mobile entrant. He also helped turn Metro FM into the country's most celebrated radio station, and recently helped The International Marketing Council put Brand South Africa on the map.

ALAN
RUSSELL
JURY: ADVERTISING

CCO, DDB Canada, Vancouver. Originally from Manchester, England, Alan emigrated in 1979 to join Baker Lovick BBDO as Senior Writer/ACD. He was Strategy Magazine's top-ranked copywriter in Canada for 5 consecutive years, and was on Ad Age's List of Top 10 Creatives 2003. Awards include Cannes Lions, One Show pencils, C.A., Clios, Marketing and London International.

HELENE
SILVERMAN
JURY: GRAPHIC DESIGN

Helene was senior designer at Mademoiselle, design director of Metropolis, and is a founding member of Hello Studio, a design co-op. Clients include Random House, Atlantic Records, the NYT, and McCann. Since 1990 she's been design director for the Red Hot Organization, an AIDS fundraising group. Helene's work was included in US Design, 1975-2000 at the Denver Art Museum.

DOUGLAS
RICCARDI
JURY: GRAPHIC DESIGN

Owner of Memo Productions, a design consultancy in NY specializing in book design, identities, signage, collateral, and advertising. He has worked for Ettore Sottsass and United Colors of Benetton in Italy, as well as egg magazine and M&Co. Douglas has a degree from RISD and teaches typography and communication at NYU, SVA, and Hunter College Graduate School of Integrated Media Arts.

LUIZ
SANCHES, JR.
JURY: ADVERTISING

Luiz is a Creative Director at AlmapBBDO, Brazil. There, he has won 14 Cannes Lions (3 gold) for work on Aner, Audi, Volkswagen, Pepsi, Effem, Stock Photos, Veja, and Fedex. He has received several awards at FIAP, Clio, London Festival, One Show, and ADC. For ten years, he been listed in the "most-awarded" in the São Paulo Creative Club Year Book.

MATT
SMITH
JURY: INTERACTIVE

Managing Director and co-founder, The Viral Factory, London. Matt has collected, created, and distributed viral videos for five years and is passionate about the ways information spreads across the Internet. Since 2002 hehas been involved in some of the most successful viral campaigns on the Web, from MTV's lightsabre Christmas card to the Trojan Games campaign.

JONATHAN
RODGERS
JURY: ADVERTISING

ECD, True Grey NY. Jonathan has earned over 100 awards including Cannes Lions, Andys, Clios, and the Grand Prix in London for clients such as McDonald's, FedEx, and Dairy Queen. He is one of the few creatives awarded for work on both Coke and Pepsi. The bulk of his career was spent at BBDO NY and Leo Burnett, Chicago; he now guides 10 accounts at True Grey.

AHN
SANG-SOO
JURY: GRAPHIC DESIGN

Korean graphic designer, typographer, and professor at Hongik University. He has an honorary design doctorate from Kingston University, London. Achievements include design and production of international exhibitions and over 40 shows featuring his work. He regularly travels abroad to lecture and promote Asian design developments and ideas.

KASH
SREE
JURY: ADVERTISING + HYBRID

Born in Singapore, Kash moved to England at 7 months, later graduating from Kent Institute of Design with a B.A. in Graphic Communications. After 5 different six-week D&AD workshops, he was hired as a writer/art director at O&M London, followed by stints at Chiat, Singapore and O&M Madras. Later came Leo Burnett Chicago as an SVP Creative Director.

BRAD REILLY

DOUGLAS RICCARDI

JONATHAN RODGERS

ALAN RUSSELL

LUIZ SANCHES, JR.

AHN SANG-SOO

HELENE SILVERMAN

MATT SMITH

KASH SREE

MIKE STERN
JURY: INTERACTIVE

Mike Stern spent 3 years as an Art Director for Digital@JWT, where he was responsible for a big part of the concepting, design, and programming on some pretty extensive projects such as Design Your Own Ring/Design Gallery at adiamondisforever.com and Tanqueray.com, to name a few. He has spent the last year as an animator at Brand New School, and also worked on cool projects for MTV and Fox Fuel.

TREFOR THOMAS
JURY: INTERACTIVE

Trefor Thomas, or Tom as he likes to be known, has worked in design and advertising for 13 years. He is now CCO, RMG Connect. He's spent the past 4 years on direct mail, events, and digital media. Awards include 6 Cannes Lions, Clios, and D&AD. Tom has judged D&AD, Precision Marketing, DMA, and the ISP awards. He's ridden over the highest road in the world, dived with great white sharks, and rafted down the Peruvian Andes.

SCOTT STOWELL
JURY: GRAPHIC DESIGN + HYBRID

Proprietor of Open, a NY design studio that has redesigned the TV networks Bravo, Nick at Nite, and Trio, a signage program for Yale University's Art Gallery, and films for Jazz at Lincoln Center's hall of fame. His work has received awards from AIGA, ADC, Broadcast Designers Association, and C.A. Before Open, Scott was art director of Colors magazine and senior designer at M&Co. He teaches at Yale & SVA, and served as vice president of AIGA NY.

OLLY TAYLOR
JURY: ADVERTISING

Olly joined HOST from Fallon, London, where he was Senior Planner on BBC, Sony Europe, and Ben & Jerry's. At HOST he works most closely with the Australian Broadcasting Corporation, Virgin Atlantic, and Virgin Mobile. He's won 6 APG Creative Planning Awards, including a Grand Prix in 2004 for Virgin Mobile, for which he also won a Cannes Lion Direct Grand Prix and a UK IPA Effie Award.

ROB STRASBERG
JURY: ADVERTISING + HYBRID

Rob started his career as a copywriter at Grace and Rothschild then in 1999 moved to C,P+B where he is now V.P. Creative Director. He has helped launch campaigns for MINI, EarthLink, and BCBS, and writes for Burger King, IKEA, truth, Virgin Atlantic, Coca Cola, and GAP. He's won enough awards that his parents can Google him and not be embarrassed. In 2003, Details Magazine named him one of America's 50 most influential men.

ELIZABETH TALERMAN
JURY: INTERACTIVE

Co-founder of Studio Panepinto, Elizabeth also runs Talerman + Partners, a marketing collaborative that develops brand strategies. She was formerly Senior Parner at Ogilvy & Mather NY, Marketing Director of Harvard Business School, and held direct marketing positions at Epsilon, Harte Hanks, and Fidelity. Elizabeth works pro bono for inMotion, VCU's AdCenter, The Ad Club, and Robin Hood Foundation.

MIKE STERN

TREFOR THOMAS

SCOTT STOWELL

OLLY TAYLOR

ELIZABETH TALERMAN

ROB STRASBERG

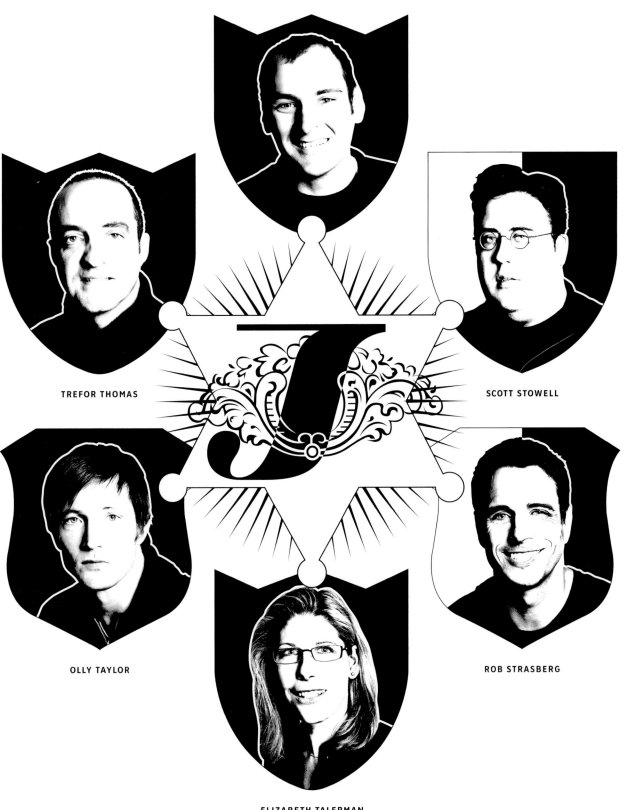

ALICE
TWEMLOW
JURY: GRAPHIC DESIGN

Design writer, editorial consultant, and event curator. Alice writes for Eye, New York Magazine, Grafik, I.D., Print, and Step, and is the author of Style City: New York (Thames & Hudson, 20TK). She is a guest critic at Yale's MFA graphic design program, sits on the board of AIGA NY, and in 2004 was program director for GraficEurope. Previously, Alice produced 8 design conferences at AIGA.

JAMES
VICTORE
JURY: GRAPHIC DESIGN

James' work ranges from publishing, posters, and advertising to animation. Clients include Moet & Chandon, Watson Guptill, The Shakespeare Project, and the NYT. Awards include an Emmy, a gold BDA, the Grand Prix from the Brno Biennale, and ADC gold and silver medals. His posters are in the collections of the Louvre, the Library of Congress, and the Museum für Gestaltung, Zurich.

JONATHAN
WELLS
JURY: INTERACTIVE

Wells developed Flux Television, a cable show that Wired proclaimed "a half-hour gem in which electronic music video collide with excellently-reported segments on digital culture." Wells co-founded the Low Res Film and Video Festival in the basement of his San Francisco apartment. It ran for 2 years in San Francisco, NY, LA, and London. He then founded RESFEST and co-founded RES Magazine.

SHARON
WERNER
JURY: GRAPHIC DESIGN

Founder, Werner Design Werks, Inc., which specializes in visual language and sound design solutions. Clients include Target, Chronicle Books, Nick at Nite, and Levi's. Their work is included in 100 World's Best Posters and is in permanent collections of The Library of Congress, Musée De La Poste, Victoria and Albert Museum, Musée des Arts Décoratifs, and the Cooper Hewitt Museum.

JUDGES

WANG
XU
JURY: GRAPHIC DESIGN

Founder, Wang Xu & Associates Ltd., Beijing. He teaches at Hunan University, Guangzhou Academy of Fine Arts, and is design director of Guangdong Museum of Art. He has won many design awards, including the Icograda Excellence Award. His work has been published in Idea, High Quality, AIGA Journal of Graphic Design, International Professional Scene 90, Area, and World Graphic Design.

GARSON
YU
JURY: GRAPHIC DESIGN

Founder, yU+co., a motion graphic design company specializing in film sequence, network graphic branding, and commercial productions. Born in Hong Kong, he received an M.F.A. from Yale's Graphic Design Program. He began at R/GA NY before starting yU+co in L.A. He is often invited to speak at conferences and schools in China, Hong Kong, Germany, and the U.S.

ALICE TWEMLOW

JAMES VICTORE

JONATHAN WELLS

SHARON WERNER

WANG XU

GARSON YU

HYBRID

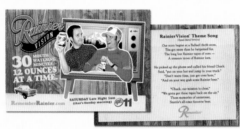

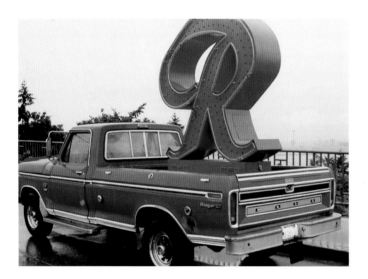

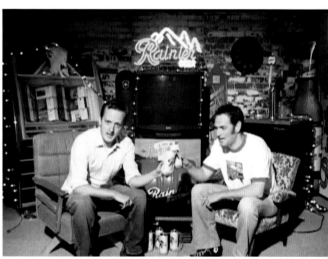

To reintroduce a once-beloved beer to an audience who had forgotten it, CWRC created a late-night television show in which two regular guys relive the glory days of Rainier Beer. Starting by revisiting old commercials, episodes were based on one hundred years of brewery lore. As the episodes unfold, the guys have adventures all over the city involving Rainier Beer. After an actual bear was discovered passed out in a national park after drinking thirty-six cans of Rainier Beer (and bypassing other brands), CWRC created the first new commercials for Rainier Beer in many years. In "Tourist," Swiss tourists at a campground discover the Rainier Beer-drinking bear raiding their cooler. In "Tackle," Tim and Chuck witness a pivotal confrontation between Rainier Beer and the Rainier Beer-drinking bear in the

wild. Last, in "Box Trap Mansuit," the Rainier Beer-drinking bear is discovered to be a man in a bear suit. Other elements in the campaign included a website with video clips and detailed bar listings; weekly e-mailed newsletters; trucks with a giant neon "R"; endless bar promotions; posters; postcards; and the re-release of a vintage can. Also included were re-broadcasts of three of the old commercials as well as the creation of three new ones. The television show was produced in-house and aired weekly at 1 AM Sundays (when barroom patrons returned home). Viewers were encouraged to call and share their memories. The two actors from the original commercials made promotional appearances driving a 1970s-era pick-up truck with a large, red neon "R" (a replica of the brewery's old logo).

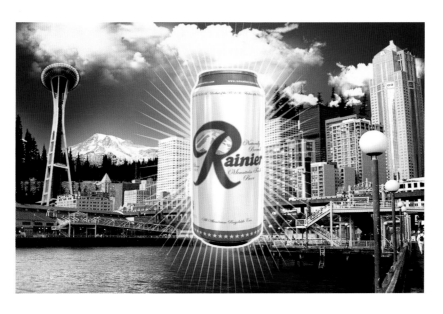

Yahoo! Big Idea Chair Recipient

GOLD Multi-Channel, Campaign **Remember Rainier Campaign: Remember Rainier Campaign
Overview, Box Trap Mansuit :30 TV Spot, Website, Press Kit, Rainier "R" Truck Events | Guerilla Theatre**

Art Directors Guy Seese, Todd Derksen (ACD), Sunshine Stevens, Travis Britton, Dylan Bernd **Creative
Director** Guy Seese **Copywriters** Guy Seese, Jim Elliott (ACD), Kevin Thomson, Mike Tuton **Designers** Dylan
Bernd, Todd Derksen, Nate Johnson, Jeremiah Whitaker **Sound Design** Eric Johnson (Clatter & Din) **Web
Development** Karl Norsen **Digital Artist** Sean Onart **Music** Mick Philp (theme song only) **Talent** Tim Hornor,
Kevin Brady, Mike Tuton **Account Management** Brenda Narciso, Jen Scott, Megan Eulberg, Megan Greene
Directors Wyatt Neumann, Mike Prevette, Jack Hodge, Carol Hodge **Editors** Wyatt Neumann, Mike Prevette,
Matt Ralston **Producers** Nicole Hartshorn, Jessica Cohoon, Sue Mowrer, Kelly Showalter **Production
Companies** Ellipsis Pictures, Lenz Films, Alarming Pictures **Agency** Cole & Weber/Red Cell **Client** Rainier
Brewing Co. **Country** United States

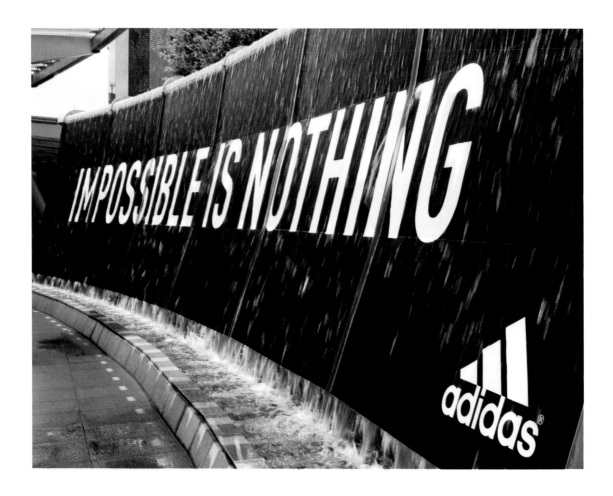

 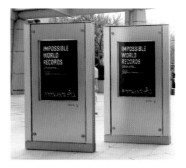

SILVER Other, Campaign **Impossible World Records**

Art Directors Clementine Tourres, Tadashi Tsujimoto
Creative Director John Merrifield **Copywriters** Wei Ling
Gwee, Hiroshi Takahashi **Agency** TBWA\Japan **Client**
adidas **Country** Japan

(see related work on pages 83 and 167)

How high is high? How fast is fast? How heavy is heavy? We
wanted to take advantage of the Olympic games to help
people in Tokyo answer these questions for themselves. We did
this by creating an exhibition that gave people a real sense of
what it takes to set a world record. (The show allowed us to
demonstrate Impossible is Nothing, not just talk about it.) Most
of the exhibits allowed for interactivity. People were encouraged
to attempt the long jump record or race against LED lights
programmed to light up at world record speed. The result? A raft
of articles in newspapers and magazines, as well as appearances
on sports, entertainment, and news shows throughout Japan. Nadia
Comeneci even showed up and put aspiring gymnasts through their
paces. It went beyond the bounds of traditional advertising and
became something people actually wanted to see, touch and feel.

 +105kg SNATCH (MEN)
WR 213kg
14/09/2003, QINHUANGDAO, CHINA
+75kg SNATCH (WOMEN)
WR 137.5kg
21/11/2003, VANCOUVER, CANADA

 JAVELIN (WOMEN)
WR 71.54m
01/07/2001, RETHIMNON, GREECE

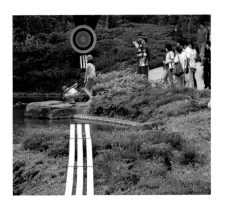

 18 ARROW MATCH (MEN)
WR 177 POINTS
08/09/2001, HAMYANG, KOREA

 60m (MEN)
WR 6.39sec.
03/02/1998, MADRID, SPAIN
60m (WOMEN)
WR 6.92sec.
11/02/1993, MADRID, SPAIN

 LONG JUMP (MEN)
WR 8.95m
30/08/1991, TOKYO, JAPAN
LONG JUMP (WOMEN)
WR 7.52m
11/06/1988, LENINGRAD, USSR

 POLE VAULT (MEN)
WR 6.14m
31/07/1994, SESTRIERE, ITALY

 10m PLATFORM (MEN)
WR 724.53 POINTS
30/09/2000, SYDNEY, AUSTRALIA

 HIGH JUMP (MEN)
WR 2.45m
27/07/1993, SALAMANCA, SPAIN

SILVER Multi-Channel, Campaign **Renault Modus MultiChannel Campaign Zapping**

Art Directors Gunther Schreiber, BjörnRühmann **Creative Director** Lars Rühmann
Copywriters Ingmar Bartels, Christoph Bielefeldt, Philipp Dörner **Designers** Nicole
Fiebig, Bertrand Kirschenhofer **Director** Marc Malze **Editors** Pictorian, Das Werk
Producers Birgit Damen, Wiebke Schuster **Production Company** Silbersee Film **Director**
Marketing Communications Jörg-Alexander Ellhof **Other** Astrid Kauffmann, Heiko
Gerber, Christoph Schüler, Michaela Wauschkuhn (Renault Germany), Wolfram Irmler
Agency Nordpol + Hamburg **Client** Renault Nissan Deutschland AG **Country** Germany

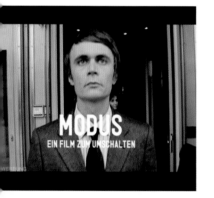
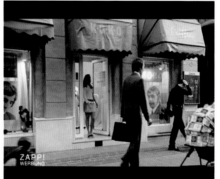
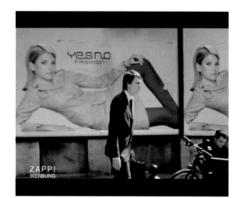

For the launch of the Renault MODUS, an attention-grabbing TV event was needed to generate test-drives on the internet. For the first time in German television, channel-hopping became the basic principle. Two slightly different versions of one short film were parallel broadcast on two TV stations, "happy" and "sad." Via ads in newspapers and magazines, TV guides, TV trailers, websites, and a banner campaign, the audience was asked to join the film "MODUS" by switching between the channels for visual effects. The ending of the film was shown on the website www.modus.de, where the car appeared for the first time in the whole teaser phase. The films had eight million viewers. In the teaser phase, 820,000 people visited www.modus.de. Before the launch, 20,278 prospective customers registered in the internet contact data base. The press coverage (seventy-two publications with a total print run of forty-nine million) nearly doubled the media value. Script: A man gets home, nothing special. But the film is shown in parallel on two channels. By switching the viewer discovers slight but striking contrasts between the same actor on the same route. Every press on the button of the remote control could have a effect on sound and vision: On the one channel the actor sees the whole world through rose tinted glasses, on the other one through gray ones. While on channel one his silly walks bemuse a school class, he feels disturbed by the pupils on channel two. Even the whole surrounding changes, slightly but strikingly. In the end, the actor faces his doppelganger and both head to very different cars.

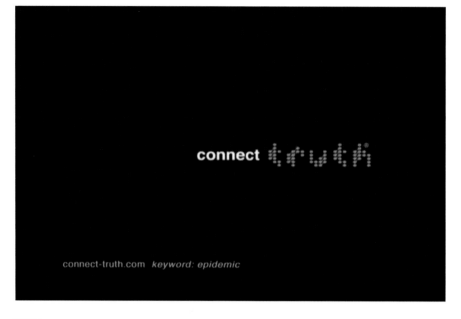

connect truth

connect-truth.com *keyword: epidemic*

SILVER Multi-Channel, Pro Bono, Campaign **Connect Truth: Disappeared, Models, Price Czech, Crazyworld 2, Saharan Breeze, Blubb-erase, Combustaroos**

Art Directors Meghan Siegal, Tiffany Kosel, Paul Stechschulte, Paul Keister, Lee Einhorn, Rob Baird, Dave Swartz **Creative Directors** Ron Lawner, Alex Bogusky, Pete Favat, Roger Baldacci, Tom Adams **Copywriters** Marc Einhorn, Scott Linnen, Bob Cianfrone, Mike Lear, John Kearse, Mike Howard **Designers** Meghan Siegal, Cindy Moon, David Chung, Max Pfennighaus **Directors** David Gordon Green, Bart Smith **Editors** Tom Scherma, Jon Stefansson **Producers** Carron Pedonti Barry Frechette, Rupert Samuel, Terry Stavoe, Teri Vasarhelyi **Production Companies** Chelsea Pictures, bartradio, inc. **Agencies** Arnold Worldwide, Crispin Porter + Bogusky **Client** American Legacy Foundation **Country** United States

After four years of looking through tobacco company documents you start to see how it's all connected—how one fact or document leads to another. How this decision led to that. And how they all lead to the final human toll. Most people don't have time to make those connections. But we did. The TV spots draw connections from something the tobacco industry said or did to its human toll. We use orange discs as a sort of visual cue, literally connecting the dots. The radio raises questions about the human toll taken by tobacco products, and asks what the industry is doing, if anything, to remedy it. The website pulls everything together. Each piece of creative—TV, web banners, print—has a keyword associated with it that one can submit on the website. Then, the computer program shows all the other facts and statements and documents that are connected to it.

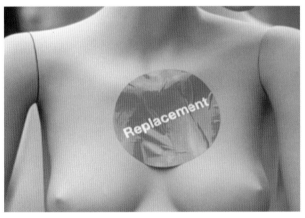

In "Survey," by handing out orange dots to people on the street, we connect the fact that every eight seconds someone in the world dies due to tobacco to a question posed by a coroner in a NYC morgue. He rhetorically ponders why the tobacco industry fought to not list tobacco as a cause of death on death certificates.

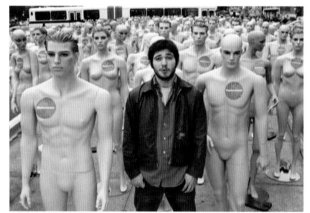

In "Replacement Smokers," we connect the dots between the new smokers who replace dead smokers—whom tobacco execs have referred to as "replacement smokers"—with a young girl whose father actually died from smoking. She hasn't met his replacement yet.

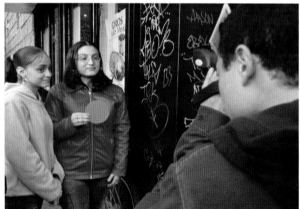

In "Epidemic," we hand out surgical masks to people on the streets to raise awareness of an epidemic that kills 50,000 people a year—secondhand smoke. We then connect the dots to a non-smoking waitress who worked where people smoked and got lung cancer.

DISTINCTIVE MERIT Multi-Channel, Campaign **Hype**

Creative Directors Peter Hodgson, Chris Aldhous (HP Europe) **Interactive Creative Director** Robin Garms **Copywriter** Martin Gent **Designer** Doug MacKenzie **Producer** Suzanne Melia **Agency** Publicis Dialog **Client** Hewlett Packard **Country** United Kingdom

Challenged to make HP relevant to the iMac generation, Publicis chose a unique tactic to get under the radar of these savvy and media cynical consumers. The Hype gallery started out as an empty space waiting to be filled by anyone who brought his artwork on a disc or CD to be printed out on large format HP printers, or projected, in the case of films, on HP digital projectors. We specifically targeted the creative community with viral activity both real (such as clean grafitti) and digital (chatrooms, blogs, and hypertag posters), and with teaser ads in cinemas and the design press. The success of the exhibition was measured not just by the quality of the work, which was remarkably high, nor the number of visitors—4000 people at the gallery, four million hits on the website—but by the enormous goodwill generated among the 2000 artists whose work was showcased.

We used clean graffiti to introduce the target audience to Hype

We put up fly posters and gave out postcards

We seeded it in design communities, blogs and chatrooms. They started to bite

We transmitted the 'pre-content' films on JVTV. A web based broadband network of plasma screens in student union facilities

We sent information pack to college lecturers, incentivising them (with free hardware) to include Hype in their course syllabuses

We launched hypegallery.com - the phase 1 inspiration site. Prelaunch, traffic was low (purely word of mouth) but conversion to registration was running at 40%

We started to advertise online, again just using a tease of the pre-content and the URL

We aired the pre-content films in the cinema

We started to place the pre-content in national press and relevant monthly magazines

We incentivised entry with an online campaign of banners and skyscrapers

We opened the website for entries from around the world

We executed an outbound email programme. We implemented a recontact strategy

We ran an underground film screening of 60 films in an underground car park in Soho, to incentivise the young filmmaking community

We deployed small space advertising in the listing magazines mimicking art exhibitions and film posters

We rolled out the first street deployment of Hypertaged posters

www.hype4awards.com

The website metamorphosised into the phase 3 gallery site ...mirroring the real life gallery in Brick Lane

We rolled the Hype Gallery in Brick Lane. It had no art on display. It was filled by the young designers, artists and film-makers who bought over 1,000 pieces of art along

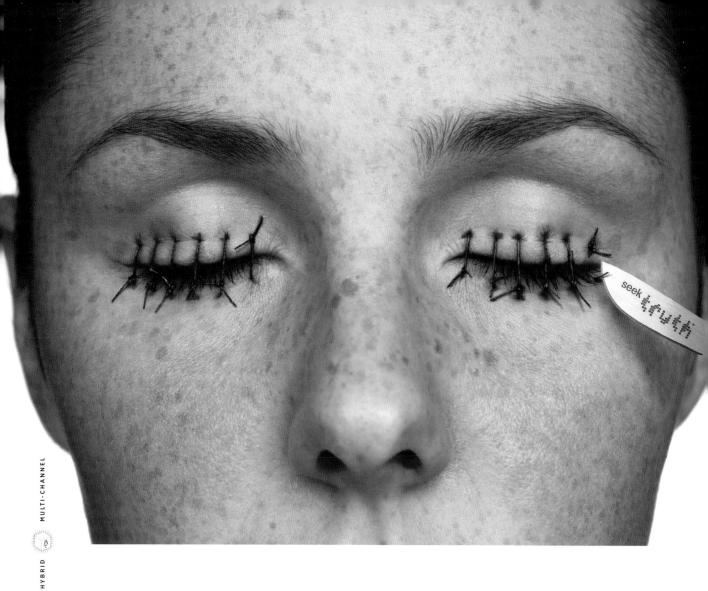

40

{**MULTIPLE AWARD WINNER**} (see also page 58)

DISTINCTIVE MERIT Multi-Channel, Pro-Bono, Campaign
Seek Truth: Cherry Picker, Voice, Flag, Mouth, Ear, Eyes, Seek Q + A, Drill

Art Directors Phil Covitz, Brandon Sides, Meghan Siegal, Tricia Ting **Creative Directors**
Ron Lawner, Alex Bogusky, Pete Favat, John Kearse, Tom Adams **Copywriters** John
Kearse, Marc Einhorn, Jackie Hathiramani, Annie Finnegan, Bill Hollister **Designers**
Meghan Siegal, Chris Valencius, Max Pfennighaus, Suzanne McCarthy **Director** Christian
Hoagland **Editor** Tom Scherma **Producers** Carron Pedonti, Barry Frechette, Linda Donlon,
Kathy McMann **Production Company** Redtree Productions **Agencies** Arnold Worldwide,
Crispin Porter + Bogusky **Client** American Legacy Foundation **Country** United States

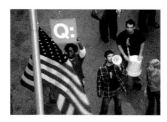

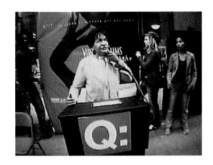

There are a lot of unanswered questions surrounding cigarettes and the tobacco industry. We wanted to encourage kids to ask questions. No matter how powerful or how much money someone has, he or she should still have to answer for his or her actions (except in Washington). The print is a call-to-arms—urging teens not only to stay aware of the world around them, but to be prepared to act. The TV then demonstrated a manner in which kids do act: They head down to a major tobacco company's headquarters and ask questions. A woman's father was sent an electric drill from a tobacco company. Two years earlier he'd died from smoking their cigarettes. She builds a billboard that asks, "Why do you sell a product that kills your customers?"

In "Voice," to point out the irony of some tobacco advertising, a woman who uses an electronic voicebox asks whether her voice was what the tobacco industry meant when its ads urged women to "find your voice."

In "Flag," the Truth kids raise a flagpole in front of Big Tobacco HQ, then lower it to half-mast, urging big tobacco to do the same in honor of the 440,000 people who die from using their products every year. A podium is set up for big tobacco to respond. They don't. And the web became a place where kids who were motivated to do something could do it—through a photo-blog about things that "really piss you off"; through dialogue with each other; and through access to information. Seektruth.com was one of our sharpest tools. Funny, but the more kids know, the more they want to know. Seek Truth.

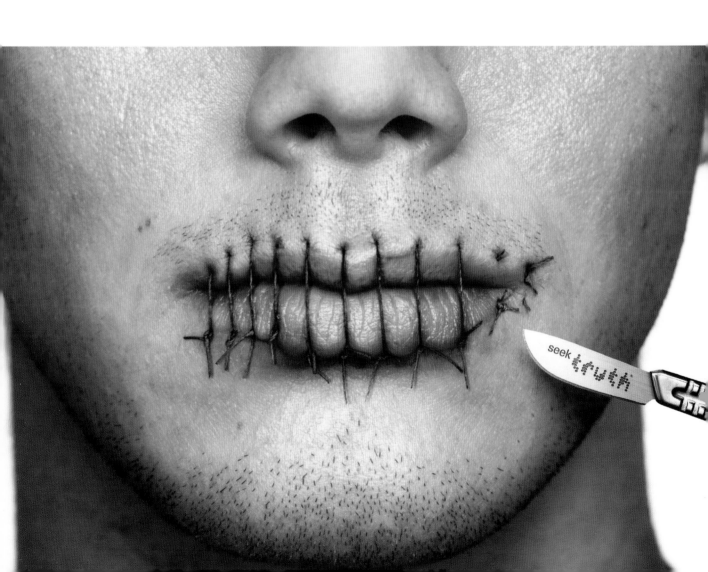

DISTINCTIVE MERIT Other **Silent Movie**

Art Director Erica Valente **Creative Director** André Piva
Copywriter André Piva **Designer** Erica Valente **Producer** Marcio
Quartilho **Agency** Lo-V **Client** 2001 Video **Country** Brazil

One of the most traditional video rental stores in São Paulo, 2001
is renowned for its large collection, complete in all genres. In
this piece, the challenge was to promote the Chaplin Collection,
digitally restored and with scenes not included in the originial movie
versions—a treat for movie lovers. Using an e-mail with a Microsoft
Word attachment, we left technology out and rescued the essence
and humor only found in silent movies.

MERIT Multi-Channel, Campaign

Nike Basketball Chamber of Fear: Scroll, LP, Magazine Ads, TV Commercial

Art Directors John C. Jay, Jayanta Jenkins **Creative Directors** John C. Jay, Sumiko
Sato, Jimmy Smith **Copywriter** Jimmy Smith **Animation** Sumiko Katsura **Account
Director** Byron Oshiro **Sound Design** 740 **Music** RZA **Animators/Directors** Tatsuyuki
Tanaka, Koji Morimoto, Shinichiro Watanabe, Hideki Hamasu **Animation Production
Company** STUDIO4 **Production Company** @radical.media **Director** Dave Meyers **Editor**
Chris Davis (Outpost Digital) **Producer** Tieneke Pavesic **Agency** Wieden+Kennedy
Tokyo **Client** Nike Asia Pacific **Country** Japan

dimensions: 11" h x 17" w

The commercial follows LeBron James as he goes through a mythical chamber, each room
representing one of his actual fears.
VOICEOVER/SUPER: And so the Chosen One was forced to face his fears. LeBron then
overcomes his fear of "Hype" (living up to it) and his fear of "Temptation" (having access to
things most teenagers can only dream of).
VOICEOVER/SUPER: The Chosen One grew in wisdom with each challenge.
LeBron goes on to battle imaginary foes representing "Envy" (competitors) and
"Complacency" (proving he wouldn't be affected by sophomore jinx).
VOICEOVER/SUPER: Finally, the Chosen One confronted his greatest test.
LeBron comes face to face with what may prove to be his greatest fear: himself, or "Self
Doubt."
Music track written/recorded by the RZA (Wu-Tang Clan), which includes musical hook/
chorus: "On comes the darkness, the lightness will appear. And you got to persevere thru
this Chamber of Fear."

Lebron James came directly out of high school and into the NBA with more pressure and
expectations than any other athlete in the past decade. By overcoming his fears, he proved
to be an inspirational leader to young players all over the world, including in Asia, where
this campaign was first developed. Asian players often lacked self-confidence, and looked
at star NBA players as untouchable. Lebron, on the other hand, was only nineteen years old.
Our goal was to show he had his own fears to conquer and that this was indeed possible. His
fears were expressed by progressive challenges he to overcome: from Hype to Temptation to
Envy to Complacency to the ultimate fear, Self-Doubt.

MERIT Viral Campaign **Zenigata Kintaro (TV Show) Propagation: Propagation Overalls, Overall Flags, Overall Posters, TV Graphics, Sticker**

Art Director Masaru Yokoi **Copywriter** Yoshihiro Mita **Designers** Masaru Yokoi, Haruki Minami, Sumie Kouchi, Chihiro Murasawa **Other** Hiroshi Nakatsuka **Producer** Wakana Koide (TV Asahi Public Relations Division) **Production Companies** TV Asahi CG design room, Hearts Oricom **Agency** TV Asahi Corporation **Client** TV Asahi Corporation **Country** Japan

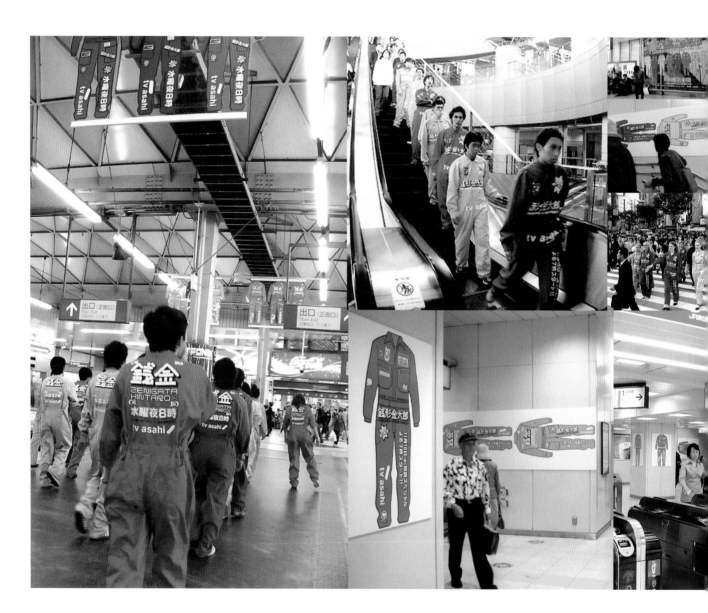

"Zenigata Kintaro" is a TV program broadcast in Japan. In this entertainment show, actors play reporters and visit people in their homes. They visit people who do not have much money and try to make their dreams come true. The reporters wear overalls in different colors which symbolize this uplifting program; in fact, this program's design has evolved and been built around the overalls. Zenigata Kintaro's overalls were seen in metropolitan Tokyo, in train stations, and on trains—and, needless to add, on TV!

We reinvented the concept of "late night" with the introduction of our "Don't Sleep" campaign. We focused on the period of time between midnight and 4 a.m. when most of our consumers are just getting going. Our campaign was executed in a broad range of media, including late night cable, in-bar point-of-sale, guerilla packaging, and street artist interpretations of Rheingold painted on metal nightshades.

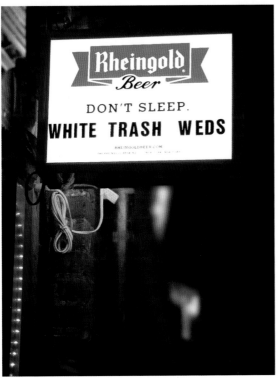

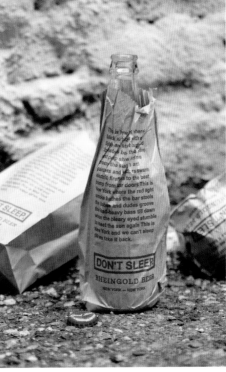

MERIT Viral Campaign
Rheingold Beer "Don't Sleep" Campaign: Nightshade 1, 2, 3

Art Director Neil Powell **Creative Director** Neil Powell **Copywriter** Josh Rogers **Other** Rob Sinclair,
Eddie Martinez, Gina Triplety, Justin K **Agency** Powell **Client** Rheingold Beer **Country** United States

MERIT Branded Content **Nike Battlegrounds**

Creative Director Jimmy Smith **Director** Derek Cianfrance **Editors** Josh Pearson, Brett Mason **Producer** Justin Wilkes **Other** Frank Scherma, Paul Bozymowksi, Bill Davenport, Davi Russo, Jon Kamen **Production Company** @radical.media **Agency** Wieden+Kennedy (New York) **Studio/Design Firm** @radical.media **Client** Nike **Country** United States

As a core component to the summer 2004 launch of Nike's successful "Battlegrounds" line of basketball shoes and gear, Nike turned to Wieden+Kennedy and @radical. media to develop original content and communication around the Battlegrounds concept—gritty, realistic stories about struggling players seeking to take the prize as the top street basketball player in their city—and turn it into a summer television series for MTV and MTV2. Premiering in July 2004, the five-part series and integrated website (created in collaboration with RG/A) chronicled street basketball players from New York, LA, Chicago, and Philadelphia competing against players from Spain, France, Germany, and Italy in hopes of winning the coveted "King of the World" title.

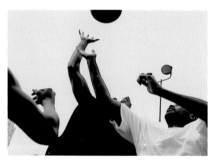

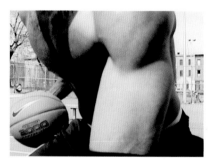

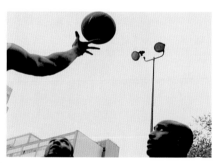

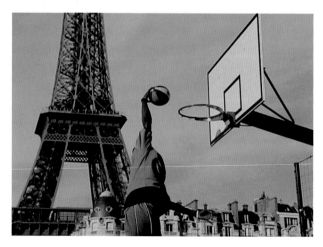

MERIT Branded Content, Campaign **Ideas Shop: Exterior, Poster, Web**

Art Director Taro Kamitani **Creative Director** Junya Ishikawa **Copywriter** Kazue Saito **Designer** Taro Kamitani
Production Manager Mikiko Nakagawa **Web Producer** Katsushi Kurigami **Web Art Director** Keigo Saito
Director of Photography (Movie Model) M. Hasui (Snappin' Buddha) **Director of Photography** (Products)
Shinichi Masumoto (Snappin' Buddha) **Food Stylist** Wakana Takahashi **Hair/Make-Up** Natsuka **Music** Hiroki
Ishii **Stylist Casting** Anthony Moynihan **Model/Counselor** Nicole Bargwanna **Model/Cool** Sergio A. Ropez
Model/Peace Timothy Wellard **Model/Sexy** Marilyn Klein **Model/Biz** Ben Klein **Printing Director** Tadao
Sekiguchi (Techno Japan) **Public Relations** Miki Nakamura (Vector Standard) **Production Designers** (Set
Designers) Yohei Ishikawa, Yasuo Sahara, Shoji Kamiya (Pacific Furniture Service) **Producer** Eiichiro Oshiro
Production Company dreamdesign **Illustrator** Ohgushi **Studio/Design Firm** dreamdesign co., ltd. **Client** Mori
Building (academy hills) **Country** Japan

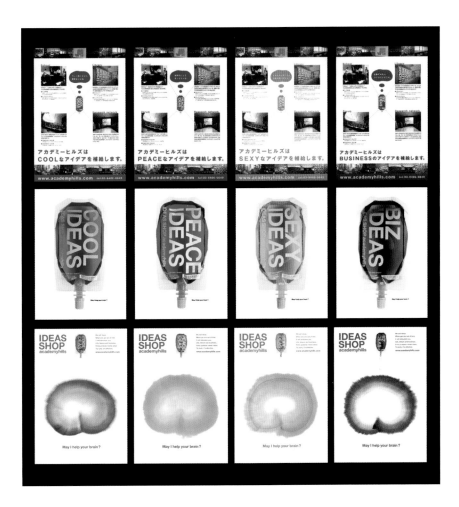

"Academyhills" was created as an intellectual hub at Roppongi Hills, Asia's largest commercial complex. Our goal was symbolic representation of the site as a gateway into the intellectual sphere while renovation is under way. More than 100,000 people daily pass through the doors of Roppongi Hills, which leads into a cinema complex, schools, and business offices. We decided to take advantage of the rare communication opportunity presented by the complete removal of the revolving door, and poured energy into creative media to engage the maximum attention of passersby. We began with "drinks that inspire the mind with ideas" (in Sexy, Cool, Peace, and Biz, flavors not available commercially) and set up the mysterious Ideas Shop. Drinks were laid out in a fashionable showcase, and film showing a doctor and patient in discussion was played endlessly. The project message, "May I help your brain?" and "Creative Media" succeeded in maximizing communication. The project found that people are always in search of breakthrough ideas.

Art Director Scott O'Leary **Creative Directors** Bruce Bildsten, David Damman **Copywriters** Dean Buckhorn, Ryan Peck **Associate Producer** Tracy Tabery-Weller (Fallon) **Director** Jon Nowak **Editor** Brody Howard **Producers** Tammy Auel (Fallon), Michael Aaron (UncleForehead) **Production Company** Uncle Forehead Filmworks **Agency** Fallon Minneapolis **Client** Lee Dungarees **Country** United States

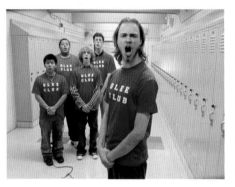

HYBRID BRANDED CONTENT

The challenge? Help Lee Dungarees reach today's elusive, media-savvy, young male audience. Our solution? Buddy Lee, Guidance Counselor, an interactive mini-series on MTV starring the indestructible "spokesdoll," Buddy Lee. This mini-series was designed specifically to work within MTV's Control Freak, a new show where viewers get to control which music video is played next by voting online. In each episode of Guidance Counselor, hapless students inexplicably come to Buddy Lee for career advice. After Buddy shares a few of his own ill-fated, extremely painful job experiences, MTV viewers were able to vote for a more suitable career for the student. After the voting was completed, Buddy immediately demonstrates the winning career, usually at great personal risk to himself. In many cases, the mini-series received more votes than the actual videos.

On Friday, November 5, 2004 Burger King Corporation sponsored the true fight of the century, "Chaos in the Coop." This tongue-in-beak bout pits "T.C." (Tendercrisp sandwich) and "Spicy" (Spicy Tendercrisp) against each other in a winner-take-all match for the title of World's Best Chicken Sandwich! The two contenders were fired up for this DIRECTV® event, which was viewed multiple times on Friday, November 5, from 10:00 to 11:00 PM EST. It was also shown at www.chickenfight.com, a website where more than two million had voted for their champion chicken. Since October 18, 2004 in anticipation of the battle between the two contenders, www.chickenfight.com has had non-stop hits, as food and fight fans alike continue to peck-in to support their favorite. You've seen the training ads and then the weigh-in ads, now you can see the main event on DIRECTV®.

 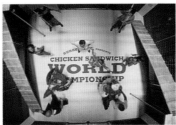

MERIT Branded Content **Chicken Fight**

Art Director James Dawson-Hollis **Creative Directors** Alex Bogusky, Andrew Keller, Rob Reilly **Copywriter** Rob Strasberg **Other** Jon Kamen, Frank Scherma **Director** The Glue Society **Editor** Chan Hatcher **Producers** Rupert Samuel, Dave Rolfe **Production Company** @radical.media **Agency** Crispin Porter + Bogusky, Miami **Studio/Design Firm** @ radical.media **Client** Burger King **Country** United States

MERIT Branded Content **United Airlines: In-Flight Documentaries**

Art Director Bob Barrie **Creative Directors** David Lubars, Bruce Bildsten, Stuart D'Rozario **Copywriter** Stuart D'Rozario **Director** Jeremy Warshaw **Editor** Mark Nickelsberg **Producers** Kate Talbott (Fallon), Jennifer Carter-Campbell **Production Company** Highway 61 **Agency** Fallon Minneapolis **Client** United Airlines **Country** United States

49

ADVERTISING

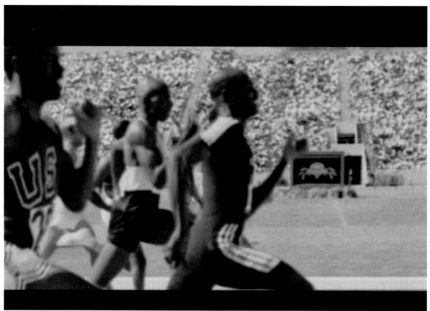

GOLD TV: 30 Seconds, Campaign **Impossible is Nothing Olympics: Jesse, Nadia, Haile**

Art Director / Associate Creative Director Dean Maryon **Executive Creative Directors**
Peter McHugh (180\TBWA), Lee Clow (TBWA Worldwide) **Copywriter/Creative Director**
Richard Bullock **Executive Agency Producer** Peter Cline **Agency Producer** Cedric Gairard
Sound Design Ren Klyce (Mit Out Sound) **Special Effects** Fred Raimondi (Digital Domain)
Director Lance Acord **Editor** Eric Zumbrunnen (Spot Welders) **Executive Producer** Jackie
Kelman Bisbee **Producer** Deannie O'Neil **Production Company** Park Pictures **Agency** 180
Amsterdam (180\TBWA) **Client** adidas International **Country** Netherlands

(see related work on pages 60, 72, and 97)

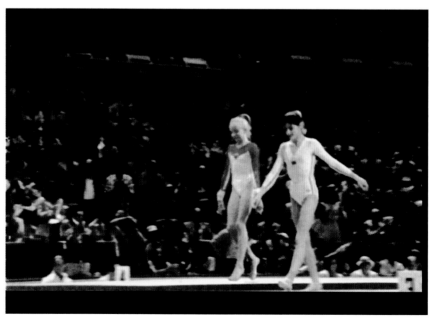

Communications Objective: Our objective was to tap into the emotion and truth felt in all athletes for whom sport is more than a way to stay physically fit or a means to a large paycheck. It's about accomplishment, passion, love of the game, and competition against themselves and others...it's about the spirit of people who believe "Impossible is Nothing." Creative Strategy/ Solution: We used adidas athletes from the past and present to show that the brand has always been about the spirit of people who strive to express themselves through sport.

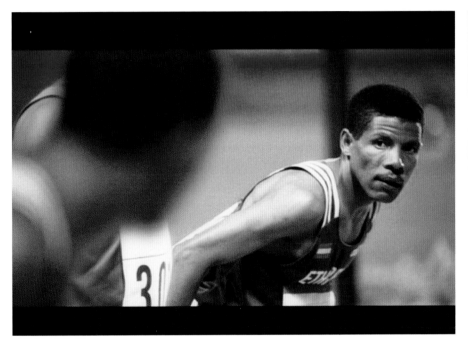

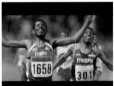

NADIA:

The 13-year-old gymnast Nastia Liukin literally follows in the path of the legendary Nadia Comaneci, the first gymnast ever to score a perfect "10."

HAILE:

The greatest runner of all time, Haile Gebrselassie, takes on the seemingly impossible challenge of beating himself.

JESSE:

The current world 100-meter champion Kim Collins encounters 1936 four-time Olympic Gold medal winner Jesse Owens on the track.

In this spot, a female prisoner is being visited by her emotional daughter. They are separated by a glass wall. The camera pulls back to reveal that the woman isn't in prison—she's in a bathtub behind a glass shower door and she's cleaning. Unfortunately, she's not using Vim Cream.

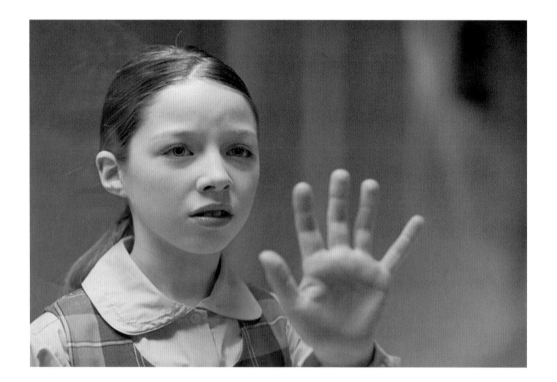

54

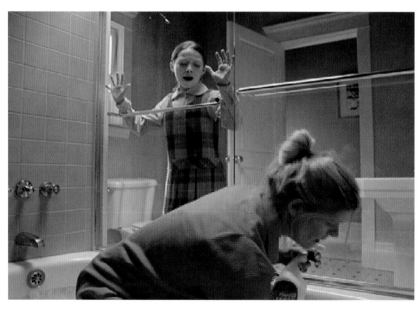

Cleaning is a horrible thing. There's nothing remotely fun about it. If you dance and smile while you clean, you have some major issues. These are the kinds of things we heard from focus groups. And after hearing people talk like this, it became clear what we had to do: show just how bad cleaning can be (if you're using the wrong product).

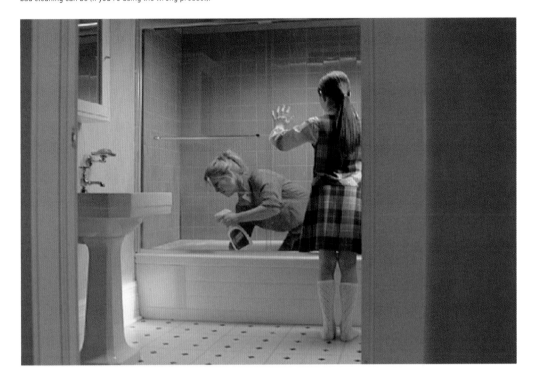

GOLD TV: 30 Seconds **Prison Visitor**

Art Director Stephen Leps **Creative Directors** Elspeth Lynn, Lorraine Tao **Copywriter** Aaron Starkman **Sound Design** Ted Rosnick (Rosnick Mackinnon Webster) **Agency Producer** Janet Woods **Project Manager** Christine Harron **Directors** The Perlorian Brothers **Editor** Michelle Czukar (Panic & Bob) **Producer** Bridgette Flynn **Executive Producer** James Davis **Production Company** Reginald Pike **Agency** ZiG **Client** Vim, Unilever **Country** Canada

This campaign demonstrates the problem of DVD players that don't play smoothly. People discuss a movie they saw in which the DVD skipped. An office worker told a colleague about the film he saw pevious night. A great bit of acting turns his stuttering attempts to relate the story of "Kill Bill" in to a memorably funny spot for the smooth-playing Soken DVD player. Soken DVD players were promoted by the woman's attempt to tell her friend about the film "Titanic" in an elevator. Her poor quality DVD player obviously kept sticking.

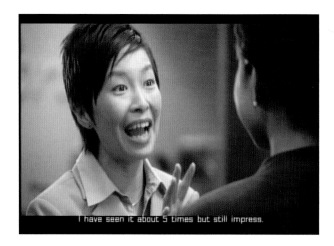

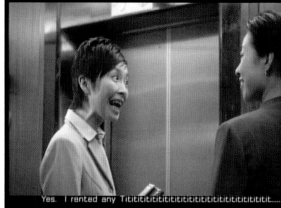

{MULTIPLE AWARD WINNER}

GOLD TV: Over 30 Seconds, Campaign **Soken DVD: Titititanic, Kill Bill Kill Bill, X...X...X**
GOLD TV: Over 30 Seconds **Kill Bill Kill Bill**
SILVER TV: Over 30 Seconds **Titititanic**

Art Directors Nimit Songsri, Wiboon Leepakpreeda **Creative Directors** Chukiat Jaroensuk, Wiboon Leedpakpreeda, Passapol Limpisirisan **Copywriters** Sittichai Okkararojkij, Passapol Limpisirisan **Director** Suthon Petchsuwan **Editor** Pongsathon Kosolpothisap **Producer** Phunyawee Intamas **Production Company** Matching Studio **Agency** Euro RSCG Flagship Ltd. **Client** Soken Electronics Co., Ltd. **Country** Thailand

56

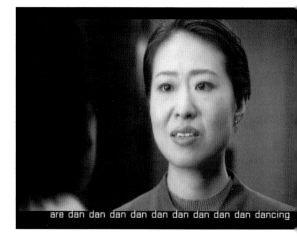

WOMAN 1: Have you seen DVD movie this week?
WOMAN 2: Yes.
WOMAN 1: I rented the Titititititititititititititi...tita...tita...titanic. I have seen it about 5 times but still impress. I really like the dancing party scene when Jack and Rose are Dan dan dan dan dan dan dan dancing...
MVO: Soken DVD...plays smoothly.

OFFICER: Hi! Bob, I bought "Kill Bill" DVD yesterday. Have you seen it before? Oh! It's so exciting. I like the scene that gangsters are trying to kill the heroine while she is holding...(freeze)...Then she sta...sta...sta...stabs one of the gangsters. Suddenly suddenly suddenly suddenly...

MVO: Soken DVD.....plays smoothly.

then she sta...sta...sta...stabs one of the gangsters.

heroine while she is holding............

I like the scene that the gangsters are trying to kill the

MAN: Last night, I watched a Japanese porn DVD. Fantastic! The schoolgirl is being...(Freeze)...In the bathroom...(Freeze)...

MVO: Soken DVD...plays smoothly.

in the bathroom............

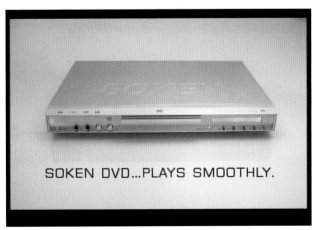

SOKEN DVD...PLAYS SMOOTHLY.

57

{**MULTIPLE AWARD WINNER**} (see also page 40)

GOLD Cinema: Public Service | Non-Profit, Campaign **Seek Truth: Drill, Voice, Flag**
GOLD Cinema: Public Service | Non-Profit **Voice**

Art Directors Phil Covitz, Brandon Sides, Tricia Ting **Creative Directors** Ron
Lawner, Alex Bogusky, Pete Favat, John Kearse, Tom Adams **Copywriters** John
Kearse, Marc Einhorn, Jackie Hathiramani **Director** Christian Hoagland **Editor**
Tom Scherma **Producer** Carron Pedonti **Production Company** Redtree Productions
Agencies Arnold Worldwide, Crispin Porter + Bogusky **Client** American Legacy
Foundation **Country** United States

There are questions that the folks from truth have for Big Tobacco. They head down to a
major tobacco company's headquarters and ask them questions. A woman's father was
sent an electric drill from a tobacco company. Two years earlier he'd died from smoking
their cigarettes. She builds a billboard that asks: "Why do you sell a product that kills
your customers?" In " Voice," pointing out the irony of some tobacco advertising, a
woman who uses an electronic voicebox asks whether her voice was what the tobacco
industry meant when its ads urged women to "find your voice." In "Flag," the Truth kids
raise a flagpole in front of Big Tobacco HQ, then lower it to half-mast, urging big tobacco
to do the same in honor of the 440,000 people who die from using their products every
year. A podium is set up for big tobacco to respond. They don't.

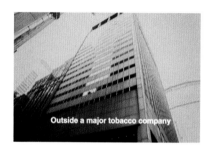

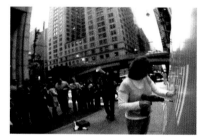

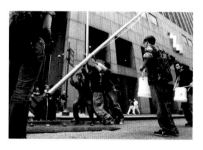

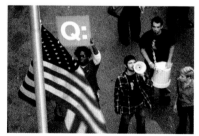

Seek Truth comes out of the idea that there are a lot of unanswered questions surrounding cigarettes and the tobacco industry. We wanted to encourage kids to ask questions. Because no matter how powerful or how much money someone has, he or she should still have to answer for his or her actions (except in Hollywood). To that end, we headed down to the headquarters of a giant tobacco corporation and let loose with the questions. The objective of this spot was to once again expose the hypocrisy and blatant lies that Big Tobacco has continued to tell consumers. In the tradition of other "truth" spots, a group of teens and a woman take on the monolithic tobacco industry. They use the tobacco company's very own words against them, which is a tobacco ad urging young women to "find your voice." In a chilling reveal, we find an electronic voice box assisting this woman's voice as she asks, "Is this the voice you wanted me to find?" The tag "Ask questions, seek truth" urges teens to questions the true motives of Big Tobacco.

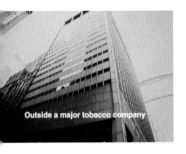

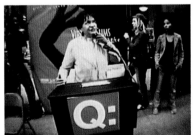

Open on the back of a moving truck.

TEEN: Let's go! Let's go!

Cut to quick shots of several truth teens unloading two podiums and a p.a. system in front of a tobacco company in New York City. People on the street stop and look to see what's going on.

TEEN: Get the platform!

The teens set up one podium with an "A:" sign on it in front of the tobacco office building. On the other side of the street facing the tobacco company, they set up another podium with a "Q:" sign on it. Behind the podium a giant Virginia Slims ad hangs with the tagline, "find your voice." A truth teen standing behind the "Q:" podium addresses the building and a gathering crowd. Next to her is a woman in her mid-50s, Grace.

TEEN: Tobacco companies have been targeting women for the past 70 years, asking us to find our own voice. Today, my friend Grace has a question for you guys.

Grace approaches the microphone. We realize she's a throat cancer patient, who's had a tracheotomy/laryngectomy. She speaks through an electronic voice box.

GRACE: (looking up to building) Is this the voice you expected me to find?

Cut to the "A:" podium in front of the tobacco company. No one comes out from the building or approaches the podium. It remains vacant. Cut back to Grace and the crowd waiting for an answer.

SUPER: Ask questions

SUPER: Seek truth

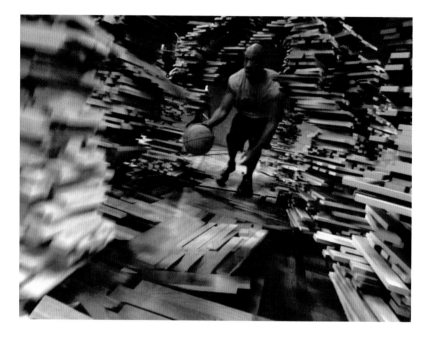

{MULTIPLE AWARD WINNER} (see related work on pages 52, 72, and 97)

GOLD Special Effects, Campaign **Impossible is Nothing Basketball: Improvisation, Carry, Unstoppable**
DISTINCTIVE MERIT Special Effects **Carry**
DISTINCTIVE MERIT TV: Over 30 Seconds **Unstoppable**

Art Director Geoff Edwards **Creative Director** Chuck McBride, Geoff Edwards **Copywriter** Scott Duchon
Directors Jake Scott (Improvisation), Brian Beletec (Unstoppable), Noam Murro (Carry) **Editors** Kirk Baxter
(Improvisation), Maury Loeb (Unstoppable), Avi Oron (Carry) **Directors of Photography** Barry Peterson,
Jeff Cronenweth **Effects Supervisor** Cedric Nicolas **Visual Effects** Method, Digital Domain **Sound Designer**
Ren Klyce **Agency Executive Producer** Jennifer Golub **Producer** Brian Carmody (Unstoppable) **Assistant
Producer** Andrea Bustabade **Production Companies** RSA USA (Improvisation), Smuggler (Unstoppable),
Biscuit Filmworks (Carry) **Agency** 180 Amsterdam (180\TBWA) **Client** adidas **Country** United States

Adidas has made great strides in recent years by signing some of the top basketball players in the world. The
objective was to show the world that adidas basketball has a point of view that encompasses the game's
leadership, tenacity, and creativity. The challenge was to disrupt the basketball category with smart, sophisticated
work that showed the personality and skill of the players in a new way. Since all the work had to live up to the tagline
"IMPOSSIBLE IS NOTHING," we had a large mind space to operate in. Whether it was demonstrating leadership
by having one man carrying 500 people on his back or giving a peek into what's inside a great players head while he's
practicing, it had to elevate the brand as well as the players.

"Carry" is a story of Kevin Garnett's leadership. As he walks down a street we see friends, family, teammates and fans all climb onto his back. In the end he is gladly carrying 500 people down the street. "Unstoppable" is a story of Tracy McGrady against a miniature army of helicopters, paratroopers, and land vehicles that all try to stop him with ropes. In the end McGrady breaks free of their web of ropes on his way to scoring a basket. "Improvisation" is a story of the wood on a basketball court coming to life to form obstacles to try to throw Chauncey Billups off his game. Billups makes it through the gauntlet of wood and then walks off the court into a waiting room to hand the ball to the next player.

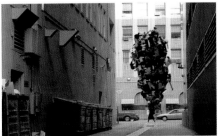

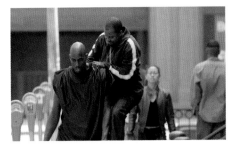

MUSIC: "He's Got the Whole World in his Hands," sung by Etta James.

Open on KG and a friend walking out of a doorway and onto a downtown street. KG stops walking and braces himself as his friend climbs up his body and onto his shoulders. KG then continues to walk down the street, where we see more and more people climb on top of him. His childhood friends, his sister, and his teammates from the Minnesota Timberwolves all join the rest of the people in the city who are jumping out of moving cars, off of five-story buildings, and out of public buses to climb on to KG. Finally, we see KG walking down the street with over 500 people on top of him.

SUPER: Impossible Is Nothing

LOGO: adidas

Open on T-MAC in the middle of a private workout. T-MAC makes one shot and is instantly passed another basketball. As T-MAC turns to run to the other end of the court, we begin to see and hear a pair of miniature helicopters heading toward his neck with a choke line. T-MAC is now under a full aerial and land attack. Helicopters deploy paratroopers, who land on T-MAC with rope packs that they drop to the ground, where they are picked up and anchored to moving land vehicles. T-MAC rises to dunk the ball with hundreds of ropes, helicopters and land vehicles attached to him. Just as he is about to dunk the ball, all of the ropes snap and the defeated troops spiral away. When T-MAC lands on the ground he returns to his workout with no trace of the attack.

SUPER: Impossible Is Nothing

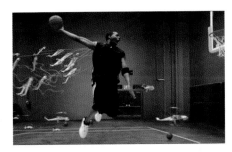

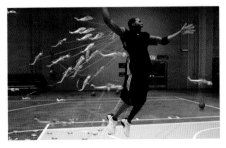

We added a paranormal twist to the Ghost Pops delivery
vehicles by adding contravision decals. These vehicles did the
rounds at stores, shopping mall parking lots, and schools.

GOLD Guerrilla | Unconventional **Driverless Delivery Vehicle**

Art Director Marion Bryan **Creative Directors** Mike Schalit, Julian Watt
Copywriter Asheen Naidu **Producer** Clinton Mitri **Production Company**
Beith Digital **Photographers** Gerard Turnley, Michael Meyersfeld **Agency**
NET#WORK BBDO **Client** Simba Ghost Pops **Country** South Africa

SILVER TV: 30 Seconds, Campaign **MTV: Foosball, Nail Artist, Salesman**

Art Directors Randy Krallman/Aaron Stoller **Creative Director** Kevin Mackall **Copywriter** Randy Krallman **Co-Directors** Randy Krallman/Aaron Stoller **Editor** Rob Auten (Brand New School) **Executive Producer** Amy Campbell **Producer** Keif Matera **Production Company** MTV On-Air Promos **Agency** MTV **Client** MTV **Country** United States

I thought it would be funny to arbitrarily and boldly claim MTV's superiority without a shred
of empirical data. Then it seemed funny to personify MTV, and even funnier (and less self-
congratulatory) if these people were dominant at careers no one gives a shit about. Kevin Mackall
(head of MTV promos) is a true Renaissance man and the most unassuming genius you'll ever meet.
Once he likes something, he'll throw twenty good ideas at you and then send you out to make
the thing. That trust is incredibly motivating and explains the quality of work from MTV promos. Alec
Baldwin made these spots what they are. He's a living legend whose generous involvement would
not have been possible if not for the silken charm of producer Brent Stoller. Lastly, co-directing with
Brent's brother, the supremely talented and handsome Aaron Stoller, was a dream.

Open on the inside of a sparsely furnished classroom. On the wall of the room is a blackboard with "Short film workshop: Good Cop/Bad Cop" written on it. A group of students sit cross-legged on the floor, their backs to camera. Two students are sitting facing one another, one playing a cop and the other a suspect. Another student playing a cop stands looking on. The teacher stands off to the side watching.

STUDENT 1: Where'd you hide the gun? We know you did it, scumbag!

The standing student interrupts:

STUDENT 2: Hey, Mary, take it easy—let's get her a cuppa coffee or something.

The teacher sighs and takes a step forward, looking at his watch.

TEACHER: And roll the credits. Too long, sit down.

The two students get up and head off to sit down, leaving the student acting as the suspect sitting in front of the class.

TEACHER: "Good cop/bad cop" is very tough to do in a short film. Luckily I've developed a method.

The teacher moves over and sits with the student who is playing the suspect.

TEACHER: The Heidegger method.

The teacher turns to the student.

TEACHER: Confess bitch, nice hair.

He turns to the class with a knowing nod.

Cut to the end slate and the "Worldwide Short Film Festival" logo.

Open on the inside of a sparsely furnished classroom. On the wall of the room is a blackboard with "Short film actor's workshop: Love Scene" written on it. A group of students sit cross-legged on the floor, their backs to us, watching the scene. The teacher is standing before the group with two students. After a moment he says:

TEACHER: Steve, John, make passionate love to each other.

The two students look at one another, then begin to move closer together, beginning to hug.

The teacher stops the students.

TEACHER: Enough; that was terrible. Sit down.

The two students head off to sit down.

TEACHER: It's a short film, okay.

The teacher calls up another student to help him demonstrate.

TEACHER: Ron, please come up here.

The student hurries to the front of the class.

The teacher begins to take off his shirt, saying:

The love scene technique I'm about to show you will allow you to make love effectively in less than three seconds. Pay attention; this is going to happen very fast.

He then begins to run across the room toward the horrified student.

Cut to the end slate and the "Worldwide Short Film Festival" logo.

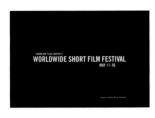

{MULTIPLE AWARD WINNER}

SILVER TV: 30 Seconds, Campaign **Good Cop/Bad Cop, Love Scene, Establishing a Character**
DISTINCTIVE MERIT TV: 30 Seconds **Good Cop/Bad Cop**
DISTINCTIVE MERIT TV: 30 Seconds **Love Scene**
MERIT TV: 30 Seconds **Establishing a Character**

Art Director Dave Douglass **Creative Director** Zak Mroueh **Copywriter** Pete Breton **Director of Photography/Cinematographer** Andre Pienaar **Agency Producer** Sam Benson **Sound Design** Rene Bharti **Music House** Company X **Editing House** Third Floor Editing **Account Manager** Amanda Gaspard **Director** Tim Godsall **Editor** Brian Wells **Producer** James Davis **Production Company** untitled **Agency** TAXI **Client** Canadian Film Centre's Worldwide Short Film Festival **Country** Canada

Strategy: To attract new ticket subscribers to the festival by playing off its distinguishing feature, shorter films. Inspiration: We were inspired by our client, who opened the door and gave us a lot of creative freedom. It was terrifying, but exhilarating.

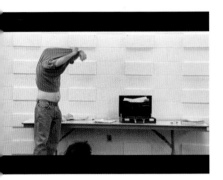

Open on the inside of a sparsely furnished classroom. A blackboard with "Short film actor's workshop—Establishing a Character" written on it is in the background. A group of students sit cross-legged on the floor, their backs to us, watching the scene. The teacher is standing before the group with two students, and after a moment one of the students begins the scene.
STUDENT 1: Flavious, you have angered the Gods.
STUDENT 2: And what of the Senate, Minimus?
The teacher immediately stops the students.
TEACHER: What?? I don't get it? Who's who?
The teacher points to one of the students.
TEACHER: Okay, sit down. When establishing your character in a short film, it's got to be quick.
The teacher stands in the scene with the remaining student. He looks at the class, then to the student in the scene with him, motioning to him.
TEACHER: Like this. Go again.
The student again begins the scene.
STUDENT 1: Flavious you—
The teacher reaches out and twists the student's nipple.
STUDENT 1: Ouch!
The teacher steps back and points to the student and them to himself as he speaks to the class, tapping his watch. The student nurses his nipple.
TEACHER: See that? Good guy/bad guy. Two seconds.
Cut to the end slate and "Worldwide Short Film Festival" logo.

SILVER TV: 30 Seconds **VW Golf Kids on Steps**

Art Directors Bart Kooij, Scott Smith **Creative Directors** Amir Kassaei, Wolfgang Schneider, Mathias Stiller **Copywriters** Nico Akkermann, Vinny Warren **Director** Sebastian Strasser **Producer** Pieter Lony **Production Company** Cobblestone Filmproduktion GmbH/Hamburg **Agency** DDB Berlin **Client** Volkswagen AG **Country** Germany

The Golf commercial "Kids on Steps" aimed to illustrate in a clever and humorous way the innovative technology of the Golf V: the direct shift gearbox. We see two boys sitting on the steps in front of a house, playing "driving." While one boy imitates motor sounds and changes gear, the other one just buzzes without a single break, running out of breath. He knows DSG—it shifts gears without any interruption.

69

The Golf with Direct Shift Gearbox.

eBay was founded in 1995 on the belief that people are inherently good. Since then, eBay has over 135 million registered users in 32 international markets. Each day there are millions of transactions.

{MULTIPLE AWARD WINNER}

SILVER TV: Over 30 Seconds, Campaign **The Power Of All Of Us: Toy Boat, Belief, Clocks**
DISTINCTIVE MERIT TV: Over 30 Seconds **Toy Boat**

Art Director Rob Palmer **Creative Directors** Jeff Goodby, Jamie Barrett, Rob Palmer **Copywriter**
Jamie Barrett **Assistant Producer** Mary Jane Otto **Director** Noam Murro **Editor** Avi Oron **Producer**
Cindy Fluitt **Production Company** Biscuit Filmworks **Agency** Goodby, Silverstein & Partners
Client eBay **Country** United States

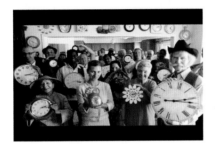 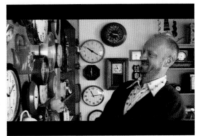

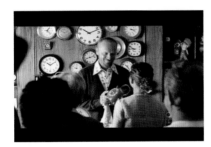

BELIEF:
eBay succeeds because people treat each other fairly on the site. In "Belief," we show different acts of kindness
happening in the real world, making the point that people are essentially good.
TITLE CARDS: We began with the belief that people are good. You proved it. eBay. The power of all of us.

TOY BOAT:
A young boy's toy boat is left behind after a trip to the beach and gets washed out to sea with the tide. The boat is
adrift as it weathers storms and boat traffic, and eventually sinks when hit by a propeller. Years later, it appears
again in the net of an Asian fisherman. The final scene shows the boy, now a man, discovering his long-lost toy boat
for sale on eBay.
VO: What if nothing was ever forgotten? What if nothing was ever lost? eBay. The power of all of us.

CLOCKS:
A clock collector is surprised to find thousands of of fellow collectors from around the world showing up in his
living room, at his front door, in his yard, in his neighborhood streets, and all the way out in the bay a mile or so
from his home. All hoping for a chance to sell him their unique clock.
VO: There are thousands of people who love what you love. How will you find them? eBay. The power of all of us.

{MULTIPLE AWARD WINNER}
(see related work on pages 52, 60, and 97)

SILVER TV: Spots of Varying Length, Campaign
Impossible is Nothing: Laila, Long Run, Stacy
SILVER Special Effects **Laila**

ArtDirector/Associate Creative Director Dean
Maryon **Executive Creative Directors** Peter
McHugh (180\TBWA), Lee Clow (TBWA Worldwide)
Copywriter/Creative Director Richard Bullock
Executive Agency Producer Peter Cline **Agency
Producer** Cedric Gairard **Special Effects** Fred
Raimondi (Digital Domain) **Sound Design** Ren Klyce
(Mit Out Sound) **Director** Lance Acord **Editor** Eric
Zumbrunnen (SpotWelders) **Executive Producer**
Jackie Kelman Bisbee **Producer** Deannie O'Neil
Production Company Park Pictures, New York
Agency 180 Amsterdam (180\TBWA) **Client** adidas
International **Country** Netherlands

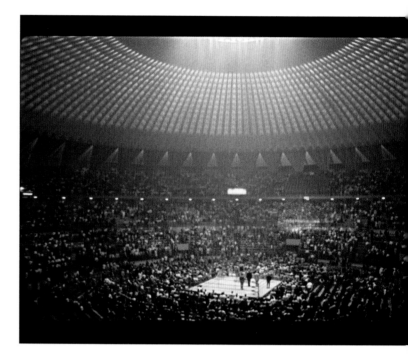

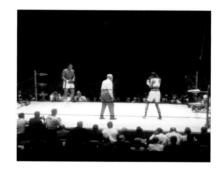 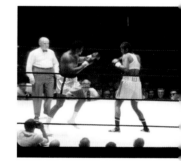

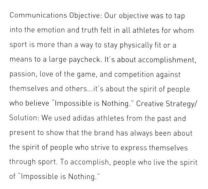

Communications Objective: Our objective was to tap
into the emotion and truth felt in all athletes for whom
sport is more than a way to stay physically fit or a
means to a large paycheck. It's about accomplishment,
passion, love of the game, and competition against
themselves and others...it's about the spirit of people
who believe "Impossible is Nothing." Creative Strategy/
Solution: We used adidas athletes from the past and
present to show that the brand has always been about
the spirit of people who strive to express themselves
through sport. To accomplish, people who live the spirit
of "Impossible is Nothing."

LAILA: Past and present collide when Laila Ali steps
into the ring and faces her father, Muhammed Ali.

LONG RUN: A young Muhammed Ali is joined for his
morning run by current stars from the world of sports.

STACY: Para-Olympian Stacy Kohut demonstrates
his extraordinary ability to drop into a fourteen-foot
vertical ramp in a wheelchair.

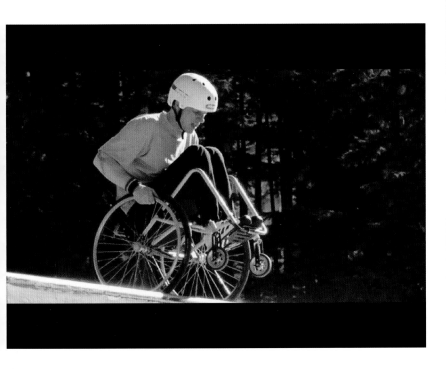

SILVER TV: Over 30 Seconds **Russian Family**

Art Director Stefan Copiz **Creative Directors** Jeff Goodby,
Rich Silverstein **Copywriter** Tyler McKellar **Assistant
Producer** Alex Lind **Director** Noam Murro **Editor** Dylan
Tischner **Producer** Tod Puckett **Production Company** Biscuit
Filmworks **Agency** Goodby, Silverstein & Partners **Client**
California Milk Processor Board **Country** United States

Eleven years after the inception of the got milk? campaign, we
faced the challenge of creating an ad that was unique from its
memorable, award-winning predecessors.

The Pillsbury Doughboy turns a Russian family's dull dinner
into a cookie-filled celebration. The absence of milk brings
them back to cold reality.

INTERVIEW:

All animated. Open on a window shade being pulled up. A young man jumps out of bed early. It's an important day. He grooms himself carefully and changes ties several times. Cut to him flying. Cut to him hailing a cab. In an elevator, he looks down, and is appalled to see that his shoes don't match. Then, he's rigorously interviewed by three people. They shake hands, and he leaves. He's walking down the street, a little despondent (the music reflects this). He answers his cell phone, breaks into a grin, and literally jumps for joy. (He obviously got the job.) (The music rises.) He's on a plane, sleeping near the window. A flight attendant leans over and pulls down the shade.

VO: Where you go in life is up to you. There's one airline that can take you there. United. It's time to fly.

LOGO: United. It's time to fly.

{MULTIPLE AWARD WINNER}

SILVER Animation **Interview**
MERIT Animation, Campaign **Interview, Rose, Light Bulb**
MERIT Art Direction **Interview**

Art Director Bob Barrie **Creative Directors** Bruce Bildsten, Stuart D'Rozario, David Lubars **Copywriter** Stuart D'Rozario **Directors** Wendy Tilby, Amanda Forbis, Joanna Quinn, Alexander Petrov **Editor** George Khair **Producers** Kate Talbott (Fallon), Sofia Akinyele-Trokey (Fallon), Ron Diamond (Acme Filmworks), Holly Stone (Acme Filmworks), Howard Huxham (PPBmex Animation) **Production Companies** Acme Filmworks, PPBmex Animation **Agency** Fallon **Client** United Airlines **Country** United States

To stand out from the mind-numbing sameness of today's televison advertising, we chose to tell stories executed in traditional animation styles.

ROSE:

All animated. Open on a man finishing dressing. He picks a rose from his garden, smells it, and gets in a cab, where he carefully places it in his briefcase. At the United counter, two agents see the rose in his briefcase and smile. On the plane. He orders water, puts the rose in the glass, and places it in the window. Cut to him finishing his meeting and packing up. He adjusts the rose again. Cut to his cab pulling up outside an apartment building. He's in the elevator, rose in hand. It's all quite romantic. He rings the doorbell, and an old woman opens the door. It's his mother. He smiles, hands her the rose, enters, and the door shuts behind them.

VO: Where you go in life is up to you. There's one airline that can take you there. United. It's time to fly.

LOGO: United. It's time to fly.

LIGHTBULB:

All animated. An exasperated woman is working late. Suddenly, a lightbulb appears above her head. Cut to her talking with a colleague. Suddenly, the lightbulb appears over her head, too. Now our woman is flying off to present the idea. It's received well: a lightbulb appears over her client's head. They shake hands. She boards another plane, now more confident. The lightbulb is now above her head and her business partner's head, too. They make one successful presentation after another. The idea is contagious; many more lightbulbs appear over heads. Now, the lightbulb is flying off assembly lines and being promoted on billboards. At the end, our woman's lightbulb is hovering above everyone's head all over the city.

VO: Where you go in life is up to you. There's one airline that can take you there. United. It's time to fly.

LOGO: United. It's time to fly.

SILVER Special Effects **Carbot (Citroen C4)**

Art Directors Matthew Anderson, Steve Nicholls **Creative Director**
Justin Hooper **Copywriters** Matthew Anderson, Steve Nicholls
Stunts Marty Kudelka **Animators** Winston Helgason, Simon Van
De Lagemaat, Neill Blomkamp **Director** Neill Blomkamp **Editors**
Stephen Pepper, Jon Anastasiades **Producers** Winston Helgason (Spy
Films), Nicola Tucker (Euro RSCG) **Production Company** Spy Films
Agency EuroRSCG London **Client** Citroen **Country** United Kingdom

The Objective: Launch Citroen's new small family car, the C4. The Challenge:
Produce an engaging ad in an already cluttered sector, to work across
Europe. The Solution: Write something simple and single-minded; work
with never-say-die agency people; employ Marty Kudelka to do your motion
capture dance moves (he's Justin Timberlake's choreographer); and shoot
with the hottest young director and VFX team in town. Oh, and hope that 1,512
decisions go your way.

The new Citroen C4 bristles with electronic gadgetry. So much so that it can't
help but to get up and have a dance. The new Citroen C4. Alive with technology.

SILVER Special Effects **Francois**
DISTINCTIVE MERIT Special Effects **Picture Book**
MERIT TV: Spots of Varying Length, Campaign
Picture Book: Francois, Relay, Picture Book

Art Director John Norman **Creative Director** Rich Silverstein
Associate Creative Directors Steve Simpson, John Norman
Copywriter Steve Simpson **Assistant Producer** Brian
Coate **Director** Francoise Vogel **Editor** Hal Honigsberg
Producer Josh Reynolds **Production Company** Paranoid
Project: Tool of North America **Agency** Goodby, Silverstein
& Partners **Client** Hewlett Packard **Country** United States

In HP's "Picture Book," we celebrate the magic of digital
photography through the squares, streets, and studios of
Stockholm. Everyone plays with pictures—and plays with reality.
In "Francois," we see photos being pulled "out of thin air." It
is a simple scene, designed to show the magic, and ease, of
photo-making. In "Relay," we follow a photographic "relay game,"
in which the players travel the streets of Stockholm through a
series of photos within photos within photos. HP's strategy in
digital photography is simplicity, radical simplicity. The director
Francois Vogel's visual trickery met this brief neatly.

SILVER Radio: Over 30 Seconds **Genius/Mr. Really Big Pet Snake Owner**
MERIT Radio: Over 30 Seconds, Campaign **Genius: Mr. Over-The-Top Carb Counter, Mr. Really Big Pet Snake Owner, Mr. Cargo Pants Designer**

Group Creative Director John Immesoete **Creative Directors** Mark Gross, Bill Cimino, Bob Winter **Associate Creative Director** Chris Roe **Copywriters** Mark Gross, Bill Cimino, Bob Winter, Chris Roe **Other** Scandal Music **Audio Engineer** Dave Gerbosi **Executive Producer** Marianne Newton **Production Company** Chicago Recording Company **Agency** DDB Chicago **Client** Anheuser-Busch **Country** United States

Winner's Statement by Mark Gross (Group Creative Director): As co-creator of the Real Men of Genius Campaign people often ask me if any of the people responsible for writing the actual spots are in fact real geniuses. The answer is no. But, in case you were wondering, I've listed the actual IQ's of all the people who helped make Real Men of Genius possible. Please note, 140 and above is considered genius. Mark Gross – 137 Bill Cimino – 138 John Immesoete – 139 Bob Winter – 136 Marianne Newton – 136.

bud light presents, real.men.of genius.

Mr. Over-the-Top Carb Counter
MUSIC UP
ANNOUNCER: Bud Light Presents, Real. Men. of Genius
SINGER: Real Men of Genius!
ANNOUNCER: Today we salute you...Mr. Over-the-top Carb Counter
SINGER: Mr. Over-the-top Carb Counter
ANNOUNCER: Brushing aside such follies as work and family, you wisely adopted carbo counting as your primary pastime.
SINGER: I'm crazy for carbs
ANNOUNCER: From breakfast through dinner you tirelessly record every precious carb, hoping it might add up to your target number: zero.
SINGER: Hold on to your dream now.
ANNOUNCER: What's that artichoke you ate 13.5 carbs or 13.6? Better look it up while you help yourself to another package of bacon.
SINGER: I like it crispy
ANNOUNCER: So crack open an ice cold Bud Light, oh Count of Monte Carbo (SFX: BEER OPENING.)... because the only thing better then meat and potatoes is meat and meat.
ANNOUNCER: Bud Light Beer. Anheuser-Busch, St. Louis, Missouri.

Mr. Really Big Pet Snake Owner
MUSIC UP
ANNOUNCER: Bud Light Presents, Real. Men. Of Genius.
SINGER: Real men of Genius!
ANNOUNCER: Today we salute you, Mr. Really Big Pet Snake Owner.
SINGER: Mr. Really big pet snake owner
ANNOUNCER: No walks, no barking, no picking up poo. Just the remote chance it might strangle you.
SINGER: Ohhhh!!!
ANNOUNCER: Sure, dogs are faithful companions. But can they swallow sheep whole?
SINGER: Totally Awesome!!
ANNOUNCER: It's not as creepy as a tarantala. But you probably have one of those too.
SINGER: One Big happy family!!!
ANNOUNCER: Best of all, it doesn't hurt your social life to be known around town as the guy with the giant snake.
SINGER: Ninety-six inches!!!
ANNOUNCER: So crack open an ice cold Bud Light, Mr. Slither.
(SFX: BOTTLE OPEN)
We'd like to shake your hand, but first put away your snake.
SINGER: Put our Snake Away!!!!!
ANNOUNCER: Bud Light Beer. Anheuser-Busch, St. Louis, Missouri.

Mr. Cargo Pants Designer
MUSIC UP
ANNOUNCER: Bud Light Presents, Real. Men. Of Genius.
SINGER: Real men of Genius!
ANNOUNCER: Today we salute you, Mr. Cargo Pants Designer.
SINGER: Mr. Cargo Pants Designer
ANNOUNCER: You finally gave us what we wanted: the military look without all the bothersome drilling, marching, and shooting.
SINGER: Fashion Victory!!
ANNOUNCER: Is that a banana in your pocket? Yes. And an orange and a pocket comb and an extra set of keys and my sunglasses
SINGER: Totally Prepared Now!!
ANNOUNCER: How many times have you been in a restaurant and thought, "man, I wish I brought my own jar of mayonnaise"? Now you can.
SINGER: Yeah!!!!!!
ANNOUNCER: So crack open an ice cold Bud Light oh Prince of the Pockets (SFX: BEER OPENING.) Some may fill your shoes but none can fill your pants.
SINGER: Mr. Cargo Pants Designer!
ANNOUNCER: Bud Light Beer. Anheuser-Busch, St. Louis, Missouri.

SILVER Newspaper, Public Service | Non-Profit, Full Page **Bridge**

Art Director Daryl Gardiner **Creative Director** Alan Russell **Copywriter** Kevin Rathgeber
Account Manager Christina Tan **Producer** Gayle Robson **Photographer** Frank Hoedl **Agency**
DDB Canada, Vancouver **Client** United Way of the Lower Mainland **Country** Canada

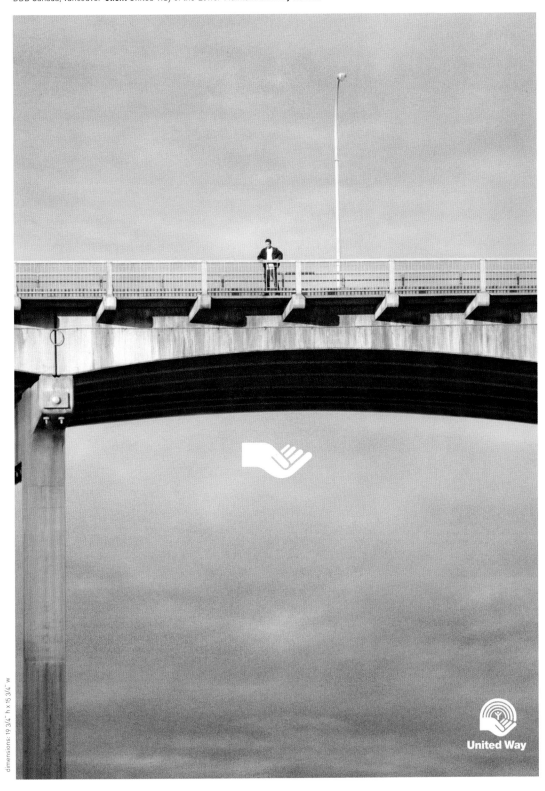

dimensions: 19 3/4˝ h x 15 3/4˝ w

We wanted the United Way to get noticed. We wanted people to understand what the United Way does in the community. And, of course, we wanted to raise money. This campaign was a departure from what United Way has done in the past. There were no smiling faces. No laughing children. No happy families. We still wanted to connect with people emotionally, but in a starkly realistic way. We created a simple solution: negative situations turned positive through the intervention of the United Way "hand." We had few resources. Photographer Frank Hoedl donated much of his time. Thanks Frank. And special thanks to Christina Tan, Bill Baker, and Frank Palmer for making this campaign a reality.

On the *Strasse des siebzehnten Juni*, Berlin, 1989 & 2004

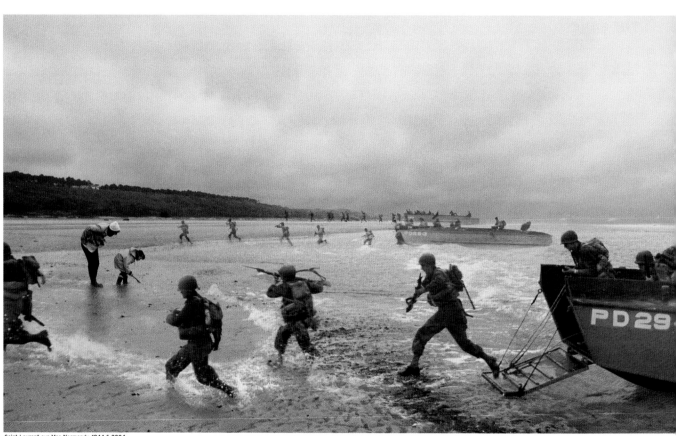

Saint-Laurent-sur-Mer, Normandy, 1944 & 2004

 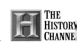

SILVER Magazine, Consumer, Spread, Campaign
History Channel International/Know Where You Stand: Berlin Wall, Normandy, Hindenburg

Art Director Jeff Lable **Creative Director** Court Crandall **Copywriter** Tom O'Connor **Photographer** Seth Taras **Photo Retoucher** Leo Chapman **Producer** Linda Ehrke **Agency** Ground Zero **Client** International History Channel **Country** United States

In our daily life, the great events of history are invisible to us—all we can see is the present. In a visually striking way, this campaign reminds us that truly amazing things have happened in our world, and tells us we can still see them—on The History Channel.

SILVER Outdoor | Billboard **Pendulum**

Art Director Molly Sheahan **Creative
Director** Ari Merkin **Copywriter** Marty
Senn **Producer** Louise Doherty
Photographers Steve Liss, Paula Bronstein
Agency Fallon New York **Client** TIME
Magazine **Country** United States

The existing Red Border print campaign
served as inspiration, and a lucky head-start.
How do you evolve one of the most classic
campaigns of all time for the outdoors? It
became about new ways to use the Red Border
that would be impossible in other mediums.
For Pendulum, the board was going to be
up for one month before the election, so it was
a natural fit. It let people know about TIME's
balanced approach to the election, and also
served as a countdown to the actual day.

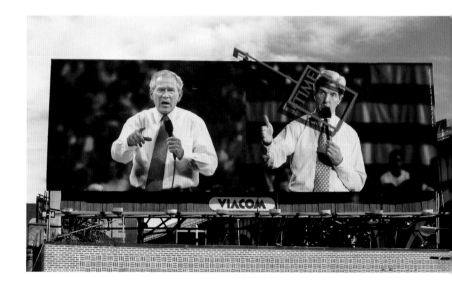

82

The challenge was to bring the excitement and spectacle of the Olympics to this part of the world when the games themselves are taking place on the other side of the world. Our solution was to take the glamour event of the summer Olympics to death-defying heights by placing 100-meter tracks on the sides of skyscrapers in Hong Kong and Osaka and running heats, semis, and a final over the three weekends of the games. This allowed us to demonstrate the spirit of Impossible is Nothing, not just talk about it. The result? It has earned over $80 million in free publicity locally, regionally, and globally. A CNN reporter rappelled down the length of the track and filed his report vertically (albeit nervously). Best of all, both the Gravity Games and the X-Games have expressed interest in making it a "real sport."

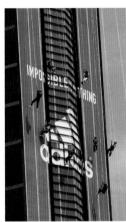

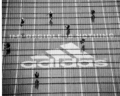

SILVER Outdoor | Billboard **Impossible Sprint**

Art Directors Shintaro Hashimoto, Hirofumi Nakajima **Creative Director** John Merrifield
Copywriter John Merrifield **Agency** TBWA\Japan **Client** adidas **Country** Japan

(see related work on pages 32 and 167)

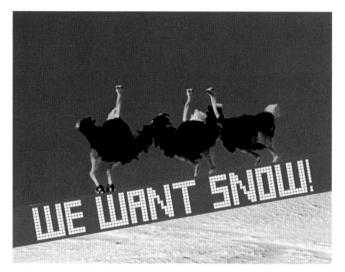

The client gave us one simple request: to make a strong campaign that would once again excite people's interest in skiing, which has been on an all-out downtrend. What we cared about most in the development was to make the ostrich look as realistic as possible. We could find no prior example anywhere for reference, so we ended up taking a month just to develop the right methodology. And I guess we made it happen.

This commercial is the sequence of a campaign that was launched last year. A dying man who just absolutely loves to ski wishes to be reincarnated so that he can once again engage in his one passion. His wish is granted and he is reborn, but instead of as a human being, he comes back as an ostrich, which should seemingly prevent him from skiing. But the man/ostrich is determined. He arrives at the mountain and succeeds in showing off his amazing skill, becoming the hero of the slopes. His wish has truly been granted. The second commercial in this series sees the ostrich joined by two other friends/ostriches, displaying an even higher level of skiing technique.

DISTINCTIVE MERIT TV: 30 Seconds **Triple Jump**

Creative Director Yasumichi Oka **Copywriter** Taku Tada **Director** Hideyuki Tanaka **Editor** Kumio Onaga, Rokurota Shimizu **Producers** Hiroyuki Taniguchi, Kazuya Nemoto **Product Company** Tohokushinsha Film Corporation **Agencies** Tugboat, East Japan Marketing & Communications Inc. **Client** Japan Snow Project **Country** Japan

With all of MTV's properties, it is now about more than just the network. This spot nods to that by boldly proclaiming that if MTV were personified, it would be dominant at whatever it tried. In contrast to the brash confidence of the claim, the personifications are distinctly non-MTV demographics. However, in each case, there is something distinctly MTV about their character.

A confident industrial supplies sales rep slides into a meeting with middle management at a pipe factory. By playing cool, he charms the person responsible for all purchasing decisions and wins the sale. A super comes up and boldly proclaims that if MTV were an industrial supplies sales rep, it would dominate all other industrial supplies sales reps. Narration by Sir Alec Baldwin.

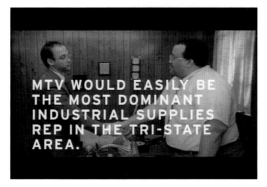

DISTINCTIVE MERIT TV: 30 Seconds **Sales Rep**

Art Director Aaron Stoller **Creative Director** Kevin Mackall **Copywriter** Randy Krallman **Director of Photography** Brian Neuman **Music/Sound Design** Paul Goldman **Directors** Aaron Stoller, Randy Krallman **Editor** Rob Auten (Brand New School) **Producer** Keif Matera **Production Company** MTV On-Air Promos **Agency** MTV On-Air Promos **Client** MTV **Country** United States

We open on what appears to be a "normal" wedding: a groom, a bride, a best man, and a maid of honor. The justice of the peace walks out and settles in the center of the group. After he opens his book to start the ceremony, those to be wed hold hands. But the groom reaches out and holds the best man's hand and the bride reaches out and holds the maid of honor's hand.
SUPER: MTV logo.
SUPER: Watch and learn.

Open on a group of friends sitting around a table having dinner and talking. In the left-hand corner we see a graphic, the word "lull" in a box. It looks like an unilluminated applause sign at a television studio. The story reaches its climax.
MAN: ...and Marci says to the bell hop... that's not my bag!
Everyone bursts out laughing after hearing the ending. At this point a number "5" appears next to the "lull" sign. As soon as the number pops onto the screen it begins to count down. The laughter lingers, but soon dies down. Just as the counter reaches "0" the laughter is completely gone and everyone at the table is awkwardly quiet. It is at this point that the "lull" sign becomes illuminated. After a few seconds of silence, someone breaks it by talking again.
MAN 2: This one time...
The "lull" sign turns off.
SUPER: MTV logo.
SUPER: Watch and learn.

Open on a music video of a rap group singing: Bling Bling baby. Bling Bling.
Cut to the audience at the concert. Cut to a close-up of one man at the concert listening. Cut to that same man walking up to a friend. He points to his diamond earing and says, Bling Bling.
Cut to man's friend being interviewed by a sports reporter. We realize that he is a basketball player. He points to the championship ring on his finger and says, Bling Bling.
Cut to the interview playing on a tv. Cut to a teenage boy watching the interview on television. Cut to that same boy at school at his locker. As he points to the chain around his neck, he says to one of his friends, Bling Bling.
Another kid next to them overhears the teenage boy who says, Bling Bling to his friend. Cut to her. She points to her bracelet and says, Bling Bling.
Cut to a teacher who has overheard the girl talking to her friend. Cut to that teacher at home with his wife. He gives her some jewelery and says, Bling Bling.
Cut to his wife with her mother. She shows her mother the jewelry and in a nerd-like voice says, Bling. Bling.
SUPER: Bling. Bling. 1997-2003
SUPER: MTV logo.
SUPER: Watch and learn.

Open on a parent and her 7 or 8-year-old child watching television. As we watch the mother and son watch television we hear dialogue and sound effects from the movie.
WOMAN: James, thanks for dinner.
MAN: Anytime, Claire.
We hear two thugs kick in the door.
MAN: Who are you?!
THUG: Give us the girl!
MAN: Never!
We hear a fight break out with punches thrown, glass breaking, table smashing, etc. Woman screams as we hear guy getting his throat slit.
MAN: Come here and I'll slit your throat too!
We hear more fighting.
MAN: Have a nice trip down.
We hear him throw the thug out the window. After all the violence stops the woman very sweetly says,
WOMAN: James, you saved my life, come here and kiss me.
The mother covers her child's eyes.
SUPER: MTV logo.
SUPER: Watch and learn.

DISTINCTIVE MERIT TV: 30 Seconds, Campaign
Watch and Learn: Wedding, Lull, Bling Bling, Watching TV, Elevator Fakeout

Creative Director Kevin Mackall **Copywriter** Matt Vescovo **Sound Design** Metatechnik **Graphic Design/Editorial Company** Fad **Director** Matt Vescovo **Producer** Michael Bellino **Production Company** MTV On-Air Promos **Agency** MTV Networks **Client** MTV **Country** United States

As MTV's programming becomes more diverse, its brand identity runs the risk of blurring. This campaign's objective was to take everything that MTV has become and boil it down to one concise brand message. On the most basic of levels, MTV is where people tune in to get updated on what's in. Our message: when people turn on MTV, they watch and learn. To avoid this message coming across as too preachy, it was important that it be delivered in a voice consistent with MTV—funny, innovative, and cool. The result was MTV's fresh, animated how-to guide to living.

Open on a man in an elevator. We see another man running to try to catch that same elevator. The man in the elevator sees him and reaches for the open door button.
MAN RUNNING: Can you hold that please?
Cut to the man's arm moving toward the door open button. We see an arrow graphic which starts at the tip of his finger and follows a path to the door open button.
Cut back to the man running; he is getting closer.
MAN RUNNING: Can you hold that please?
Cut back to the man's finger getting closer to the button.
MAN RUNNING: Can you hold that please?
As soon as the elevator doors close far enough to block the vision of the man who is running, the graphic arrows directs the man to push just to the right of the door open button onto the metal panel. His finger follows the path of the arrow and hits the metal just to the right of the button, making it appear that he tried to open the doors.
MAN RUNNING: Can you hold that pl...
He is cut off by the elevator doors closing.
Cut to the man in the elevator going up by himself.
SUPER: MTV logo.
SUPER: Watch and learn.

DISTINCTIVE MERIT TV: 30 Seconds **Chameleons**

Art Directors Christina Yu, Alan Madill **Creative Directors** Jack Neary, Alan
Madill, Terry Drummond **Copywriters** Ian MacKellar, Terry Drummond
Special Effects AXYZ **Director** Kuntz & Maguire **Editor** David Hicks **Producer**
Margaret John **Production Company** newnew films **Agency** BBDO Canada
Client FedEx Canada Ltd. **Country** Canada

The insight is one we all know quite well: when in doubt, hide out.

We open in an open-concept office. We see a group of
employees going about their day. Some are filing. Some
are working on computers, and some talk on the phone.
A man walks in who is clearly in a position of authority.
BOSS: Hey, who shipped the two hundred boxes to Boston?
The employees look intimidated. This could only be a
question about a botched shipment, and no one wants to
take the blame for it. Like chameleons, the employees
start blending into their surroundings so the boss won't
see them. First, the guy near the filing cabinet starts to
fade into the background. His gray pants match the filing
cabinet. His cream white shirt matches the wall, and his
face merges perfectly with a poster of faces that hangs
on the wall behind him. A woman wearing a garden print
dress camouflages herself by stepping in front of a plant.
We cut to the boss. We see him straining to find his
employees, who have disappeared right in front of his eyes.
Then we see one individual who doesn't seem to have this
camouflaging skill. The boss's eyes settle on him.
BOSS: Was it you, Lewis?
Lewis looks around for support. He too can't see his co-
workers. He turns back to his boss.
LEWIS: (cautiously) I shipped it with FedEx.
The boss gestures approvingly at Lewis.
BOSS: You're a heck of a man doing a heck of a job, Lewis.
The boss looks around the room once more, then back to
Lewis. The boss leaves and Lewis's colleagues reappear.
They look jealous of his success.
VO: Trust the proven reliability of FedEx for all your
important packages...relax, it's FedEx.
LOGO: FedEx

DISTINCTIVE MERIT TV: Over 30 Seconds **Thanksgiving**

Art Director David Horowitz **Creative Director** Kevin Mackall **Copywriter** David Horowitz
Director of Photography Jim Fealy **Music/Sound Design** Paul Goldman **Director** David
Horowitz **Editor** Nathan Byrne **Producer** Betsy Blakemore **Production Company** MTV On-Air
Promos **Agency** MTV On-Air Promos **Client** MTV **Country** United States

MTV is made for young people and exists completely in their world. When adults get involved,
it just doesn't work. Here, a Thanksgiving dinner is interrupted when the grandfather has what
appears to be massive heart attack. While the emotionally shocked family frantically tries
to help him, he seems to be nearing death. Then suddenly he starts laughing, telling the family
they have been "Punk'd." It does not go over well.

DISTINCTIVE MERIT TV: Over 30 Seconds **Snowflakes**

Art Directors Wayne Best, Marcus Woolcott **Creative Directors** Ari
Merkin, Wayne Best **Copywriter** Adam Alshin **Designer** Kim Haxton
Directors Tom Kuntz, Mike Maguire **Editor** Jun Diaz **Producer** Zarina Mak
Production Company Morton Jankel Zander **Agency** Fallon New York
Client Virgin Mobile USA **Country** United States

Virgin Mobile USA rang in the 2004 holiday season with a unique approach to
traditional holiday advertising. Tasked with the objective of driving a larger
acquisition of new users than ever before, the campaign strategy focused on
the idea that the all-inclusive nature of Virgin Mobile Pay As You go makes it the
perfect holiday gift. To bring this to life, Virgin Mobile created a fictitious holiday
celebration called Chrismahanukwanzakah (the all-inclusive celebration with
no contractual obligations), communicating the idea that, over the holidays,
EVERYONE can live without a plan.

An oddly diverse cast of characters sing an upbeat song inspired by an
all-inclusive holiday named Chrismahanukwanzakah. Iconographies from
several religions are blended together to show that Virgin Mobile wants
to celebrate everyone's beliefs by bringing an eclectic group together for a
multidenominational celebration.

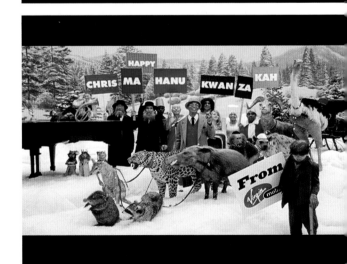

DISTINCTIVE MERIT TV: Over 30 Seconds **Glen**

Art Director Rob Baird **Creative Directors** David Lubars, Ari Merkin **Copywriter** Allon
Tatarka **Director** Noam Murro **Editor** Avi Oron **Producer** John Cline **Production Company**
Biscuit Filmworks **Agency** Fallon New York **Client** North American Coffee Partnership
Country United States

BRING ON THE DAY

Glen is drinking a Starbucks DoubleShot in his kitchen.
The song "Eye of the Tiger" starts to play. We see the band
Survivor chanting his name: "Glen, Glen, Glen, Glen!"
Survivor personalizes the song, telling Glen's story as they
follow him through his morning routine. The commercial
ends as Glen strides out of an elevator and another guy
walks in drinking a Starbucks DoubleShot. Survivor starts
playing the song again, singing to the new guy, "Roy!"

91

Our objectives with the Starbucks DoubleShot "Glen"
campaign were threefold: to increase awareness; to
motivate trial by offering clear reasons for when and
why you'd want to drink DoubleShot; and to create brand
fame with a campaign consumers would talk about.
Additionally, with a target of 18- to 34-year-olds, we
knew that there would be a lot of inveterate, marketing
related skepticism to overcome. We would have to
deliver our message in a unique and entertaining
way. Our solution came in the form of a guy named
"Glen" and a band that you might remember, Survivor.
We harnessed the power of music with Survivor's
personalized version of "Eye of the Tiger," and in doing
so brought the brand promise of liquid motivation to life.

DISTINCTIVE MERIT TV: Over 30 Seconds **Toys**

Art Director Eric Holden **Creative Director** Rémi Babinet **Copywriter** Rémi Noel **Director** Philippe André **Production Company** Wanda **Agency** BETC Euro RSCG, Euro RSCG Worldwide **Client** Peugeot Automobiles **Country** France

The Peugeot 407, following the success of the 406, is in the top-end family saloon category—in line with Peugeot's lineage and in step with the German "descent" of Mercedes, Audi, and BMW. In the campaign, Peugeot is expressed as a prominent brand that represents a blend of technical superiority with Latin style. Thus the striking, sleek Peugeot 407 emerges in a world where other cars seem mere toys—fun perhaps, but not very solid or practical: a doorless cab, a wooden car without a screen, a battery-powered car, and so on. The 407's advertising story unfurls around the return to a real automotive-centered message, a renaissance of sorts brought about by the advent of a new generation of cars. For what if the four-wheel drive vehicles we know today were actually just toys—fun, perhaps, but ultimately just that, toys? About as real as a doorless cab, a wooden car without a windscreen, a recycled car, a battery-powered car, and so on. Against this plastic and cardboard cut-out backdrop, the striking and avant-garde 407 emerges. The message is clear, and brought home by the final shot of a taken-aback toy-car driver beholding the dazzling 407.

DISTINCTIVE MERIT TV: Over 30 Seconds **What If?**

Art Director Hal Curtis **Creative Directors** Hal Curtis, Mike Byrne **Copywriter** Mike Byrne **Agency Producer** Jennifer Smejia
Director Ulf Johansson **Editor** Gavin Cutler **Producer** Sundy Proctor **Production Company** Smith & Jones Films **Agency**
Wieden+Kennedy **Client** Nike **Country** United States

"What If " had a couple of key objectives. First, bring back the Nike "Just Do It" message in an impactful way, and second, launch two key
spring footwear products, the men's Zoom Vapor Trainer and the women's Zoom Vapor Control. The premise of this campaign is that a great
athlete in one sport could be a great athlete in another sport, and it touched on the speed, athletic ability, heart, strength, desire, and drive of
Nike's marquee athletes. "What If" transports the viewer into an alternate reality to show what might have happened if the world's greatest
athletes had decided to play a different sport than the one for which they are known. For example, what if Michael Vick had been given a
hockey stick instead of a football when he was a child? When combining talent, skill, and heart, athletes believe that they can do anything.

93

DISTINCTIVE MERIT TV: Over 30 Seconds **Michael Vick Experience**

Art Director Ryan O'Rourke **Creative Directors** Mike Byrne, Hal Curtis
Copywriter Derek Barnes **Agency Producer** Vic Palumbo **Director**
Ulf Johansson **Editor** Russel Icke **Producer** Philipa Smith **Production**
Company Smith & Jones Films **Agency** Wieden+Kennedy **Client** Nike
Country United States

They say to truly understand someone else, you need to walk a day in his
or her shoes. Well, the only way to understand the speed, agility, creativity,
power, and confidence of the most dynamic athlete on the planet is to
do just that—get into his shoes. Michael Vick's shoes. The Michael Vick
Experience is a thrill ride that puts a young fan in the shoes of Michael Vick,
gives him instructions from Vick himself, drops him into the middle of a
real NFL play, and lets him experience what it is like to shred an All-Star
NFL defense and score the winning touchdown.

94

Open outside amusement park ride, "The Michael Vick Experience."
Cut inside ride. Kids are getting into MVE harnesses. Cut to boy getting in
harness and the attendant helping him. Cut to wide to ride starting up. Boy
carried forward. Cut to employee slapping boy's helmet. Boy cheers, raises
his hand in excitement. Cut to POV behind boy being taken into tunnel. Cut to
inside the tunnel. Holograms of Michael Vick giving instructions materialize
throughout tunnel. Cut to boy nervously checking his chinstrap. Screen goes
black as boy leaves tunnel. Cut to boy being lowered in darkness. Suddenly,
stadium lights flip on. The kid is in a real football game. Cut to NFL defensive
players preparing to blitz. Cut to boy in QB position. Cut to ball snapped and
he catches it by surprise; he is yanked backwards and his harness carries
him through the game as if he were Vick. Boy yells in fear as he is charged
by the players, and he narrowly misses a series of tacklers. As he crosses
the endzone, he flips over a defender and scores. Cut to boy relieved as he
realizes the ride is over. Falcons teammates pat his helmet. Vick hologram
shows up on the field.
SUPER: Photo of boy in ride.
SUPER: Just Do It
SUPER: nikegridiron.com
FEMALE VO (on loudspeaker): Welcome to the Michael Vick Experience
FEMALE VO: Please go to the next available chair
EMPLOYEE: Enjoy the ride.
MICHAEL VICK: Welcome to my ride. Before the fun starts, here's a few tips...
ANNOUNCER VO: Urlacker and Vick showing blitz...
SFX: Boy screams
MICHAEL VICK: Well, that's not in the playbook, but it should be.

DISTINCTIVE MERIT TV: Over 30 Seconds **Heart Attacks**

Art Directors Mariana Sa, Luiz Gustavo Dias **Creative Directors** Sergio Valente,
Pedro Cappeletti **Copywriter** Miguel Bemfica **Director** Luiz Gustavo Dias **Producer** Movi
& Art Team **Production Company** Movi & Art **Agency** DDB Brasil **Client** Bonjour Paris
French School **Country** Brazil

A hotel room. French music is playing and food and drinks are being enjoyed.
VO: In Japan, very little fat is eaten and the heart attack rate is lower than in the USA. In
France a lot of fat is eaten and the heart attack rate is lower than in the USA. In India very little
red wine is drunk and the heart attack rate is lower than in the USA. In Spain a lot of red wine
is drunk and the heart attack rate is lower than in the USA. In Brazil people have much more
sex than in Algeria. And the heart attack rate in both countries is lower than in the USA. In
other words: Drink. Eat. Have as much sex as you like. What can kill you is speaking English.
LOGO: Bonjour Paris L'École French School

In France a lot of fat is eaten and
the heart attack rate is lower than in the USA.

What can kill you

In Spain a lot of red wine is drunk and
the heart attack rate is lower than in the USA.

is speaking english.

DISTINCTIVE MERIT TV: Public Service | Non-Profit **Bus**

Art Director Kevin R. Smith **Creative Directors** Mark Andeer, Denny Haley **Copywriter** Ross Phernetton **Sound Design** Greg Geizenauer (Babble-On Recording) **Directors** Mark Andeer, Bill Weiss **Editor** Ross Phernetton **Producer** Amy Jo Shulteis **Agency** BBDO Minneapolis **Client** American Red Cross **Country** United States

With the blood supply running very low, we had to do more than remind people that the Red Cross needed donations. We needed to show people how desperate the situation was and challenge the idea that people are in control. We also wanted to do it in a memorable way that appealed to the sensibilities of a younger generation. After all, they're the future of the blood supply.

A man with a briefcase falls asleep on the bus. Fade to some time later: he's completely asleep. He then wakes up to find his sleeve rolled up with a bandage at the elbow. On his shirt is a red sticker that says, "Be nice to me. I gave blood today." On his briefcase are a cookie and a juice box. He's bewildered and confused.
SUPER: If we could just take it, we would. Reserves are critically low. Please give. American Red Cross 1-800-GIVE-LIFE

DISTINCTIVE MERIT TV: Low Budget **adidas: Plastic Ball**

Art Director Chuck McBride **Creative Director** Chuck McBride
Copywriter Chuck McBride **Director of Photography** Igor Jadue
Lillo **Post-Production** Final Cut Editorial **Executive Producer**
Jennifer Golub **Assistant Producer** Andrea Bustabade **Director** David
Frankham **Editor** Kirk Baxter **Production Company** Smuggler
Agency 180 Amsterdam (180\TBWA), San Francisco **Client** adidas
Country United States

(see related work on pages 52, 60, and 72)

Opens on a boy looking up to the sky. Cut to pink plastic bag blowing around in the sky. Cut to boy retrieving bag from the air. Stepping on it, he picks it up and places it in his pocket. Cut to him walking along the street, where he puts another bag in his pocket. A chain link fence is in the foreground. Cut to him climbing the fence and carefully picking a bag out of the barbed wire. He jumps down and walks on his way. Cut to the boy jumping up and leaning over into a city garbage bin. The shopkeeper comes out and bids him to leave. The boy walks away with a bag in his hand. Cut to a man sleeping. Cut to the boy watching the man sleep, carefully watching as he gently pulls a plastic bag from the man's shopping cart; he quickly walks away. Cut to the boy picking up bags as he walks along the streets. Cut to the boy entering a slashed chain link fence. He walks into the yard and sits cross-legged with his bags. Various close-up shots of him working with the bags; he stuffs and ties them together. Cut the boy getting up with his plastic ball; the city in the background. He does a back kick, sending the ball into the air, and bounces it from knee to knee.
Logo: Impossible is Nothing
Logo: adidas

In March 2004 adidas successfully launched the "Impossible Is Nothing" brand campaign, which featured some of the best and most famous athletes in the world. The challenge of the next stage of the campaign was to try to broaden the IIN Message to different athletes and sports and to localize the message. This is where the launch of Plastic Football took place. The goal of Plastic Football was to tell a true IIN story that adds to the look and feel of the brand campaign. Ultimately, showing the inspiration that lies within IIN, and the passion for football that is embodied by the adidas brand, were also key objectives. "Plastic Football" was a success. It tapped into the idea that anyone can compete on the global stage, regardless of wealth or ethnicity. It also demonstrated the breadth of the IIN message by showcasing how impossible stories are achieved by athletes on all levels.

{MULTIPLE AWARD WINNER}

DISTINCTIVE MERIT Cinema: Over 30 Seconds, Campaign **Vancouver International Film Festival: Geisha Cop, Hail Storm, The Pants I Have Owned**
DISTINCTIVE MERIT Copywriting **The Pants I Have Owned**

Art Director Jay Gundzik **Creative Director** Lisa Francila **Copywriter** Brent Wheeler **Designer** Calvin Yu **Director** Mark Gilbert **Editor** Melanie Snagg **Producers** James Davis, Josefina Nadurata, Carla Olson, Sam Ferguson **Production Company** Reginald Pike **Agency** TBWA\Vancouver **Client** Vancouver International Film Festival **Country** Canada

Vancouver's International Film Festival has always considered itself very "un-Hollywood." But this year we wanted to say something new. So we asked our client lots of questions. After a while, we hit paydirt. It turns out the Vancouver International Film Festival screens thousands of films every year. Very few make it in. So we thought to ourselves, "what were the films that didn't get in like?" From there we came up with lots of ideas for crappy films. Which, as it turns out, is very fun and easy to do.

Open on a foreign film filled with lots of Hollywood clichés. Cut to a row of film festival judges watching said film and then crossing it off their list of entries.
SUPER: Thousands are submitted. Few are Chosen.
Logo: Vancouver International Film Festival

Open on the beginning of a Croatian documentary. The subject of the documentary, "Dragon," is walking through a shopping district and shopping for pants.
VO: Over the course of my life I have owned many pants. Each pair is indelibly linked to my past: my successes, my failures, my hopes, and my dreams. Not many people take the time to consider the pants they have owned but I do.
SUPER: The Pants I Have Owned (Hlaãe Imam Je Dugovao)
VO: My first pair of pants were the center of much debate.
Cut to Dragon with his mother and father.
FATHER: The first pair we got him were corduroy.
DRAGON: They were plaid.
MOTHER: They were jeans!
Cut to a panel of judges watching the film. We see the title getting crossed out.
SUPER: Thousands are submitted. Few are chosen.
Logo: Vancouver International Film Festival

DISTINCTIVE MERIT Animation **Hallway**

Art Directors Doris Cassar, Bill Bruce **Creative
Director** Bill Bruce **Copywriters** Bill Bruce,
Doris Cassar **Sound Design** Francois Blaignon
Director Traktor **Editor** Tom Muldoon **Producers**
Traktor, Hyatt Choate (BBDO) **Production
Company** Partizan **Agency** BBDO New York
Client Mountain Dew **Country** United States

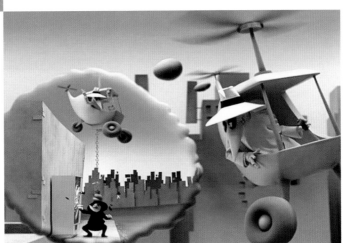

DISTINCTIVE MERIT Animation **Helicopter**

Art Directors Doris Cassar, Bill Bruce **Creative Director** Bill Bruce **Copywriters** Bill Bruce, Doris Cassar **Sound Design** Francois Blaignon **Director** Traktor **Editor** Tom Muldoon **Producers** Traktor, Hyatt Choate (BBDO) **Production Company** Partizan **Agency** BBDO New York **Client** Mountain Dew **Country** United States

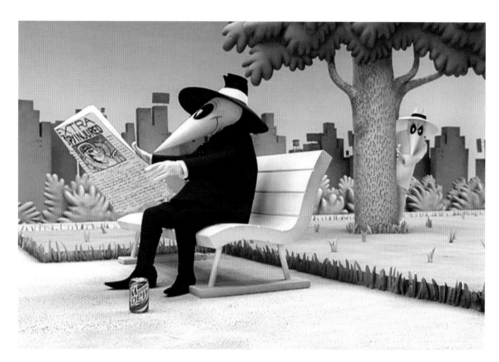

DISTINCTIVE MERIT Animation **Helicopter**

Art Directors Doris Cassar, Bill Bruce **Creative
Director** Bill Bruce **Copywriters** Bill Bruce,
Doris Cassar **Sound Design** Francois Blaignon
Director Traktor **Editor** Tom Muldoon **Producers**
Traktor, Hyatt Choate (BBDO) **Production
Company** Partizan **Agency** BBDO New York
Client Mountain Dew **Country** United States

(see related work on page 143)

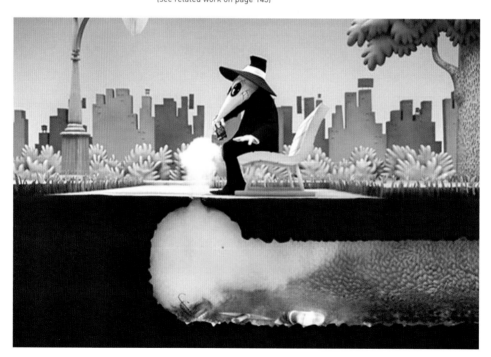

DISTINCTIVE MERIT Magazine, Consumer, Spread
Personality (Bin Laden)

Art Director Roberto Fernandez **Creative Director**
Marcello Serpa **Copywriter** Sophie Schoenburg **Designer**
Roberto Fernandez **Agency** AlmapBBDO **Client** Editora
Abril/Veja Magazine **Country** Brazil

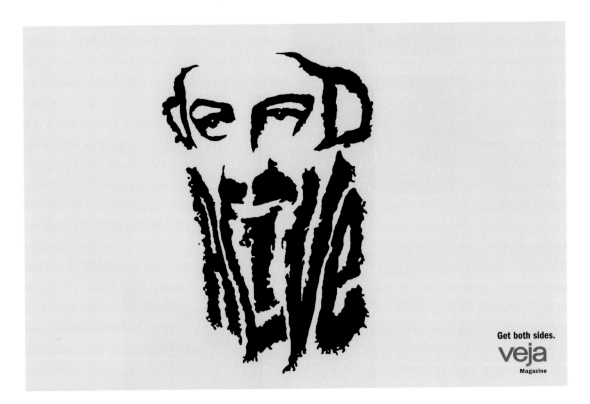

Veja is Brazil's top news magazine, and it needed to consolidate that
position by reenforcing its credibility. We wanted to show that the Veja's
mission is to provide profound and impartial analysis of the week's events
so that readers can reach their own conclusions. Using the ambigram
technique, we were able to communicate that everything in life can have
more than one interpretation, and that the function of an independent,
unbaised magazine is to show readers all aspects of a single issue. The
tag reinforces this idea: Veja. Get both sides.

Open on a woman sitting in a dentist's office. She is looking at the camera, telling us a story. When she opens her mouth to speak, it is actually a Leslie Nielson-like man's voice lip-synched to hers. The voice is lounge lizard-like—think a seedier Leslie Nielson. The woman is a prim, proper, Asian lady, perhaps a dental assistant/technician. Very much in the tradition of Lilith on "Cheers" or "Frasier."

WOMAN: I used her credit card to treat myself to a little chunk of heaven, baby. That singles weekend in Tijuana. Freaky-deaky. But first, I needed to power-up my babe magnet. Self-tanning cream, fresh hair plugs and a complete wax job on the old chassis. Ouch, uh, slow down, ladies, there's enough Larry for everyone (laughs cheesily).

SUPER: Helen D. Identity Theft Victim

VO: Fraud Early Warning. If someone's using your card, we'll alert you and stop it. Citi Identity Theft Solutions. That's using your card wisely.

SUPER: Fraud Early Warning.

Logo: Citi® Live richly.® 1-800-246-CITI citicards.com

Open on a man sitting on his riding mower. He is looking at the camera, telling us a story. When he opens his mouth to speak, it is actually a woman's southern-drawl voice lip-synched to his.

MAN: Once I got his credit card, I hit the ritziest shopping channel on TV. I got two Black Hills Gold ankle bracelets, some stirrup pants, oh, and a set of those press-on nails with diamonds built right in (fans nails at the camera). I, I know it's wrong, but I do not care (gets visibly choked up). I feel...like the prettiest girl...in the whole development.

SUPER: Bruce L. Identity Theft Victim

VO: Fraud Early Warning. If someone's using your card, we'll alert you and stop it. Citi Identity Theft Solutions. That's using your card wisely.

Card Flip: Fraud Early Warning. Citi® Identity Theft Solutions

Logo: Citi® Live richly. ® 1-888-CITICARD citicards.com

{**MULTIPLE AWARD WINNER**} (see related work on page 139)

DISTINCTIVE MERIT Copywriting, Campaign
Chassis, Home Shopping, Ooh La La
DISTINCTIVE MERIT Copywriting **Chassis**
MERIT TV: 30 Seconds **Ooh La La**

Art Director Steve Driggs **Creative Directors** David Lubars, Steve Driggs, John Matejczyk **Copywriter** Ryan Peck **Director** Kevin Thomas **Editors** Josh Towvim, Andre Betz **Producers** Rob van de Weteringe Buys, Sofia Akinyele-Trokey **Production Company** Thomas Thomas Films **Agency** Fallon Minneapolis **Client** Citi **Country** United States

Our goal was to introduce people to Citi's innovative Identity Theft Solutions service in a way that would engage people without scaring them. Luckily we came up with a solid idea that kept improving at every stage, thanks to the talent and uncompromising efforts of everyone involved in the production.

Open on a couple. the woman is looking at the camera, telling us a story. When she opens her mouth to speak, it is actually a French man's voice lip-synched to hers.
WOMAN: She left her card at ze café and voilà, I am off to Las Vegas, Ooh, Lady Luck, she is my lover (KISSES). Dancing water, ze laser beams, and ze girls with the hoochy-coochy! Oooh. Expensive? Not for moi! Uh huh huh huh huh...
SUPER: Phyllis J. Identity Theft Victim
VO: Fraud Early Warning. If someone's using your card, we'll alert you and stop it. Citi Identity Theft Solutions. That's using your card wisely.
Card Flip: Fraud Early Warning. Citi®
Identity Theft Solutions
Logo: Citi® Live richly.® 1-888-CITICARD citicards.com

bud presents, real.

{MULTIPLE AWARD WINNER}

DISTINCTIVE MERIT Radio: Over 30 Seconds, Campaign **Genius: Mr. Giant Pocket Knife Inventor, Mr. Pro-Sports Heckler, Mr. Pontoon Boat Builder**
MERIT Radio: Over 30 Seconds **Genius/Mr. Pontoon Boat Builder**
MERIT Radio: Over 30 Seconds **Genius/Mr. Pro Sports Heckler**

Group Creative Director John Immesoete **Creative Directors** Mark Gross, Bob Winter **Associate Creative Director** Chris Roe **Copywriters** Bob Winter, Chris Roe, John Immesoete **Other** Scandal Music **Audio Engineer** Dave Gerbosi **Executive Producer** Marianne Newton **Production Company** Chicago Recording Company **Agency** DDB Chicago **Client** Anheuser-Busch **Country** United States

Winner's Statement by Mark Gross (Group Creative Director): As co-creator of the Real Men of Genius Campaign people often ask me if any of the people responsible for writing the actual spots are in fact real geniuses. The answer is no. But, in case you were wondering, I've listed the actual IQ's of all the people who helped make Real Men of Genius possible. Please note 140 and above is considered genius. Mark Gross – 137 Bill Cimino – 138 John Immesoete – 139 Bob Winter – 136 Marianne Newton – 136.

Mr. Giant Pocket Knife Inventor
MUSIC UP
ANNOUNCER: Bud Light Presents, Real. Men. Of Genius.
SINGER: Real men of Genius
ANNOUNCER: Today we salute you, Mr. Giant Pocket Knife Inventor.
SINGER: Mr. Giant Pocket Knife Inventor!
ANNOUNCER: Because of you, we'll never be lost in the middle of a dense forest without a little plastic toothpick again.
SINGER: Won't get lost again!!
ANNOUNCER: What's that bulge in my pocket? It's my knife. And my tweezers. And my scissors. And my spoon. And my bottle opener. And my fish scaler.
SINGER: Take It To The Max!!
ANNOUNCER: And my leather awl. And my corkscrew. And my nail file. And my paring knife. And my hasp.
SINGER: What's A Hasp ?!!!
ANNOUNCER: So crack open an ice cold Bud Light, Mr. Giant Pocket Knife Inventor. (SFX: BOTTLE TWIST OFF). Because you make our pockets bulge humongously with pride.
SINGER: Mr. Giant Pocket Knife Inventor!
ANNOUNCER: Bud Light Beer. Anheuser-Busch, St. Louis, Missouri.

Light
men.
of genius.

Mr. Pro-Sports Heckler

MUSIC UP

ANNOUNCER: Bud Light Presents, Real. Men. Of Genius.

SINGER: Real men of Genius

ANNOUNCER: Today we salute you, Mr. Pro-Sports
Heckler Guy

SINGER: Mr. Pro-Sports Heckler Guy!

ANNOUNCER: They say those who can't play coach.
Apparently those who can't coach sit thirty rows back,
shirtless, shouting obscenities.

SINGER: Look at me!!!

ANNOUNCER: Thanks to you, our team is armed with
game winning tips like, catch the ball and throw it.

SINGER: Shout It out Now!!

ANNOUNCER: You stink. That sucks. What a bunch of
losers. Not just catcalls but subtle psychological ploys to
prod your team to victory.

SINGER: Reverse Psychology!

ANNOUNCER: So here's to you, oh Sultan of Shouting.
Because we all know, if you don't have anything nice to
say, say it really, really loud!

SINGER: Mr. Pro-Sports Heckler Guy!

ANNOUNCER: Bud Light Beer. Anheuser-Busch,
St. Louis, Missouri.

Mr. Pontoon Boat Builder

MUSIC UP

ANNOUNCER: Bud Light Presents, Real. Men. Of Genius.

SINGER: Real men of Genius

ANNOUNCER: Today we salute you, Mr. Homemade
Pontoon boat maker.

SINGER: Mr. Homemade Pontoon Boat Maker!

ANNOUNCER: What happens when you cross ten
discarded drum barrels with two sheets of plywood and a
cast aside barbecue? A pontoon boat.

SINGER: We're boating and grilling!

ANNOUNCER: It's a boat. It's a dance floor. It's a boat
AND a dance floor.

SINGER: We're boating and dancing!

ANNOUNCER: Throw up a string of tiki lights, hit the
stereo, power up the blender, and what have you got?
Way too much electricity on top of a lot of water.

SINGER: We're Boating and Getting Electrocuted!!

ANNOUNCER: So crack open an ice cold Bud Light,
oh Pirate of the Pontoon (SFX: BOTTLE TWIST OFF).
Because you really shiver me timber.

SINGER: Mr. Homemade Pontoon Boat Maker!

ANNOUNCER: Bud Light Beer. Anheuser-Busch,
St. Louis, Missouri.

The lowest call rates to Senegal & Germany.

Telefónica

{MULTIPLE AWARD WINNER}

DISTINCTIVE MERIT Magazine, Consumer, Full Page, Campaign **Mixed Faces: 1, 2, 3**
DISTINCTIVE MERIT Magazine, Consumer, Full Page **Mixed Faces 2**
MERIT Magazine, Consumer, Full Page **Mixed Faces 1**

Art Director Christian Giménez **Creative Directors** Guillermo Vega, Pablo Capara, Sebastián Olivieri **Copywriter** Sebastián Moltedo **Designer** Christian Giménez **Illustrator** Daniel Romanos **Photographer** Juan Salvarredi **Agency** YR Buenos Aires **Client** Telefónica **Country** Argentina

Telefónica is a telecommunications company that links people all over the world. We mixed people from different countries to show that we can all be connected. In the first example, we put a Senegalese man together with a German man. In the second one, we put a Scottish man with a Japanese man, and in the third one, a Turkish man with a Swedish man.

The lowest call rates to Japan & Scotland. *Telefónica*

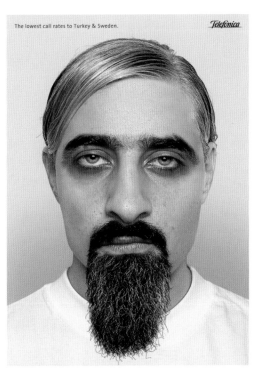

The lowest call rates to Turkey & Sweden. *Telefónica*

The ad demonstrates the ability of Parmalat Everfresh milk to last a long time through the use of obviously outdated promotions advertised on the pack.

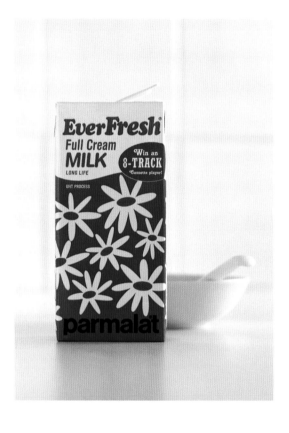

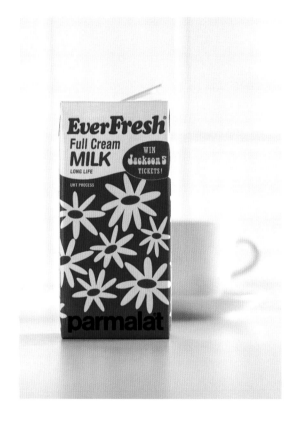

{MULTIPLE AWARD WINNER}

DISTINCTIVE MERIT Promotional, Campaign **Parmalat Everfresh: 8-Track Cassette, Jackson 5, Rhodesia**
MERIT Promotional **Parmalat Everfresh: Rhodesia**
MERIT Promotional **Parmalat Everfresh: 8-Track Cassette**

Art Director Michael Lees-Rolfe **Creative Directors** Ryan Reed, Greg Burke, Mark Fisher, Chris Gotz
Copywriter Jake Bester **Designer** Michael Lees-Rolfe **Producer** Merle Bennett **Production Companies** Spin
Images, Ogilvy Repro **Agency** Ogilvy Cape Town **Client** Parmalat South Africa **Country** South Africa

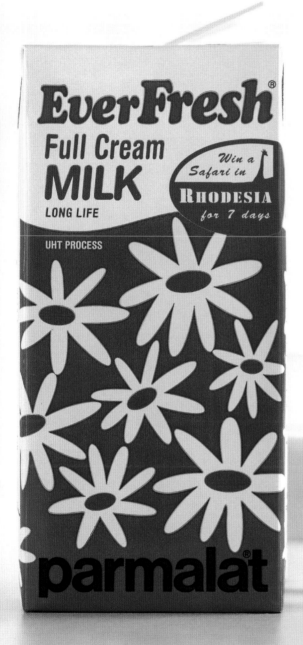

dimensions: 23 1/2" h x 16 1/2" w

To maintain awareness of this fun ghost-themed snack, we created these paranormal posters. Using lenticular technology, the eyes of the eerie characters quite literally follow you around the room. These posters appeared in malls and stores around the country.

{MULTIPLE AWARD WINNER}

DISTINCTIVE MERIT Point-of-Purchase, Campaign **Eyes: Girl, Lady, Twins**
DISTINCTIVE MERIT Point-of-Purchase **Girl**

Art Director Marion Bryan **Creative Directors** Mike Schalit, Julian Watt
Copywriter Asheen Naidu **Producer** Clinton Mitri **Production Company** Beith
Digital **Photographer** Michael Meyersfeld **Agency** NET#WORK BBDO **Client**
Simba Ghost Pops **Country** South Africa

dimensions: 27 1/8" h x 23 1/2" w

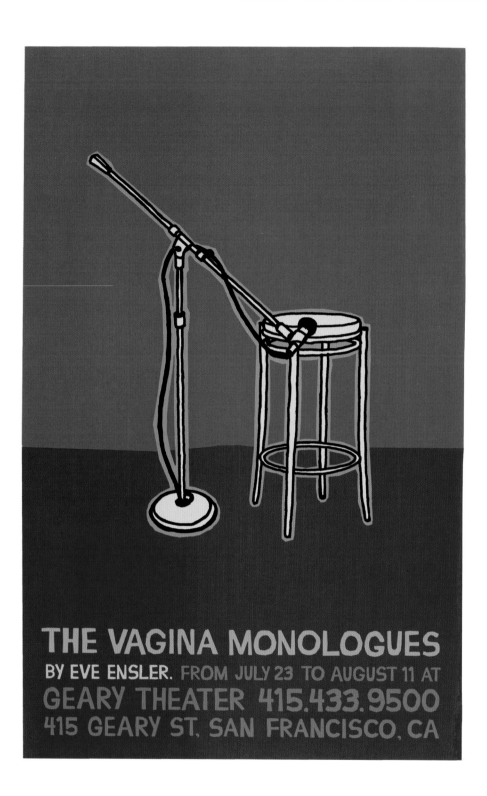

dimensions: 28" h x 19" w

{MULTIPLE AWARD WINNER} (see also page 209)

MERIT Promotional **Microphone**

Art Director Rudi Anggono **Creative Director** Sean Austin **Copywriter**
Sean Austin **Designer** Rudi Anggono **Agency** Downtown Partners
Chicago **Client** Geary Theater **Country** United States

The title of the show is pretty provocative all by itself. So we decided
to use the name and create a simple visual around it. At first we
thought of doing it as a photo, but we kept trying to push the look of it.
And in the end, we decided that the crude lines and bright colors of the
illustration were most arresting.

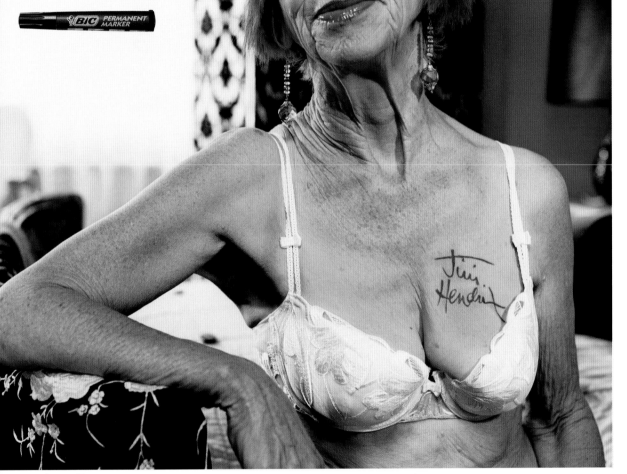

dimensions: 16 1/2" h x 23 1/2" w

DISTINCTIVE MERIT Point-of-Purchase **Old Lady**

Art Director Nick Hine **Creative Director** Erik Vervroegen **Other** Jack Rusznyak
Photographer Garry Simpson **Agency** TBWA\Paris **Client** Bic **Country** France

When you choose to use a Bic permanent marker, be sure it's because you want
something to last for a long long time.

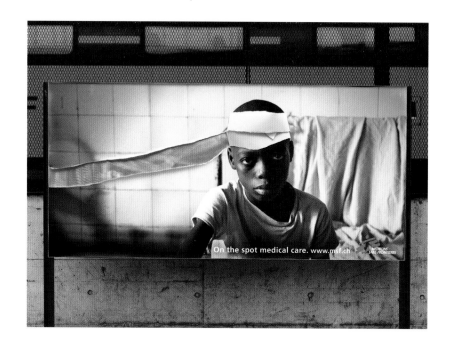

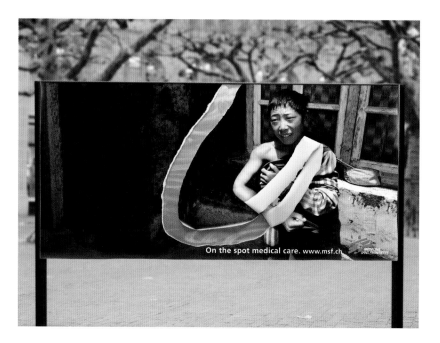

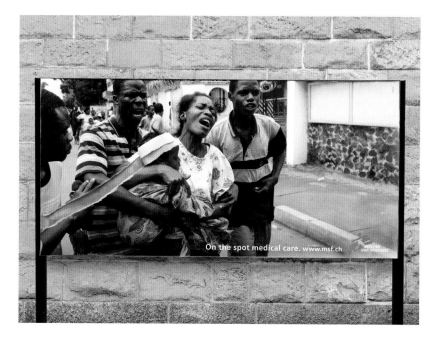

DISTINCTIVE MERIT Public Service | Non-Profit | Educational, Campaign
Doctors Without Borders: On the Spot Medical Care: Bandage Boy, Sling Boy, Bandage Family

Art Director Isabelle Hauser **Creative Director** Philipp Skrabal **Copywriter** Markus Traenkle
Photo Editors Suesstrunk & Jericke, Straumann **Photographers** Noël Quidu, Peter Casaer, Carl
De Keyzer, Mathias Zuppiger **Agency** Publicis Werbeagentur AG, BSW **Client** Medecins Sans
Frontieres **Country** Switzerland

Posters can help in a hurry. With their striking design, the posters created by Publicis Zurich on behalf of
the international aid organization, Doctors Without Borders, created a stir. They dramatize, in a conspicuous
and effective way, the greatest benefits the organization offers: lightning speed in reacting to emergencies
around the world and providing aid to those affected by famine, epidemic, civil war, and natural catastrophe.
Just as doctors in crisis situations often must reach for and make do with anything helpful at hand, the
injured poster subjects wear improvised, three-dimensional emergency bandages formed from the poster
paper itself. It's an eye-catching device that prevents passersby from looking away.

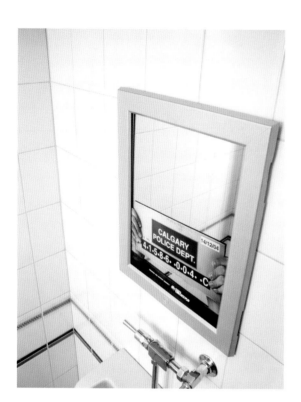

118

DISTINCTIVE MERIT Public Service | Non-Profit | Educational
Checkstop—Mugshot

Art Directors Mike Meadus, Kelsey Horne **Creative Directors** Paul Long,
Ric Fedyna **Copywriter** Mike Meadus **Designers** Mike Meadus, Kelsey
Horne **Production Company** McGill Productions **Photographer** Ken Woo
Photography **Agency** MacLaren McCann West **Client** Calgary Police
Services **Country** Canada

This poster, created for Alberta Checkstop, was posted in bar and restaurant
bathrooms in Alberta, Canada. By placing die-cut images on top of mirrors
placed in the ad frames, we reminded drinkers of the consequences of being
pulled over while driving under the influence.

DISTINCTIVE MERIT Transit **Frosted Glass**

Agency Hakuhodo, Inc. **Country** Japan

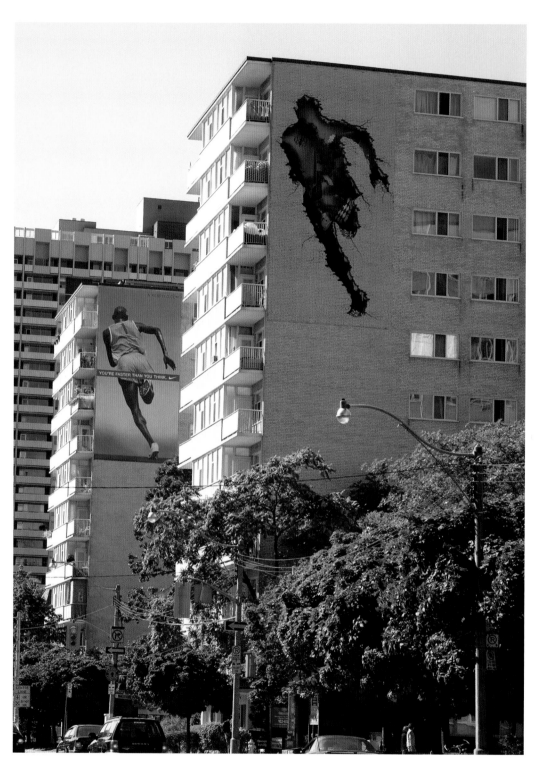

DISTINCTIVE MERIT Outdoor | Billboard **Bernard Wall**

Art Director Ron Smrczek **Creative Director** Zak Mroueh **Copywriter** Kira Procter **Account Director**
Catherine Marcolin **Account Manager** Josh Folliott **Account Planner** Francesca Birks **Media**
Company Cossette Media **Typographer/Mac Artist** Doug Scott **Producers** Judy Boudreau, Alex Cresswell
Illustrator Jason Edmiston (Three in a Box, Inc.) **Agency** TAXI **Client** Nike **Country** Canada

Strategy: A Canadian campaign that leveraged the Nike "Speed" theme, and ran around the same time as the Summer
Olympics. Murals were placed on consecutive buildings to show distance runner Bernard Lagat bursting through the murals.

The development of innovative safety concepts is one of the
most important Renault objectives. Every year, $100 million is invested
in this commitment. That makes Renault one of the world's leading
safety-minded carmakers. The new Renault Modus, the safest of all
small cars—only recently honored with the top 5-star rating in the
independent Euro NCAP crash tests—was to be advertised by means
of an exceptional media idea. The idea: The new Renault Modus is
so safe that it can even brave falling trees. To dramatically
demonstrate this, the devastating consequences of a storm were
depicted on an 18/1 billboard. An overturned tree destroys the billboard
frame—but the safe Renault Modus is so rugged, it remains unscathed.

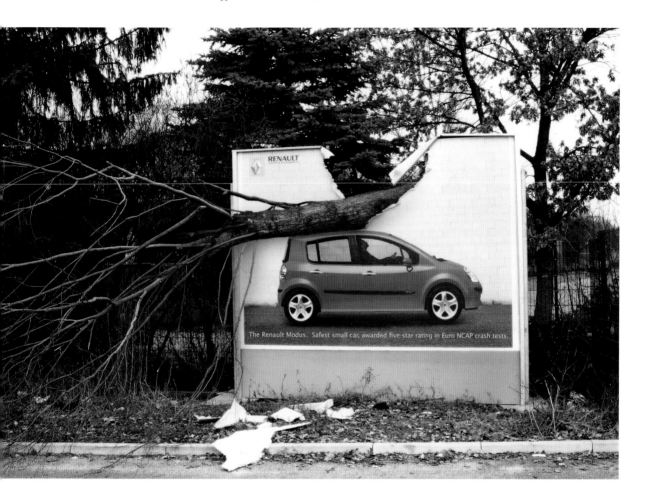

DISTINCTIVE MERIT Outdoor | Billboard **Tree**

Art Director Nico Juenger **Creative Director** Claudia Willvonseder **Copywriter**
Konstantinos Manikas **Photo Editor** Robin Preston **Photographer** Teresa Kinast
Agency Publicis Frankfurt GmbH **Client** Renault Deutschland **Country** Germany

Bookshop before the campaign

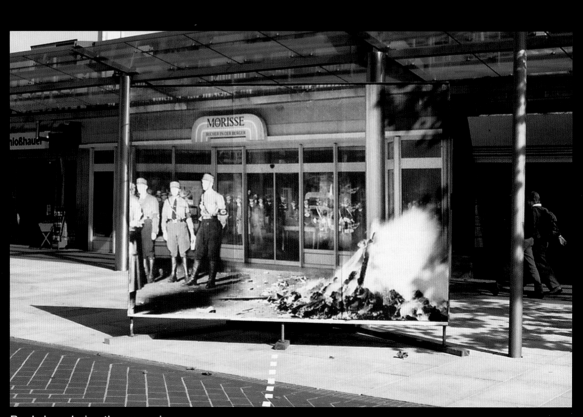

Bookshop during the campaign
On May 10, 1933, the Nazis publicly burned more than 25,000 books by Jewish and ideologically unacceptable authors.

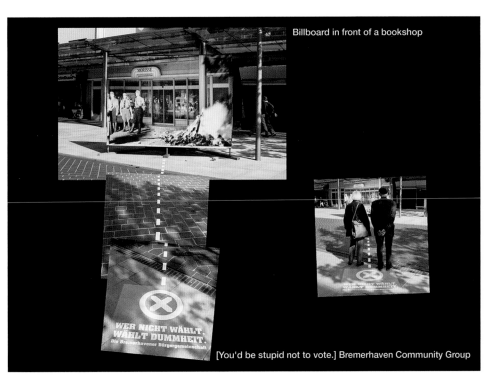

Billboard in front of a bookshop

WER NICHT WÄHLT,
WÄHLT DUMMHEIT.
Die Bremerhavener Bürgergemeinschaft

[You'd be stupid not to vote.] Bremerhaven Community Group

DISTINCTIVE MERIT Outdoor | Billboard, Campaign **Bremerhaven Community Group/Bookshop 1-3**

Art Director Klaus Schwieker **Creative Directors** Michael Barche, Vera Hampe **Copywriter** Claudia Bach **Photographer** Jan C. Schultchen **Agencies** KNSK Werbeagentur GmbH, GWA **Client** Bremerhavener Bürgergemeinschaft **Country** Germany

123

Our Challenge: To prevent radical right-wing parties from winning seats on the town council of Bremerhaven, a small northern German city, a campaign was needed to mobilize voters. Our Solution: Mobile billboards were positioned at heavily frequented locations in downtown Bremerhaven. These portrayed original scenes from the Nazi era as well as fictional visions of a future dictated by the far right. Using digital processing, the life-size scenes were integrated into photographs of the billboards' environments. A viewer standing at a designated point several yards from the billboard experiences a perfect optical illusion and is transported back in time to the horrors of Hitler's Germany. This demarcated "view-point" also exhibits the association's logo and various versions of the claim, "If you don't vote, you don't have a choice."

DISTINCTIVE MERIT Outdoor | Billboard **Wading Depth**

Art Director Tomas Tulinius **Creative Directors** Ralf Nolting, Patricia Pätzold **Chief Creative Officer** Ralf Heuel **Copywriter** Martien Delfgaauw **Photographer** Nico Weymann **Agency** Grabarz & Partner Werbeagentur GmbH **Client** Volkswagen AG **Country** Germany

The Volkswagen Touareg can drive through up to fifty-eight centimeters of water. To demonstrate this, we placed a billboard at the Hamburg harbour, the cities major tourist attraction, and waited for the flood waters.

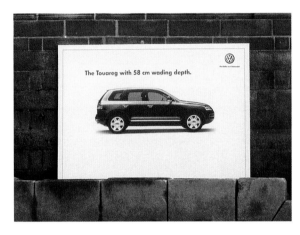

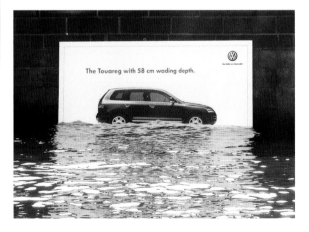

A small landscape architecture company with a limited marketing budget asked for an idea which would help both retain and deepen customer relationships and gain new clients—a mailing that will not be headed straight for the rubbish bin. The top of a low plastic box depicts a development plan, with the area surrounding the buildings perforated by small holes. Water the box daily, and after only a few days a gentle green will sprout through the holes. Recipients rang the company, proudly reporting their success in growing the plants. A number of those informal talks have resulted in new orders, and the company is now working at full capacity.

dimensions: 16 1/2" h x 23 1/2" w

DISTINCTIVE MERIT Direct Mail **Tur & Partner Live Mail**

Agency Jung von Matt AG **Country** Switzerland

DISTINCTIVE MERIT Product | Service Promotion **City Mission: Litter Bins**

Art Directors Teboho Mosothoane, Ryan Reed **Creative Director** Greg Burke **Copywriter** Gordon
Ray **Producer** Merle Bennett **Production Company** Ogilvy Repro **Agency** Ogilvy Cape Town **Client**
City Mission **Country** South Africa

The poster was designed to draw attention to the plight of the homeless who feed from the city's litter bins.
Posters with silver knives and forks where placed horizontally around the circular bins, creating the illusion
of a restuant table setting. The message to people discarding leftovers was, "some eat out every day."

DISTINCTIVE MERIT Guerrilla | Unconventional **Ice Car**

Art Directors Graeme Hall, Gavin Siakimotu **Creative Director** Jeremy Craigen **Copywriters** Gavin Siakimotu, Graeme Hall **Agency** DDB London **Client** Volkswagen UK, Ltd. **Country** United Kingdom

To promote the fact that air conditioning comes as standard on the Volkswagen Polo Twist, a life-size, exact replica of the car was sculpted from ice and installed on a busy London street.

The Sun, Thursday May 13, 2004.

Hello magazine.

The Guardian, Thursday May 13, 2004.

Tonight with Jonathan Ross.

Zoo magazine.

Daily Mirror, Thursday May 13, 2004.

DISTINCTIVE MERIT Guerrilla | Unconventional, Campaign
Crosses

Art Director Thierry Buriez **Creative Director** Erik Vervroegen
Other Alain Jalabert **Photographer** Vincent Dixon **Agency** TBWA
\Paris **Client** Medecins du Monde **Country** France

Copy: "Every winter, hundreds of homeless die on the sidewalks.
React." Guerrilla campaign carried out in winter for Medecins du Monde
in major cities in France. Tactical strips were placed on existing street
posts to form the shape of crosses.

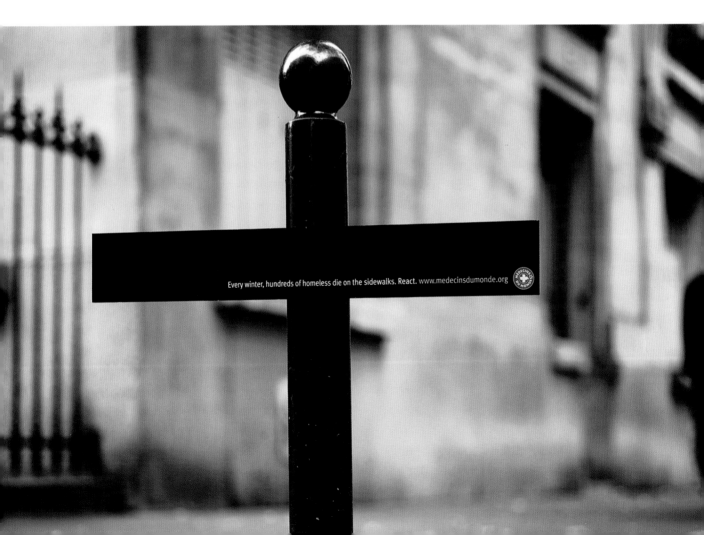

A beautiful Corvette Stingray that is parked in a basement garage reveals
itself to be a fairly authentic model as soon as another car enters the scene.

MERIT TV: Under 30 Seconds **Stingray**

Art Director Klaus Trapp **Creative Directors** Peter Steger,
Andreas Heinzel **Copywriter** Mathias Henkel **Strategic Planner**
Oliver Miller **Sound Design** Studio Funk **Agency Producer**
Gabriele Heck **Production Company** MagnaMana **Agency** Leo
Burnett, Frankfurt **Client** Revell **Country** Germany

Target audience: Teenagers and adults (predominantly male) who
are looking for a fascinating hobby or who are already interested in
model making. Communications objective: To set the name REVELL
in stone as the benchmark for model kits true to the detail. Creative
strategy: The TV ads demonstrate the impressing accuracy of
REVELL products by showing model kits in real surroundings (e.g., a
car model in a real basement garage) that look authentic until they
get unmasked by the size of a real object that enters the scene.

MERIT TV: Under 30 Seconds **Altoids Gum: Hair**

Art Director Noel Haan **Creative Directors** Noel Haan, G. Andrew
Meyer **Copywriter** G. Andrew Meyer **Director** Douglas Avery
Producer David Moore **Production Company** Villains **Agency** Leo
Burnett, Chicago **Clients** Kraft, Altoids **Country** United States

(see related work on page 202)

130

The objective was to introduce people to the notion that Altoids, makers of
The Curiously Strong Mints, were introducing a Curiously Strong Gum into
the world, while maintaining the subversive sensibilities that make the brand
what it is. The challenge was to do so with a tiny fraction of the budget of our
major competitor. The solution was to violate the "rules" of the category, (i.e.,
never show gum being spit out), create irreverent demonstrations of "Curious
Strength," and maximize our small budget through the use of extremely
targeted :15 spots.

Various cuts of the backs of kid's heads. They have all different kinds of funky
hair—a severe bob; a big, fluffy Afro; a stick-straight Jan Brady style; a surfer
mop—but each kid has a small but very conspicuous patch cut out of his or her
hair. Cut to a young boy in the back row of the band room. He's chewing gum. He
becomes alarmed at the strength of it, and spits it out. It flies through the air, and
into the hair of the clarinetist in front of him, thus resolving the mystery of the
missing patches of hair. (Action collapses into tin on Mint green sweep.)
Title Card: Altoids. The Curiously Strong Gum.

MERIT TV: Under 30 Seconds **Crying**

Art Director Felipe Cama **Creative Directors** Sergio Valente, Pedro Cappeletti **Copywriter** Ricardo Chester **Sound Design** Ludwig Van **Director** Joao Daniel Tikhomiroff **Producer** Jodaf Team **Production Company** Jodaf **Agency** DDB Brasil **Client** Companhia Athletica **Country** Brazil

Inside a house on a hot day. A plump shirtless father notices that his baby is crying in the cot. He takes the baby in his arms and starts to comfort him. To everyone's surprise, the baby tries to suck on his father's breast. The father finds the baby's reaction strange.
SUPER: Get in shape.
Logo: Companhia Athletica Health And Wellness www.ciaathletica.com.br

MERIT TV: 30 Seconds **Reaction**

Art Directors David Seah, Aaron Phua **Creative Directors** Calvin Soh, Yang Yeo **Copywriter** Craig Howie **Director** Lawrence Hamburger **Producer** Gwynn Wong **Production Company** Stink **Agency** Fallon Singapore **Client** Volkswagen **Country** Singapore

We open on a Volkswagen Golf travelling leisurely along a suburban street. Suddenly, and without warning, a delivery truck veers into its lane. Luckily, due to the Golf's agile suspension, a collision is narrowly avoided. The Golf driver breathes a sigh of relief and continues safely on his way. Further down the road he realizes what has just happened. He honks the horn angrily and shouts "Moron!" Unfortunately, the truck is now long gone.
SUPER: The new Golf with Dynamic Safety Suspension. Reacts quicker than you do.
Logo: VW

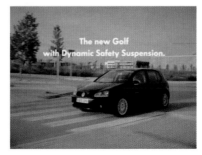

MERIT TV: Under 30 Seconds, Campaign
**Emerald Nuts: Nomads, Norwegians, Normans,
Nay Sayers, Nurses**

Art Director Jon Soto **Creative Director** Jeff Goodby
Copywriter Mike McCommon **Director** Jim Hosking **Editor**
Jean Kawahara **Producer** Michael Damiani **Production
Company** Partizan **Agency** Goodby, Silverstein & Partners
Client Diamond of California **Country** United States

(see related work on page 352)

How do you put a tiny brand new snack nut company on the map?
We toyed with many clever ways and strategies to accomplish this.

Each spot tries to make Emerald Nuts memorable by pairing other
whimsical words starting with E and N.

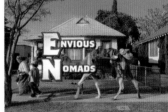

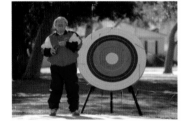
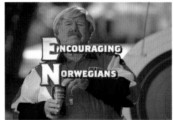

MERIT TV: Under 30 Seconds, Campaign
Sealy Olympic TV: Pommel Horse, High Jump, Diver

Art Director Bill Starkey **Creative Director** John
Brockenbrough **Copywriter** Richard Parubrub
Director Jeff Gorman **Editor** Paul Bertino **Producer**
Lilly LaBonge **Production Company** JGF Films
Agency Mullen **Client** Sealy **Country** United States

We started with the existing campaign idea of people immediately dropping off to sleep on Sealys and the client's desire to promote their Olympics involvement. It occurred to us that top athletes all have their own styles and idiosyncrasies while training during the day—why should nights be any different? After that, the spots pretty much wrote themselves. An athlete maneuvering on the footboard of a bed as if it were a pommel horse, someone Fosbury-flopping into the top bunk, a guy diving off his dresser. Jeff Gorman, our director, did a terrific job of keeping it about the idea—simple and unadorned. (We did have a brief scare, though, when our pommel guy did an unprompted handstand on a rickety director's chair.) We've had unprecedented enthusiasm from retailers, and the client's thrilled. We never expected mattress stores in Australia wanting to run the spots.

Pommel Horse:
Open on a dormitory-style room at night. A man hops on to the footboard of a bed and maneuvers on it as if it's a pommel horse. After a couple of twists, he presses himself into a handstand and then dismounts with a backward flip. Upon contact with the bed, the man instantly falls asleep.
Cut to Sealy logo and super.
SUPER: Official Supplier of the U.S. Olympic Team

Diver:
Open on a dormitory-style room at night. We see a man standing on top of a dresser that's directly across from the foot of his bed. After wiggling his arms and legs, he reaches up to his forehead and pulls down a sleep mask over his eyes. He then crouches into the set position and dives forward. Upon contact with the bed, the man instantly falls asleep.
Cut to Sealy logo and super.
SUPER: Official Supplier of the U.S. Olympic Team

High Jump:
Open on a dormitory-style room at night. We see bunk beds with someone already sleeping in the lower bunk. We then hear the pounding of footsteps as someone gets closer and closer to the bed. Suddenly, a man enters frame and Fosbury flops (a high jump motion) into the top bunk. Upon contact with the bed, the man instantly falls asleep.
Cut to Sealy logo and super.
SUPER: Official Supplier of the U.S. Olympic Team

In a world that has become too serious, Mikado is the light-hearted break everyone deserves in his o r her daily life. The campaign aims to give Mikado a role in consumption to go beyond the pure "temptation" that the brand has been claiming for years.

MERIT TV: 30 Seconds **Star Wars**

Art Director Rémy Tricot **Creative Director** Michèle Cohen **Copywriter** Olivier Couradjut **Director** Christopher von Reis **Production Company** Les Télécréateurs **Agency** BETC Euro RSCG **Client** Lu/Mikado **Country** France

Close-up on a Mikado.
A second Mikado appears, and they start fighting as in a duel. The accompanying soundtrack is one of adult voices imitating a laser sword battle.
We then discover two men playing, concentrating heavily.
MAN: No, Luke, I am your father.
Then suddenly they stop in the middle of the fight.
We discover that the two men are actually in a business meeting, surrounded by people dressed in dark suits and ties who stare at them, puzzled. They then have no choice but to eat their Mikados. As they pretend to listen to the meeting, we hear the sound of a laser sword being turned off.

MERIT TV: 30 Seconds **Space Anchors**

Art Director Jesse Coulter **Creative Directors** Todd Waterbury, Kevin Proudfoot, Ty Montague **Associate Creative Director** Paul Renner **Copywriter** Greg Kalleres **Director** David Shane **Editors** Dave Koza (Mackenzie Cutler) **Producer** Temma Shoaf **Executive Agency Producer** Gary Krieg **Production Company** Hungry Man **Agency** Wieden+Kennedy New York **Client** ESPN Sportscenter **Country** United States

Open on Stuart Scott talking to the camera.
STUART SCOTT: Ever since the show went to High Definition technology, we've had to hire a much more sophisticated staff.
Cut to the breakroom, where we see Chewbacca banging a coffee pot against the counter as a stormtrooper reads the paper next to C-3PO and a Sportscenter anchor.
CHEWBACCA: Arrrghhhh!
Cut to the tape room, where Darth Vader brandishes his lightsaber toward Lennox Lewis, who happens to be walking by.
LENNOX LEWIS: Excuse me.
Cut to Andy Roddick trying to give C-3PO tennis lessons. C-3PO accidentally drops the racket.
ANDY RODDICK: Just—no—why you gotta throw my racket?
Cut to Stuart Scott talking to the camera.
STUART SCOTT: Once they start to grasp sports, the possibilities are endless.
Cut to Sportscenter set, where Scott Van Pelt sits at the anchor desk with R2-D2.
SCOTT VAN PELT: So, is there a quarterback controversy in New York?
R2-D2: Help me Obi-Wan Kenobi. You're my only hope. Help me Obi-Wan Kenobi.
SUPER: THIS IS SPORTSCENTER.

With the entire broadcast industry moving further and further into the world of HDTV, it was time to recognize ESPN's evolution and address the question, "Just how are those guys in Bristol dealing with this new world of high-tech?" By turning to the experts, of course. By bringing Chewbacca, R2-D2, Darth Vader, and C-3PO into the SportsCenter universe we not only found an engaging way to call attention to a rather straightforward product benefit; we also caught the early momentum leading up to the release of the final Star Wars movie.

MERIT TV: 30 Seconds, Campaign **ESPN Brand—One On One: Swish, Free Throw, Tired**

Art Director/Associate Creative Director Paul Renner **Creative Directors** Todd Waterbury, Ty Montague **Associate Creative Director/Copywriter** Kevin Proudfoot **Sound Designer** Tom Jucarone (Sound Lounge) **Director** Lance Acord **Editor** Dick Gordon (Mad River Post) **Producer** Temma Shoaf **Executive Agency Producer** Gary Krieg **Production Company** Park Pictures **Agency** Wieden+Kennedy New York **Client** ESPN **Country** United States

(see related work on page 153)

Is there anything more pure than the bonding that takes place when a father schools his baffled four-year-old son in a ruthless game of driveway basketball? Perhaps. But there's nothing quite as funny, or quite as good at bringing to life the real look of familial sports connections. Driveway basketball with Dad is a rite of passage for many young boys (and girls) in America. It's just one of the many ways in which sports play a powerful emotional role in our lives. We wanted to capture that rite of passage in a way that was true to the ESPN voice—not overly sentimental or precious, but still respectful of the power of sports.

Dad's hyper-competitive attitude makes this spot fun, but the message behind his histrionics is what's important. Through some unique methods, Dad is teaching Son about so much more than basketball: trying your best, never giving up, taking pride in your work and, oh, how it feels to get beaten badly.

135

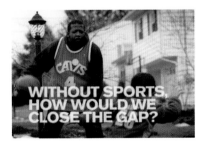

As a man folds laundry, he tries on a pair of tight jean shorts. He then ties the shirt he's wearing with a little knot. His daughter walks in and looks at him like he's crazy. A super explains that the Dukes of Hazzard is coming to CMT. "We can't wait either."

MERIT TV: 30 Seconds **Pre Dukes-Shorts**

Art Director Stephen Leps **Creative Directors** Elspeth Lynn, Lorraine Tao **Copywriter** Aaron Starkman **Director** Mark Gilbert **Editor** Aaron Dark (School Editing) **Producer** James Davis **Production Company** untitled **Agency** ZiG **Client** CMT **Country** Canada

CMT's objective was to build anticipation around the Dukes of Hazzard series coming to the network. People remember certain things about the show— jumping through windows and Daisy's shorts. We tried to capitalize on those icons by showing just how excited people can get once they hear the news.

MERIT TV: 30 Seconds **Must Live**

Art Director Mike Sundell **Creative Directors** Elspeth Lynn, Lorraine Tao **Copywriter** Michael Clowater **Agency Producer** Sharon Nelson **Director** Mark Gilbert **Editor** Matthew Kett (Panic & Bob) **Producer** Sam Ferguson **Executive Producer** James Davis **Production Company** Reginald Pike **Agency** ZiG **Client** IKEA **Country** Canada

IKEA makes really nice bedroom furniture. But not everyone knows it. So we wanted to present people with a story of a person that loves her bedroom furniture so much she's willing to go to extreme lengths to spend more time with it.

An older woman, surrounded by friends and family, dies in her bed. As she is about to move onto the next world, she notices how lovely her bedroom furniture is and decides to stay.

Putting together Ikea furniture is annoying. That's why
Ikea has a furniture assemble service. Unfortunately
people don't really know about it. In order to make people
aware of the service, we tried to show what happens when
a family can't assemble the furniture themselves.

MERIT TV: 30 Seconds **Table**

Art Director Stephen Leps **Creative Directors** Elspeth
Lynn, Lorraine Tao **Copywriter** Aaron Starkman **Director**
John Mastromonaco **Editor** Chris Van Dyke (School Editing)
Producer James Davis **Production Company** untitled
Agency ZiG **Client** IKEA **Country** Canada

A mother asks her son to pass the potatoes, which are on a
sideboard. The whole family gets annoyed with this request.
We discover why when see that the table has no legs—it was
just resting on their laps. Unfortunately, they didn't know
about Ikea's furniture assembly service.

MERIT TV: 30 Seconds **Pencil**

Art Director Mark Taylor **Creative Director** Andrew Keller
Executive Creative Director Alex Bogusky **Copywriter**
Bob Cianfrone **Director** Rocky Morton **Editor** Paul Kelly
Producer Terry Starvoe **Production Company** MJZ **Agency**
Crispin Porter + Bogusky **Studio/Design Firm** Morton
Jankel Zander **Client** Burger King **Country** United States

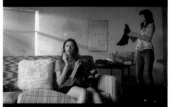

MERIT TV: Over 30 Seconds **Vivre**

Director Nagi Noda **Copywriter** Takashi Ando **Director of Photography** Shoji Uchida **Producer** Hiroaki Nakane **Account Executive** Naoya Yamanaka **Agency** uchu-country, ltd. **Client** Vivre **Country** Japan

Vivre is a "fitness video for being appraised to be an ex-fat girl" created for Vivre's sale. Vivre is a fashion building in Tokyo.

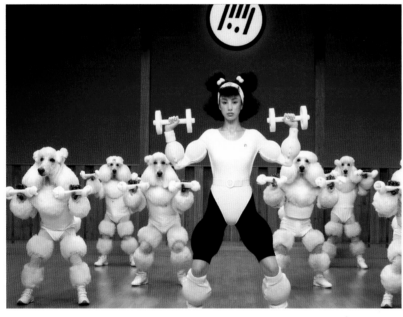

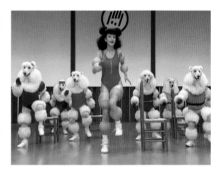

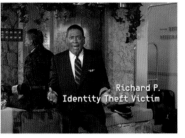

Open on an African-American airline pilot. He is looking at the camera, telling us a story. When he opens his mouth to speak, it is actually a young woman's New York-accented voice lip-synched to his.

MAN: I got his card just in time. My apartment needed a serious upgrade and now I had mucho moolah! (LAUGHS) And this time, nothing but the classy stuff: black lacquer, Roman columns, a statue of David. But with some underpants on! Hey, I'm no hussy. (LAUGHS) Sure, it's not my money, but great taste don't come cheap, cookie. (SNORTS)

SUPER: Richard P., Identity Theft Victim

VO: Fraud Early Warning. When we see suspicious spending, we'll alert you and stop it. Citi Identity Theft Solutions. That's using your card wisely.

Card Flip: Fraud Early Warning. Citi® Identity Theft Solutions

Logo: Citi® Live richly.® 1-888-CITICARD citicards.com

MERIT TV: 30 Seconds **Black Laquer**

Art Director Steve Driggs **Creative Directors** David Lubars, Steve Driggs, John Matejczyk **Copywriter** Ryan Peck **Director** Kevin Thomas **Editor** Andre Betz **Producers** Rob van de Weteringe Buys, Sofia Akinyele-Trokey **Production Company** Thomas Thomas Films **Agency** Fallon Minneapolis **Client** Citi **Country** United States

(see related work on page 104)

Our goal was to introduce people to Citi's innovative Identity Theft Solutions service in a way that would engage people without scaring them. Luckily we came up with a solid idea that kept improving at every stage, thanks to the talent and uncompromising efforts of everyone involved in the production.

MERIT TV: Over 30 Seconds **Ripe**

Art Directors Ricky Vior, Julian Montessano **Creative Directors** José Mollá, Joaquín Mollá, Ricky Vior **Copywriters** Martin Jalfen, Leo Pratt **Directors** Agustín Alberdi, Andy Fogwill **Editor** Diego Faur **Producer** Facundo Perez **Production Company** L A N D I A **Agency** la comunidad **Client** VH1 Latin America **Country** United States

A rapper is doing some grocery shopping. It's an everyday situation. Everything seems normal except for the fact that every time we see the rapper, we hear rap music and see several female butts shaking next to him, as if in a rap music video. It's as if all those visual icons from the music videos would follow him throughout his life.

SUPER: A musician's life is more than just videos. VH1. Beyond music.

The challenge was to launch VH1 in all of Latin America as an alternative to MTV. It was important to differentiate between the two channels. MTV is about videos, songs, and the surface of the music world. VH1 digs deeper. It goes beyond the music to show what happens behind the scenes and in the artists' lives.

MERIT TV: Over 30 Seconds **Watercooler**

Creative Directors Jamie Barrett, Mark Wenneker **Director** Noam
Murro **Editor** Bill McCullough **Producers** Marc Rosenburg, Rachel
Salazar **Production Company** Biscuit Filmworks **Agency** Goodby,
Silverstein & Partners **Client** HBO **Country** United States

HBO was losing a little of its buzz. Sex and the City was ending
its run, and some of the new shows weren't being talked about
quite as much. So we thought, hey, let's take back our rightful
place as the King of Watercooler talk. After all, what network has
inspired more conversations around the cooler than HBO? The
idea developed from there.

"Watercooler" shows how the exciting new shows on HBO increase
traffic at office watercoolers, which in turn provides a boon in business
for the whole watercooler industry.

MERIT TV: Over 30 Seconds **Bucket Brigade**

Art Director Gerard Caputo **Creative Directors** Bruce Bildsten, Mike Gibbs
Copywriter Dean Buckhorn **Director** Elias Merhige **Editor** Rick Lawley
Producers Rob van de Weteringe Buys, Nicholas Gaul **Production Company**
Independent Media, Inc. **Agency** Fallon **Client** PBS **Country** United States

Enchanting music plays throughout. Open on
a tiny village high in the mountains. The local
schoolmaster has just discovered that the village
library is on fire. As the distraught villagers race
to form a bucket brigade, they quickly discover
that their well has run dry. No matter how hard
they pump, they can only coax a trickle of water
from the rusty well. Suddenly, an inspired village
elder grabs a bucket and strides directly into
the blazing inferno. He will reverse the bucket
brigade. He scoops up a bucket full of flames and
immediately begins to pass the flames backwards
down the bucket brigade. Bucket after bucket of
flames is extinguished in the well until the fire
is out. As the village idiot extinguishes the final
bucket, the villagers cheer.
SUPER: Be more inventive.
SUPER: Be More PBS.

This commercial is part of a long-running campaign
for PBS that reminds viewers of the power PBS
programming has to inspire, challenge, and educate.

MERIT Online Commercial, Campaign
The Man Without Feelings: Sister, Cat, Kiss

Art Director Björn Rühmann **Creative Director** Lars
Rühmann **Designer** Björn Rühmann **Cameraman**
Björn Haneld **Sound** Jassin Challah (Massive Music)
Audio Producer Carolin Kott (Hastings Audio
Network) **Director** Daniel Steiner **Editor** Marty Schenk
Producer RobertGold **Production Company** Big Fish
Filmproduktion GmbH **Agency** Nordpol + Hamburg
Client Riccardo Cartillone Schuheinzelhandels GmbH,
Cinza Bonafide **Country** Germany

(see related work on page 360)

"L'uomo senza sentimenti" or "The man without feelings" is a
bad guy with good style. The shoe brand Riccardo Cartillone
just appears in the advert breaks.

Riccardo Cartillone produces bad shoes for bad guys. To reach
the young target group a very special character was created:
the man without feelings. He really is a bad guy in both
meanings—both cool and bad at the same time. In a drastic,
ironic, and unusual manner the spots show short occurances
of his everyday life. The ad break is the final proof that a decent
style and a decent character do not have to go together.

{MULTIPLE AWARD WINNER}

MERIT Art Direction **VW A Life in a Day**
MERIT Music | Sound Design **Life in a Day**

Art Director Grant Parker **Creative Directors** Jeremy Craigen, Ewan Patterson **Copywriter**
Patrick McClelland **Agency Producer** Richard Chambers **Director** Chris Palmer **Editor** Paul Watts
(The Quarry) **Producer** Rupert Smythe **Production Company** Gorgeous Enterprises **Agency** DDB
London **Studio/Design Firm** Gorgeous Enterprises **Client** Volkswagen **Country** United Kingdom

The Golf Mark 5 is a culmination of thirty years of expertise. This commercial shows a new recruit arriving at the Volkswagen design center in the early 1970s. His career is condensed into a day at the office that spans thirty years. We see the previous Golf models over the years and finally the finished Golf Mark 5 in 2004. At the end of the commercial, our new recruit—now head of the design department—is seen meeting the next new recruit, and the cycle starts over again.

MERIT Copywriting **Welcome Aboard**

Art Director Jonathan Mackler **Creative Director** Eric
Silver **Copywriter** Jim LeMaitre **Director** Hank Perlman
Editor Ian Mackenzie **Producer** Elise Greiche (BBDO)
Production Company Hungry Man **Agency** BBDO New
York **Client** FedEx/Kinko's **Country** United States

An employee gets fired, quits, and is then rehired all in one conversation.

FedEx's advertising targets small businesses. So we needed to find a way to talk to the small business man in a way he understands—to feel his pain, so to speak. Obviously, office politics and personality conflicts are daily problems for people in the work force, so it was a natural place to set the spot. "Welcome aboard" examines the gray area of being fired/quitting, which we thought every manager and employee could relate to. FedExKinkos once again had the last word in the argument.

MERIT Music | Sound Design **Canopy**

Art Directors Doris Cassar, Bill Bruce **Creative Director** Bill Bruce **Copywriters** Bill Bruce, Doris Cassar **Sound Design** Francois Blaignon **Director** Traktor **Editor** Tom Muldoon **Producers** Traktor, Hyatt Choate (BBDO) **Production Company** Partizan **Agency** BBDO New York **Client** Mountain Dew **Country** United States

(see related work on pages 100, 102)

MERIT Special Effects **Change**

Art Director Paul Foulkes **Creative Directors** Rich Silverstein, Steve Simpson, John Norman **Copywriter** Tyler Hampton **Director** Tim Hope **Editor** Tony Kearns **Producers** Hilary Bradley, Brian Coate **Production Company** Passion Pictures **Agency** Goodby, Silverstein & Partners **Client** Hewlett Packard **Country** United States

MUSIC: "Blue Skies" by Maxine Sullivan.
SINGERS: "Blue skies, smiling at me. Nothing but blue skies do I see. Blue birds signing a song. Nothing but blue ..."
Open on a modern city sidewalk scene. Buildings and lampposts start turning and changing into updated versions. A man wearing a suit enters screen left walking along, unphased by the environment. The camera follows him as he continues into an office building. The façade of the building shifts to reveal a revolving door. He continues past two rooms, which both change from offices to conference rooms to server rooms. He then enters his office with big windows and a desk. The man pauses to look out the window. The buildings outside and his desk then also start changing, like the rest of the commercial. The man then sits down to work on his computer. Colored arrows begin appearing in all directions near the buildings outside the window.
VO: Today's great companies are adapting to change using highly scalable HP BladeSystem servers powered by reliable Intel Xeon Processors.

The brief: HP Technology and Services help global companies manage change. We wanted to tell this story by showing a global executive experiencing massive change all around him as if it were nothing at all. We immediately gravitated to Tim Hope because of his special effects ability and unique visual style. The challenge for him was making the "change effects" realistic despite their unrealistic nature. Another challenge was making it look like a single shot all the way through. To do this, Tim and his crew created the office interior in a green screen studio before shooting the exteriors in East London. The real task was compositing it all together, as the actor, the exterior, the office, and the extras were all separate elements. Not to mention the background stuff, almost all of which was created by Tim and his effects wizards.

To raise **awareness** among a cross-section of influential consumers of the **Mount Sinai** Medical Center various "centers of excellence" and **superiority** as an innovator and caregiver.

MERIT Radio: Over 30 Seconds, Campaign **Mount Sinai Medical Center: Spinal Cord, Aneurysm, Voicebox**

Creative Director Sal DeVito **Copywriter** Wayne Winfield **Producer** Barbara Michelson **Production Company** McHale Barone **Agency** DeVito/Verdi **Client** Mount Sinai Medical Center **Country** United States

144

SPINAL CORD

Brian Gobbi suffered a devastating injury. Brian Gobbi suffered a devastating injury. He damaged his spinal cord in a surfing accident. He damaged his spinal cord in a surfing accident. In a split second, he became a quadriplegic. In a split second, he became a quadriplegic. Doctors were convinced Brian would never walk again. Doctors at Mount Sinai Rehabilitation Center believed that Brian might walk again. He was resigned to spending his life in a wheelchair. He couldn't accept spending his life in a wheelchair. He lapsed into a deep depression. He launched into a fierce regimen of exercise. Brian can never forget the day he was injured. Brian will never forget the day he walked again.

ANNOUNCER: Which hospital you choose can make all the difference in the world. Mount Sinai. Another day, another breakthrough. For more information, call 1-800-MD Sinai.

ANEURYSM

74-year-old Howard Arzt went to the doctor for a routine checkup. 74-year-old Howard Arzt went to the doctor for a routine checkup. It was discovered he had an aortic aneurysm. It was discovered he had an aortic aneurysm. He was rushed to a hospital. He was rushed to Mount Sinai. Doctors said the operation could be devastating to a man his age. Doctors said the operation was routine, even for a man his age. He was afraid to undergo such extremely invasive surgery. He willingly went ahead with non-invasive surgery. He left the hospital knowing his aneurysm could burst at any time. He left the hospital knowing he was out of danger. Howard became preoccupied with dying. Howard became obsessed with living.

ANNOUNCER: Which hospital you choose can make all the difference in the world. Mount Sinai. Another day. Another breakthrough. For more information, call 1-800-MD Sinai.

VOICEBOX

Attorney Lawrence Glynn had cancer of the throat. Attorney Lawrence Glynn had cancer of the throat. Radiation failed to remove the tumor. Radiation failed to remove the tumor. Most of his larynx was removed. Most of his larynx was removed. Doctors said there was nothing more they could do. Doctors at Mount Sinai were able to reconstruct his voicebox. He lost his voice and his livelihood. He still had his voice and his livelihood. He never stepped foot in the courtroom again. He is a commanding presence in the courtroom. Lawrence felt like there was no justice in the world. Lawrence felt like he had gotten a reprieve.

ANNOUNCER: Which hospital you choose can make all the difference in the world. Mount Sinai. Another day. Another breakthrough. For more information, call 1-800-MD Sinai.

MERIT Radio: Public Service | Non-Profit, Campaign
Step Up Speak Out Radio Campaign: Screamin' in the Trunk, On Your Knees, What's Poppin'

Creative Director Clint Runge **Director** Joe Goddard **Production Company** Soundscapes **Agency** Archrival **Client** Nebraska Domestic Violence Sexual Assault Coalition **Country** United States

Step Up Speak Out is a campaign fighting gender abuse in mainstream media. Targeting teens, the goal was to find a way to empower youth by providing them with a filter to hear how gender abuse, particularily toward women, is embodied in much of the most popular top 40 music. Since actually changing the music industry would be impossible, we focused on the listener. The biggest challenge was to find a way to insert that filter without sounding "adult" and "uncool" by trashing the artists and their music. It's ok to listen to; what's wrong is when you begin to take your relationship advice from the music. The solution was simply to remove all the hype (music and beats) from the lyrics and actually spell out what it is that we're listening to; the result is unnerving suggestions that most people would be opposed to celebrating.

SCREAMIN' IN THE TRUNK
(Eminem, Stan)
FEMALE VOICE: That's my girlfriend screamin' in the trunk but i didn't slit her throat, i just tied her up, see i ain't like you cause if she suffocates she'll suffer more, and she'll die too. These are the words of a nine-time Grammy-Award-Winning Artist. Music has a special effect on all of us. For women, it's not always a great one.
Don't get sold. Step Up. Speak Out. Dot com.

ON YOUR KNEES
(Nickelback, Figured You Out)
FEMALE VOICE: I like your pants around your feet. And I like the dirt that's on your knees. And I like the way you still say please while you're looking up at me. And I love your lack of self respect while you're passed out on the deck I love my hands around your neck.
These are the words of a multi-Grammy-Nominated Artist. Music has a special effect on all of us. For women, it's not always a great one.
Don't get sold. Step Up. Speak Out. Dot com.

WHAT'S POPPIN'
(Chingy, Holidae In)
FEMALE VOICE: I took a chick in the bathroom seeing what's poppin you know what's on my mind, shirts off and panties dropping Handled that, told ol' G, bring tha camera Then I thought about, no footage while I ram her Walked out the bathroom smiling. These are the words of a #1 Billboard Chart-Topping Artist. Music has a special effect on all of us. For women, it's not always a great one.
Don't get sold. Step Up. Speak Out. Dot com.

145

Mark Sweeney randomly calls his old second grade teacher, a sweet old lady, just to say hello. He does this because he has a Sprint calling plan that gives him a lot of minutes. She doesn't quite remember him, but she's nice to him anyway. It gets awkward at the end and they say goodbye.

146

MERIT Radio: Over 30 Seconds **Mrs. Chavez**

Creative Director Mark Sweeney **Copywriters** Mark Sweeney, Laura Mulloy **Producer** Eliezar Goco **Production Company** One Union Recording **Agency** Publicis & Hal Riney **Client** Sprint PCS **Country** United States

The objective of the spot/campaign was to announce a calling plan that had a lot of minutes for not a lot of money. So we figured that a guy using all these minutes to call people from his past to just catch up might be pretty funny. So we hooked my phone up to some recording equipment and just started calling people. In this spot we couldn't track down any of my old teachers, so we called my wife's grandmother, told her to play my second grade teacher, and just messed around for a few minutes.

MERIT Newspaper Consumer, Less Than a Full Page
Answer

Art Director Mariana O'Kelly **Creative Director** Mike Schalit **Copywriter** Gary DuToit **Designer** Mariana O'Kelly **Production Company** Beith Digital **Agency** NET#WORK BBDO **Client** The Economist **Country** South Africa

Whenever a publication prints a puzzle or quiz, the answers are usually written upside down in small type at the bottom of the page. By printing The Economist in this way, we are implying that no matter what you need to know, The Economist has the answer.

Note: ad ran this way up

A: The Economist

BALANCED COVERAGE
ON BOTH SIDES OF THE ETHNIC-CLEANSING ISSUE.

the ONION

IT'S JUST A NEWSPAPER.
YEAH, AND GANDHI WAS JUST A MEXICAN.

READ ABOUT THE WORLD
THAT'S PASSING YOU BY AS YOU MASTURBATE.

the ONION

WE FIRED OUR FACT-CHECKERS
AND PASSED THE SAVINGS ON TO YOU.

ALWAYS POLITICALLY CORRECT.
EXCEPT FOR THE STORIES ON RETARDS.

MERIT Newspaper Consumer, Less Than a Full Page, Campaign
The Onion: Ethnic Cleansing, Gandhi, The World, Fact Checkers, Politically Correct

Art Directors Lou Flores, John Parker **Creative Director** Mike Lear
Copywriters Mike Lear, Adam Moroze, Keith Greenstein, Rob Katzenstein
Agency The Martin Agency **Client** The Onion **Country** United States

Historically, The Martin Agency has worked with some of the most respected and sought-after brands in the world. The Onion is certainly no exception. After extensive testing and retesting, this work was released only after the tightest scrutiny, with attention paid to the three hallmarks of great Onion work: strategic accuracy, factual precision, and, above all, journalistic integrity.

MERIT Newspaper Consumer, Full Page, Campaign **Score, Review, Schedule, Notice, Storyboard**

Art Director Dave Douglass **Creative Director** Zak Mroueh **Copywriter** Pete Breton **Designer** Dave Watson **Account Manager** Amanda Gaspard **Typographer/Mac Artist** Peter Hodson **Producer** Mark Prole **Illustrator** Jeff Norwell **Photographer** Ron Fehling **Agency** TAXI **Client** Canadian Film Centre's Worldwide Short Film Festival **Country** Canada

Strategy: To attract new ticket subscribers to the festival by playing off its distinguishing attribute: Shorter films. Inspiration: We were inspired by our client who opened the door and gave us a lot of creative freedom. It was terrifying, but exhilarating.

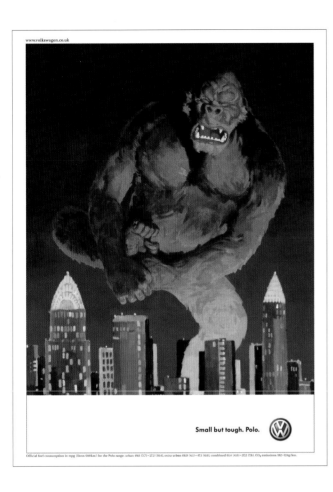

MERIT Newspaper Consumer, Full Page **King Kong**

Art Director Nick Allsop **Creative Directors** Jeremy
Craigen, Ewan Paterson **Copywriter** Simon Veksner
Typographer Peter Mould **Illustrator** Paul Slater **Agency**
DDB London **Client** Volkswagen **Country** United Kingdom

The brief for this ad was grounded in a truth about the car,
which helps. The Polo is seen as tougher than other small cars,
thanks to Volkswagen's legendary build quality. As a result,
Polo owners have a warm relationship with their cars that is
supported by advertising of an understated wit. We didn't need
to feature the car, as its appearance is familiar to the audience.
By implying that it was the object that hurt the gorilla's foot,
we create a puzzle for the viewer to solve, which is always
satisfying. We also credit them with intelligence. Rarely are
clients brave enough to do this as consistently as Volkswagen.
For the art direction, we appropriated the lurid look of the
hand-painted posters for the original "King Kong" film,
heightening the comedy and making an interesting image.

MERIT Newspaper Consumer, Full Page **Camouflage**

Art Director Justin Tindall **Creative Director** Andrew Fraser
Copywriters Adam Tucker, Matt Lee **Designer** Peter Mould **Agency**
DDB London **Client** The Guardian **Country** United Kingdom

There can be few people with even a passing knowledge of the Ryder
Cup who are unaware of the bitter and, on occasion, ugly rivalry
that exists between us (fair and sporting) Europeans and the (anything-
it-takes-to-win) Americans. This time, the hostilities were resumed
at Oakland Hills, Michigan. Our job was to get Guardian newspaper
readers to pick up their free guide to the tournament as well as (we
hoped) give them something entertaining to look at. Having seen a
map of the course itself, we quickly saw the potential of a graphic
depiction of golf as war. Thanks to the jury, and thanks to our victorious
Ryder Cup team, for keeping our cup on our side of the pond.

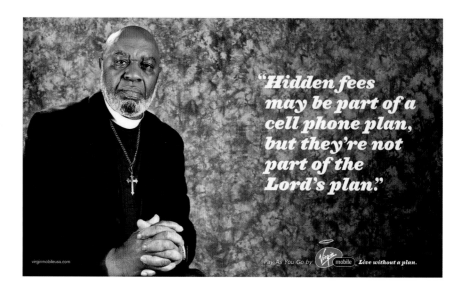

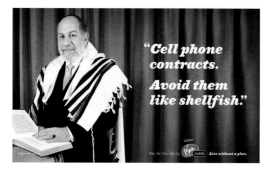

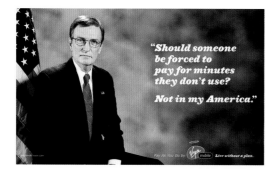

MERIT Magazine, Consumer, Full Page, Campaign
Morality: Pastor, Rabbi, Politician, Sunday School Teacher

Art Director Jerome Marucci **Creative Director** Ari Merkin **Copywriter** Scott Cooney **Producer** Louise Doherty **Photographer** Guido Vitti **Agency** Fallon New York **Client** Virgin Mobile USA **Country** United States

Virgin Mobile launched in the US in 2002 with a series of successful promotional campaigns, helping them to acquire record numbers of users in a very short period of time. While the user base after one year was impressive, research indicated that there was still a significant job to do to raise overall awareness for the Virgin Mobile brand and the benefits of the Pay-As-You-Go model. The resulting "Morality" campaign was built from the common ground of moral "righteousness" that Virgin Mobile shares with the country's religious leaders. Choosing to "Live without a Plan" is to choose the more moral path in wireless. It elevates our user-friendly Pay-As-You-Go benefits to the moral high ground and communicates that Virgin Mobile is the brand for young people who want to make their own considered choices.

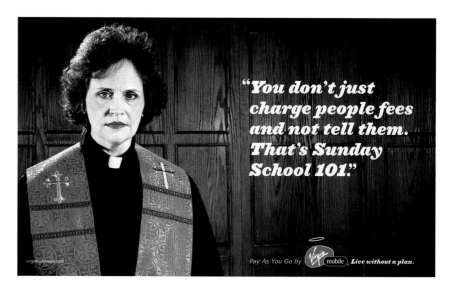

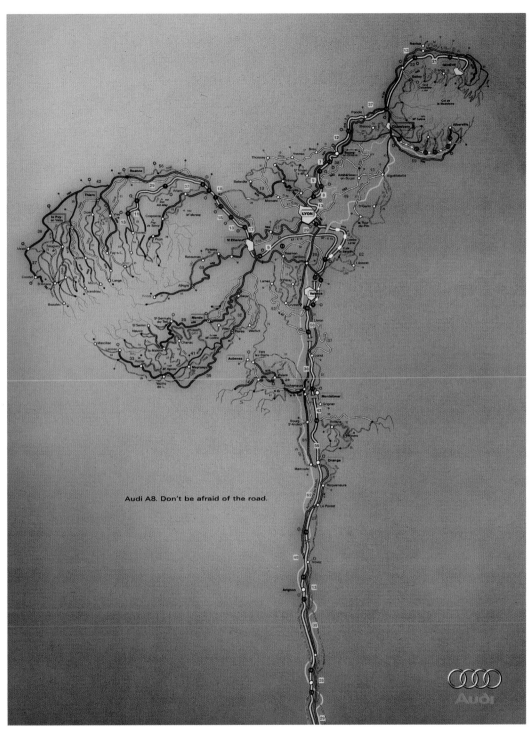

Audi A8. Don't be afraid of the road.

MERIT Magazine, Consumer, Full Page, Campaign
Audi A8: Flower, Carnivore, Alien, Insect

Art Director Pierrette Diaz **Creative Directors** Sylvain Thirache,
Alexandre Hervé **Copywriter** Céline Lescure **Designer** Olivier
Danglas **Agency** DDB PARIS **Client** Audi **Country** France

The new Audi A8 is the largest and most sporty sedan in the Audi range.
It is also the most powerful in its category. With its new V6 3.0 TDI engine,
it turns out to be a monster on the road. Don't be afraid of the road.

{MULTIPLE AWARD WINNER}

MERIT Magazine, Consumer, Full Page, Campaign
TIME: Greenspan, Burkas, Implants
MERIT Magazine, Consumer, Full Page **TIME: Burkas**

Art Director Bob Barrie **Creative Director** Ari Merkin
Copywriter Dean Buckhorn **Photographers** Alex Wong,
James Nachtwey, Les Stone **Agency** Fallon Minneapolis
Client TIME Magazine **Country** United States

As part of TIME's decade-long brand campaign, these three
ads use the magazine's iconic red border to demonstrate
the in-depth insight and understanding that TIME brings to
complex world, economic, and social issues

Every face tells a story.

Join the conversation.

If he ever retires, will there
be a Social Security system left
to support him?

Join the conversation.

Are the best minds in medicine
busy fighting disease, or gravity?

Join the conversation.

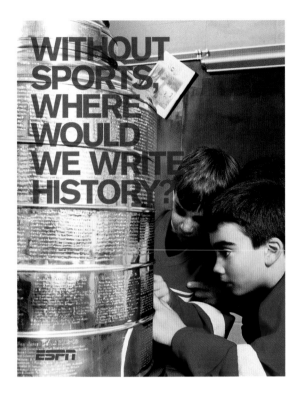

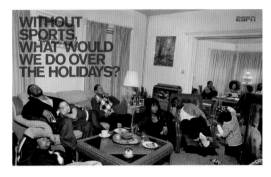

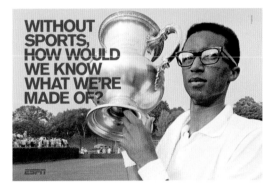

{**MULTIPLE AWARD WINNER**} (see related work on page 135)

MERIT Magazine, Consumer Spread, Campaign
ESPN Brand: Holidays, History, Arthur Ashe
MERIT Magazine, Consumer Spread **Holidays**

Art Directors Alan Buchanan, Stephanie Sigg **Art Director/Associate Creative Director** Paul Renner **Creative Directors** Todd Waterbury, Ty Montague, Kevin Proudfoot **Associate Creative Director** Kevin Proudfoot **Copywriters** Charles Hall, Andy Carrigan, Greg Kalleres **Photographers** Bellmann (CORBIS), Melodie McDaniel, Ron Haviv **Director of Photography** Melodie McDaniel **Agency** Wieden+Kennedy New York **Client** ESPN **Country** United States

The goal of this campaign has always been to illustrate the wide variety of ways in which sports touch our lives. Sometimes we do this through the use of historically significant photos (as in "Arthur Ashe") and sometimes we use snapshot images of everyday moments in life (as in "Holidays"). We want to reach as many different kinds of people as possible and remind them of the many ways sports have influenced their lives and our culture. In doing so, we continue to solidify ESPN's position as a true champion of all that is great about sports.

MERIT Magazine, Consumer, Full Page **Life Lines**

Art Director Thomas Kurzawski **Creative Directors**
Kurt Georg Dieckert, Stefan Schmidt **Copywriter** Pete
Engelbrecht **Graphics** Angela Schubert **Producer** Katrin
Dettmann **Production Company** 24+7 **Photographer** Billy
& Hells **Agency** TBWA\Germany **Client** Sony Computer
Entertainment Deutschland GmbH **Country** Germany

The brief was to communicate, as simply as possible, that the
PlayStation2 gives gamers the opportunity to live many lives.

154

MERIT Magazine, Consumer Multipage
Study in Choice

Art Director Micah Walker **Creative Directors**
Richard Flintham, Andy McLeod **Copywriter**
Ross Ludwig **Typographer** Micah Walker
Photographer Giblin & James **Agency** Fallon
London **Client** Skoda **Country** United Kingdom

Since being a really good car sometimes loses
out to "what's everyone else driving?" Skoda
wanted to talk to people who like to think for
themselves. We came up with the idea of a Study
in Choice, and showed a series of images to
people, asking them to make a selection based
on their own preference. After determining how
they scored, we used the least common choices in
each category to write the endline.

MERIT Magazine, Trade Full Page, Campaign
Stihl Blower: Snow, Desert, Volcano

Art Director Martin Darfeuille **Creative
Directors** Sylvain Thirache, Alexandre Hervé
Copywriter Edouard Perarnaud **Agency** DDB
Paris **Client** STIHL **Country** France

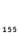

155

How to continue to build the Stihl communication territory by communicating the performance of its blowers? By basing the presentation on a product tangible attribute—the air flow power—and by using the exaggeration as a blower's performance demonstration.

MERIT Magazine, Trade Full Page
Where Do You See Yourself?

Art Director Cody Spinadel **Creative Director** Joe Alexander
Copywriter Joe Alexander **Agency** The Martin Agency **Client**
Dick Gerdes Recruiting **Country** United States

Everybody in the creative business knows headhunters are,
well, always headhunting. You can't really trust them.
We've been creating ads for Dick Gerdes for ten years now.
We've always strived to present him as the recruiter who really
understands creative. He's not just trying to place you in the
shop where he's going to get the biggest cut. He knows each
agency's culture and vibe. He honestly wants to place you in an
environment that fits not only your book, but your personality
as well. So that's how we ended up here. For the styling and
wardrobe, we used our knowledge of each place (we've worked
at a couple ourselves), plus some of the perceptions we have
through the press, friends, etc. Great retouching job, too. The
model is actually an art director who worked at the agency at
the time. Recently, he left the agency. So, ironically, maybe he's
using this piece to see how he'd fit in at Goodby, Wieden, or
Crispin.

MERIT Promotional **Stretchposter**

Art Director Klaus Trapp **Creative Directors**
Peter Steger, Andreas Heinzel **Copywriter**
Mathias Henkel **Designer/Photographer** Klaus
Hagmeier **Account Executives** Levin Reyher,
Nadine Bürger **Agency** Leo Burnett, Frankfurt
Client Kellogg's Germany **Country** Germany

Target audience: Women who want to keep or find their personal shape—and who are willing to do
something for it. Communications objective: To convince people how easy it is to find their own shape:
with a low-fat breakfast and a slight exercise. Creative strategy: Most people who regularly work out at a
gym are concerned about their shape. For these people, Kellogg's Special K is the perfect product, as it
guarantees full taste even though it's 99% fat-free. We demonstrate the impressive effect of a balanced
diet in combination with slight physical exercises by fixing a stretch poster to the weights of fitness
equipment. As soon as somebody lifts the weights, the poster gets stretched—and the woman shown on
the poster apparently optimizes her shape.

Art Director Alexandre Pagano **Creative Directors** Luiz Sanches, Roberto
Pereira **Copywriter** André Faria **Agency** AlmapBBDO **Client** FedEx **Country** Brazil

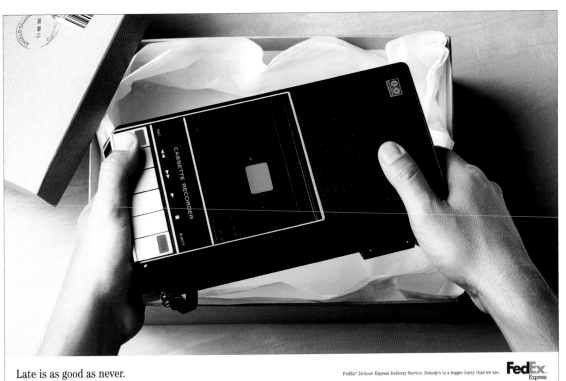

Late is as good as never.

FedEx® 24-hour Express Delivery Service. Nobody's in a bigger hurry than we are.

Late is as good as never.

Late is as good as never.

157

MERIT Promotional, Campaign **The Bite Light I-IV**

Art Director Shumei Takahashi **Creative Director** Yuji Kano **Copywriters**
Takuma Takasaki, Marc X Grigoroff **Designers** Tsubasa Adachi, Yutaka Sugiura
Agency Producer Michiko Ishihara **Production Companies** Dentsu Tec Inc.,
Adbrain Inc., Foton Inc., Ad Seeds Inc. **Photographer** Shintaro Shiratori **Agency**
Dentsu Inc., Tokyo **Client** Meiji Seika Kaisha, Ltd. **Country** Japan

The key selling point of this gum is the addition of a new ingredient, dextranase,
which claims to make teeth beautiful. The posters show this feature humorously,
an easy-to-understand manner: teeth so beautiful and bright that they are used as
a light. The targets are all the people who care about beautiful teeth; the primary
targets, however, are young men and women in their teens to their 30s.

{**MULTIPLE AWARD WINNER**} (see also page 280)

MERIT Promotional, Campaign
CMYK Campaign: Clockwork, Creature, Panther, Riding Hood

Art Directors Hamish McArthur, Adam Lewin **Creative Directors** Tony
Granger, Tod Seisser, Lee St. James **Copywriters** Jason Graff, Jeff
Greenspan **Agency** Saatchi & Saatchi New York **Client** Hudson Repro
Country United States

The target audience for Hudson Repro are communication and marketing
professionals of Fortune 500 companies. The communication objective was
to highlight the company's expert print production capabilities. Our creative
strategy positioned Hudson Repro's print production professionals as people
who were not just into color, but people who were driven by the exactness of
color. The campaign consisted of print, radio, TV, and web ads.

dimensions: 16 1/2" h x 23 1/4" w

159

Fiat Stilo with Sky Window **R$ 54.697,00**

MERIT Promotional, Campaign **Heads**

Art Director Virgilio Neves **Creative Directors** Adriana Cury, Virgilio Neves **Copywriter** Virgilio Neves **Photographer** Rodrigo Ribeiro **Agency** Ogilvy Brasil **Client** Fiat **Country** Brazil

We created this particular campaign to communicate the Fiat Stilo with Sky Window, whose principal feature is the biggest sunroof in its category. Capitalizing on the habit people have of placing their sunglasses on top of their heads, we created the illusion that an unusual and humorous face is enjoying the beauty of the sky through the sunroof.

Proud sponsor of the Toronto International Film Festival.™ Drivers wanted.® VW

MERIT Promotional **Filmstrip**

Art Director Angela Sung **Creative Directors** Tim Kavander, Bill Newbery **Copywriter** Gord Yungblut **Agency** Arnold Worldwide Canada **Client** Volkswagen Canada **Country** Canada

The challenge we faced with this assignment was to somehow try to link the Film Festival to our client's product, in this case well-built, German-engineered automobiles. Faster than you can say, "Verr is mein schnitzel, Fraulein," we had our solution. Create a piece that, from a distance, looks like an actual strip of film, but upon closer inspection reveals that its sprockets comprise images of the iconic Volkswagen Beetle.

MERIT Promotional **Candida: Dental Tape**

Agency Advico Young & Rubicam **Country** Switzerland

Teeth can look white and clean even if they're not. Destructive bacteria grows in the interspace between them, where the toothbrush can't reach and where only Dental Floss works. How do we use billboards to best explain this context? We had three billboards, each with a poster of a big tooth. The interspace between the posters was used to show the problem of growing bacterias in a very surprising way: with real growing plants that look like dirt.

MERRY CHRISTMAS WITH TABASCO

MERIT Promotional **Santa**

Art Directors Philippe Taroux **Creative Director** Erik Vervroegen
Other Benoît Leroux **Photographer** Bruno Clément **Agency** TBWA\
Paris **Client** Tabasco **Country** France

The idea for this ad was to take advantage of the warm,
delicious atmosphere of Christmas to talk about a very warm,
delicious product: Tabasco. Santa Claus, the symbolic character
of the season, loves fire. He is not afraid of burning his behind
when he comes down the chimney, and he is not afraid of
burning his whiskers when eating Tabasco sauce. It may be cold
outside, but thanks to Tabasco it is very warm inside.

162

MERIT Point-of-Purchase **High Jump**

Art Directors Peng Ji, Fan Ge, Tif Wu, Eddie Wong **Creative
Directors** Eddie Wong, Tif Wu **Copywriter** Rabbit Shen **Account
Handlers** Ruth Ang, Annie Ye, Sebastian Liang, Brandy Yu
Agency TBWA\Shanghai **Client** adidas China **Country** China

"High Jump" was one of several executions that Adidas China
developed for its retail stores in Shanghai during the 2004
Athens Olympics. The main objective was to create "excitement
and atmosphere" during the Olympics fever. Disrupting the
convention of 2-D posters with an impactful execution of a
simple fold, it communicates, "Men's world record for high
jump—2.45m. IMPOSSIBLE IS NOTHING."

MERIT Point-of-Purchase **Moby**

Art Director Bren Postma **Creative Directors** Mark
Hurst, Steve Babcock **Copywriter** Bren Postma
Designer Bren Postma **Agency** W Communications
Client Jiffy Lube **Country** United States

Getting your car lubed and oiled is a simple thing. Get
the customer in and out fast. Our client needed to get
back to their promise: speed. They had lost their way
and their brand voice.

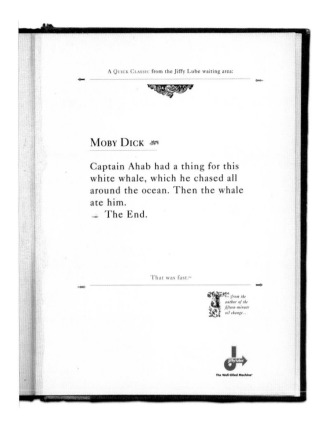

163

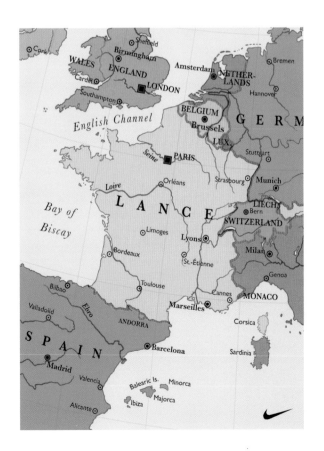

MERIT Point-of-Purchase **Conqueror**

Art Director Tim Forte **Creative Director** Darren
Spiller **Copywriter** Paul Bootlis **Agency** Publicis
Mojo **Client** Nike **Country** Australia

This advertisement was designed to celebrate
quintessential Nike personality, Lance Armstrong,
and commemorate his sixth consecutive Tour de
France win and dominance of that event.

MERIT Point-of-Purchase **Plugs**

Art Director Chris Garbutt **Creative Director** Erik Vervroegen **Other** Matthew Branning **Photographer** Dimitri Daniloff **Agency** TBWA\Paris **Client** Sony Playstation **Country** France

In response to the development of online gaming, this ad repositions the Playstation as a collective (as opposed to isolating) experience.

164

Banana flavoured condoms.

MERIT Point-of-Purchase **Monkey**

Art Director Jessica Gérard-Huet **Creative Director** Erik Vervroegen **Other** Jean-François Bouchet **Photographer** Philippe Gueguen **Agency** TBWA\Paris **Client** Hansaplast **Country** France

The idea behind this ad was to set up a dissonance between the visual with the pack shot and the visual without the pack shot. Without the pack shot, you only see Tarzan alongside his friend Cheetah. But when you are shown the pack shot, you begin to realize what may have transpired between them. We decided to use Tarzan since the campaign is intended to sell banana-flavoured condoms. Given the nature of the product, we opted to focus on the fun side of sexuality. We chose to take a humorous approach rather than a serious tone such as that used in AIDS prevention campaigns. There is some humor in making light of using condoms while conveying the idea that it is possible to have fun and still protect yourself.

{MULTIPLE AWARD WINNER}
MERIT Point-of-Purchase, Campaign **Tomato, Steak, Potato**
MERIT Point-of-Purchase **Tomato**
MERIT Point-of-Purchase **Potato**

Art Director James Clunie **Creative Director** David Lubars
Copywriter Tim Cawley **Designer** James Clunie **Agency** BBDO
New York **Client** Dexter Russell Cutlery **Country** United States

The objective of this campaign was to simply and quickly illustrate
the precision in which these knives are forged. These posters had
multiple uses, but their primary use was in-store, so they needed to
stand out in a fairly cluttered space—which is partly why the tomato,
the potato, and the slab of meat are surrounded by many inches
of white space. Other cutlery companies make the claim of quality,
precision, and craftsmanship, but fail to tell us why this is important.
This campaign effectively tells us why precision is important by simply
showing it. If you're this anal and exacting about the preparation of
your food, you need to work with tools that can meet that need.

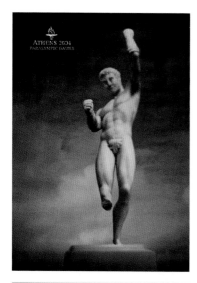

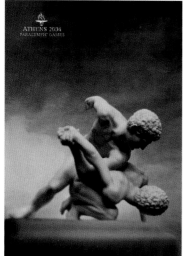

MERIT Public Service | Non-Profit/Educational, Campaign **Paralympic Boxer, Wrestlers, Discus**

Art Director Gido van der Vlies **Copywriter** Stan van Zon
Image Editing Nick Strong **Photographer** Jan Holtslag
Agency Leo Burnett Amsterdam **Client** National Funds
for Disabled Sporters **Country** Netherlands

The objective of this campaign was to achieve
awareness for the Paralympics 2004. The main
problem of these games is the perception is
that it's not a natural part of the Olympics, but
more an obligation to let disabled sporters take
part of the games. The challenge therefore was
to convince people that the Paralympics should
be an accepted part of the Olympics. The use of
the well-known Olympic statues, in the way we
know and accept them, shows how natural the
Paralympics actually are.

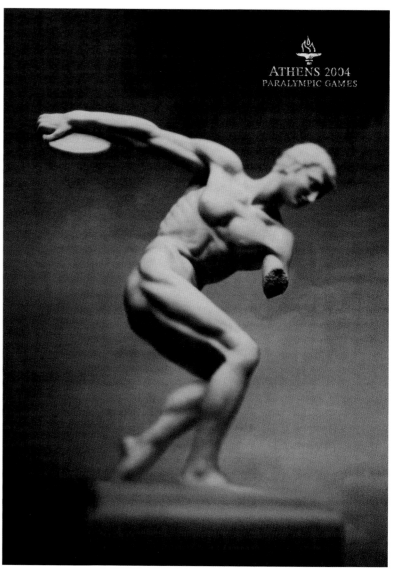

MERIT Transit **Impossible Bus Pull**

Art Directors Tadashi Tsujimoto, Hirofumi Nakajima **Creative Director**
John Merrifield **Copywriter** Katsuhisa Fujita **Agency** TBWA\Japan **Client**
adidas **Country** Japan

(see related work on pages 32 and 83)

We wanted to launch the new Impossible is Nothing campaign by demonstrating the
impossible as opposed to just talking about it. In each of the major cities in Japan,
we painted a number of buses. But instead of driving them around, we placed them
in different locations each morning before dawn. Then we had people pull them
along the road. We even invited members of the public to have a try. This resulted
in a whole slew of articles and appearances on sports, entertainment, and news
shows throughout Japan. It created considerable buzz wherever the buses were seen
(often outside stadiums during major sporting events). One of the most famous Sumo
wrestlers in Japan even gave it a go and insisted that the bus be full of people. He
hardly even leaned forward.

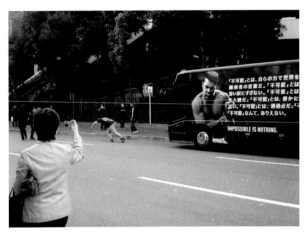

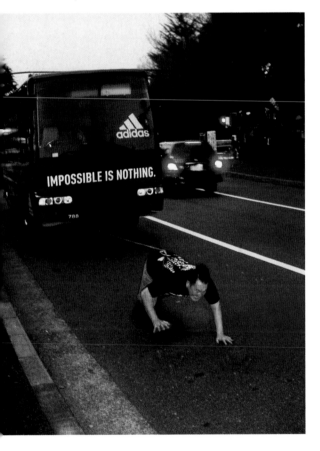

POSTERS & BILLBOARDS

ADVERTISING

167

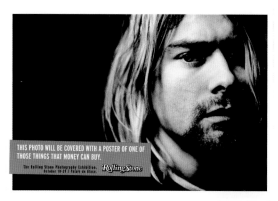

MERIT Transit, Campaign **Rolling Stone: Cobain, Lennon, Richards**

Art Director Federico Callegari **Creative Directors** Joaquín Mollá, José Mollá, Ricardo Vior **Copywriter** Francisco Ferro **Producer** Facundo Perez **Agency** la comunidad **Country** United States

The value of the thirty-six years of Rolling Stones Magazine's hectic history is something that no other magazine has. They were there when all the most interesting things in rock happened. Their covers are a great platform to remind new readers that they are the authority when it comes to music.

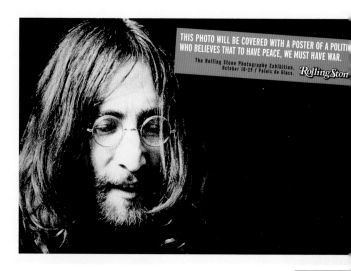

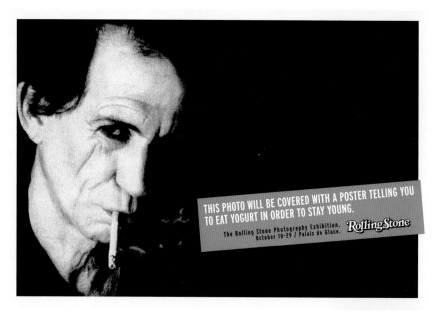

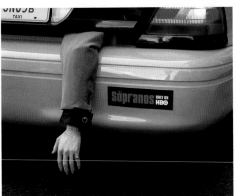

MERIT Transit **Arm**

Art Directors Chris Maiorino, Frank Anselmo, Jayson Atienza
Creative Directors David Lubars, Don Schneider **Copywriters** Chris
Maiorino, Frank Anselmo, Jayson Atienza **Agency** BBDO New York
Client HBO **Country** United States

The assignment was to promote and create buzz for HBO's award-
winning hit series The Sopranos. The Sopranos is a modern age, down-
and-dirty Mafia drama (think Godfather or Goodfellas) presented in a
series format on a premium cable television network HBO. A lifelike arm
was made to look just like one of an assassinated Mafia hit man. The
arm consisted of a suit jacket with a silk shirt, cufflink, and the traditional
gold pinky ring—indicative of the typical Mafia get-up. The hand itself
was constructed from a plastic mold of an actual human hand. The arms
were then affixed to the trunks of NYC taxi cabs to create the impression
that an actual body was stuffed inside. To pay off the series, a simple
bumper sticker with the Soprano's logo was stuck beside the hand.

MERIT Outdoor | Billboard **Green & Red Curry**

Art Directors Nils Andersson, Keiichi Sasaki **Creative Director**
Mitsuaki Aota **Copywriters** Nils Andersson, Keiichi Sasaki
Designers Nobuya Mochinaga, Hitoshi Miyamoto, Nanae Sega
Other Chihiro Aono, Tsuneo Toriyama, Yasuhiro Hashida **Producer**
Tomoko Higuchi, Nick Uemura **Agencies** Hakuhodo Inc., TBWA\
G1\Tokyo **Client** House Foods **Country** Japan

The world's first curry tree. Chiba prefecture. Near Tokyo. Japan
House, Japan's largest food company, wanted to launch two
natural curry products. To accompany the launch, we decided to try
something unconventional. As the Japanese have a love affair with
nature, the changing of the seasons was used to deliver the clear
message that Japan House now offers both green and red curry. The
outdoor board went up next to a busy road in June. On it, all that was
printed was a large plate and two pack shots. It was then erected
directly in front of a leafy green tree. The branches of the tree were
pruned to look as if they were the curry on the plate on the board. A
huge fork was added as a finishing touch. The optical illusion worked
and remained in place until autumn, when the leaves turned red.
One broadcaster even remarked that maybe people should travel to
Chiba this year, not Kyoto, to see the leaves turn.

Spring

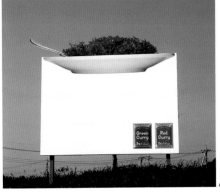

Autumn

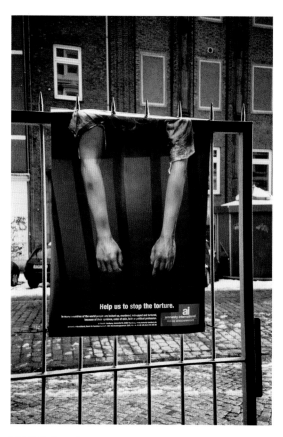

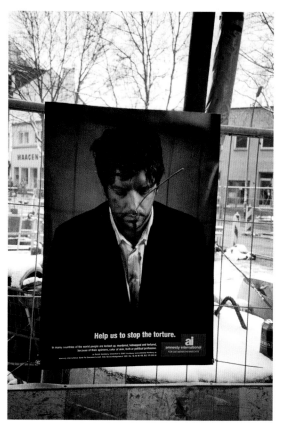

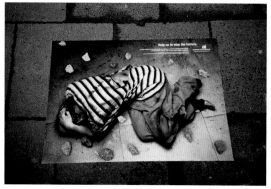

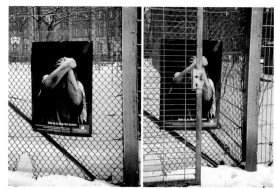

170

Objectives: Appeal to act for human rights. Challenges: High involvement with low investment. Solution: Ambient Media Campaign using the environmental possibilities (e.g., fences, spikes) to sensitively show how people are tortured in many countries.

MERIT Wild Postings, Campaign **Amnesty International, Street Torture: Hanging, Skewering, Stoning, Batting**

Art Director Mitoh **Creative Director** Michael Hoinkes **Copywriter** Elena Tresnak **Designer** Mitoh **Other** Stefan Försterling **Agency** He Said She Said **Client** Amnesty International **Country** Germany

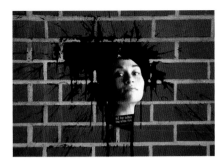

Hairstyle Sticker for M2 Hair-Culture, the hairdresser with the "true urban style." True urban style is not found in classifieds of city magazines, but downtown itself. That is why it makes sense to promote there. In the city of Frankfurt, M2 Hair-Culture stickers with faces were pasted on walls, depicting a new hairstyle.

Promotion „Hairstyle-Sticker"

True urban style is not found in classifieds of city-magazines, but downtown itself. That's why it makes sense to promote there. In the city of Frankfurt M2 Hair Culture-stickers with faces were pasted upon walls, in a way that made up new hairstyles. The campaign took place in summer 2004.

MERIT Wild Postings, Campaign **Hairstyle Sticker**

Art Director Olga Potempa **Creative Directors** Simon Oppmann, Peter Roemmelt
Photographer Georg Gottbrath **Agency** Ogilvy & Mather Frankfurt **Client** M2 Hair
Culture, Frankfurt **Country** Germany

MERIT Outdoor | Billboard **McDonald's Milkshake "Straw"**

Art Director Brian Shembeda **Creative Directors** Mark Tutssel, John
Montgomery **Copywriter** Avery Gross **Designer** Brian Shembeda
Producer Laurie Gustafson **Photographer** Greg Mohrs **Agency** Leo
Burnett, Chicago **Client** McDonald's **Country** United States

Without question, the most potent tool for cutting through an
oversaturated ad market is the adoption of new and disruptive media
types. Not having that option for this particular assignment, we
instead did the next best thing, applying some new thinking to one of
the oldest media types, the outdoor board. Incorporating the pole into
the concept of the ad, we created what amounted to the world's largest
product demonstration for McDonald's Triple Thick Shakes.

172

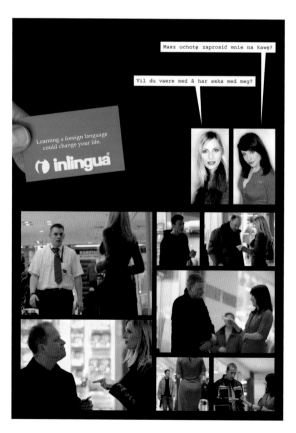

MERIT Product | Service Promotion **Language Barrier**

Art Directors Susanne Weber, Andreas Krallmann **Creative
Directors** Sven Klohk, Christoph Hildebrand **Photographer**
Bianca Radziwanowska **Agency** Kolle Rebbe Werbeagentur
GmbH **Client** Inlingua Language Center **Country** Germany

Inlingua language school wanted to introduce its latest course
program and find new course participants at the same time. Due
to a low advertising budget, attention-grabbing cost-effective
actions were developed. Beautiful women from different countries
approached men in Germany, speaking in their native tongues
(e.g., Polish or Swedish). Lacking foreign language skills, the men
were not able to take advantage of this rare opportunity to flirt, so
the women gave them little cards with the contact address of the
Inlingua Language School.

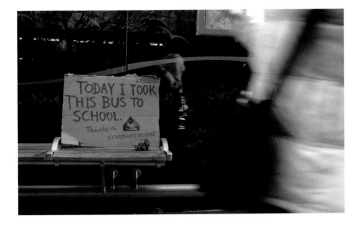

Art Director Tony Hird **Creative Director** Grant Fraggalosch
Copywriter Grant Fraggalosch **Agency** Young and Rubicam
Client Covenant House Vancouver **Country** Canada

Our goal was to let people know Covenant House is more than just
a homeless shelter. We placed these cardboard signs in downtown
Vancouver to create discussion about the positive outcomes of
Covenant House services for Vancouver's street youth.

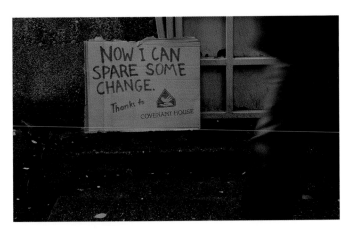

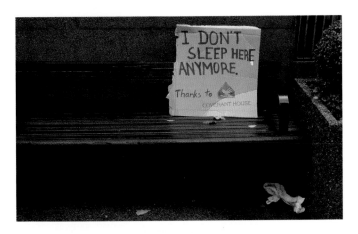

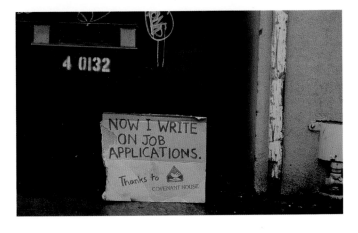

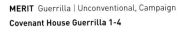

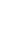

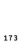

ADVERTISING COLLATERAL

173

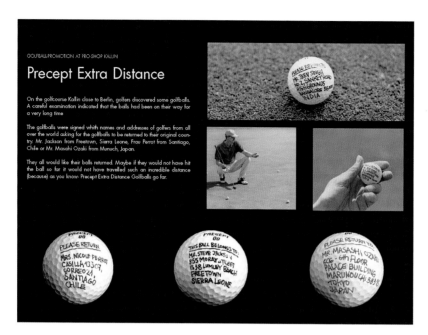

GOLFBALL·PROMOTION AT PRO-SHOP KALLIN

Precept Extra Distance

On the golfcourse Kallin close to Berlin, golfers discovered some golfballs. A careful examination indicated that the balls had been on their way for a very long time

The golfballs were signed whith names and addresses of golfers from all over the world asking for the golfballs to be returned to their original country: Mr. Jackson from Freetown, Sierra Leone, Frau Perrot from Santiago, Chile or Mr. Masashi Ozaki from Munuch, Japan.

They all would like their balls returned. Maybe if they would not have hit the ball so far it would not have travelled such an incredible distance (because) as you know- Precept Extra Distance Golfballs go far.

The brief was to communicate that Precept Extra Distance Golf Balls go incredibly far. On the Kallin golf course near Berlin, golfers discovered some golf balls. So far nothing special. But a closer examination indicated that the balls had been traveling for a long time. They were signed with names and addresses of golfers from all over the world, asking that the golf balls be returned to their owners. Mr. Jackson from Freetown, Sierra Leone, Mrs. Perrot from Santiago, Chile, and Mr. Masashi Ozaki from Japan—they would all like their balls returned. As we already mentioned: Precept Extra Distance Golf Balls go far.

MERIT Guerrilla | Unconventional **Precept Extra Distance Golf ball Promotion**

Art Director Philip Borchardt **Creative Directors** Kurt Georg Dieckert, Stefan Schmidt **Copywriter** Helge Blöck **Designer** Christine Taylor **Agency** TBWA\Germany **Client** Golfanlage Kallin Betriebs GmbH **Country** Germany

MERIT Guerrilla | Unconventional **Cement Shoes**

Art Directors Chris Maiorino, Frank Anselmo, Jayson Atienza **Creative Directors** David Lubars, Don Schneider **Copywriters** Chris Maiorino, Frank Anselmo, Jayson Atienza **Agency** BBDO New York **Client** HBO **Country** United States

174

The assignment was to promote and create buzz for HBO's award-winning hit series The Sopranos. The Sopranos is a modern age down-and-dirty Mafia drama (think Godfather or Goodfellas) presented in a series format on a premium cable television network HBO. The use of cement shoes is a traditional Mafia method of body disposal. Mafia hit men would place their victim's feet in a box filled with cement. After it formed and dried to concrete, the victim would be thrown into the water to sink and perish without the possibility of surfacing later. The prop contains a pair of real boots molded into cement shoes. The shoes were placed in display windows of several high-traffic shoe stores around New York City. A typical shoe plaque, custom engraved with "The Sopranos" logo, was placed beside the shoes.

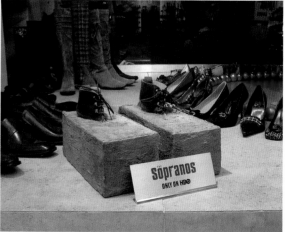

MERIT Guerrilla | Unconventional, Campaign
Stains: Tie, Pants, Shirt, T-Shirt, Dress

Art Directors Chris Garbutt, Matthew Branning, Eve Roussou **Creative Director**
Erik Vervroegen **Other** Chris Garbutt, Matthew Branning **Photographer** Eve Roussou
Agency TBWA\Paris **Client** K2R **Country** France

K2R is France's top-selling stain remover. This campaign used existing oil spots and stains
throughout the city to create guerrilla "ads."

175

PHOTOGRAPHY & ILLUSTRATION

SILVER Magazine Editorial, Series **1954: 1-5**

Photographer Achim Lippoth **Studio/Design Firm**
Achim Lippoth Photography **Other** Catrin Hansmerten
Client Kids Wear Magazine **Country** Germany

(see related work on page 300)

The inspiration for this fashion story came from the
incredible win of the German soccer team at the World
Championships in Switzerland in 1954. The challenges were
to find authentic locations and, of course, the styling. All
clothes are taken from the latest collections, and the whole
editorial was shot in a museum for coal mine workers.

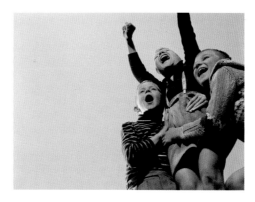

SILVER Magazine Editorial, Series
Swimmers: pp. 24-25, pp. 26-27, pp. 28-29, pp. 30-31, p. 32-33

Art Director Arem Duplessis **Creative Director** Janet Froelich **Designer**
Nancy Harris **Photo Editors** Kathy Ryan, Justin O'Neill **Photographer**
Ryan McGinley **Publisher** The New York Times **Studio/Design Firm** The
New York Times Magazine **Country** United States

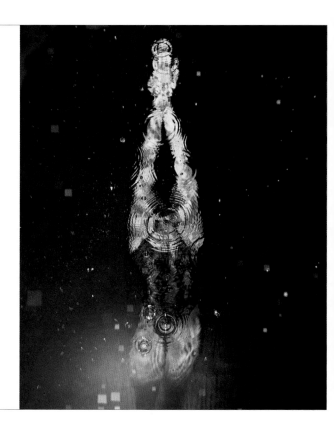

Photographs of the U.S. Olympic swim team.

The Strokes

By Ryan McGinley

24

When Ryan McGinley set out to photograph the Olympic swimmers, he had
a singular goal in mind. He wanted to convey the silent power and singular
beauty of being underwater. He wanted to show us the extraordinary
gracefulness of the swimmers and give us a sense of what a life spent below
the surface is like. What is it like to spend endless hours a day underwater,
as these swimmers do? These pictures make the viewer want to jump into
their world. Ryan traveled all over the country, and swam right along, behind,
or above the athletes to bring us in close to his subjects.

Kaitlin Sandeno, 21 | Lake Forest, Calif. | 400 Freestyle | 200 Butterfly | 400 Individual Medley | 800 Freestyle Relay

In photographing the New York Times Magazine's choices for the best performances in film in 2003, Inez van Lamsweerde and Vinoodh Matadin acted as directors as well as photographers to create a theatrical style of portraiture. Over the course of several months, van Lamsweerde and Matadin traveled to four cities for the shoots, almost all of which took place in less than an hour.

Benicio Del Toro | 21 Grams

Ralph Fiennes | Spider

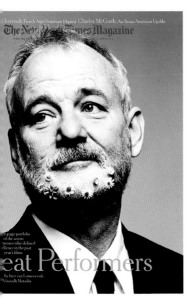

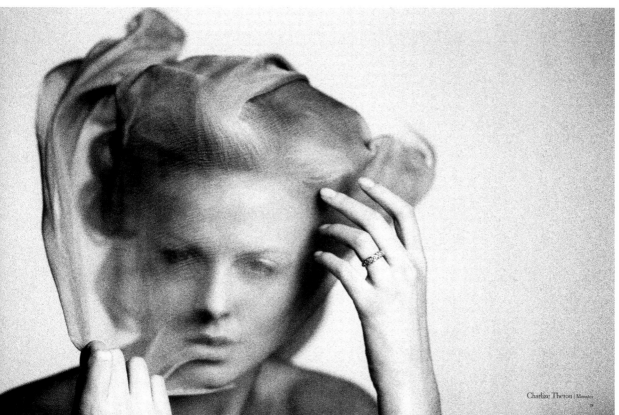

Charlize Theron | Monster

Chiaki Kuriyama | Kill Bill - Vol. 1

SILVER Magazine Editorial, Series **Great Performers: Oscars cover,
Oscars pp. 64-65, Oscars pp. 66-67, Oscars pp. 68-69, Oscars pp. 70-71**

Creative Director Janet Froelich **Designer** Joele Cuyler **Photo Editors** Kathy Ryan, Kira
Pollack **Photographers** Inez van Lamsweerde, Vinoodh Matadin **Publisher** The New
York Times **Studio/Design Firm** The New York Times Magazine **Country** United States

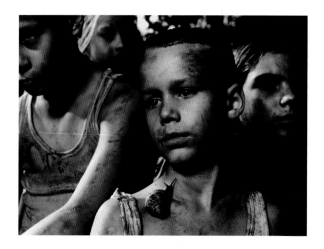

DISTINCTIVE MERIT Magazine Editorial, Series **Woelflinge 1-5**

Photographer Achim Lippoth **Other** Catrin Hansmerten **Studio/Design Firm**
Achim Lippoth Photography **Client** Kids Wear Magazine **Country** Germany

This fashion story was inspired by the movie Lord of the Rings. All kids have a
deep wish to explore the world in a great adventure with their friends, without the
protection of their parents. The piece was shot in Greece and the kids had great fun.

PHOTOGRAPHY | MAGAZINE EDITORIAL

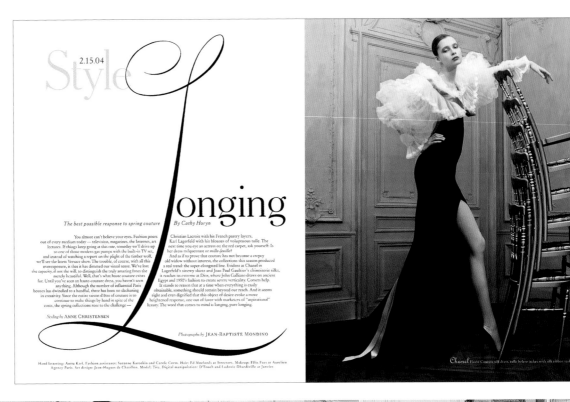

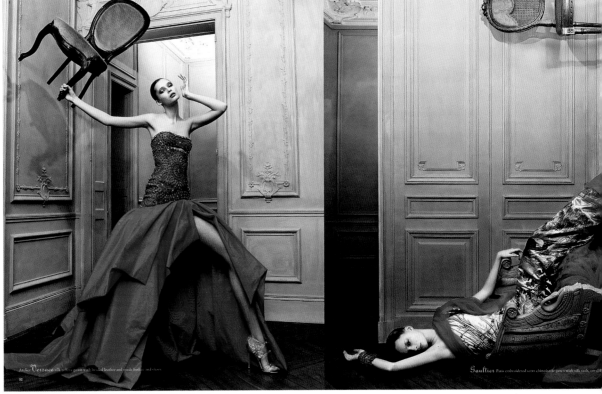

186

DISTINCTIVE MERIT Magazine Editorial, Series
Longing: pp. 48-49, pp. 50-51, pp. 52-53, pp. 54-55

Creative Director Janet Froelich **Designer** Joele Cuyler **Fashion Editor** Anne
Christensen **Photographer** Jean-Baptiste Mondino **Publisher** The New York Times
Studio/Design Firm The New York Times Magazine **Country** United States

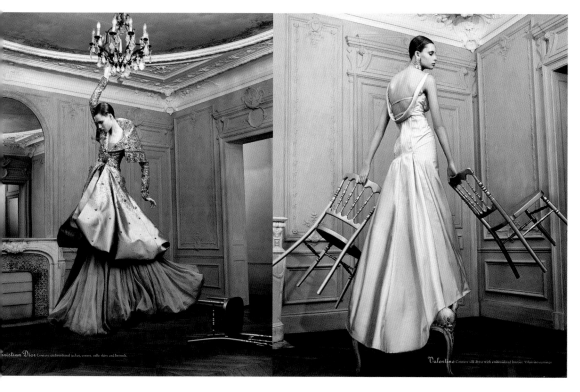

Christian Dior Couture embroidered jacket, corset, tulle skirt and brooch.

Valentino Couture silk dress with embroidered bustier. Valentino earrings.

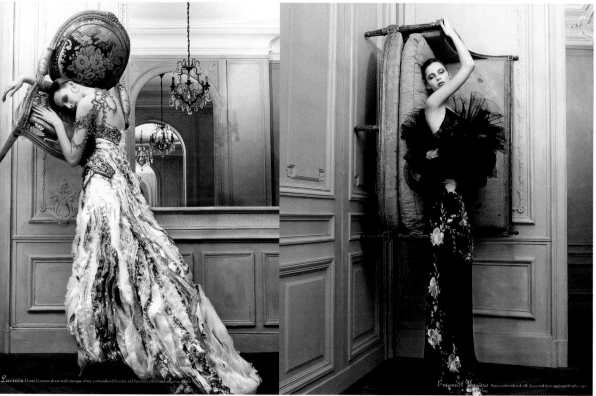

Lacroix Haute Couture dress with antique silver embroidered bustier and layered taffeta and organza skirts.

Emanuel Ungaro Paris embroidered silk dress and rose-appliquéd tulle cape.

Photographer Jean Baptiste Mondino, working with the stylist Anne Christensen, created a series of images that try to give the reader a sense of the truly breathtaking quality of haute couture fashion. This particular season had a trend, the super-elongated line. In Mondino's pictures, we see this exaggerated line in each image as he plays with distortion and fantasy: the model hangs from a chandelier, or stands on a series of chairs like a lion tamer, or stretches improbably across the ceiling (or is it the wall?). Chairs turn into fixtures and fly into space. Nothing is real, and so the model too is improbably elongated. The headline, of course, follows suit. An elegantly elongated script, hand lettered by Anita Karl.

Zai is the dream of an uncompromising ski, manufactured by hand in the Swiss mountains: a ski that redefines the concept of value, timelessness, and perfect form. The visual execution was to be as uncompromising as the mountains. Only someone born and raised in the mountains of Switzerland is up to the challenge of realistically capturing this area. Jules Spinatsch, photographer and artist, ventured in fierce conditions to the most remote valleys to find the precise angle, the perfect moment, and the right atmosphere.

DISTINCTIVE MERIT Corporate | Institutional, Series
Zai Mountains: Cristallina 1, Cristallina 2, Lukmanier 1, Lukmanier 2, Punteglias 01

Art Director Oliver Fennel **Creative Director** Alexander Jaggy **Other** Karin Knapp,
Ilonka Galliard **Photographer** Jules Spinatsch **Studio/Design Firm** Jung von Matt AG
Clients Zai AG, Disentis **Country** Switzerland

DISTINCTIVE MERIT Self-Promotion, Series **Zu Hause ist Vaillant (Home is Vaillant): Gletscher (Glacier), Strasse (Street), Regenschirm (Umbrella)**

Creative Director Claus Lieck **Art Buying** Bettina Tetens **Production** Leonora Sheppard **Coordination** Angelika Synek Etat **Director** Holger Wengelnik **Client Marketing Director** Corinna Scheer **Photo Assistants** Meike Nixdorf, Jean-Claude Winkler **Retouchers** Recom, Thomas Fritz **Photographer** Christian Schmidt **Studio/Design Firm** BMZ und More **Client** Vaillant **Country** Germany

Campaign for the heater and air condition supplier Vaillant. The concept
for this campaign was to show people in cold, rainy, snowy situations trying
to get home soon. The headline "Vaillant is Home" explains the concept.
The challenge for me as the photographer was to capture these extreme
weather situations and to make the concept visible.

192

Art Director Burkhard Schittny **Other** Julia Neubauer (Styling at Bigoudi), Claudia Wegener (Hair and makeup at LigaNord) **Photographer** Burkhard Schittny **Country** Germany

This series forms part of Burkhard Schittny's continuing exploration of idealized advertising photographic imagery. It captures the quiet introspective moment that shields the urban dweller from the hustle and bustle of the metropolis around them. Noise—both audible and visible—blurs into an amorphous backdrop against which a very private scene unfolds. The blurred backdrop, however, retains the agressive and unfocused energy of the urban jungle, while the vulnerability and deeply intimate personal space of the people depicted is expressed through their unremitting exposure in full focus.

DISTINCTIVE MERIT Self-Promotion, Series
Knob Creek Series 2: Back of Truck—Smoke Cloud, Old Man Watching,
Back of Man/Overalls, Fat Man on Left, Gun Line

Art Director Todd Cornelius **Photographer** Michael Graf **Studio/Design**
Firm Graf Studios **Country** Canada

A documentation of the world's largest gun festival and machine gun shoot.

{MULTIPLE AWARD WINNER} (see also page 258)

DISTINCTIVE MERIT Cover, Newspaper | Magazine **T Design Issue Cover**

Art Director David Sebbah **Creative Director** Janet Froelich **Designers** David Sebbah,
Janet Froelich **Photo Editor** Kathy Ryan **Photographer** Raymond Meier **Publisher** The New
York Times **Studio/Design Firm** The New York Times Magazine **Country** United States

The photographic identity of T: The New York Times Style Magazine, is an uncommonly tight close-up. There are
no cover lines, except for the simple line at the bottom which announces the particular focus of that issue, and the
large Fraktur T, which dominates the upper left corner. This logo was developed to take advantage of the unique
typographic identity of The New York Times. Typographer Matthew Carter was asked to flesh out and modernize
the letterform, making it fuller, rounder, and more graphic. For this launch issue, T: Women's Fashion, Kate
Winslet was the perfect subject. Having recently given birth to her second child, she was glowing. Photographer
Raymond Meier, who shoots all T covers, took full advantage of her beauty with his extraordinary lighting and
perfect composition. With no cover lines, the image is allowed to fully dominate the cover.

MERIT Magazine Advertisement, Campaign
Einer muss da sein (One Has To be There): Strom (Energy), Braunkohle (Brown Coal), Wasser (Water)

Art Director Axel Domke **Creative Director** Katrin Öding **Retoucher** Sven Mamero (PX3) **Photographer** Christian Schmidt **Agency** Philipp und Keuntje **Client** RWE **Country** Germany

Campaign for the power supplier rwe, where we shot real workers from the company in their real working situations. Headline: "one has to be there." The challenge for me as the photographer was to deal with the existing places and people and to find a way to visually capture these situations.

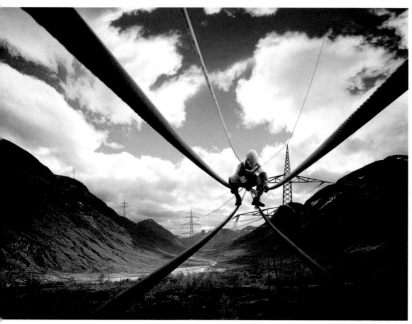

PHOTOGRAPHY

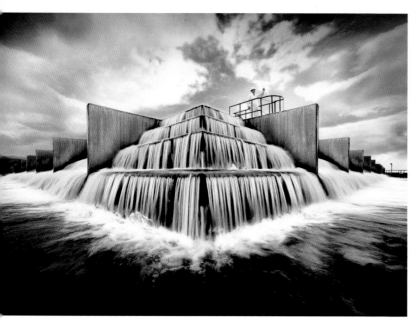

MERIT Newspaper Advertisement, Campaign
**Volkswagen Petrol Station: Wusrt Felle,
Goodburger, Bratpfanne**

Art Director Ralf Nolting **Creative Directors** Ralf
Nolting, Patricia Pätzold **Chief Creative Officer**
Ralf Heuel **Copywriters** Thies Schuster, Reinhard
Patzschke **Photographer** Emir Haveric **Agency**
Grabarz & Partner Werbeagentur GmbH **Client**
Volkswagen AG **Country** Germany

Due to Volkswagen's TDI ® technology, diesel engines
use even less petrol and customers can buy great
products, where once only boring fuel was on display.

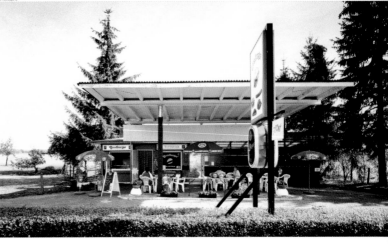

TDI®. Volkswagen diesel technology.

TDI®. Volkswagen diesel technology.

TDI®. Volkswagen diesel technology.

MERIT Magazine Editorial, Series
**Olympics: Olympic Pride, The High Diver, The Rower,
The Runners, The Swimmers**

Creative Director William Stoddart **Fashion Editor** Sophie
Michaud **Photographer** Esther Haase **Studio/Design Firm**
Esther Haase Photographie **Country** Germany

In collaboration with Madame Figaro, I shot this Olympic-themed
story in Paris last year. We wanted to create a very dynamic, graphic
story in black and white that reflected the energy of the games. In
order to capture this vibrancy, we cast a mix of models and real-life
athletes. The authenticity of their movements was added inspiration.
We then found a stadium in which to shoot, and this location added
to the spirit and created the right energy for us to bring together the
elements of our Olympic interpretation.

MERIT Magazine Editorial, Series
(t)here Magazine Issue Seven

Art Director Jason Makowski **Creative Director** Christopher
Wieliczko **Photographers** Philippe Schlienger, Patti Smith,
Robert Bomgardner, Diego Uchitel, John Hultberg, Garth
Meyer, Anne Katrine Senstad **Publisher** ThereMedia, Inc.
Studio/Design Firm ThereMedia, Inc. **Country** United States

(t)here magazine provides a creative outlet for the most talented
and innovative artists of the moment and presents imaginative
features without compromising the integrity of content. (t)here
is a new space for art. Its pages bring together the singular
visions of artists working in all media. Each issue is the fruition
of experiments, explorations, and collaborations that can't be
found anywhere else. Artists invited to contribute also choose
(t)here as a vehicle for new work, new ideas, and the opportunity
to reach a sophisticated audience. The artists who bring each
issue alive represent a community of emerging voices as well as
familiar ones seen in a new light. The magazine exists to bring
an unique combination of images and words to an audience that
is seeking a new aesthetic. Past contributors include Timothy
Greenfield-Sanders, Fabrizio Ferri, Mira Nair, Billy Corgan, Arlo
Guthrie, Quentin Crisp, Stephen Shames, Komar & Melamid,
Yelena Yemchuk, Ford Crull, Curtis Taylor, Gerry Slota, Edward
Mapplethorp, Patti Smith, and Bill Plympton, to name just a few.
(t)here intends to link all art forms through its pages. Any activity
that brings beautiful things to life will find a place inside (t)here.

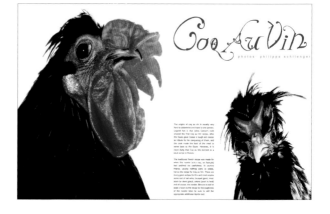

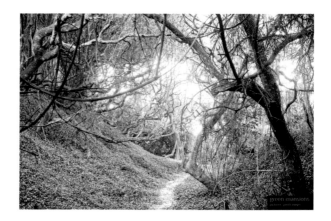

Italian Glamour creative director Alexander Wiederin asked us
to come up with an editorial using bags and shoes. We asked to
include clothes, and did a National Geographic-inspired wild life
story. We built animals out of the clothes sent from Italy and placed
them in a natural setting in upstate New York.

Photographers Bela Borsodi, Paul Graves **Publisher** Condé
Nast **Studio/Design Firm** Art Department **Client** Italian Glamour
Country United States

MERIT Magazine Advertisement
Altoids Gum: Jaw Strength

Art Director Mikal Pittman **Creative Directors** Noel Haan, G. Andrew Meyer **Illustrator** Mike Williams **Photographer** Tony D'Orio **Agency** Leo Burnett **Clients** Kraft, Altoids **Country** United States

(see related work on page 130)

The objective was to introduce people to the notion that Altoids, makers of The Curiously Strong Mints, were introducing a Curiously Strong Gum into the world, while maintaining the subversive sensibilities that make the brand what it is. The challenge was to do so with a tiny fraction of the budget of our major competitor. The solution was to suggest that you must "prepare yourself" for the coming of The Curiously Strong Gum.

202

MERIT Magazine Editorial **Afro Disiac**

Art Directors Topher Sinkinson, Mary Kysar **Creative Director** Richard Christiansen **Designer** Topher Sinkinson **Photo Editor** Sara Fisher **Photographer** Michael Brandt **Publisher** Essence Communication Partners **Studio/Design Firm** Suede Magazine **Country** United States

The concept was to explore the Afro hairstyle for African-American women. The photography focused on the beauty of the model and the hairstyle at its extreme glamour. The background was kept white and stark to further enhance the hairstyle and to show a modern view of an age-old style.

The goal of "Air Show" was to accurately portray the work of Misaki Kawai. Her work is both excitingly raw and meticulously beautiful in its obsessiveness, and accurately representing the two was our greatest challenge. The solution was to compartmentalize her work stylistically so that it could be appreciated fully.

MERIT Book Jacket **(Air Show) Work by Misaki Kawai**

Art Directors Brett Kilroe, Tracy Boychuk **Creative Director** Kevin Christy
Designers Brett Kilroe, Tracy Boychuk **Editor** James Hughes **Photo
Editors** Brett Kilroe, Tracy Boychuk **Photographer** Warren Darius Aftahi
Publisher Broken Wrist Project **Studio/Design Firms** Brett&Tracy, Broken
Wrist Project **Client** Broken Wrist Project **Country** United States

MERIT Self-Promotion **Cuba Libre**

Creative Director Greg Samata **Designer** Goretti Kao
Photographer Stephen Wilkes **Studio/Design Firm** Stephen Wilkes
Country United States

The goal of this self-promotion piece is to create a series of images on the artists of Latin America and to capture the unique connection between a creator and his or her art. To fully portray this connection, I explored the artists' life, surroundings, and inspirations. Not only did I photograph the artists, I captured various aspects of their everyday life in the cities in which they live. Through my study, I gained access to some of the artists' favorite rooms. Finally, I captured street scenes, which conveyed the essence of each artist's town.

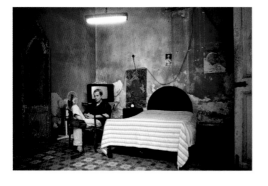

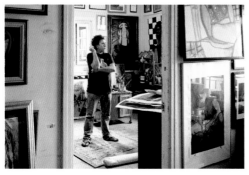 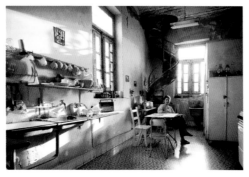

"Game-Face" is an explorative portrait series.

MERIT Self-Promotion, Series **Game—Face: Joey, John, Rick, Nikolai**

Art Director Daniel Vendramin **Photographer** Michael Graf
Studio/Design Firm Graf Studios **Country** Canada

MERIT Self-Promotion, Series **Africa: Spirit Dancer 1-5**

Art Director Todd Cornelius **Photographer** Michael Graf **Studio | Design**
Firm Graf Studios **Country** Canada

These photographs are part of an extended series on African Voodoo.

MERIT Calendar Or Appointment Book **2005 Agenda**

Art Director Louis Gagnon **Creative Director** Louis Gagnon **Designer** Sebastien Bisson **Photographers** Louis Gagnon, Rene Clement, François Brunelle, David Sanders **Publisher** Eric Leblanc **Studio/Design Firm** Paprika Communications **Client** Transcontinental Litho Acme **Country** Canada

Transcontinental Litho Acme, a major printing company, gave Paprika Communications the mandate to design this 365-page 2005 Agenda. In fact, it's a sequel of the 2004 piece Paprika created in collaboration with this same client. For this 2005 edition, creative director Louis Gagnon and senior designer Sebastien Bisson decided to push the design even further in addition to pushing the photography and production envelope. They didn't hesitate to invite some special collaborators to join the team. Their obsessive quest for numbers in everyday life took them to family archives, vintage shops, and untouched winter nature.

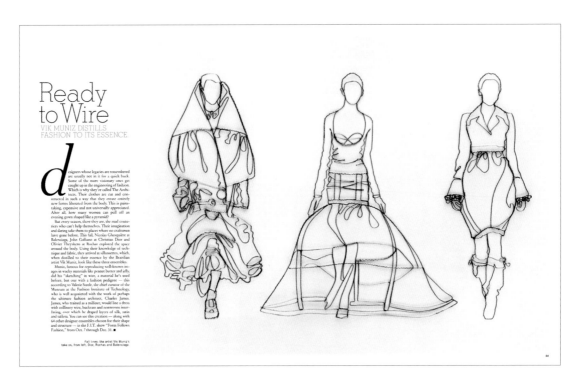

DISTINCTIVE MERIT Magazine Editorial **Ready to Wire**

Art Director David Sebbah **Creative Director** Janet Froelich **Designers** Janet Froelich, David Sebbah **Illustrator** Vik Muniz **Photo Editor** Kathy Ryan **Photographer** Vik Muniz **Publisher** The New York Times **Studio/ Design Firm** The New York Times Magazine **Country** United States

Photo editor Kathy Ryan asked the artist Vik Muniz, famously known for creating artwork out of wacky materials like coffee and peanut butter and jelly, to create silhouettes of the work of fashion designers Nicholas Guesquiere, John Galliano, and Olivier Theyskens. Muniz sketched the silhouettes in wire and photographed them.

DISTINCTIVE MERIT Book
Guinness Traveler's Journal

Creative Director David Carroll **Other** John Simmons
Illustrator Peter Arkle **Studio/Design Firm** R&D&Co.
Client Jon Potter **Country** United Kingdom

The Guinness brand team was returning to its
spiritual home in Dublin from London. With writer
John Simmons, we developed this traveller's
journal to inspire the new "keepers of the essence"
through twelve success stories of the brand from
its major markets around the world. The journal
followed a character who experienced and recorded
stories from different cultures, learning various
brand truths along the way. The journey started out
in the bars of O'Connell Street and went via London,
Paris, Cameroon, Nigeria, South Africa, Singapore,
Australia, Japan, Canada, the US, and Jamaica
before coming to rest in the brand's new home and
the hallowed halls of Trinity College, Dublin. We
commissioned the New York–based illustrator Peter
Arkle to draw the sketchbook to John's stories. We
had to create a seamless blend between the words
and pictures so that they would appear as if they
were created as one.

Creative Strategy: Communicating with
twelve keywords from the phrase "communica-
tion design." Twelve keywords and illustrations
of faces from the imagination represent the
message for ourselves, and the title "365&36.5
communications" represents communication with
sensibility (36.5 degrees celsius is the same as
the temperature of the human body) for 365 days.

DISTINCTIVE MERIT Calendar Or Appointment Book
365 & 36.5 Communications

Art Director Kum-jun Park **Creative Director** Kum-jun
Park Copywriters Joon-young Bae, Eun-ju Ahn, Myoung
Hwa Shin **Designers** Kum-jun Park, Seung-youn Nam,
Jong-in Jung **Illustrator** Kum-jun Park **Photo Editor**
Joong-gyu Kang **Photographer** Jae-hee Park **Publisher**
Jong-in Jung **Studio/Design Firm** 601 Bisang **Client** 601
Bisang **Country** Korea South

DISTINCTIVE MERIT Miscellaneous **Miho Murmur**

Art Director Keiko Itakura **Designer** Keiko Itakura **Illustrator**
Keiko Itakura **Studio/Design Firm** Keiko Itakura **Client** Victor
Entertainment, Inc. **Country** Japan

The piece is a music album by singer Miho, who has decided to
come back to work after resting for some period of time. It shows
Miho's actions in the future. It also depicts the depth of herself
as a singer (her soul) and as a human being. The piece also shows
how kind a girl can be. Lastly, it expresses the alluring "mystical"
aspect of Miho's song, which is different from before. Working
artistically and making it simple while capturing people's minds, the
album does not picture Miho herself or contain any pictures.

In order to sell Panasonic's flat-screen TVs in the Japanese
market, we focused on the thinness of the product and
decided to make a poster ad like a Japanese picture
scroll, in which the product is shown as a long, thin sheet
of paper. In view of Japanese citizens' love for beautiful
traditional picture scrolls of Hokusai and other painters,
we chose several pictures from Hokusai's "36 Views of Mt.
Fuji" that were suitable for the ad, and carefully modified
the product to fit in with Hokusai's world of beautiful works
painted on a long, long sheet of paper. Our poster was
hugely successful in selling the product, and brought us
this great award, which we are very excited about.

MERIT Poster or Billboard—For Advertising **Viera**

Art Directors Tsutomu Takada, Keitaro Shirai **Creative Directors** Tsutomu Takada, Toshinori
Matsuda **Copywriters** Yasutada Nohara, Tomonori Matsushita **Designers** Yousuke Asayama,
Suguru Watanabe, Nobuhiko Ueno **Production Company** Tokyo Great Visual Inc. **Agency** Dentsu,
Inc. Kansai **Client** Matsushita Electric Industrial Co., Ltd. **Country** Japan

MERIT Magazine Editorial **Box Warrior**

Art Director Arem Duplessis **Creative Director** Janet
Froelich **Designer** Todd Albertson **Illustrator** Nathan Fox
Publisher The New York Times **Studio/Design Firm** The
New York Times Magazine **Country** United States

The military has created video games that are used to train
and recruit soldiers. We felt the only way to capture this was
to hire the illustrator Nathan Fox, whose comic book-like style
and graphic use of color brought this surreal world to life.

{**MULTIPLE AWARD WINNER**} (see also page 114)

MERIT Poster or Billboard—For Advertising **Microphone**

Art Director Rudi Anggono **Creative Director** Sean
Austin **Copywriter** Sean Austin **Designer** Rudi Anggono
Agency Downtown Partners Chicago **Client** Geary Theater
Country United States

The title of the show is pretty provocative all by itself. So we
decided to use the name, and create a simple visual around it.
At first we thought of doing it as a photo. But we kept trying to
push the look of it. And in the end, we decided that the crude
lines and bright colors of the illustration was more arresting.

MERIT Poster or Billboard, Campaign—For Advertising
Nike Retro Basket Part I: Polaroid, Bic, Felt Pen, Box Stickers

Art Directors Sylvain Thirache, Taschi Bharucha **Creative Directors**
Sylvain Thirache, Alexandre Hervé **Graphiste** Tashi Bharucha
Illustrators Tashi Bharucha, Billy Jean, Pierrette Diaz, Emmanuel
Begon, Guillaume Huger **Agency** DDB Paris **Client** Nike **Country** France

The campaign celebrates the thirty year evolution of Nike's basketball shoes,
and launches alongside an exhibition set to take place at the Metro Station
in Paris, that charts the many distinctive styles of footwear that Nike created
during the 70s and 80s. The idea was to suggest the developing artistic skills of
a teenager born in 1972, the year Nike first released their "Blazer" tennis shoe.

210

The Modernist

THERE'S A REASON THAT A JIL SANDER SUIT
IS THE ART WORLD'S FAVORITE UNIFORM. THE DESIGNER
TALKS ART AND TECHNIQUE WITH GUY TREBAY.
PORTRAIT BY FRANÇOIS BERTHOUD

"Sometimes you see fashion, and you could throw up," Jil Sander says with a shrug and a sigh. In New York for a 48-hour business trip, the German designer is seated in the rear of a Lincoln Town Car on one of those May days when the weather plays bait-and-switch and Manhattan is plunged into stifling summer before one has even registered spring. Despite the heat and an atmosphere that adheres to the skin like toasty cling wrap, New Yorkers — in this particular part of Midtown, right across from the Condé Nast building — seem to be doing their best to keep up the civic bargain. That is, they are decked out with a vengeance, with a dedication and passion — snub-toed shoes and big belts and Thom Browne suits, with trousers hemmed to heights not seen since the days of Pee-wee Herman — that demonstrate to the truly committed that dressing oneself is a competitive sport with no room for amateurs. Yet, in Sander's view, the contestants are faltering. They don't ap-

pear altogether modern, to use a word that gets a lot of play whenever fashion people are around. They seem, to Sander's eye, to be walking illustrations of the Oscar Wilde epigram that "most people are other people," their lives a mimicry and their passions a quotation. "If you look as a professional, 98 percent of what we see now is cut-and-paste," she says. "It's all old-fashioned, the work. It's coming from vintage, and so it's almost as if fashion today has become a stupid store."

In truth, it is Sander herself who is something of a throwback, and the term is intended here as praise. Where most designers now function as glorified stylists or D.J.'s — fashion samplers with a lively relationship to eBay and running accounts at Gallagher's, the bookshop where back issues of Harper's Bazaar go to die — Sander is a formalist concerned primarily with structure and shape. And where other designers talk in terms of "inspirations" and of narra-

Illustrator and artist François Bertaud was asked to create a portrait of Jil Sander, a famously reluctant photographic subject. Berthaud's pure, minimalist approach perfectly compliments Sander's spare aesthetic, and the page design was intentionally minimal as well.

MERIT Magazine Editorial **The Modernist**

Art Director David Sebbah **Creative Director** Janet Froelich **Designers** Janet Froelich, David Sebbah **Illustrator** Francois Berthoud **Publisher** The New York Times **Studio/Design Firm** The New York Times Magazine **Country** United States

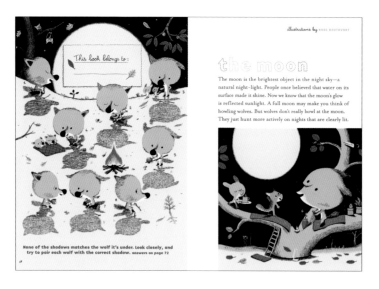

MERIT Magazine Editorial **Fall How Now**

Art Director Deb Bishop **Creative Director** Gael Towey **Designer** Jennifer Dahl **Illustrator** Marc Boutavant **Photo Editor** Rebecca Donnelly **Photographer** Catherine Ledner **Publisher** Martha Stewart Living Omnimedia **Studio/Design Firm** Martha Stewart Omnimedia **Country** United States

This was designed as an educational yet fun activity book for kids to do by themselves. In order to reduce visual chaos, and still be able to combine photography and illustration effectively, we chose to assign only one illustrator and photographer. The result was a kids' product that is visually pleasing, cohesive, and easy to read. The book-like quality, complete with bookplate in the front, makes kids feel like it is theirs alone to enjoy.

MERIT Magazine Editorial **Winter How Now**

Art Director Deb Bishop **Creative Director** Gael Towey **Designer** Jennifer Dahl **Illustrator** Greg Clarke **Photo Editor** Rebecca Donnelly **Photographer** Victor Schrager **Publisher** Martha Stewart Living Omnimedia **Studio/Design Firm** Martha Stewart Omnimedia **Country** United States

This was designed as an educational, yet fun, activity book for kids to do by themselves. In order to reduce visual chaos, and still be able to combine photography and illustration effectively, we chose to assign only one illustrator and photographer. The result was a kids' product that is visually pleasing by being cohesive and easy to read. The book-like quality, complete with bookplate in the front, makes them feel like it is theirs alone to enjoy.

MERIT Cover, Newspaper | Magazine
Big Detroit Cover Illustration

Art Director John Hobbs **Creative Director** Toni Torres **Designer** John Hobbs **Illustrator** John Hobbs **Publisher** Big Magazine, Inc. **Studio/Design Firm** BBH **Client** BIG **Country** United States

The car, a '78 Lincoln Mark V, had a knack for being parked outside a number of bars, galleries, studios, residences, and restaurants we were frequenting while putting the Detroit issue together. And like the city itself, it seemed to be getting on just fine despite being a bit tattered and bruised. It was placed in a launch position as a bit of a nod to Detroit's cultural momentum.

MERIT Cover, Newspaper | Magazine **Missed Connection Cover**

Art Editor Françoise Mouly **Illustrator** Adrian Tomine **Studio/Design Firm** The New Yorker **Country** United States

PRICE $3.95

THE
NEW YORKER

MAY 10, 2004

ILLUSTRATION COVER, NEWSPAPER | MAGAZINE

MERIT Cover, Newspaper | Magazine **Open Wound Cover**

Art Editor Françoise Mouly **Illustrator** Ana Juan **Studio/Design Firm** The New Yorker **Country** United States

MERIT Corporate | Institutional **Take Me Out**

Art Director Lisa Wagner Holley **Designer** Lisa Wagner Holley **Illustrator** Paul Brookhart Davis **Studio/Design Firms** Harpy Design, Paul Davis Studio **Client** Geffen Playhouse **Country** United States

This illustration was one of a series painted by Paul Davis to advertise the plays produced for the 2004-2005 season at the Geffen Playhouse in Los Angeles. The season was promoted with the slogan "American Originals," and featured American playwrights and American themes. The illustration appeared in advertising inserts in the Los Angeles Times as well as in postcards, ads, and posters.

MERIT Book, Series
ADC Switzerland Annual 2004 Illustrations

Studio/Design Firm Advico Young & Rubicam **Client**
ADC Switzerland **Country** Switzerland

(see related work on page 305)

We wanted to introduce the different categories of the ADC Switzerland
Book with remarkable, outstanding illustrations. Of course they should
fit to our book-theme, "slaves of the idea." Every chapter starts with
a cover page of a fictive magazine called sklave. These covers are
designed by well known artists and illustrators from around the world.

Target Audience: UK broadsheet, including broadsheet supplement, and current affairs magazine art directors. Communications Objective: to acquire a greater amount of commissioned work from this sector (the majority of my work is commissioned by fashion and technology magazine editorial, the music industry, and advertising clients). The artwork was printed as an (approximately) A3 poster and rolled for mailing. The illustration was inspired by an anecdotal story of a Scarborough guest-house landlady—also a British National Party member—who raised her young children on xenophobic "adaptations" of popular fairy tales.

GRAPHIC DESIGN

GOLD Museum, Gallery, or Library Book
Friedrich Christian Flick Collection im Hamburger Bahnhof

Designers Detlef Fiedler, Daniela Haufe, Katja Schwalenberg, Julia Fuchs **Publisher** Smb/Dumont
Studio/Design Firm cyan **Client** Hamburger Bahnhof–Museum Für Gegenwart, Berlin **Country** Germany

Marcel **Broodthaers**
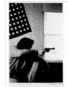
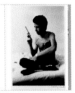

Larry **Clark**

This book is an art catalogue for a large exhibition of contemporary art in Berlin. The thirty-nine artists chosen for this exhibition from the Flick Collection are presented alphabetically. In this way, the catalogue becomes both an exhibition catalogue as well as a kind of encyclopedia/reference book. Each artist is presented with an opening spread containing general information (resume, list of works, etc). We used the following pages as a virtual stage: works of the artists are combined with their statements for an environment in which the art itself is the focus. By using various materials and techniques such as fold-out-pages, pop-ups, and embossed parts, we attempted to do justice to the varying approaches of the individual artists.

Stan **Douglas**

Duane **Hanson**

Martin **Kippenberger**

Bruce **Nauman**

Nam June **Paik**

Raymond **Pettibon**

Thomas **Ruff**

GOLD Juvenile Book **Brooch**

Art Director Yoshie Watanabe **Designer** Yoshie
Watanabe **Illustrator** Yoshie Watanabe **Publisher**
Little More **Other** Liric Yayako Uchida **Studio/
Design Firm** DRAFT Co., Ltd. **Country** Japan

At the outset, there was my dreamlike picture and the title. Ms. Yayako Uchida saw my picture,
wrote the words by isolating the picture, cut out the words, and placed each one on the picture. I
then designed the piece. The result has retained a nice sense of distance between the picture and
words. Ultimately, the words enabled the picture and the title to unite. It is made of thin, translucent,
inexpensive wrapping paper.

NO!
Sean is mine.
Minemineminemine.

No, she DID NOT go there...
Oh, she went there
Paige=BRUTUALLY honest
Evil. Pure evil.

What???

Did you see that??
She can HAVE him!

Et tu Craig?
What??!?
How much can Ashley take?
I'm SO over Craig.

Emma+ Chris?
Destined.

Sooooo destined

No
she
didn't
Um, she SOOO did

+

Sooooo destined

U watching?
Duh.

GOLD TV Identities, Openings, Teasers, Series
DeGrassi 100% Intense IM Campaign: OMG, Emma/Sean, Pure Evil

Art Director Matthew P. Duntemann **Creative Director** Angela Leaney **Designer** Jennifer Juliano **Writer/Producer** Emily Campion **Studio/Design Firm** Nick Digital Networks Brand Communications **Client** The N **Country** United States

Black Screen, low typing noises, TV (Degrassi) sounds, and ambient track throughout.
Incoming IM *bling*: OMG.
Quick clip from episode #321: Alex, Sean, Jay, and Ellie find Amy with alcohol poisoning.
Black Screen.
Incoming *bling*: OMG!
Bling: OMG.
Bling O.
Bling MG.
Quick clip from 317: Paige making out with Spinner hard core.
Black Screen.
O.
Bling.
Bling. M.
Bling. GGGGGGG!!!!!!
Quick clip from episode #317: Spinner about to beat up Rick. Black Screen heartbeat very fast, loudest *bling* omg.
Bling.
GFX: DEGRASSI and Tags
Bling.
GFX: 100% INTENSE bling

225

GOLD TV Identities, Openings, Teasers, Series
MTV Artbreaks—Instrumentbreaks: Wolfgang, Maiphi, Uschi, Fiedel, Kurt

Art Directors Manuel Hernandez y Nothdurft, Sascha Koeth, Jan Litzinger, Frank Zerban **Creative Directors** super2000 For MTV, Peter Moller (Creative Director International), Cristián Jofré (Senior Vice President, Creative International) **Studio/ Design Firm** super2000 **Client** MTV International **Country** Germany

Since the existence of MTV (1981), innovative animations and live action around the MTV logo have created an unmistakably unique and creative worldwide brand. MTV Idents, or "Art Breaks," stand for the creativity and independence of the brand. In 2004 MTV commissioned the creatives of super2000 to develop and produce a clip-package of the new series for the worldwide network: the "instrumentbreaks." People of any age and type destroy musical instruments at common places. When the instrument hits the ground and falls apart, multiple small MTV logos appear near every piece. Content started to air on October 18, 2004 and since then, all spots have been made available for the global network of MTV and will continue to air in coming years. The project represents a symbiosis of artists, talents, and MTV. The international networks offer global exposure.

Wimbledon was a main title sequence targeted for US and international release. The creative approach for this piece was to base the sequence on the back and forth motion so dominant in tennis, and to reduce this concept to its simplest, most playful form. The sequence begins with a black screen and white text, simply popping back and forth between credits on opposite sides of the screen to the sound of a tennis ball being hit. As the music picks up, shots of the audience are introduced, freezing the frames, as they all look one way and then the opposite direction. The end result is a funny and playful visualization of the experience of watching the game.

GOLD Title Design **Wimbledon Main Title**

Prologue Director Kyle Cooper **Prologue Designer** Kyle Cooper **Prologue Editor** Lauren Giordano **Prologue Producers** Phyllis Weisband, Josh Laurence **Feature Director** Richard Loncraine **Studio/Design Firm** Prologue Films **Client** Universal Pictures **Country** United States

SILVER Magazine, Consumer Cover **Ideas Issue Cover**
MERIT Magazine, Consumer, Full Issue, Series **Ideas Issue: Cover, p. 49, pp. 50-51, pp. 74-75**

Art Director Arem Duplessis **Creative Director** Janet Froelich **Designer** Kristina DiMatteo
Illustrators Christoph Niemann, Nicholas Blechman, Brian Rea, Alexandra Compain-Tissier (ISM)
Photo Editor Kira Pollack **Photographer** Zachary Scott **Publisher** The New York Times **Studio/
Design Firm** The New York Times Magazine **Country** United States

The Annual Ideas Issue celebrates some of the most
noteworthy ideas of the previous twelve months. It
covers everything from science and technology to
politics and policy. When dealing with such a broad
subject range, the challenge is always finding the
most interesting items to illustrate. The "idea" was to
approach the issue as if we'd been asked to redesign
an encyclopedia. With the assistance of photographer
Zachary Scott, we accomplished our goal by using
functional and practical design mixed with humorous
photography and informative illustration.

SILVER Book Jacket **Bush on the Couch**

Art Director Michelle Ishay **Designer** Rodrigo Corral **Photography** Corbis
Images **Publisher** Regan Books **Studio/Design Firm** Rodrigo Corral Design
Client Regan Books/HarperCollins **Country** United States

Bush on the Couch is a psychoanalyst's portrait of George W. Bush. The project
aimed to answer the question, "Why does he (as President of United States) think
the way he does?" After several rounds of attempting to illustrate picking apart
the mind, dissecting, etc., it boiled down to the question every sane person asks
themselves about George W.: "What the !@#$%/&* is he thinking?"

SILVER Limited Edition, Private Press, or Special Format Book
Blame Everyone Else: Paul Davis

Creative Director Jonathan Ellery **Designers** Jonathan Ellery, Lisa Smith **Account Director** Philip Ward **Illustrator** Paul Davis **Photographer** Paul Davis **Publisher** Browns **Studio/Design Firm** Browns **Client** Paul Davis **Country** United Kingdom

The brief was to once and for all establish Paul Davis as a substantial British artist with a publication of gravitas and substance. Published and designed by Browns, the book was designed as experimental in format, with fourteen different paper stocks, three different poster/dust jackets, and numerous experiments with printed inks and paper stocks. The book was launched in London and New York City.

Blame everyone else
by Paul Davis

Hal Sumpter

Paul Davis' drawings mimic and subtly subvert the dumb omnivorousness of the camera. They often have the off kilter quality of snapshots that reveal more than the picture taker intended. The work is hugely sophisticated yet going through it en masse feels a bit like being in the company of a hyperactively inquisitive ten year old – it can be infuriating and demanding in its refusal to accommodate complacency and intellectual laziness. Its buzzing energy is infectious though. It demands we try and make sense of things while at the same time trumpeting the absurdity and tragic-comic impossibility of ever doing so.

Growing up in this society we are taught that we can't draw. Not directly of course but in so far as reading, writing and hard sums take greater precedence. In small children, what is a natural and unselfconscious activity becomes, as they get older and compare their work to the images they see around them, a skill at which they feel increasingly inadequate. And for most of us drawing just quietly falls away and with it the particular curiosity about the world that it expresses. We should give thanks that Paul Davis' environment forgot to beat this out of him.

EVoLuTion

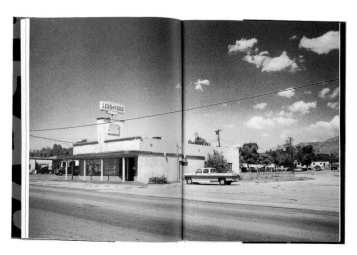

IT'S LIKE A SOLILOQUY BASED EPIPHANY.
AS EPITAPH.

SILVER Limited Edition, Private Press or Special Format Book
Visualization

Art Directors Shotaro Sakaguchi, Keizo Tada, Kenichi Hatano, Emiko Oishi, Noritoshi Nishioka, Yousuke Kojima **Creative Director** Katsumi Yutani **Copywriter** Katsumi Yutani **English Translation** Naoko Odaka **Director of DTP** Tsunetoshi Onodera **Production Producer** Chinami Aoki **Agency** Dentsu, Inc., Tokyo **Studio/Design Firms** Digital Palette, Inc., Designing Gym Inc., Art Printing Co., Ltd. **Client** Dentsu, Inc./Dentsu Communication Institute **Country** Japan

Visualization is a compilation of artworks directed by Dentsu Forum over fifteen years. The existing material (e.g., photographs, posters, invitation letters, conference kits) for each year was combined into one chapter. It is an omnibus of fifteen short stories on the birth, production, and development of the Visual. The Dentsu Forum is held annually for senior executives of Dentsu's top clients. Dentsu hosted the event, and the Dentsu Institute was in charge of planning. Though a different theme is chosen every year, the underlying theme is Japan in the midst of globalization—its identity and the changes it has undergone.

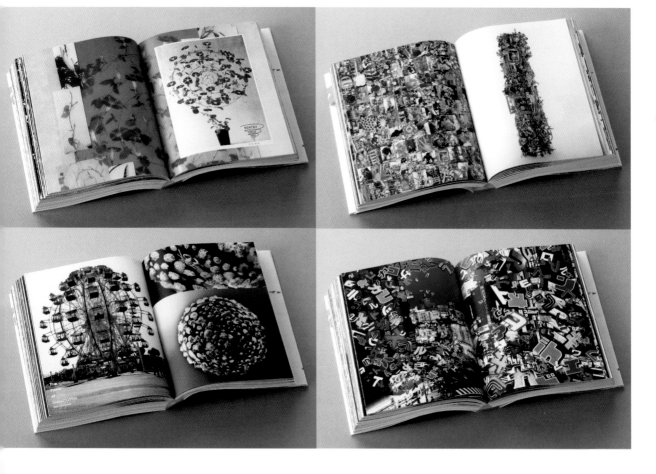

The 2004 Biennial Exhibition was organized by Whitney Museum of American Art curators Chrissie Iles, Shamim M. Momin, and Debra Singer. Together we developed a catalogue comprised of a more traditional book and a box containing artwork created by each of the 108 featured artists. Each artist worked within one of eight prescribed formats—rectangular poster, square poster, eight-page 'zine, round sticker, bumper sticker, uncoated square card, glossy postcard, or filmstrip—to create an original contribution for the box. To complement this eclectic collection, the book became a container of controlled chaos. The three curators' essays were designed with an array of typefaces within a strict grid system, while commissioned and reprinted texts broke out of those constraints to reflect their diverse origins. A third entity, the individual artist entries, was uniform in typeface and grid structure as a counterbalance to the varied range of work.

SILVER Museum, Gallery or Library Book **2004 Biennial Exhibition**

Art Director Rachel Wixom, Head of Publications, Whitney Museum of American Art **Designers**
Alice Chung, Karen Hsu (Omnivore, Inc.) **Publishers** Steidl Verlag, Harry N. Abrams, Inc. **Studio/
Design Firm** Whitney Museum of American Art **Country** United States

Sugahara Glassworks, Inc. is a manufacturer that produces over 3,000 kinds of glass products. To emphasize its biggest selling point, "made by hand," I depicted their products with a crude drawing of childlike simplicity. Then I added the abbreviation "Sghr," which comes from "Sugahara," to generate brand awareness.

dimensions: 40 1/2" h x 28 3/4" w

SILVER Promotional, Series **Handmade: A, B, C**

Art Director Koji Iyama **Designer** Koji Iyama **Illustrator** oco **Studio/Design Firm** iyama design **Client** Sugahara Glassworks Inc. **Country** Japan

Sghr

THE LIFE CYCLE OF LITTER *

Paper: 2.5 months
Milk Carton: 5 years
Cigarette Butt: 10 years
Plastic Bag: 10 years
Disposable Diaper: 75 years
Tin Can: 100 years
Beer Can: 200 years
Styrofoam: Never
This Poster: When you want it to

WITHIN TWO MONTHS OF EXPOSURE TO DIRECT SUNLIGHT AND AIR, THIS POSTER WILL BIODEGRADE. A small amount of additive has been introduced in the manufacturing process, changing the behaviour of the plastic, which can be 'programmed' to degrade in as little as a few months to as long as a few years. After it has biodegraded, the amount of plastic is reduced to nothing but CO_2, water and humus. There is little or no additional cost in the production of items made from this plastic. It's competitively priced, stronger and more versatile. Hang it up outside and watch it biodegrade.

Stop. Think. Design.

DESIGN INDABA 06

23-25 FEBRUARY 2005
CAPE TOWN INTERNATIONAL
CONVENTION CENTRE
SOUTH AFRICA

Limited seating. Think.
Book online **before**
22 December 2004 to
qualify for the **early bird**
registration offer.
Find us on the web at:
WWW.DESIGNINDABA.COM

OFFICIAL SPONSORS:
INTERACTIVE AFRICA,
WOOLWORTHS, SOUTH AFRICAN
AIRWAYS, HEWLETT-PACKARD,
SAPPI, ARABELLA SHERATON
GRAND HOTEL

OFFICIAL MEDIA SPONSORS:
DESIGN WEEK, NOVUM, CLEAR,
CREATIVE REVIEW

OFFICIAL ASSOCIATES:
ADVANTAGE, REDSHIFT, ENJIN
MAGAZINE, ICON MAGAZINE,
iD MAGAZINE, BIS PUBLISHERS

OFFICIAL SUPPLIER:
THE JUPITER DRAWING ROOM

* "The Life of Litter.
Decomposition Rate for
Trash" - The New York Times

ASTRAPAK FILMS

recyclable

dimensions: 16 1/2" h x 11 3/4" w

SILVER Promotional **Indaba 8 Poster**

Art Director Carla Kreuser **Creative Director** Joanne Thomas **Copywriter** Iain Thomas **Designer** Carla Kreuser **Publisher** Astrapak/Syreline **Studio/Design Firm** The Jupiter Drawing Room **Client** Cape Town Major Events Co. **Country** South Africa

Design Indaba 8 is among the world's top design conferences. This poster, created for Design Indaba, explores the potential longevity of design. While certain designs are beautiful or functional enough to develop a second life beyond their original form, many become garbage bin fodder. This poster encourages responsible design. The poster reveals "The Life Cycle of Litter" and details the lifespan of commonly discarded items. While a tin can last a century, the poster ceases to exist "When you want it to." Traditionally, a poster lives as a piece of cardboard attached to a wall and is eventually relegated to waste. The Design Indaba poster is a perfect marriage of function and form. Created from oxo-biodegradable plastic, the bag contains an additive which allows it to decompose once exposed to the environment, until all that remains are water and carbon dioxide.

Every once in a while, we get a chance to use our powers for good, so when we got the call from Air America Radio we jumped at the chance. They needed a logo that would immediately communicate their political nature and put them on the map as a national contender in the talk radio genre. We decided that the logo should be an emblem of what Air America Radio stands for—patriotism. We wanted to make it clear that conservatives do not own patriotism. We wanted Air America to take back the country. Then we took on the advertising. They wanted it to be clear that they were not just bashing George Bush and his crew, but also criticizing the conservative media. So we decided to take the logo and obliterate these people with our thoughts about the way they conduct themselves. This communicated the tone, personality, and politics that the station itself would have.

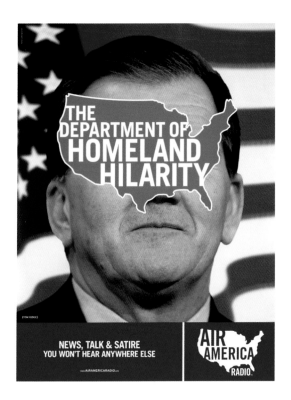

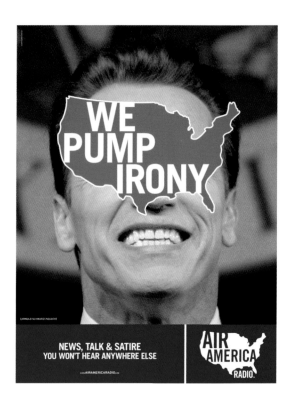

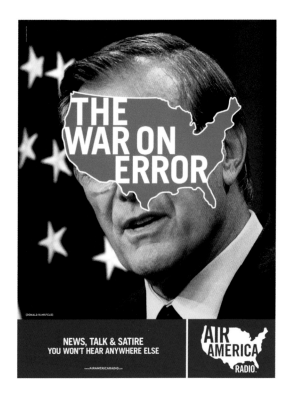

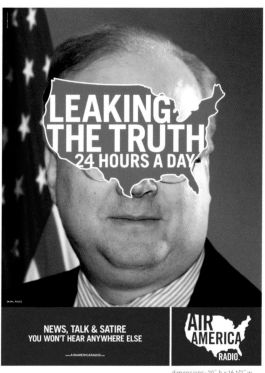

dimensions: 20″ h x 16 1/2″ w

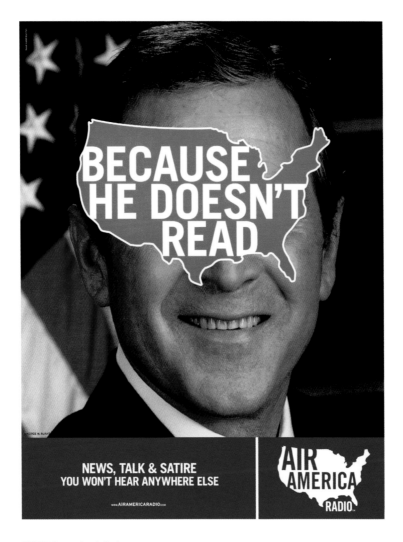

SILVER Promotional, Series
Air America Launch Campaign: Bush, Ridge, Arnold, Rove, Rumsfeld

Art Directors Emily Oberman, Bonnie Siegler **Creative Directors** Emily Oberman, Bonnie Siegler
Designers Emily Oberman, Bonnie Siegler **Writer** Glenn O'Brien **Studio/Design Firm** Number
Seventeen **Client** Air America Radio **Country** United States

SILVER | **83rd Awards** Promotional, Series
Calligraphy of Hair

Art Director Eiji Yamada **Designer** Yukiko Yamada **Photographer** Mikiya Takimoto **Hair/
Make-Up** Ryuji Ikebe **Studio/Design Firm** UltRA Graphics **Client** Eight and a Half **Country** Japan

dimensions: 28 3/4" h x 40 1/2" w

SILVER Environment **The Children's Museum of Pittsburgh**

Art Director Paula Scher (Principal) **Designers** Paula Scher, Rion Byrd, Andrew Freeman **Project Architects** Koning Eizenberg Architecture **Project Photography** (Signage) Peter Mauss/Esto **Studio/Design Firm** Pentagram **Client** The Children's Museum of Pittsburgh **Country** United States

The environmental graphics for the Children's Museum of Pittsburgh were inspired by the architecture and activity of the building. The expansion, designed by Koning Eizenberg Architecture, is crowned with a wind sculpture made of thousands of plastic tiles that move in the breeze. The marquee signage is lit by neon from within a wire mesh to create letterforms that look like something out of superhero comics, and the lobby signage and donor wall consist of colorful, fluorescent Plexiglas panels that hover in the space. Identification signage appears as playful treatments of words: "Garage" has been set in rubber tread; "Theater" appears in forward on one side and reverse on the other, as though projected; "Studio" was created by kids painting over a stencil on the floor. The Nursery, a hands-on section for infants and toddlers, is wallpapered with Pop graphics of giant baby heads. Throughout the museum, the signage utilizes inexpensive materials and fixtures that are easily repaired or replaced.

SILVER Title Design **Dawn of the Dead**

Prologue Director Kyle Cooper **Prologue Designers** Kyle Cooper, Stephen Schuster **Chrome Editor** Nick Lofting
Feature Director Zach Snyder **Studio/Design Firm** Prologue Films **Client** Universal Pictures **Country** United States

Dawn of the Dead was a main title sequence targeted for US and international release. The main objective of the sequence was to create the feeling of an all-consuming terror that would slowly rise up and take over the screen. The news broadcast was used as a vehicle for delivering the message in order to ground the horror in something familiar. The creative approach was based on an analogue strategy, making the letters physically bleed without using the computer, and then filming the result rather than generating the effect digitally. The end result, cut to Johnny Cash, is a harrowing portrait of evil, most disturbing for its solid grounding in reality.

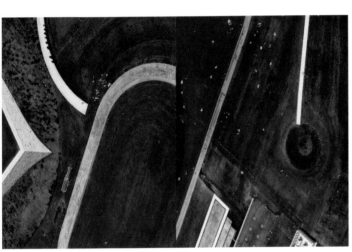

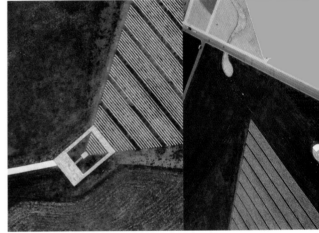

We asked Taiji Matsue, who is known for his images of the surface of the Earth, to photograph the park designed by Isamu Noguchi. By photographing from above, we tried to realize Noguchi's intended bird's-eye view in the editorial pages.

DISTINCTIVE MERIT Magazine, Consumer Spread | Multipage, Series
Isamu Noguchi: A Centennial Celebration

Art Director Masayoshi Kodaira **Designer** Masayoshi Kodaira **Photographer**
Taiji Matsue **Agency** FLAME, Inc. **Client** X-Knowledge Co., Ltd. **Country** Japan

nsions: 11 3/4" h x 18 1/4" w

foam
·Quarterly Photography Magazine·

SPORT

Sport furnishes us with myths, heroes and villains, with situations rife with emotion, anxiety, sorrow and joy. And all that presented in the form of a more or less understandable story. It is life in a regulated, stylized, concentrated form. The narrative qualities of a contest, of a race or even a complete sports career and the way in which these interrelate may well be the driving force behind the popularity of sport.

In this Issue:
Robert Davies, Gustavo Di Mario,
Bill Peronneau, Charles Fréger,
Claudio Hils, Giasco Bertoli

06>

8 710966 055236

NL/B/D/I € 10
F € 11,20
UK £ 6,95 ISSN 1570-4874

foam
·Quarterly Photography Magazine·

NEAR

Nowadays, many would have us believe, we live in a 'global village' where distances are as good as obsolete and everything is within easy reach. But what consequences does this have for what is actually close by, for the social cohesion of a community and for the way we treat our fellow creatures? How complex is the actual relationship between physical and emotional nearness?

In this Issue:
Bernard F. Eilers, Peter Fraser,
Stanley Greene, Annaleen Louwes,
Ellen Mandemaker, Ken Schles

05

8 710966 055236

NL/B/D/I € 10
F € 11,20
UK £ 6,95 ISSN 1570-4874

254

DISTINCTIVE MERIT Magazine, Consumer Full Issue, Series
Foam Magazine: No. 6 Sport, No. 5 Near, No. 7 Self

Creative Director Pjotr de Jong **Designers** Serge Rompza (Near), Serge Rompza (Sport), Marcel de
Vries (Self), Anders Hofgaard (Near), Rianne Petter (Near), Bieneke Bennekers (Sport), Pascal Brun
(Sport) **Publisher** Artimo **Studio/Design Firm** Vandejong **Client** Foam **Country** Netherlands

Foam Magazine is created in cooperation with Foam Fotografiemuseum Amsterdam (Museum for Photography). During the last few years Foam Magazine has developed into a nationally and internationally renowned photography magazine. Every issue has a different theme, in which six photographers get the unique opportunity to show their portfolio on twelve pages. The theme is deepened and different perspectives are shown.

Published five times a year by Simon Finch Rare
Books, Zembla is a "literary magazine that people
actually want to read." Signaling a new era in
magazine design, Zembla is completely free from
the formal constraints of its predecessors. For
emeryfrost and Frost Design, London, it was an
opportunity to create an entirely new magazine
and to indulge a passion for typography. The only
rule: there are no rules. No fixed approach; a grid
only when needed; typeface size and character
flexible. The confidence of Zembla's design lies
in its refusal to adhere to the traditional rules of
magazine design. It's graphic design at full volume
and completely faithful to Zembla's strapline of
"fun with words." This magazine is truly global,
designed across the world in three studios: London,
Sydney, and Melbourne.

DISTINCTIVE MERIT Series Magazine, Consumer Full Issue
Zembla Magazine: Issues 4, 5, 6

Art Director Matt Willey, London **Creative Director** Vince Frost,
London and Sydney **Designers** Anthony Donovan, Sydney; Tim
Murphy, Melbourne **Studio/Design Firm** emeryfrost **Client**
Simon Finch Rare Books **Countries** Australia/United Kingdom

(see related work on page 381)

{MULTIPLE AWARD WINNER} (see also page 196)

DISTINCTIVE MERIT Magazine, Consumer, Cover **T Design Issue Cover**

Art Director David Sebbah **Creative Director** Janet Froelich **Designers** David Sebbah, Janet Froelich **Photo Editor** Kathy Ryan **Photographer** Raymond Meier **Publisher** The New York Times **Studio/Design Firm** The New York Times Magazine **Country** United States

Raymond Meier, who photographs all of the covers for T: The New York Times Style Magazine, took this photograph at The Villa Garbald in Castasegna, Switzerland. The subject is the Barok chair designed by Maarten Baas, from his "Where's There's Smoke" series: a nineteenth-century antique chair, burnt and varnished, then covered in green silk. Meier turned the chair upside down and placed it at the foot of an exquisitely simple modern staircase. Like an Edwardian lady in an evening gown who has wandered down the wrong hall and taken a tumble, you wonder what just happened.

DISTINCTIVE MERIT Magazine, Trade Full Issue **SEE: The Potential of Place**

Art Director Todd Richards **Creative Director** Steve Frykholm **Designer** Todd Richards **Editor** Clark Malcolm **Illustrators** Jonathon Rosen, Joseph Hart, Gary Clement **Photographers** Robert Schlatter, Andy Sacks, Dwight Eschliman, Kenji Toma **Publisher** Herman Miller, Inc. **Studio/Design Firms** Cahan & Associates, Herman Miller, Inc. **Client** Herman Miller, Inc. **Country** United States

SEE: The Potential of Place reinforces Herman Miller's longstanding position as a knowledge leader in understanding the effects of the built environment on human performance and creativity. Published twice a year, SEE magazine combines articles dealing with the potential of place with inventive graphic design for architects, designers, and organizational leaders.

261

DISTINCTIVE MERIT Museum, Gallery, or Library Book, Series
Nara Yoshitomoto/Hirosaki: Cover, Whole of the Cover, Inside 1, Inside 2, Inside 3

Art Director Masayoshi Kodaira **Designers** Masayoshi Kodaira, Yositomoto Nara **Photographer**
Mikiya Takimoto **Studio/Design Firm** FLAME, Inc. **Client** NPO harappa **Country** Japan

(see related work on page 331)

An exhibition of work by Yoshitomo Nara, a Japanese contemporary artist, took place at a brick brewhouse that was built
one hundred years ago. The book records the process of making the exhibition space, from renovation to installation.
When I visited the site to design the signage, I was impressed by the space as well as by the people who are renovating
this old unused warehouse. The exhibition was made possible solely by the volunteer staff and the book was planned and
produced with this staff.

DISTINCTIVE MERIT Museum, Gallery, or Library Book
Cotton Puffs, Q-Tips®, Smoke and Mirrors: The Drawings of Ed Ruscha

Art Director Rachel Wixom, Head of Publications, Whitney Museum of American Art **Designer** Simon Johnston, Praxis Design
Publishers Steidl Verlag, Harry N. Abrams, Inc. **Studio/Design Firm** Whitney Museum of American Art **Country** United States

The main challenge with the design of this Whitney Museum of American Art exhibition catalogue was to find an appropriate typographic tone of voice for an artist whose work is grounded in visible language, and to do so in a way that was sympathetic with the work itself. In this sense, the design had to provide a kind of frame for the work, allowing the art to shine and reinforcing the voice of the artist without interference. The title came from a comment made by Ruscha in an interview with curator Margit Rowell. The cover design allowed the poetry of the title to be stated as plainly as possible, maximizing the declarative simplicity of the artist's language and linking it to similar formal qualities in his work. The subtitle, "The Drawings of Ed Ruscha," was bumped to the back cover so that the poetic resonance of the exhibition title would stand on its own. The title typeface, Foundry Gridnik, relates to a homemade typeface Ruscha sometimes uses in his work and which he refers to as "Boy Scout Utility Modern." The font, with its vernacular reference, connects us to Ruscha's work without looking like a piece of it. The text font is Monotype Grotesque Light, a relatively neutral but nuanced face.

DISTINCTIVE MERIT Annual Report **Police Division Gooi en Vechtstreek, Annual Report**

Art Director Jacques Koeweiden **Creative Director** Jacques Koeweiden **Designer** Patrick Keeler **Illustrator** Marion Deuchars **Studio/Design Firm** Koeweiden Postma **Client** Police division of Gooi and Vechtstreek **Country** Netherlands

263

This annual report was about the restructuring of the police division. As part of the restructuring process, it was important to give ample space and support to the division's staff so they could develop their talents and fulfill their ambitions. Nine staff members were interviewed to reveal their passions and daily inspirations. Illustrator Marion Deuchars (UK) was commissioned to portray these stories in a sketchbook format.

DISTINCTIVE MERIT Annual Report **Channel 4 Annual Report 2003**

Creative Director Jonathan Ellery **Designers** Jonathan Ellery, Lisa Smith **Account Director** Philip Ward **Illustrators** Luke Best, Elliot Thoburn, Gwyn Vaughan Roberts, Lorna Miller **Studio/Design Firm** Browns **Client** Channel 4 Television **Country** United Kingdom

DISTINCTIVE MERIT Booklet | Brochure **Emerging Designers**

Art Directors Fons Hickmann, Markus Büsges, Gesine Grotrian-Steinweg **Creative Directors**
Fons Hickmann, Markus Büsges, Gesine Grotrian-Steinweg **Designers** Markus Büsges, Gesine
Grotrian-Steinweg, Barbara Bättig, Iris Fussenegger, Fons Hickmann **Illustrators** Gesine
Grotrian-Steinweg, Barbara Bättig, Markus Büsges **Photo Editors** Simon Gallus, André Müller
Studio/Design Firm Fons Hickmann m23 **Client** GraficEurope **Country** Germany

Emerging Designers was an exhibition of the work of sixteen of the
freshest and most exciting young graphic designers working in Europe
today. They were selected by a panel of leaders and luminaries in the
European design community on the initiative of Alice Twemlow for the
Design Conference GraficEurope 2004 in Berlin. The Exhibition brochure
portrayed the emerging designers and their works.

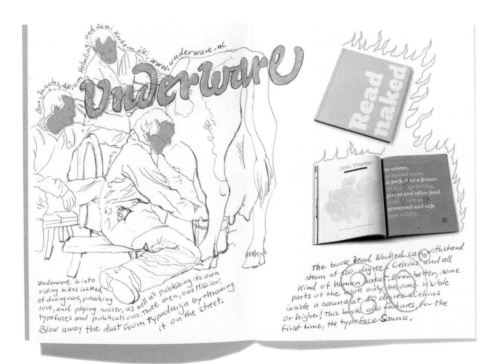

Making funny
pictures in
the driveway.

Mommy goes
into the store
for a minute.

Johnny waits in the car.

The sun is shining.

The car gets very hot inside.

Johnny begins to feel sleepy.

Johnny shuts his eyes.

The end.

DISTINCTIVE MERIT Booklet | Brochure, Series
Kids and Cars Golden Books: Funny Pictures, Into The Store, Daddy's Car

Art Director Robert Prins **Creative Director** Chris Graves **Copywriter** Jeff Spiegel
Group Creative Directors Jon Pearce, James Dalthorp **Illustrator** Mary Jane Begin
Studio/Design Firm Team One **Country** United States

Playing in
Daddy's car
is fun.

Sally draws a funny face.

Daddy begins to back up the car.

Sally doesn't see Daddy.

Daddy doesn't see Sally.

The end.

Our target audience were automotive companies, policy makers, elected officials, and opinion leaders of any kind—people in positions of influence who can, by virtue of the things they say and do, help to bring about a change in the way our collective culture thinks about protecting children in and around automobiles. The communications goal was to inspire action more than concern on the part of those who can make a difference. We created this message by dramatizing the consequences of not changing our collective behavior, by reminding people, in a visually surprising and compelling way, that the results of not making progressive change are final and dramatic, that continuing to turn a blind eye does not mean that the problem just goes away.

Stories about kids and cars have a tendency to end badly. In the U.S., more than one child is backed over and killed each week in a driveway or parking lot. The technology exists to help prevent these tragedies, but regulations are needed that specify what the driver of a vehicle should be able to see when backing up. Please help support our efforts to make cars safer for children.

www.kidsandcars.org

Never leave children alone in or around motor vehicles. Not even for a minute.

Little Bobby presses
many buttons.
He pretends to drive.
It's lots of fun.
Then the car begins to
roll down the hill.
The end.

Art of Repro

Exmouth House
Ground Floor Block B
3-11 Pine St
London
EC1R 0JH

Tel 020 7833 0088
Fax 020 7833 0117
info@artofrepro.com

www.artofrepro.com

Art Of Repro Ltd. Vat Reg No. 629 9080 05. Registered Company No. 04923249
Registered Office: Hamilton House, 16 Howard Street, Oxford OX4 3AY

Simon Nellist
Managing Director

Art of Repro

Exmouth House
Ground Floor Block B
3-11 Pine St
London
EC1R 0JH

Office 020 7833 0088
Mobile 07966 460 663
Fax 020 7833 0117
simon@artofrepro.com

www.artofrepro.com

Art of Repro

Exmouth House
Ground Floor Block B
3-11 Pine St
London
EC1R 0JH

Office 020 7833 0088
Mobile 07966 460 663
Fax 020 7833 0117
simon@artofrepro.com

www.artofrepro.com

Jeff Brewerton
Production Director

Art of Repro
Exmouth House
Ground Floor Block B
3-11 Pine St
London
SW1W 8JH

Tel 020 7833 0088
Fax 020 7833 0117
info@artofrepro.com
www.artofrepro.com

With Compliments

DISTINCTIVE MERIT Corporate Identity Program **Art of Repro**

Creative Director Lee Cook **Designer** Will Parr **Illustrator** Will Parr **Studio/ Design Firm** Design Bridge **Client** Art of Repro **Country** United Kingdom

Art of Repro, a new print reproduction facility based in Clerkenwell, London, had never briefed an agency before but had the courage to give Design Bridge some freedom in developing its identity. The company wanted a fun, lighthearted, friendly image, and certainly got what they were after with our rabbit theme. There's a subtle humor in the use of the rabbits—a creature famed for its reproductive capacity—and great graphic potential. Illustrated silhouettes, using print process colors cyan, magenta, yellow, and black, show rabbits in a variety of poses to represent different elements. Rabbits running represent quick service, while rabbits jumping from one place to another are used on address labels. It's a fertile design concept that's sure to breed more business.

DISTINCTIVE MERIT Corporate Identity Program, Series
Think London Identity: Symbol, Focus Cover, Concertina, Brochure Spread, Website Headers

Art Director Michael Johnson **Designers** Michael Johnson, Julia Woollams, Paola Faoro, Joshua Leigh
Brand Strategy Circus **Illustrators** Julia Woollams, Paola Faoro, Zara Moore **Photographer** Chris
Steele-Perkins **Studio/Design Firm** Johnson Banks **Client** Think London **Country** United Kingdom

Think London is the new name for the London First Centre, which specializes in attracting overseas businesses to
set up in London. This field, known as "inward investment," is now highly competitive, and the world's major cities
regularly compete with one other to attract the world's biggest businesses. Think London's new identity doesn't try
to distill all that London has to offer into one symbol. It uses forty-five symbols. London's classic skyline is twisted
180 degrees to form a reflection on the bottom side, while the top has a skyline of people, attractions, trees, parks,
conductors, footballers—in short, all the things that make living in London what it is.

DISTINCTIVE MERIT Stationery (Letterhead, Business Card, or Envelope)
School

Creative Director Jacques Koeweiden **Designer** Jacques Koeweiden **Studio/
Design Firm** Koeweiden Postma **Client** Diana Krabbendam **Country** Netherlands

Bringing together different creative talents from diverse disciplines, School sets out to be a catalyst to encourage change in organizations. The concept for the identity is inspired by the 3M company's philosophy, which encourages staff to be involved with the innovative thinking process. The result of this approach has resulted in such breakthroughs as the 3M Post-It Note. The identity is set up with templates using imprint text and imagebank. The result is a consistently refreshed identity filled with images and text. The quality of the images is unimportant, as they are there only to convey the idea and the message.

Art Director Yoshie Watanabe **Creative Director** Satoru Miyata **Designer** Yoshie
Watanabe **Other** Liric Kaori Sakurai **Producer** Minako Nakaoka **Illustrator** Yoshie
Watanabe **Studio/Design Firm** DRAFT Co., Ltd. **Client** D-BROS **Country** Japan

D-BROS is a product brand that provides planning and design of interior accessories
and stationaries. The calendar, "12 Stories," is a weekly calendar. It is made of thin,
translucent, and very inexpensive wrapping paper. The illustration on the back page
shows through faintly, revealing a story in sequence.

A three poster series for a CD of twelve well-known instrumental songs by Studio
Ghibliin in pedal organ, harmonica, pianica, and xylophone. These songs invoke
sentimental childhood memories of music class in a wooden schoolhouse. The poster
images are inspired by a child's doodles on a music notebook during class, as the
afternoon sunlight streams in through a window.

DISTINCTIVE MERIT Promotional, Series
A new instrumental CD, Studio Ghibli works: Humming songs into the dream, Do-Re-Mi-Fa-So-Ra-Ma-De, Howdy!

Art Director Yumiko Yasuda **Creative Director** Yuichi Muto **Designer** Yumiko Yasuda **Other** Taiyo Printing Co., Ltd. **Illustrator** 15
Children **Photographer** Jun Kumagai **Studio/Design Firm** ayr creative **Client** Dreamusic Inc. **Country** Japan

dimensions: 40 1/2" h x 57 1/4" w

SWEDEN

gg SWEDEN SPECIAL AT THE EMBASSY OF SWEDEN 2004.6.12.SAT.-6.18.FRY. KAFE & 1DAY ZAKKA

www.gooddesigncompany.com photo by naoki honjo

DISTINCTIVE MERIT Promotional, Series **Embassy of Sweden**

Art Director Manabu Mizuno **Creative Director** Manabu Mizuno **Designer** Yui Takada **Producer** Nanako Koyama
Photographer Naoki Honjo **Studio/Design Firm** good design company co., inc. **Client** Sweden Style **Country** Japan

DISTINCTIVE MERIT Promotional, Series **5e Salle: Vert, Bleu, Orange**

Creative Director Hélène Godin **Designers** Marie-Elaine Benoit, Jonathan Nicol **Writer** André Marois **Production Company** Graphiques M/H **Studio/Design Firm** Diesel **Country** Canada

It really gets to you—this is the main message of this campaign, which draws viewers by encouraging involvement and a call to action, while revealing contaminating situations. To live and enjoy a contemporary performance should not be considered an effort. With unique and modern imagery, this art form becomes non-elitist and seeks a wider audience. The series of posters, as well as television advertisements, do justice to the campaign's strategic aims, and encourage a new experience within the realm of entertainment. It's an evening dedicated to an art form that no one can ignore. The campaign was mostly used in the Francophone media. Allow yourself to be contaminated by the 5th edition at the Place des Arts.

The target audience for Hudson Repro was communication and marketing professionals of Fortune 500 companies. The communication objective was to highlight the company's expert print production capabilities. Our creative strategy positioned Hudson Repro's print production professionals as people who were not just into color, but as people who were driven by the exactness of color. The campaign consisted of print, radio, TV, and web ads.

dimensions: 16 1/2" h x 23 1/4" w

DISTINCTIVE MERIT Promotional, Series
CMYK Campaign: Clockwork, Creature, Panther, Riding Hood

Art Directors Hamish McArthur, Adam Lewin **Creative Directors** Tony Granger,
Tod Seisser, Lee St. James **Copywriters** Jason Graff, Jeff Greenspan **Studio/
Design Firm** Saatchi & Saatchi **Client** Hudson Repro **Country** United States

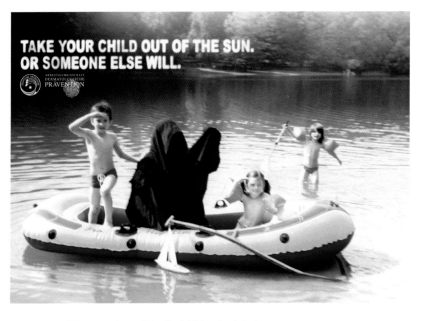

DISTINCTIVE MERIT Public Service | Non-Profit | Educational, Series
Skin Cancer Prevention: Boat, Beach, Jump

Art Director Marc Wientzek **Creative Directors** Guido Heffels, Juergen Vossen **Copywriter** Andreas Manthey
Designers Ole Bahrmann, Jois Lundgren **Photographer** Wolfgang Stahr **Studio/Design Firm** Heimat, Berlin
Client ADP e.V./ German Cancer Aid **Country** Germany

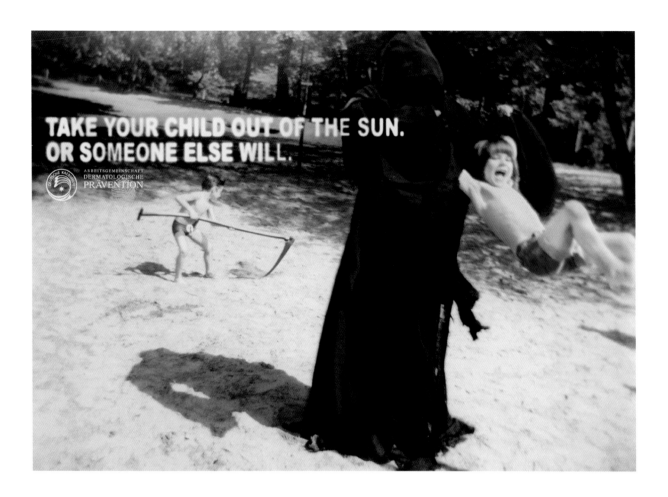

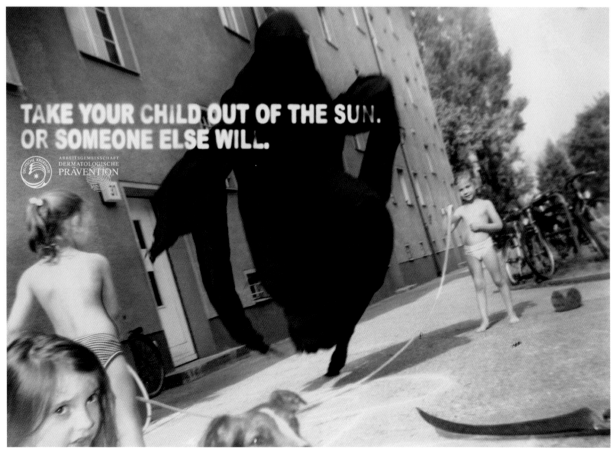

dimensions: 11 3/4" h x 16 1/2" w

Stockholm vs Tokyo på Arkitekturmuseet 5.8–26.9 2004

Befolkningstäthet

DISTINCTIVE MERIT Public Service | Non-Profit | Educational, Series
Stockholm vs. Tokyo

Art Director Lisa Careborg **Creative Director** Anders Kornestedt **Designer**
Lisa Careborg **Studio/Design Firm** Happy Forsman & Bodenfors **Client**
The Swedish Museum of Architecture **Country** Sweden

Stockholm vs Tokyo
på Arkitekturmuseet
5.8-26.9 2004

Golvyta per person

Stockholm vs Tokyo
på Arkitekturmuseet
5.8-26.9 2004

Parkareal

DISTINCTIVE MERIT Miscellaneous **Royal Mail Mint Stamps**

Designer Derek Birdsall **Studio/Design Firm** Omnific **Client** Royal Mail **Country** United Kingdom

"For this set of six stamps the first task was to select six key events from the Society's long history," says Birdsall. "I decided to make a virtue of the amount of text needed to tell each story." The Rowland Hill stamp is designed to look like a postcard addressed to him, and features his Penny Black facing the Queen's head. The stamp, which commemorates the RSA's contribution to the public examination system, features typewriter keys and the Society's name in shorthand, written by Birdsall's wife when she was a teenager. Birdsall's favorite features Eric Gill, a fellow Royal Designer for Industry, and uses his eponymous typeface. The last stamp in the set outlines the RSA's 21st century manifesto and is illuminated by the designer's favorite typographic symbol.

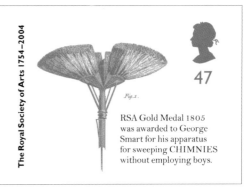

The Royal Society of Arts 1754–2004

47

Fig. 1.

RSA Gold Medal 1805 was awarded to George Smart for his apparatus for sweeping CHIMNIES without employing boys.

The Royal Society of Arts 1754–2004

The RSA's 21st century manifesto seeks to stimulate enterprise, expand education and encourage the policies and lifestyles that will ultimately eliminate waste.

68

The Royal Society of Arts 1754–2004

R S A

43

RSA Commercial Examinations began in 1882; typing and shorthand proved the most popular.

1st

Sir Rowland Hill

was awarded the first RSA Albert Medal in 1864 for his postal reforms and the introduction of the Penny Post.

The Royal Society of Arts 1754–2004

The Royal Society of Arts 1754–2004 was founded by artist and social activist William Shipley.

40

M^R W^M SHIPLEY, *whose Public Spirit gave rise to the Society Instituted at London, for the Encouragement of Arts, Manufactures and Commerce.*

Eric **Gill** created this famous typeface and was among the very first to be awarded the distinction of *Royal Designer for Industry* (RDI) by the RSA in 1938.

57

eg: abcdefghijklmnopqrstuvwxyz

The Royal Society of Arts 1754–2004

prostor za inteligentne rasističke ispade

Human**Rights**Film**Festival**

10. - 17.12.04. kino tuškanac. mama. močvara
www.humanrightsfestival.org

dimensions: 38 1/2" h x 26 3/4" w

DISTINCTIVE MERIT Public Service | Non-Profit | Educational
Human Rights Film Festival Poster

Art Director Lina Kovacevic **Creative Director** Lina Kovacevic
Designer Lina Kovacevic **Studio/Design Firm** Lina Kovacevic for
mi2lab **Clients** m ultimedijalni institut (mi2), udru enje za razvoj
kulture (URK) **Country** Croatia

The poster's idea is to promote the Human Rights Film
Festival by providing the white surface of the poster for
"smart racist outbursts." The text is written in both Croatian
and English and aims to communicate with its target
audience without a language barrier (English is included as
a common language for non-domestic citizens). The target
audience was two main groups of the wider public: those
whose human rights are abused, and those who abuse
others' human rights. The main goal was to focus attention
on human rights issues, make the public more sensitive, and
invite them to attend the festival. The creative strategy was
to avoid the usual clichés or pathetic symbols about human
rights. Inviting people to submit their "racist comments" on
the white surface promoting the Human Rights Festival was
a satirically fresh way to raise awareness about racism in
post-war Croatia. This ironic approach also embodied the
main goal of the Festival: to provide space for critical thinking
about human rights issues.

dimensions: 40 1/3˝ h x 2

DISTINCTIVE MERIT Poster Design Transit **Pig to Pork**

Studio/Design Firm Hakuhodo, Inc. **Country** Japan

I always have wondered where food comes from and
who consumes. Who are the producers and who are the
consumers? What environmental costs are we paying for, and
what do we get in return, particularly in the case of various
kind of meat? It's a profound problem, but we are not often
conscious of it. I'm very glad if I have somehow successfully
conveyed this awareness with a provocative visual message.

DISTINCTIVE MERIT Environmental Design Way-Finding Systems | Signage | Directory
Signage System Osnabrueck

Studio/Design Firm Buero Uebele Visuelle Kommunikation **Country** Germany

A sky of black letters and numbers, interspersed with red clouds. Words show the way
like stars guiding the traveler.

DISTINCTIVE MERIT Trade Show **AIGA 2004 50 Books 50 Covers Exhibition**

Art Director Glen Cummings **Creative Director** Glen Cummings **Designers** Glen Cummings, Yi
Chun Wu, Jordan Carver, Jeffrey Lai **Studio/Design Firm** The Office of Glen Cummings **Client**
AIGA NY **Country** United States

The main room is organized as a classroom facing a half-wall of video screens. The desks are varied in style and age, and each one has a book on top of it. Twenty-five screens play a synchronized video of hands flipping pages of an invisible book. Viewers may read the spatial relationships metaphorically—screen and seats = teacher and students—and arrive at the underlying questions that should be asked of any "Best of" presentation: Who says these are the best? And in what way? The makeshift video wall asks visitors to examine the books in front of them. A TV perched in the window displays each page of every book in the show at a rate of fifteen spreads per second. By presenting such a fast comparison, the video reveals each book's structure in relation to all the others—a perspective you can't achieve by browsing the actual books in the gallery space.

Working with the Port Authority of New York and New Jersey, Pentagram created a comprehensive program of wayfinding and environmental graphics for the temporary PATH station at the former site of the World Trade Center. The station is designed as a stopgap until the new transportation center is completed in 2008. The graphics make an open and welcoming gesture to the public to participate in the site's rebirth. The station perimeter has been covered with open mesh panels that allow viewing of the site. Historical quotes about New York that parallel the vitality and optimism of the rebuilding effort have been printed on the scrims, and in the station's mezzanine, heroically-sized aerial photos of Lower Manhattan cover the walls and are paired with detailed maps that show every street in the area. Street level photography provides further context: some thirty different individual street corners have been documented to provide a unique sense of place.

292

DISTINCTIVE MERIT Environment **Temporary WTC PATH Station**

Art Director Michael Gericke **Designers** Michael Gericke, Don Bilodeau **Project Architects**
Port Authority of New York and New Jersey (Robert Davidson, FAIA) **Studio/Design Firm**
Pentagram **Client** The Port Authority of New York and New Jersey **Country** United States

DISTINCTIVE MERIT Gallery, Museum Exhibit | Installation **Australian Racing Museum**

Art Director Mark Janetzki **Creative Directors** Garry Emery, Nigel Fitton **Designers** Job van Dort, Andrew Trewern, Ken Stanley, Johan Skyback, Sarah O'Keefe, Emma Fisher **Studio/Design Firm** emeryfrost **Client** Racing Victoria **Country** Australia

ENVIRONMENTAL DESIGN

GRAPHIC DESIGN

294

The permanent horse racing exhibition at the Australian Racing Museum and Hall of Fame at Federation Square combines sporting, social history, and natural history themes. An important objective is to bring the world of racing to the attention of a new, young generation and to allow them to experience something of the excitement and glamour of the sport. The exhibition design and its architectural spaces are the outcome of close collaboration between emeryfrost and Spowers Architects. An important feature of the museum is the way that conventional distinctions between exhibition design and architecture are blurred. The exhibits on display include the skeleton of Carbine, winner of the 1890 Melbourne Cup and

one of Australia's greatest horses. The three-dimensional relic has been brought to life via a liquid crystal screen placed next to it on which an animated sequence is projected. The virtual horse has been digitally "built" and several stories are told, including animations explaining the operation of the horse's heart, lungs, and legs. The Australian Racing Museum and Hall of Fame projects a sophisticated contemporary image that matches the bold architecture of its location at Federation Square and engages a new audience to marvel at the wealth of stories to be told. Through the drama of digital visual effects and their integration with the exhibition spaces, new life is breathed into the objects, artifacts, and personalities of racing's history.

DISTINCTIVE MERIT Music Video **Afra: Digital Breath**

Art Directors +CRUZ, John C. Jay **Creative Director** John C. Jay **Designer** WOOG
Technical Director Jack Peng **Animation** Yiing Fan, John Sadler **A&R Direction/
Producer** Bruce D. Ikeda **Executive Producers** Jack Peng, Arto Hampartsoumian,
Yasushi Shiina, Masao Teshima **A&R** Yasushi Takayama **Illustrator** WOOG
Photographer Asada "Pip" Setabuth (Triton Films) **Publisher** Wieden+Kennedy
Tokyo Lab **Studio/Design Firm** Wieden+Kennedy Tokyo Lab **Client** Wieden+
Kennedy Tokyo Lab **Country** Japan

Digital Breath by Afra is the fifth CD/DVD album by Wieden+Kennedy Tokyo Lab which features
original music by a young Tokyo musicians brought to life by international visual artists.
Beatbox artist Afra adds his natural sound and cadence to the touch of electronic influence of
producer Prefuse 73. The collective goal was to bring this old-school hip hop art form to a new
place musically and visually with the influence of urban Tokyo culture. Afra performs "Digital
Breath" as he explores a new visual environment. His breath creates waves of music, which
then develop into the foliage of nature. The further he walks, the more foliage and flowers he
creates, and an amazing forest unfolds as he explores. Afra eventually discovers the final point
of his journey through his music, ending at a musical and virtual Shangri-La.

The artwork of L.A.'s Clayton Brothers was brought
to life for this romance-themed promo stunt. The
inspiration came from vintage circus sideshow posters.

DISTINCTIVE MERIT Animation **Hot Couples/Hot Weddings**

Creative Director Jim Fitzgerald **Designers** Jim Fitzgerald, Rob and Christian Clayton **Animator** Pete List
Illustrators Rob and Christian Clayton **Studio/Design Firm** MTV Networks **Client** VH1
Country United States

To advertise this off-road vehicle, we chose large print and press inserts that looked like giant sheets of stamps. The sheet is composed of 180 stamps from every country in Africa.

MERIT Insert, Newspaper/Magazine **Stamps**

Art Director Jonathan Santana **Creative Director** Mike Schalit **Designers** Jonathan Santana, James Cloete
Agency NET#WORK BBDO **Studio/Design Firm** NET#WORK BBDO **Client** General Motors South Africa
Country South Africa

MERIT Magazine, Consumer Full Page **Found Space**

Art Director Ellene Wundrok **Creative Director** Vanessa Holden **Designer** Ellene Wundrok **Photo Editors** Naomi Nista, Tara Donne **Photographer** Michael Luppino **Publisher** Robin Domeniconi **Agency** Time Inc./Real Simple **Studio/Design Firm** 24th Street Loft **Country** United States

The objective of this photograph was to create a visually appealing solution to a not-so-visual story idea, foldable furniture. The idea of the pop-up book developed during a weekly brainstorming meeting between the art and photo departments. We hired artist Matthew Sporzynski to create the book. Since the idea was somewhat abstract, we decided to photograph it in a realistic environment using natural light to impart a soft, realistic feel.

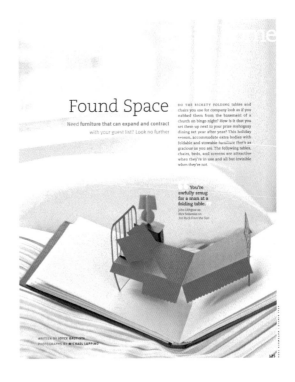

A printed homage to the great, unsung city in the middle.

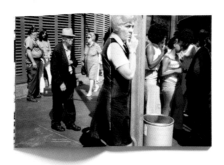

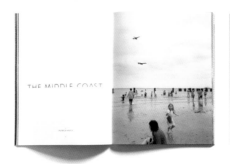

MERIT Magazine, Consumer Full Issue **Big Magazine no. 49: Chicagoland**

Art Directors Hans Seeger, John Shachter **Contributors** Richard Burbridge, Liz Chilsen, Eric Claridge, Joseph Costa, Barbara Crane, Jonathan de Villiers, Mitch Epstein, James Franklin, Kathryn Frazier, Andy Gray, Darcy Hemley, John Herndon, Keith Herzik, James Hughes, Michael Jefferson, Magnus Magnusson, Tom Raith, Jamie Robinson, Jay Ryan, Warwick Saint, Melissa Scherrer, Stephanie Serpick, Kipling Swehla, Robert The, Patrick Voigt **Publisher** Marcelo Jünemann **Client** Big Magazine **Country** United States

INNER SPACE
Hideki Nakajima

MERIT Magazine, Consumer Spread | Multipage, Series **Inner Space**

Art Director Hideki Nakajima **Creative Director** Joerg Koch **Designer** Hideki Nakajima
Other CG by Cache **Agency** Nakajima Design **Client** 032c Magazine **Country** Japan

kid's wear

Vol. 19
AUTUMN/WINTER 2004/05

BRAVE BOYS
brave girls!

A place where hope occur SHINICHI SUZUKI Thirsty, hungry, tired
THE BAG „I got angry" NEW YORK stories A FAIRY TALE
BACKYARD 6 p.m. I see a ship in the harbour 1954 A FILM

MERIT Magazine, Consumer Full Issue, Series **Kid's Wear Magazine, Autumn/Winter, no. 19: The Colours of Cologne, Perfect World, 1954,
Kid's Wear Magazine**

Art Director Florian Lambl **Creative Director** Mike Meiré **Illustrators** Manu Burghart, Esther Gebauer, Carlotta Kinze, Jasper, Zec Elie-Meiré
Photo Editor Ann-Katrin Weiner **Photographers** Shelby Lee Adams, Aorta, Mark Borthwick, Kira Bunse, Elias Hassos, Thomas Hannich, Markus
Jans, Achim Lippoth, Kymberly Marciano, Mike Meiré, Martin Parr, Ramune Pigagaite, Vanina Sorrenti **Publisher** Achim Lippoth **Studio/Design
Firm** Kid's Wear **Client** Kid's Wear **Country** Germany

(see related work on page 178)

kid's wear no. 19 was a of relaunch of the whole magazine. It now focuses even more on
kid's fashion, but also takes into account childhood in today's world. We worked together
with several famous and sensitive photographers and found some very enthusiastic writers
for the new magazine. The entire publication is illustrated by children's pictures.

The Next Cultural
Establishment

A⁴⁹

The Industry Standard

B⁵⁰

Re-Moderning

C⁶⁰

MERIT Magazine, Consumer Full Issue, Series
New York Issue: Cover, p. 49, pp. 50-51, pp. 60-61

Art Director Arem Duplessis **Creative Director** Janet Froelich **Designers** Jeff
Glendenning, Todd Albertson, Catherine Gilmore-Barnes, Kristina DiMatteo,
Nancy Harris **Photo Editors** Kathy Ryan, Kira Pollack, Cavan Farrell, Joanna
Milter, Evan Kriss **Publisher** The New York Times **Studio/Design Firm** The
New York Times Magazine **Country** United States

Where Have You Gone,
Impresarios?

E⁷⁶

Style **Patron Sweethearts**

F⁸⁴

The approach to the New York Issue was simply to look at it as an exhibition within
a magazine. An introduction to a gallery space is on the cover, and the theme
continues throughout the issue, with a signage-inspired structure for headlines,
subheads, and other text. Environmental signage and way-finding systems
inspired the movement of all of the display type, from the middle of the page to
this horizontal structure hanging from the top of the page. A map or blueprint of
the issue is introduced in the table of contents. Each feature is represented by a
series of rectangles that represent each spread of the story. Each feature story is
given a letter and a color to distinguish itself as its own section within the whole.
The five feature stories of the well make up this graphic map, which appears
throughout the issue on the opener of each feature story. This is intended to help
readers navigate the magazine as if they were walking through an art exhibit.

MERIT Magazine, Consumer Full Issue, Series
Landscape Issue: Cover, p. 39, pp. 64-65, pp. 68-69

Creative Director Janet Froelich **Designer** Catherine Gilmore-Barnes **Photo Editor** Kathy Ryan **Publisher** The New York Times **Studio/Design Firm** The New York Times Magazine **Country** United States

One of a series of themed special issues of The New York Times Magazines devoted to landscape architecture, anchored by a portfolio of proposals for the World Trade Center site. The goal was to provide a rich and varied view of current trends in landscape and garden design through photography and drawings. The lush nature of the photography inspired designer Catherine Gilmore-Barnes to rework our Cheltenham type face, using a variety of sizes, colors, and swashes to create a richly interwoven-type garden. The type reflects both the structured and organic nature of landscape design—the spontaneous and uncontrolled forces that erupt beneath layers of order and design.

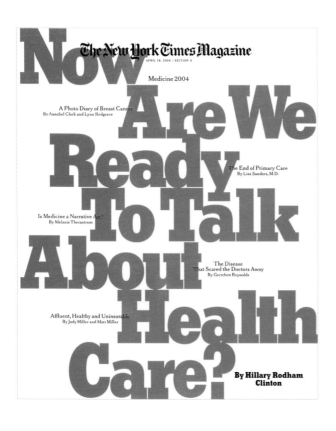

MERIT Magazine, Consumer Full Issue, Series
Health Issue: cover, pp. 26-27, pp. 36-37, pp. 42-43

Creative Director Janet Froelich **Designers** Jeff Glendenning,
Kristina DiMatteo **Photo Editors** Kathy Ryan, Cavan Farrell
Publisher The New York Times **Studio/Design Firm** The New
York Times Magazine **Country** United States

One of a series of themed special issues of The New York Times
Magazine devoted to health. In order to reflect this particular
subject, designer Jeff Glendenning developed a series of graphics
and icons that subtly reference the iconography of instruction
manuals. The cover, which sets up the theme, is an abstract
typographic reference to the Red Cross: bright red on white
ground. The feature openers are unified by a unit constructed of
a cropped version of the Red Cross combined with icons relevant
to the particular story. The photography throughout reflects the
intensely personal and powerful nature of the subject, which was
most poignantly represented by Annabel Clark's compelling series
of her mother, Lynn Redgrave, recovering from cancer.

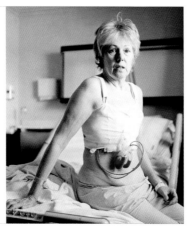

MERIT Magazine, Trade Full Issue
2wice "Formal" Issue

Art Director Abbott Miller (Principal) **Designers** Abbott
Miller, Jeremy Hoffman **Studio/Design Firm** Pentagram
Client 2wice Arts Foundation **Country** United States

Each issue of 2wice explores the visual and
performing arts through a different theme. The
Formal issue takes its cue from several sources.
The writer Andrew Solomon contributes a history
of dandyism, while the magazine's characteristic
element of performance observes the theme
through the formal language of dance: the
ballet. Pieces were commissioned from Maria
Calegari and Bart Cook, ballet masters and
répétiteurs for the Balanchine Trust, and Albert
Evans, of the New York City Ballet. The figures
in the photographs are complemented by the
use of formal script in the image captions. In
one feature, this "Fig." typography was applied
to a custom-made Hugo Boss suit which was
incorporated into the dance piece. A unique
process of white thermography was used to
create a formal pattern on the issue's cover.

304

MERIT Special Trade Book (Image Driven)
America (The Book): A Citizen's Guide to Democracy Inaction

Art Director Paula Scher (Principal) **Designers** Paula Scher,
Julia Hoffmann, Keith Daigle **Publisher** Warner Books **Studio
/Design Firm** Pentagram Design, New York **Client** The Daily
Show With Jon Stewart **Country** United States

"America (The Book): A Citizen's Guide to Democracy Inaction" is a timely, satirical look at the American
political process, created by the writers, producers, and correspondents of The Daily Show With Jon
Stewart. Pentagram collaborated with The Daily Show on the presentation of the material. They
designed the book to resemble a civics textbook that is packed with charts and graphs, including "Were
You Aware?" sidebars, a foldout chart of "The Shadow Government," and a "Dress the Supreme Court"
spread that features naked justices (which got the book banned from Wal-Mart).

MERIT Limited Edition, Private Press, or Special
Format Book
From Hell. Oder wie das Böse in den Film kam.

Designer Katrin Tüffers **Other** Professor Ulysses
Voelker **Studio/Design Firm** University of Applied
Sciences Mainz **Country** Germany

"The bad" is something that always bothered people. Since the beginning of
movie history, "bad guys" were always a fascinating topic. Is there a correlation
between "the bad" and real events in contemporary history? If the assumption
is correct that Hollywood creates a reflection of our media-influenced society,
events of the day should appear in the productions of the movie industry. This
book analyzes the various appearances of "the bad" in movies, compares
them with each other, and sorts them into a historical context. Investigations
for the book resulted in interesting findings. While it is commonly known that
the creation of Godzilla was inspired by the atomic bombing in the 1940s, it
was quite astonishing to learn that the renaissance of vampire movies had
something to do with the emerging AIDS epidemic in the 1980s.

MERIT Limited Edition, Private Press, or Special Format Book
ADC Switzerland Annual 2004

Studio/Design Firm Advico Young & Rubicam **Country** Switzerland

(see related work on page 216)

What can be the theme for a book that shows the best advertising ideas of Switzerland?
To come up with the best ideas, advertisers sometimes need to treat themselves
very badly. And because most advertisers like their jobs, you can say they're all a bit
masochistic. When you open the zipper on the mouth of the fetish mask on the cover,
you read its meaningful title: "slaves of the idea."

MERIT Museum, Gallery, or Library Book
Linda Schwarz in Dialogue with Tilman Riemenschneider

Art Director Thomas Tscherter **Creative Director** Frank Wagner **Designer**
Thomas Tscherter **Studio/Design Firm** haefelinger+wagner design **Client**
Linda Schwarz **Country** Germany

Linda Schwarz is an artist who focuses on artistic
printmaking techniques. The exhibition catalogue refers
to the subject matter of a work in which Schwarz reinterprets
the work of medieval artist Tilman Riemenschneider. The idea
of the concept is serial unique copy, which signifies that each
book, in spite of being factory-made, is a singular copy. The
spine of the catalogue was bound openly so that the bookbind-
ers, workmanship is visible. The catalogue inside gives the im-
pression of handmade paper, which reflects the artist's method
of working and her handling of material and paper.

MERIT Annual Report
Super Cheap Auto Annual Report 2004

Creative Director Vince Frost **Designer** Ray Parslow
Studio/Design Firm emeryfrost **Client** Super Cheap
Auto **Country** Australia

As the name suggests, Super Cheap Auto is not the shy
retiring type. Much of their print and packaging is big
and brash in both color and design. Instead of trying
to pare this back, emeryfrost embraced the aesthetic
and used it as the basis for the design of the company's
first annual report. With all the visual prompts for the
concept available at the Super Cheap Auto stores,
emeryfrost didn't need to look far for inspiration. The
document in effect creates a two-dimensional store,
starting off with the cover which is based on their
"redback" shelving. By doing this, we captured the
essence of their honest, approachable manner and the
uniquely hands-on approach they apply to business.

MERIT Annual Report
Chicago Volunteer Legal Services Annual Report

Art Director Tim Bruce **Designer** Tim Bruce **Photographer** Tony
Armour **Publisher** Blanchette Press **Studio/Design Firm** Lowercase,
Inc. **Client** Chicago Volunteer Legal Services **Country** United States

As the city's largest general law firm, Chicago Volunteer Legal Services
links 2,000 professionals with more than 11,000 city and suburban clients.

ARCTIC
THE COVER
EXHIBITION

307

MERIT Booklet | Brochure
Arctic the Cover Exhibition

Art Directors Lisa Careborg, Andreas Kittel **Creative
Director** Anders Kornestedt **Studio/Design Firm** Happy
Forsman & Bodenfors **Client** Arctic Paper **Country** Sweden

MERIT Newsletter, Journal or House Publication **Look here! Look here!**

Art Director Lisa Careborg **Creative Director** Anders Kornestedt **Designer** Lisa Careborg **Other** Fredrik Persson **Photographer** Mikael Olsson **Studio/Design Firm** Happy Forsman & Bodenfors **Client** The Swedish Museum of Architecture **Country** Sweden

MERIT Stationery (Letterhead, Business Card, or Envelope)
Fujii Tamotsu Photography Office

Art Director Satoru Kubo **Creative Director** Satoe Inoue **Designer** Satoru Kubo **Studio/Design Firm** This Way, Inc. **Client** Fujii Tamotsu Photography Office **Country** Japan

Art Director Abbott Miller (Principal) **Designers** Abbott Miller, Jeremy Hoffman **Photographer** James Shanks **Studio/Design Firm** Pentagram **Clients** Noguchi Foundation, Garden Museum **Country** United States

The Noguchi Museum is dedicated to the life and work of the Japanese-American sculptor and designer Isamu Noguchi (1904–1988). Housed in a converted factory near the artist's former studio in Long Island City, Queens, it is often cited as one of New York's hidden cultural treasures. In June 2004 the museum reopened following a three-year renovation of its building, and Pentagram was commissioned with the design of a new identity to coincide with the re-launch. Noguchi's sculpture is known for its formal tension—the inherent contrast of solid, natural materials like wood, stone, clay, and metal that is cast, hewn, or carved into graceful, sensuous forms. The identity captures this tension through the use of stark black–and-white typography that is set within a square with gently curved edges. The mark employs the font Balance, whose tapered verticals mimic the swell of the sculptor's characteristic shapes.

MERIT Stationery (Letterhead, Business Card, or Envelope) **V4**

Art Director Eric Dubois **Creative Directors** Daniel Fortin,
George Fok **Studio/Design Firm** Époxy **Client** V4 **Country** Canada

This stationery was created with eleven different colors of paper. On each sheet
two colors were applied in overprint, which makes the color of the paper an
illusion of four colors. Blue, yellow, and red were used for the ink. On each piece
of the stationery a combination of two of those colors was used.

MERIT Stationery (Letterhead, Business Card, or Envelope)
Graffiti Ex Stationery

Art Director Mitoh **Creative Director** Michael Hoinkes **Designer**
Mitoh **Illustrator** Mitoh **Studio/Design Firm** He Said She Said
Client Szymanski Clean Management **Country** Germany

The gray color is a silver paint press worked in screen process printing,
on which one can judder away, like German popular judder batches
from the state-run lottery. After one scratches the graffiti tag away, one
discovers the company's "Graffiti-Ex," which is kept active in cleaning
walls and removing graffiti.

MERIT Logo | Trademark **Hanes Beefy-T Logo**

Creative Director Hayes Henderson **Designer** Billy Hackley **Studio/Design Firm** hendersonbromsteadart **Client** Hanes Beefy-T **Country** United States

Want to promote your T-shirt company? Say it with meat. With a name like Beefy-T, it was amazing that no one had thought of this already. The client was worried that people might not get it, but went along with it in a few tests—as a product catalogue that looked like a Sunday circular for a butcher, trade show applications, and, of course, T-shirts. The logo has been well received and "gotten" immediately. The next step is to possibly extend it beyond specialty applications.

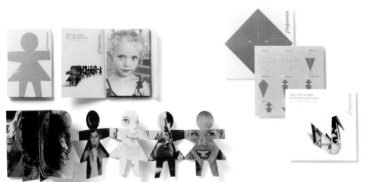

MERIT Complete Press | Promotional Kit, Series
Photonica Promotional Campaign: Swan Ad, Swan Mailer, Cards Ad, Cards Mailer, Paper Chain Mailer

Art Directors Alan Dye, Ben Stott, Nick Finney **Designer** Jodie Wightman **Studio/Design Firm** NB: Studio **Client** Photonica **Country** United Kingdom

These mailers for Photonica work along the campaign strapline of "play with images, work with Photonica." Each mailer illustrates Photonica's latest images through a creative, interactive format, intended to appeal to the creative audience that receives them. There is an origami set, a pack of cards that slot together, and a concertina that makes a paper doll chain. The supporting ads show the final product made with each mailer.

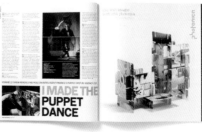

size H 1030 mm × W 728 mm

size H 148 mm × W 219 mm

Headline copy: Kids who have a lot of weak points,
are kids who have lots of room to grow.

size H 728 mm × W 1030 mm

Headline copy: It's great to be able to become friends with everyone.
It's also great not to be easily influenced by others.

size H 728 mm × W 1030 mm

Headline copy: Kids who find their favorite win, and not the one that's no.1.

size H 728 mm × W 1030 mm

Headline copy: Kids giggle when you tickle their curiosity.

size H 728 mm × W 1030 mm

MERIT Corporate and Promotional Design, Self-Promotion, Print, Series
**Feel New Sesame Street: Furry Poster, Furry Brochure, Picture Book, Hula
Hoop, Train, Paper Balloon**

Studio/Design Firm Asatsu-Dk, Inc. **Country** Japan

MERIT Self-Promotion, Print
E. Company Guidance

Studio/Design Firm E. **Country** Japan

MERIT Postcard, Greeting Card, or Invitation
Card Beierarbeit: Analog und Digital

Creative Director Christoph Beier **Designer** Christoph
Beier **Illustrator** Heinz Beier **Publisher** Beierarbeit
Studio/Design Firm Beierarbeit **Country** Germany

MERIT Postcard, Greeting Card, or Invitation Card
Christmas Card: Hand-Knitted Merry Christmas

Art Director Velina Mavrodinova **Creative Director**
Velina Mavrodinova **Designer** Velina Mavrodinova
Studio/Design Firm enthusiasm **Country** Bulgaria

Our company name is Enthusiasm and we really mean
it. So, we decided to hand-knit the Christmas greeting to
our clients, partners, and friends.

MERIT Postcard, Greeting Card, or Invitation Card
**2005 New Year's greeting card for the design magazine
"Designers' Workshop" published by BIJUTSU S**

Art Director Masami Takahashi **Designer** Masami Takahashi
Studio/Design Firm Masami Design, Ltd. **Client** Designers'
Workshop Magazine **Country** Japan

I designed Nengajyo, the New Year's greeting card, for a design
magazine. It reads, "Let's visit factories for five years. As you
pass the enclosed red string through the holes in the card ac-
cording to numbers written on it, messages appear on the card.
A "Congratulation knot": a Japanese traditional knot. "2005 The
rooster": this is the year of the rooster. Exchanging Nengajyou
is an important custom in my country, so many elements of
Japanese culture were used to design the card. The combination
of red string and white paper expresses happiness. Also, knots
are a traditional Japanese way of expressing messages. I thank
NYADC for giving me the great opportunity to introduce Japanese
culture through my work.

MERIT Promotional, Series **New Design Awards Exhibition 2004**

Art Director Chie Morimoto **Designer** Mai Inayoshi **Special Thanks**
Daisaku Nojiri **Producer** Hiroyuki Ueno **Illustrator** Ryusuke
Tanaka (TYPO) **Photographer** Mikiya Takimoto **Studio/Design Firm**
Hakuhodo, Inc. **Country** Japan

This poster announces "New Design Awards Exhibition 2004," which annually honors designers for their work in advertising, packaging, editorial design, etc. A young chicken and three tiny boxes are used to symbolize three young creative people being elected and awarded, and also their anxieties, uncertainties, freedoms they treasure, and adventures they will have. Fond memory from production: trying to pose him properly, we had to chase the stubbornly uncooperative baby chicken all around the studio with a full creative team. Also, because the shooting ground/exhibition site was my alma mater, I was scared to death of burning down the locker room where the fireworks scene was shot. Special thanks to photographer Mikiya Takimoto, production company ROBOT, and design house MAI.

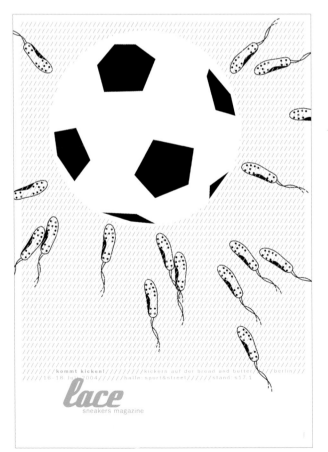

MERIT Promotional **Lace Poster**

Designer Marcus Chwalczyk **Studio/Design Firm**
smakdesign **Client** Lace Sneakers Magazine **Country** Germany

Visitors at a fashion fair were invited to join a game of table football.
The poster was been designed for promotional purposes.

MERIT Calendar or Appointment Book **The Summit Book: Diary 2005, Papierfabrik Scheufelen GmbH+Co. KG**

Art Director Kirsten Dietz **Creative Directors** Kirsten Dietz, Jochen Raedeker **Designers** Anika Marquardsen, Stephanie Zehender **Illustrators** Anika Marquardsen, Felix Widmaier **Photographers** Niels Schubert, Peter Granser **Studio/Design Firm** strichpunkt **Client** Papierfabrik Scheufelen GmbH+Co. KG **Country** Germany

PhoeniXmotion is not just any old premium paper. It is simply the tops. This is one of the reasons why the PhoeniXmotion Summit Book 2005 features a top theme—your quite personal highlights for the year. Your companion for your journey to the top: PhoeniXmotion. The PhoeniXmotion Calendar 2005 accompanies its users on every step of the path to their personal summit. Day by day. Beat by beat. As such, the parallels between the white world of the mountains and PhoeniXmotion's world are infinite. And they are shown too—on seventy-two pages in the first part, divided into four chapters: preparation, ascent, set-backs, and attack on the summit. The second part is the calendar proper, your personal summit book. Here is just the right place for your commitments as well as space to record your daily ups and downs. It comes with stickers and a mood "barometer" for each and every day, and is printed in outstanding quality using eleven different techniques—a genuinely top performance from PhoeniXmotion.

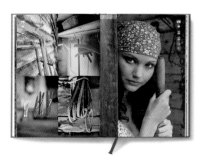

手間かけて、

できあがり。

手づくりパン
大地の実

MERIT Promotional, Series
**The Fruit of the Ground Series: It Takes Time,
Some Efforts, Before it is Ready**

Art Director Yumiko Yasuda **Creative Director** Yuichi
Muto **Designer** Yumiko Yasuda **Other** Taiyo Printing
Co., Ltd. **Illustrator** Ton **Photographer** Jun Kumagai
Studio/Design Firm ayr creative **Client** The Fruit of
the Ground **Country** Japan

This bakery crafts each piece of bread with loving care and
is very particular about their yeast and other ingredients.
Poster 1 illustrates their careful attention to their work.
Poster 2 represents the slow rising of the bread. Poster 3
shows the delicious, freshly-baked result.

時間かけて、

318

MERIT Promotional, Series **Vessel: 1, 2, 3**

Art Director Yuji Nagai **Designer** Yuji Nagai **Illustrator**
Yuji Nagai **Photographer** Yuji Nagai **Studio/Design Firm**
designhorse **Client** Kano Shikki Co., Ltd. **Country** Japan

Although a traditional Japanese lacquer-ware manufacturer,
the client has commercialized the design of wares and
housewares with nontraditional free-thinking. They expressed
themselves with the free movement of water, which is
reflected in the color. The character "Utsuwa" (vessel), located
at the top of the poster, tries expresses the daily discovery
and enjoyment. It was created using the bottom of the cup,
pressed on the table with water like a stamp. The bright and
colorful poster broke the ice of tradition in the site.

FUTAKI FABRIC FADDIE '05

FUTAKI FABRIC FADDIE '05

MERIT Promotional, Series **Futaki Fabric Faddie '05**

Art Director Gaku Ohsugi **Designer** Eiji Sunaga **Studio/ Design Firm** 702design Works, Inc. **Client** Futaki Interior, Inc. **Country** Japan

I designed this poster for the exhibition "FADDIE," a new brand by the fabric manufacturer Futaki Interior. As the basic threads overlap to create a new product, the basic letters used in the poster design also overlap to form a new message. In the poster, every basic thing interferes with every other and is reborn as something new.

319

MERIT Promotional, Series
A Beautiful Catastrophe—Bruce Gilden/Magnum: 1, 2, 3

Creative Director Jonathan Ellery **Designers** Jonathan
Ellery, Lisa Smith **Account Director** Philip Ward **Studio/
Design Firm** Browns **Client** Bruce Gilden/Magnum
Country United Kingdom

The brief was to deliver a photographic body of work by
New York photographer Bruce Gilden/Magnum in a way that
accurately portrayed the photographer and his subject matter
in a visually stimulating and appropriate way. The finished
book used typography to illustrate the aggression, energy,
dysfunctional, and claustrophobic nature of both Bruce Gilden
and New York City. Browns designed three posters to promote
the book culturally and to be used at points of sale.

MERIT Promotional, Series **Life**

Art Director Chiharu Kondo **Designer** Chiharu Kondo
Illustrator Hideto Fujimoto **Studio/Design Firm** UltRA
Graphics **Client** Hideto Fujimoto **Country** Japan

People live being enclosed by very various shapes. One
thing is changed into various shapes. Life changes into
various shapes, too.

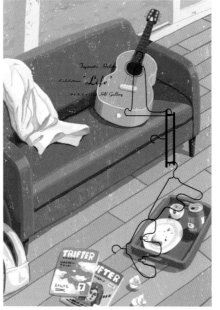

MERIT Promotional **Keiwa_A**

Art Director Koji Iyama **Designer** Koji Iyama **Studio/Design Firm** iyama design **Client** Keiwa Package **Country** Japan

Keiwa Package is a company that packs, stores, and delivers various articles. While they deal with thousands of different articles, their job is not just packing things and delivering them from point A to point B. I wanted to express Keiwa's own policy of gently packing and delivering not only contents, but also the hearts of the people involved in the process. To achieve my goal of creating a symbolic image of proper packing, I made some alterations to the form of the Chinese character "Tsutsumu," which means to "wrap" or "pack."

MERIT Promotional **Sporen**

Art Director Alvin Chan **Creative Director** Alvin Chan **Designer** Alvin Chan **Photographer** Deen van Meer **Studio/Design Firm** Koeweiden Postma **Client** Leine & Roebana **Country** Netherlands

This poster was designed for a special production by Leine & Roebana for the Holland Dance Festival. The Amsterdam–based dance company is fascinated with mathematics and the idea of coding and decoding. The poster is generated by series of pictograms, which from a distance depict a dancer in pose. Careful attention was given to embed specific pictograms with layered meaning. Numerous personal messages were written from the "designer to the dancers," generating an interaction between artists. The poster challenges the convention of traditional dance posters and reflects the the influence of mathematics upon the choreography of the performance.

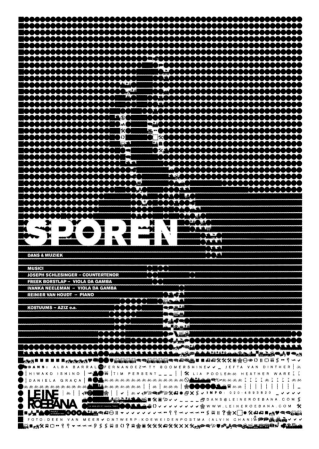

MERIT Promotional, Series **Kentaro Kobayashi 4th Producing Public Performance [LENS] LENS Posters**

Art Director Manabu Mizuno **Creative Director** Manabu Mizuno **Designers** Go Takahashi, Yuta Akimoto **Photographer** Yasunari Kurosawa **Studio/Design Firm** good design company co., inc. **Client** Twinkle Co., Ltd **Country** Japan

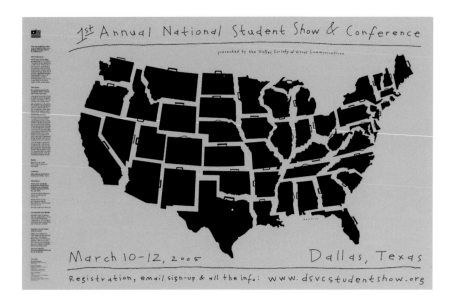

MERIT Promotional
1st Annual National Student Show and Conference poster

Art Director Jeff Barfoot **Designer** Jeff Barfoot **Illustrator** Jeff Barfoot
Studio/Design Firm Sibley/Peteet Design Dallas **Client** The Dallas Society
of Visual Commnications **Country** United States

Every year, the Dallas Society of Visual Communications (DSVC) hosts
a student visual communications competition along with a one-day
student seminar and studio tour. Due to competition from other
conferences, the DSVC decided to take the seminar to the next level.
The first ever National Student Show and Conference did just that.
The all-new, three-day conference consisted of four keynote speakers,
breakout sessions, workshops, contests, prizes, and studio tours,
and culminated with an awards gala. The poster needed to convey
to students who had attended the previous year's seminar that this
was a big, revamped event, and needed to inform students previously
unfamiliar with the conference what it was all about. The campaign
worked; the Conference drew over 500 students and their work from
twenty-five different states and three countries.

MERIT Promotional
CalArts Spring Music 2004

Art Directors Scott Taylor, Jae-Hyouk
Sung **Creative Director** Jae-Hyouk Sung
Designer Jae-Hyouk Sung **Illustrator** Jae-
Hyouk Sung **Studio/Design Firm** CalArts
Public Affairs Office **Client** CalArts School
of Music **Country** United States

This small multi-fuctional printed piece is for
CalArts School of Music's 2004 Spring Music
Festival. The Music School needed a poster,
brochure, and progam cover.

MERIT Promotional, Series
**Like a Star Exhibition Poster Series: See
for Yourself, Make an Identity, Never Stop
Exploring**

Art Director Dong-Sik Hong **Creative Director**
Mi-Jeong Hwang **Copywriter** Mi-Jeong Hwang
Designers Sung-Jae Kim, Dong-Sik Hong,
Young-Jun Park **Illustrators** Dong-Sik Hong
Photographer Dong-Sik Hong **Studio/Design
Firm** Tongmyong University of IT **Client** Busan
Asian Short Film Festival **Country** South Korea

The poster series "Like a Star" was the official
poster of the Exhibition "Like a Star," which was
held to celebrate the 2004 Busan Asian Short
Film Festival; the exhibition was organized by the
festival administration. The exhibition presented
short, independent films as experimental art
works. Wearing different colors, the stars in the
posters represent all different shapes of artists'
creative minds.

MERIT Promotional, Series
French Good Grades Poster Series

Art Director Charles S. Anderson **Creative Director** Charles S. Anderson **Designers** Sheraton Green, Jovaney Hollingsworth **Studio/Design Firm** Charles S. Anderson Design Company **Country** United States

The client (French Paper Company) wanted a series of six posters to promote their company. The posters were divided into three groups of two and corresponded with three grades of paper from the French paper family. The lines used in this promotion included Smart White, Speckletone, and Durotone Butcher. This promotion for the French Paper Company not only demonstrates the diversity of French Paper but also displays their ability to deliver a quality paper product.

MERIT Promotional, Series 'Til It Hurts: Chainsaw, Wheelchair,Violin

Art Director Yann Mooney **Creative Director** Daniel Andréani **Writer** Cameron Wilson
Typographer Yann Mooney **Production Company** Graphiques M/H **Illustrator** Louis-
Thomas Pelletier **Studio/Design Firm** Diesel **Client** Festival St-Ambroise Fringe de
Montréal **Country** Canada

As the Fringe was to embark on its 2004 edition, it had to deal with major communication
problems: although many people had heard of the Fringe, few knew what it was about. A clear and
precise positioning within the framework of an overwhelmingly competitive environment was to be
set out. "Life is like a box of chocolates; you never know what you will get." The Fringe's strategy
was to align itself to this magical thought taken from "Forrest Gump." The Fringe is chock full
of surprises: a single performance may be a great disappointment, while another may turn out
to be a pleasant surprise. The end result was to count on a unique characteristic shared by all
participants: determination. These performers are utterly determined to succeed, and are deadly
earnest. Text written in Franglais allowed the Fringe to reach both Montreal's Francophone and
Anglophone targets on a tight budget.

MERIT Promotional, Series **10ban Studio: 1, 2, 3**

Art Director Noriaki Hayashi **Creative Director** Fukuo Yasuda **Designer** Noriaki Hayashi **Photographer** Fumihito Katamura **Studio/Design Firm** Hayashi Design **Client** 10BAN Studio **Country** Japan

MERIT Promotional, Series
Investors Chronicle—Think Fast Posters: Strike, Bull, Gift Horse, Omlette, Early Bird

Art Directors Alan Dye, Ben Stott, Nick Finney **Designer** Mark Wheatcroft **Illustrator** Paul Slater **Studio/Design Firm** NB: Studio **Client** Investors Chronicle **Country** United Kingdom

Following extensive research over the last year, the new campaign is targeted at a niche market of approximately 650,000 people in the UK, identified with average investments of £180k. The campaign, created by NB Studio, consists of illustrated executions which feature on these four limited edition posters together with advertisements in the Financial Times and on FT.com. The objective of the campaign is to encourage prospective readers to think of Investors Chronicle as a rewarding challenge. Caspar De Bono, Publishing Director of Investors Chronicle, comments, "Each illustration is on the theme of opportunity or reward. The creative is deliberately thought-provoking. We want investors to stop and think and to enjoy the challenge presented. IC readers pride themselves on their knowledge of the financial markets and this campaign will reinforce their belief that when you read IC you receive a reward.

329

MERIT Promotional, Series
Montreal Jazz Big Band 15th Anniversary

Art Director Louis Gagnon **Creative Director** Louis Gagnon **Designer** Sebastien Bisson **Studio/Design Firm** Paprika Communications **Client** Montreal Jazz Big Band **Country** Canada

Paprika created this poster for the 15th Anniversary Concert of the Montreal Jazz Big Band. To celebrate the occasion, the MJBB was presenting a very special concert—a "retrospective" of their best success—with internationally acclaimeda guest, pianist Lorraine Desmarais. Paprika has developed many posters over the years for this very popular jazz orchestra, always incorporating the image of a bulldog, whose icon is part of the corporate identity of the group.

MERIT Public Service | Non-Profit | Educational
We Need More Party Animals

Designer Thomas Porostocky **Illustrator** Thomas Porostocky **Studio/Design Firm** School of Visual Arts **Country** United States

Created at the height of the rhetoric of the last presidential election, this poster reflects my view of the current bi-partisan set-up in the US. While the message is fairly direct and straightforward, I tried to make it as light-hearted as possible, since nobody needs another screaming finger pointed in his or her face.

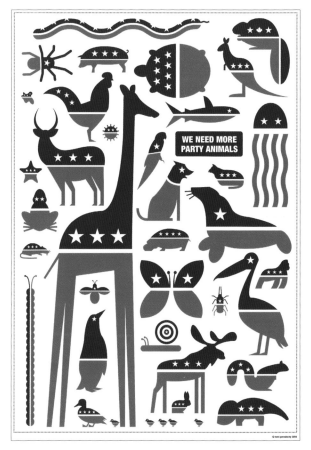

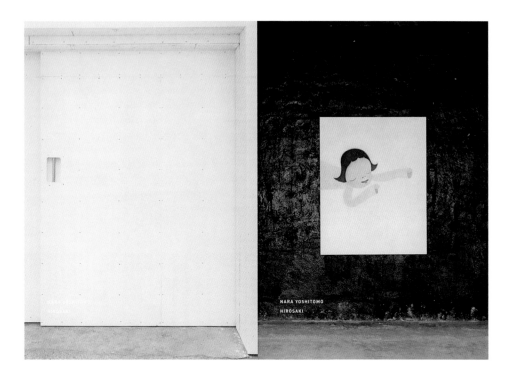

MERIT Promotional, Series
Nara Yoshitomoto/Hirosaki 1-4

Art Director Masayoshi Kodaira **Designers** Masayoshi Kodaira,
Yositomoto Nara **Photographer** Mikiya Takimoto **Studio/Design
Firm** FLAME, Inc. **Client** NPO Harappa **Country** Japan

(see related work on page 260)

An exhibition of Yoshitomo Nara, a Japanese contemporary artist, took place
at a red brick warehouse that was built 100 years ago. The book records the process
of making the exhibition space, from the renovation to the installation. In addition
to the book, we produced a promotional poster that was posted at bookshops. When
I visited the site to design the signboards, I was impressed by the space, as well
as by the people who are renovating this old unused warehouse. The exhibition
was made possible solely by the volunteer staff, and the book was planned and
produced together with this staff.

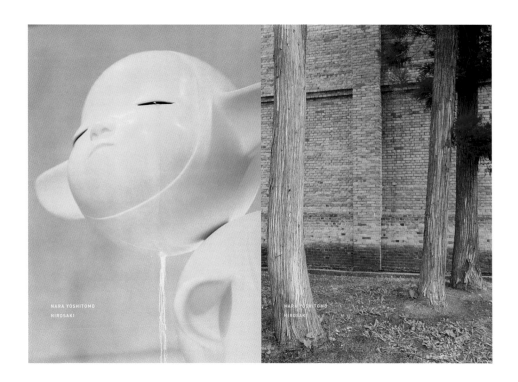

At the beginning of the 21st century, Europe is at a crossroads. What will Europe look like in 2020? Who will decide its appearance? Is there only one Europe, or several of them? Considering its people, identities, cultures, diversity, states, environment, problems, solutions, forms, future, expectations... how will Europe look? A chaotic picture of communications in Europe is represented by a confusion of elements of historical identity (the flags of forty-eight countries). Integration of countries also means an integration of their identities into a unique picture, which has yet to be designed.

Integrity/Identity

MERIT Public Service | Non-Profit | Educational, Series
Europe 2020: How Will Europe Look, Welcome to Europe, Identity Integrity

Art Director Boris Ljubicic **Creative Director** Boris Ljubicic **Designer** Boris Ljubicic **Illustrator** Boris Ljubicic **Publisher** Studio International **Studio/Design Firm** Studio International **Client** Croatian Ministry Of Foreign Affairs and European Integration **Country** Croatia

MERIT Public Service | Non-Profit | Educational
Dialogue in the Dark Poster "BLACK"

Art Director Mitoh **Creative Director** Michael Hoinkes
Designer Mitoh **Studio/Design Firm** He Said She Said
Client Dialog im Dunkeln **Country** Germany

Dialogue in the Dark is an exhibition to discover the unseen. The
poster was overprinted with a thermo-sensitive in silkscreen
process printing. The poster disappears if touched because of
the hand's body heat. In this way, you can read the text about the
exhibition, whose sensitive element is underlined. Visually impaired
or blind people experience a different world in totally dark rooms.

MERIT Transit **Laforet Grand Bazaar**

Studio/Design Firm Hakuhodo, Inc. **Country** Japan

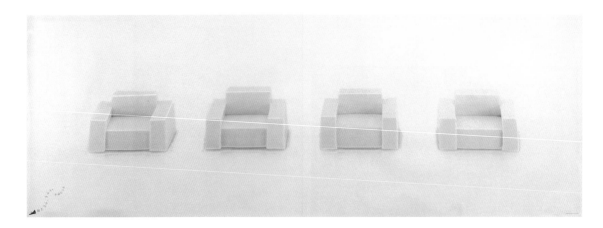

MERIT Transit **Koyama Tofu**

Art Director Masahiko Gonda **Creative Director** Masahiko Gonda **Copywriter** Makoto Takahashi
Designers Kazuaki Koyama, Satoshi Someno, Yoshiaki Okino, Seiji Ito **Photographer** Saori Tsuji
Studio/Design Firm Hakuhodo, Inc. **Client** Koyama Tofu Co., Ltd. **Country** Japan

This poster was created as a part of a brand-building campaign for a long-established tofu producer,
"Koyama Tofu," located deep in the Tanzawa mountains. What we wanted to create was a definite image
that described the whiteness, cubic shape, and softness of a piece of tofu. With that in mind, we actually
constructed an armchair made entirely out of tofu, and took pictures of it in a studio with a completely
white background. The resultant photos were so tonally subtle—essentially white on white—that we
took extra care in printing. We would like to thank Mr. Koyama, the owner of Koyama Tofu, photographer
Saori Tsuji, and all staff members.

MERIT Package Design, Entertainment
Percussive Graphics Ikuo Kakehashi

Art Director Hiroaki Nagai **Creative Director** Hiroaki Nagai
Designers Hiroaki Nagai, Yuki Iwata **Photographer** Katsuhiro
Ichikawa **Publisher** Kim Co., Ltd. **Studio/Design Firm** N.G. Inc.
Client Ikuo Kakehashi **Country** Japan

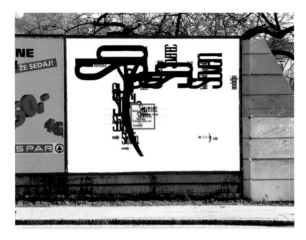

MERIT Billboard, Series **SK04: 1-5**

Art Director Eduard Cehovin **Creative Director** Eduard Cehovin
Photographer Vojko Kladivar **Studio/Design Firm** Design Center, Ltd.
Client Design Center, Ltd. **Country** Slovenia

For the 100th anniversary of the birth of Slovene avant-garde poet
Srecko Kosovel (1904–1926) I designed, with the help of company
Metropolis, a project titled SK04. The project encompasses my own visual
interpretation of selected Kosovel poems from the collection Integrals.
This collection is an example of so-called "concrete" or "visual" poetry. I
decided to change the image of five poems I selected; I gave them a new
form. The presentation all five billboards was on the corner of Slovenska
Street and Askerceva Street in Ljubljana. In the following months, other
poems were presented at the same location. Srecko Kosovel died on May
27, so the fifth and final billboard was presented on this day. Because
Europe is mentioned in the poem "Open Museums," this project was also
dedicated to Slovenia joining European Union.

MERIT Recreation: Sports, Toys, Or Games, Series
Paintura Pitch Project: Paintura

Art Director Tomomi Nakajima **Creative Director** Tomomi Nakajima
Designer Yasusuke Murai **Studio/Design Firm** Stoique&Co. **Client**
Paintura **Country** Japan

The product was developed by Puma to celebrate the harmony between the
spirit of a soccer game and the spirit of art. We challenged the package
designers to print special rubber on cardboard with silkscreen.

MERIT Food | Beverage, Series
Basic La Sirena

Studio/Design Firm Enric Aguilera Asociados **Country** Spain

MERIT Food | Beverage, Series **Fallen Vodka: Fallen Vodka, Fallen, Hero**

Art Director Garrick Hamm **Creative Director** Garrick Hamm **Designer** Fiona Curran
Typography Fiona Curran **Illustrator** Jo Ratcliffe **Studio/Design Firm** Williams Murray
Hamm **Client** Glenmorangie **Country** United Kingdom

Fallen is a vodka brand created by Virgin in partnership with Glenmorangie. True to Virgin values,
the brand offers an alternative and edgy perspective in an over-populated product sector. Fallen
offers the savvy drinker an antidote to mainstream vodka brands that typically concentrate on
crafting and product purity—it ironically celebrates impurity and imperfection. This idea is captured
in the strapline: "there's more soul in imperfection." Available in three variants, "Outlaw," "Hero,"
and "Innocent," each pack tells an engaging story that explains the imperfect theme. To support
the idea, the labels are a series of loose illustrations and spontaneous markings that evoke the
individual character of the variant.

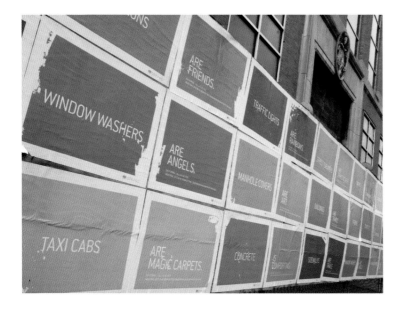

MERIT Environment
60 Spring Construction Signage

Art Director Beverly Bethge **Designer** Dan McMahon
Other Beverly Bethge, Mark Hillman **Studio/Design
Firm** Method **Client** Cityspace **Country** United States

Sixty Spring offers high-end industrial lofts to rent or
own in downtown Columbus, Ohio. We defined the likely
resident of such a home as an urban romantic. These
are people who get a little weirded out by suburbs
and picket fences and cul-de-sacs. The creative was
designed to be a celebration of all things city. We wanted
it to have a gritty feel, yet exude a sense of beauty, pride,
and wonder. We chose a newsprint paper stock to give
the materials a temporary, disposable quality. Some
of our postings have actually been covered with graffiti,
which kind of adds to the idea. Ninety-five percent of
the market will look at this signage and not get it. Five
percent will, and that's who we want.

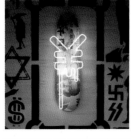
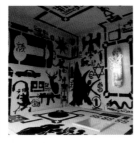
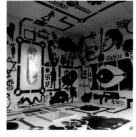

340

MERIT Gallery, Museum Exhibit | Installation, Series
Installation of Tokyo Designers Week 2004: Street Zen 1, 2, 3

Art Director Kei Saito **Designer** Kei Saito **Other** Masato Okamura **Photographer** Koichi Moriya **Studio/Design Firm** Buddha Productions **Client** Tokyo Electric Power Company **Country** Japan

The theme of this work, which was suggested by my client, is "light." I interpret "light " as "God," and the current god is "money" (the currency in Japan is the Yen). The reason I think this way is because "money" is the center of capitalism. I used a stencil technique to express "chaos" in a space similar to traditional Japanese tea housing, and put the neon of "Yen" in the middle of the space.

MERIT Gallery, Museum Exhibit | Installation
The Voting Booth Project

Art Director Michael Bierut **Designer** Jena Sher **Photographer** Michael Moran **Studio/Design Firm** Pentagram **Client** Parsons School of Design, Chee Pearlman (Curator) **Country** United States

The Parsons School of Design invited forty-seven designers, architects, and artists to respond to the infamous Votomatic punch-card voting machine from the 2000 presidential election. Participants included David Rockwell, Milton Glaser, Christo, Chip Kidd, and Frank Gehry, among others. Pentagram was a participant in the project, contributing two booths and working with guest curator Chee Pearlman on the design of the exhibition, catalogue, and supporting materials. A single all-too-apropos sentence from a Constitutional law text book ("The right to vote necessarily includes the right to be free of restrictions that deny the franchise or render its exercise so difficult or inconvenient as to amount to the denial of the right to vote") was written large in black letters on the gallery walls. Each letter "O" was filled in to suggest the perforations left by a successfully punched chad. That implied perforation, which tied together the graphic materials for the entire project, was made explicit on the catalog cover, where the holes were literally die-cut.

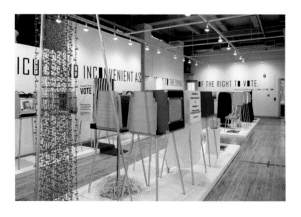

MERIT TV Identities, Openings, Teasers
Fosters Home

Art Director Kevin Fitzerald **Creative Directors** Mateus
de Paula Santos, Pete Johnson **Designers** Rafael
Grampá, Paula Nobre, Guilherme Marcondes **Sound
Design** Paulo Beto **Writer** Kevin Fitzerald **Director of
Production** Ashley Nixon **Studio/Design Firm** Lobo
Client Cartoon Network **Country** Brazil

Cartoon Network commissioned Lobo to make the opening for the new cartoon from the creator of the Power
Puff Girls, Craig McCracken. The "Fosters's Home For Imaginary Friends" opening features the characters
from the show in unusual and fun situations, recorded on a camera trip through the house. A detailed texture
work gives the visuals a realistic touch. The movie shows first the front door of a house, with dark colors, and
a somber atmosphere added with cinematographic effect. The home inside is completely different, however;
the door opens and everything is very colorful. As in the cartoon, there is lots of movement.

MERIT Animation **Diesel Dreams**

Art Director Karen Heuter **Creative Director** Mateus de Paula Santos
Copywriter Dave Bell **Designers** Cadu Macedo, Rafael Grampá, Paula
Nobre, Guilherme Marcondes, Diogo Kalil, Carlos Bêla, Mario Sader,
Rogério Marmo, Will Broadbent, Luís Blumenfeld **Sound Design**
Paulo Beto **Producers** Loic Lima Dubois, Joao Tenorio **Studio/Design
Firm** Lobo **Client** Diesel, KesselsKramer **Country** Brazil

Hanging out after work, three of Lobo's artists started a collective drawing
activity. On a single piece of paper they let their minds wander, getting
inspiration from one another's drawings and creating a continuous flow of
hand-drawn graphics. They named this collective free-association session
"Josh," after their own subconscious reasons. The odd figure combinations
this technique creates resemble hypnagogic images from the intermediate
consciousness of some periods of sleep. Hence, they fit perfectly the concept
of the Diesel Dreams project, which was all about the dreaming experience.

MERIT Title Design, Series
VH1 Hip-Hop Honors: Open, Bump, Lower Third

Creative Directors Phil Delbourgo, Limore Shur **Designers** Julian
Bevan, Carl Mok, Brian Sensebe, Ghazia Jalal **Animator** Pete List
Illustrator Julian Bevan **Studio/Design Firm** Eyeball NYC **Client**
VH1 **Country** United States

The campaign highlights the vision early hip-hop pioneers had in
creating a movement. The design takes its inspiration from early hip-
hop fliers and graffiti black books.

343

MERIT Animation **Big Kahuna Summer**

Creative Director Amanda Havey **Designer** Todd St. John **Illustrator** Todd St. John **Studio/Design Firm** Hunter Gatherer **Client** VH1 **Country** United States

The campaign highlights the vision early hip-hop pioneers had in creating a movement. The design takes its inspiration from early hip-hop fliers and graffiti black books.

MERIT Animated Logo **MTVU: Hairy Tattoo**

Designer David McElwaine **Creative Directors for
MTV** Romy Mann, Jeffrey Keyton **Art Director for MTV**
Rodger Belknap **Animator** Alex Arce **Logo Design**
Thomas Berger **Studio/Design Firm** Mr. McElwaine
Client MTV **Country** United States

Hairy Tattoo was one of series of IDs launching MTV's
college channel, mtvU. We attempted to capture the energy
of the original MTV logo animations using contemporary
software.

INTERACTIVE

GOLD Product | Service Promotion **MINI CRM**

Art Directors Paulette Bluhm, Danielle Krysa **Creative Director**
Steve Mykolyn **Designers** Andrew Harris, James Porter, Graham
Barton **Writer** Jason McCann **Sound** Simon Edwards **Producer**
Andrea Schumeth **Programmer** pixelpusher.ca **Agency** TAXI **Client**
MINI Canada **Country** Canada

(see related work on page 350)

MINI Canada had compiled a substantial e-mail list of interested consumers from auto shows and other venues.
MINI wanted to use a series of four e-mails to gather important information and whittle this database down into
a highly qualified list of leads to pass on to their retailers. The big challenge was to do all of this without boring
people to tears. We had to get info we needed while still finding a way to reinforce the fun, mischievous MINI brand.
We did it by combining music, narration, and quirky animation to guide users through the entire experience. We
ended up with a cohesive campaign that was both entertaining and informative. And by maintaining a uniform visual
style and the same narrator, we developed a strong relationship with users, which translated into very few "opt-
outs" throughout the program.

« RETURN TO MENU

« RETURN TO MENU

« RETURN TO MENU

« RETURN TO MENU

« RETURN TO MENU

MEET THE BLACK SHEEP...

« RETURN TO MENU

GOLD Minisite **MINI Black Sheep**

Art Director Paulette Bluhm **Creative Director** Steve Mykolyn **Designers** Andrew Harris, James Porter, Graham Barton **Writer** Jason McCann **Sound** Simon Edwards **Producer** Andrea Schumeth **Programmer** pixelpusher.ca **Agency** TAXI **Client** MINI Canada **Country** Canada

(see related work on page 348)

MINI Canada wanted to introduce car buyers to all five of their models. We had to convey some basic vehicle information like pricing, horsepower, etc., while reinforcing the MINI's mischievous brand identity. We decided to think of the MINI fleet as a family—a very atypical family, because each car has the personality of a sh*t disturber, an outcast who refuses to conform. Essentially, we were telling the story of a whole family of black sheep, which syncs up perfectly with the fierce individualism of our target driver. We created a flash piece, with five small animations based on the personality of each car. For example, the MINI Cooper Classic was compared to a second cousin who went to Europe to find himself in a classic story of rebellion, while the Cooper S Convertible was described as a hard-living, freewheeling lover of extreme sports.

351

SILVER Product | Service Promotion **Emerald Nuts Site**

Art Directors Yo Umeda, Tanner Shea **Creative Directors** Keith Anderson,
Jon Soto **Copywriters** Peter Albores, Jody Horn **Account Executive** Tanin
Blumberg **Producer** Victoria Brown **Production Company** WDDG **Agency**
Goodby, Silverstein & Partners **Client** Emerald Nuts **Country** United States

(see related work on page 132)

We set out to introduce Emerald to the world as a totally new kind of snack
company. The development of the site was an integral part of creating this
brand personality and introducing the brand to our audience. The objective was
to establish Emerald's unique brand personality online and to give people an
opportunity to "play" with the brand in a way that TV does not allow. It was also
used to help spread the word of Emerald Nuts through the trade industry.

SILVER Self-Promotion **Dentsu Design Tank**

Art Director Hirozumi Takakusaki **Copywriter** Shoichi
Tamura **Designer** Yusuke Kitani **Producer** Masayoshi
Boku **Production Company** Bascule Inc. **Programmers**
Hiroki Nakamura, Marcos Weskamp, Tetsuya Hoshi
Agency Dentsu, Inc. **Client** Dentsu, Inc. **Country** Japan

Dentsu Design Tank is a designer group of advertising art directors
who don't have an actual office. This site was designed to support
their activity with new ideas and concepts. The purpose of the web
page was to create a virtual office (a hot topic in the mass media)
where members can freely log in and get together to exchange
information and ideas. This office is not only an office, but a distinc-
tive space characterized by a creativity unique to network offices.
This, the first advertising campaign for the visual office, gained
Dentsu many clients and solidified the reputation of its designers. It
is a very important part of Dentsu and its branding.

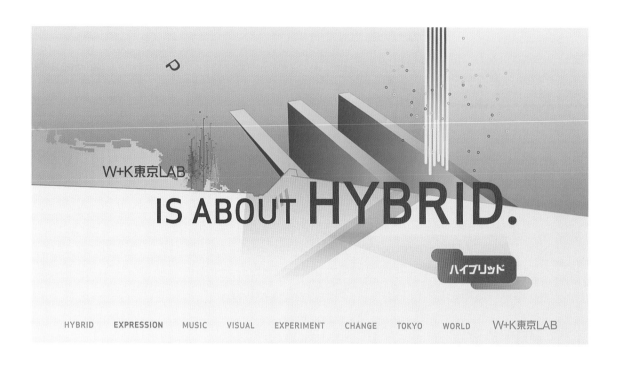

SILVER Self-Promotion **W+K Tokyo Lab**

Art Director +CRUZ **Creative Directors** John C. Jay, Sumiko Sato **Designers** +CRUZ, WOOG, Shane Lester, Shinsuke Koshio (Sunday Vision) **Sound Design** Sun An **A+R Director** Bruce D. Ikeda **Executive Producer** Arto Hampartsoumian **Director** +CRUZ **Editor** Shane Lester **Producer** +CRUZ **Production Company** Wieden+Kennedy Tokyo LAB **Programmers** Shane Lester, Shojee Kukuchi (SV), Pedro Leon (Amauta) **Agency** Wieden+Kennedy Tokyo **Client** Wieden+Kennedy Tokyo Lab **Country** Japan

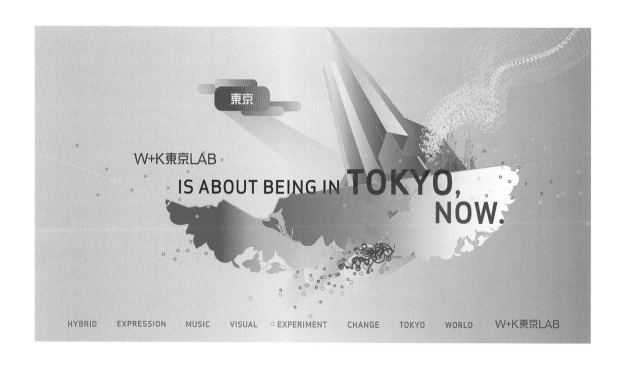

W+K Tokyo Lab is about hybridity and being in Tokyo now.
W+K Tokyo Lab creates new experiences only possible in
Tokyo through a unique global mix of music, visuals, and other
forms of creative expression. Inspired by the creative energy
of the city—its culture, architecture, people, sounds, and
colors—the website is an abstraction of Tokyo, capturing the
dynamism, energy, and diversity that are the essence of its
creative force. With this energy, W+K Tokyo Lab continues to
develop new ideas and connect to new audiences.

DISTINCTIVE MERIT Product | Service Promotion
Toshiba Presents FM Festival 2004

Art Directors Yugo Nakamura, Aco Suzuki **Creative Director**
Aco Suzuki **Designers** Yugo Nakamura, Hisayuki Takagi, Hiroshi
Koike, Atsushi Fujimaki **Producers** Ryohei Mitsuhashi, Koichiro
Tanaka, Masakatsu Kasai **Production Company** Tohokushinsha
Film Corporation **Photographer** Aco Suzuki **Programmers** Yugo
Nakamura, Keita Kitamura, Hisayuki Takagi, Akane Tsuchiya
Agency Dentsu, Inc. **Studio/Design Firm** tha Ltd. **Clients** Tokyo
FM Broadcasting Co., Ltd., Toshiba Corporation **Country** Japan

To make a webpage for the radio program that broadcasts film
festivals for independent musicians in Japan, we did a lot of
inventive design. For example, we made a map of Japan full of artist
thumbnails. When you click on one, you get detailed information on
the artists and can listen to their music, which continues playing after
leaving their profile page.

DISTINCTIVE MERIT Product | Service Promotion **The Grudge**

Art Director James Widegren **Creative Director** Michael Lebowitz **Designer** Dexter Cruz **Producer** Karen Dahlstrom **Programmer** Joshua Hirsch **Studio/Design Firm** Big Spaceship **Client** Columbia Pictures/Sony Pictures Digital **Country** United States

The Grudge site was created to promote the Columbia Pictures film. The site is an environmental experience, guiding the visitor through the house, which is the most important character in the film. Video transitions and effects were used to create a sense of tension in the house environment. In the film, anyone who enters the house is haunted by a vengeful spirit. To reflect this aspect of the film, the site tracks the user (from a name entry) through the site experience and beyond, to personalized banner advertisements placed on partner sites.

DISTINCTIVE MERIT Product | Service Promotion, Campaign
The Man Without Feelings: areyoubadenough.com

Art Director Björn Rühmann **Creative Director** Ingo Fritz **Copywriter**
Björn Rühmann **Designers** Dominik Anweiler, Mark Höfler, Björn
Rühmann **Programmer** Marcel Berkmann **Agency** Nordpol + Hamburg
Client Riccardo Cartillone Schuheinzelhandels GmbH **Country** Germany

(see related work on page 141)

The source of the website, for footwear brand Riccardo Cartillone, blends
almost into the background as a viral concept, and only draws attention to its
own products with occasional breaks for advertising.

DISTINCTIVE MERIT Public Service | Non-Profit | Educational **Tick-tock**

Art Director Steve Mitchell **Creative Directors** Doug Adkins, Steve Mitchell **Designer** Aesthetic Apparatus **Producer** Eric Schafer **Production Company** Images Designed **Programmer** Aaron Cooper **Agency** Hunt Adkins **Studio/Design Firm** Images Designed **Clients** American Cancer Society/ BlueCross BlueShield **Country** United States

By using satire and respecting the intelligence of our audience, we were able to get students to take a long, hard look at themselves and their smoking behavior.

DISTINCTIVE MERIT Public Service | Non-Profit | Educational
UNESCO World Terakoya Movement: Kururinpa

Art Director Hirozumi Takakusaki **Creative Director** Tetsu Goto **Copywriter** Fumihiko
Sagawa **Designer** Yusuke Kitani **Producer** Takako Matsushiro **Production Company**
Maxmouse, Inc. **Programmer** Hiroki Nakamura **Agency** Dentsu, Inc. **Client** National
Federation of UNESCO Associations in JAPAN **Country** Japan

This work was designed to advertise UNESCO's project of reducing the number of poor
people by improving their literacy rate. Our goal was to receive wide publicity, mainly in
Japan, and seek cooperation on the project. It is hard to imagine that there are illiterate
people in Japan, a country that boasts an almost 100 percent literacy rate. It was very
important to give Japanese people a chance to understand the difficulties of writing and
reading. We were successful in gaining public acceptance from people who visited to our
web page, which is now widely used as an interactive tool at various expos and exhibitions.

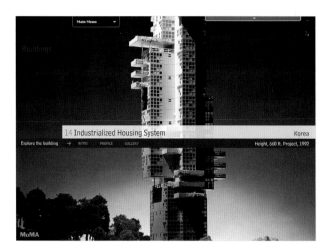

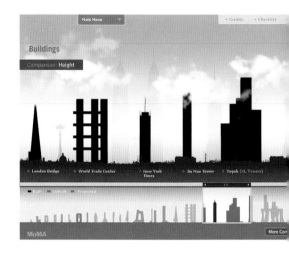

DISTINCTIVE MERIT Public Service | Non-Profit | Educational
MoMA, Tall Buildings

Art Director Anh Tuan Pham **Creative Director** Anh Tuan Pham
Designers Anh Tuan Pham, Chris Lasch, Jodie Gatlin **Producer**
Shannon Darrough **Production Company Programmers** Anh
Tuan Pham, Chris Lasch, Kimba Granlund **Agency** For Office Use
Only **Studio/Design Firm** For Office Use Only **Client** The Museum
of Modern Art **Country** United States

The launch of the MoMA, Tall Buildings website coincided with the
exhibition held at MoMA QNS in the summer of 2004. The exhibit
presented twenty-five skyscrapers from around the world designed
within the last decade. These buildings redefine the genre for the
twenty-first century. The Tall Buildings website focused on providing
a comparative analysis of the exhibition buildings in relation to one
another and within the larger social, cultural, and technological
contexts in which they were designed. The website complemented
the physical exhibition and exhibition catalogue while capitalizing on
the visual and technical capabilities of interactive media to provide a
unique way of experiencing the work—whether in conjunction with
the musuem experience or independent of it.

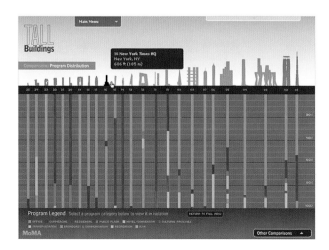

DANIEL 4 YEARS OLD

4 10 20 45 75
AGE

DANIEL 12 YEARS OLD

4 10 20 45 75
AGE

DANIEL 22 YEARS OLD

4 10 20 45 75
AGE

DANIEL 47 YEARS OLD

4 10 20 45 75
AGE

DANIEL 70 YEARS OLD

4 10 20 45 75
AGE

The length
of my life
is up to you.

Did you get it?

GRAACC Group of Support
to Adolescents and
Children with cancer

To donate or volunteer, click here.

DISTINCTIVE MERIT Public Service | Non-Profit | Educational **Morph**

Copywriter Miguel Genovese **Agency** Ogilvy Brazil **Country** Brazil

Scenario: GRAACC is a non-governmental organization that gives support to children and teenagers who have cancer. This organization has been having great difficulty in keeping up its activities, and needed to increase its number of donors and volunteers. Our creative solution: we created a viral on-line campaign through a superstitial of emotional appeals that was sent to all current donors and volunteers of the institution, asking them to forward it on to their friends. This is where a great online solidarity chain began, with friends sending the piece to friends.

DISTINCTIVE MERIT Minisite **Chrismahanukwanzakah Microsite**

Art Directors Paul Bichler, Wayne Best, Marcus Woolcott **Creative Directors** Paul Bichler, Wayne Best **Executive Creative Directors** Ari Merkin, Kevin Flatt **Copywriter** Adam Alshin **Designer** Paul Bichler **Account Executive** Kim Schultz **Music Composer** Ween **Site Operations** Mark Hines **Producer** Michelle Domeyer **Illustrators** Fiona Hewitt, David Annis **Programmers** Dan Boen, Jason Streigal **Agency** Fallon **Client** Virgin Mobile USA **Country** United States

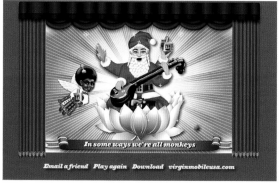

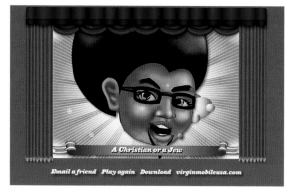

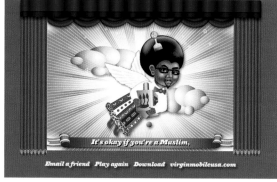

Virgin Mobile, a pay-as-you-go wireless phone provider, is a youth brand in the incredibly competitive wireless category, which spends some $2 billion annually on advertising. The holiday promotion assignment came at a critical time in Virgin Mobile's year. Faced with a sea of hard-selling offers from competitors, the two-year-old upstart needed to significantly increase its number of subscribers. Fortunately, Virgin Mobile's all-inclusiveness made it a perfect, no-strings-attached gift. A new creative campaign brought this idea to life with the invention of a new, all-inclusive holiday "Chrismahanukwanzakah." The campaign included three TV spots, an online viral e-card, and a free ringtone of the campaign song performed by the band Ween. In addition to meeting impressive sales goals, Chrismahanukwanzakah became a viral hit, with 336,000 page views of the e-card and 285,000 ring tone downloads.

Happy Holidays

DISTINCTIVE MERIT Minisite **HP Festive Holiday Card**

Creative Directors Steve Simpson, Keith Anderson **Associate Creative Director** Will McGinness **Writer** Peter Albores **Account Executive** Megan Reinhardt **Producer** Mike Geiger **Production Company** unit9.creative.production **Agency** Goodby, Silverstein & Partners **Client** Hewlett-Packard Inc. **Country** United States

The holiday card was created for executives to send partners and clients. Its objective was to deliver holiday messages of peace, love, and a happy new year in an innovative and entertaining manner.

Schöne Ferien

良いご休暇をお過ごしください

¡Felices Fiestas!

DISTINCTIVE MERIT Web Application
Germanwings Dynamic Screensaver

Art Director Bejadin Selimi **Creative Director** Olaf Czeschner **Designers**
Melanie Lenz, André Bourguignon **Programmer** Heiko Schweickhardt
Agency Neue Digitale GmbH **Client** Ruediger Peters **Country** Germany

The Germanwings realtime screensaver keeps the user
in touch with the brand Germanwings—even when not
online—and inspires the purchase of tickets. The web
tool shows a map of Europe with Germanwings aircraft
flying over it in real time and illustrates the positions
of all Germanwings aircraft. Offers such as the "Crazy
Night" can be announced on short notice. An online
connection guarantees current information updates,
and a link from the destination to relevant offers and
the online booking facility generates sales. Updates
are requested by the active screensaver via an online
connection. New data is automatically requested and
saved. Text data can be saved locally on the user's
computer so that it can also be viewed offline.

DISTINCTIVE MERIT Web Application **MusicLens**

Art Director Mario Jilka **Designer** Mario Jilka **Editor** Claus Zimmermann **Producers**
Markus Schwarze, Chris Kurt **Production Company** DDD System GmbH **Programmer**
Claus Zimmermann **Agency** DDD System GmbH **Client** Musicline **Country** Germany

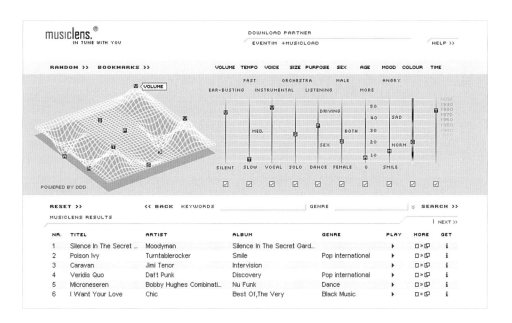

Without the benefit of a tool such as MusicLens, music lovers are having a harder and harder time trying to find what they need among the increasingly extensive repertoires offered by music download shops. When you only have a general idea of what you're looking for, the MediaLens search technology (MusicLens is based on MediaLens technology) meets the search requirements by using clever abstractions and an intelligent interface. Users are given recommendations that genuinely match their search intentions. Using the slide control navigation (similar to the mixing panel in hi-fi systems), users can perfectly describe the kind of music they like. The program suggests not only well-known song titles, but also pieces of which the respective user may have been previously unaware. MusicLens makes it possible for users to broaden their personal musical repertoire, and international recognition is confirming that we are on the right path.

782

◆ Click.

$78\frac{3}{2}$

783 clicks.

See? We know how to get results.

OgilvyInteractive. Click to check our cases. ◆

DISTINCTIVE MERIT Self-Promotion **Results**

Copywriter Miguel Genovese **Agency** Ogilvy Brazil **Country** Brazil

We created this banner to attract prospects and clients to OgilvyInteractive's new website, where they could check successful cases and understand more about the 360-degree concept. The brief? Show that OgilvyInteractive is results-oriented with solid communication skills to help clients achieve their business goals. Why can we claim this? We know how the internet works better than anyone.

DISTINCTIVE MERIT Hybrid | Art | Experimental **Aiwaworld**

Art Directors +CRUZ, David Lai, Jose Caballer, Jack Peng **Creative Directors** Tony Davidson, Kim Papworth, John C. Jay, Sumiko Sato **Designers** Hiro Niwa, Christel Leung, Guy Featherstone, Yiing Fan, Sun An, Paul Hwang, Kellis Landrum, Rudy Manning, Joshua Trees, Grace Chia, Freda Lau, Earl Burnley, Saadi Howell, Ogo Kunio, Aldo Pucion, Sophie Hayes, Nicholla Longley, Michael Russoff, Lem Jay Ignacio, Chaz Windus, Jorge Verdin **Other** Mumbleboy, Tokyoplastic **Editors** Sean Thompson, Joshua Homnick **Producers** Sam Brookes, Arto Hampartsoumian, Ash Makkar, James Guy, Kenshi Arai, Hisaki Kato, Kenji Tanaka, Charlie Tinson, Tony Wong, Frank Mele, Sharon Tani, Szu Ann Chen **Production Companies** Hello Design, Oceanmonsters, THE_GROOP **Programmers** Carlos Battilana, Eric Campdoras, Aureliano Gimon, Pedro Leon, Dan Phiffer, Arnaud Icard, Roger Obando, Eduardo Polidor, Will Amato, Scott Lowe, Martin Cho, Damon O' Keefe **Agency** Wieden+Kennedy London and Tokyo **Studio/ Design Firm** Hello Design **Client** Aiwa, Inc. **Country** United States

Aiwa is an electronics brand centered around audiovisual products for the youth market. In lieu of traditional media, Aiwa wanted to create an online community that inspired creativity in music and visuals thru aiwaworld, an online youth network that delivers audio visual experiences. A surreal, topsy turvy world consisting of "aiwamals" and "instrumals," aiwaworld is a televisual web station that youth culture will want to visit again and again because of its fresh, dynamic content and programs, which are based on Aiwa brand values of simplicity, fun, and madness. The site is based on the theme of "hybrid music," which explores unexpected musical fusions such as Punk/Hawaiian, Folk/ Hip-hop, and Techno/Latino. The site features global content creators, who express their audiographic creativity through technology such as Mumbleboy and Tokyoplastic.

371

DISTINCTIVE MERIT Banners **Convenient Life**

Art Director Kaori Mochizuki **Creative Director** Takeshi Mizukawa
Designer Kaori Mochizuki **Account Executive** Yuichi Arai **Producers**
Katsuhiko Iwasaki, Tomohiro Arakawa **Production Company** Dentsu,
Inc. **Programmer** Hiroki Nakamura **Agency** Dentsu, Inc. **Client**
Sankyo Co., Ltd. **Country** Japan

Now is the era of technology, and our fast lives are becoming more and
more extreme. Can technology benefit daily life? Sankyo's main products
are medicines for those with diseases such as diabetes, myocardial
infarction, and high blood pressure. Too much fat, lack of sleep, lack of
exercise, and stress cause these diseases.

Art Director Will McGinness **Creative Director** Keith Anderson
Associate Creative Director Will McGinness **Account Executive**
Daisy Uffelman **Writer** Aaron Griffiths **Producer** Kenan Gregory
Production Company North Kingdom **Agency** Goodby, Silverstein
& Partners **Client** Saturn **Country** United States

 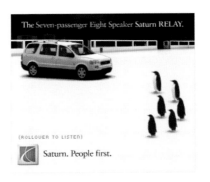

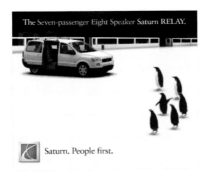 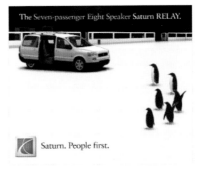

Take a seven passenger van, penguins in a hockey rink, and a
rock anthem, and what have you got? Instant banner. The banner
highlighted the sweepstakes that Saturn was having to give away a
Relay. Clicking on the banner drove you to the Relay mini site, where
you could enter the sweepstakes.

MERIT Product | Service Promotion **Smart USA**

Art Director Oliver Hering **Creative Director** Rob Nikowitsch **Designers** Georg Streibl, Oliver Kochs
Editor Markus Nikowitsch **Producers** Anita Ragette, Robert Schlittenbauer **Production Company** h2o
media AG **Programmers** Bernd Leinfelder, Rich Gabler, Kriz Eideloth **Agency** h2o media AG **Clients**
Julia Knittel, Scott Keogh (smartUSA) **Country** Germany

 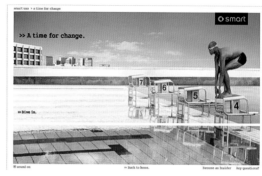

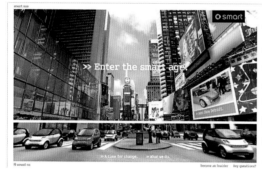 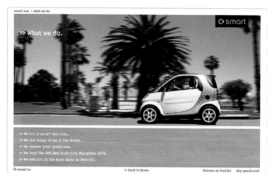

Before the actual market launch of smart vehicles in the U.S., h2omedia was asked to design and produce an internet brand campaign that would introduce the smart brand to the American public. The site was to be "typically smart," i.e., to convey smart's core brand values of innovation, functionality, and joy of life. The resulting online campaign, "enter the smart age," centers around the website www.smartusa.com. There, users can experience what the smart world will feel like, and learn why a time for change has arrived. To conjure up the true "smart feeling," video, animation, image, text, and audio are interlaced. The website's intuitive interface is just as simple and natural as a smart car itself. We are delighted that, given the challenges, we were able to produce such an award-winning site, and greatly appreciate the recognition!

MERIT Product | Service Promotion **Muzak.com**

Art Director Brian Jacobs **Designers** Brian Jacobs,
Douglas McDonald, Rob Duncan, Charles Mastin
Writer Nancy Murr **Photographers** Jeff Corwin,
Jock McDonald, Barry Robinson **Studio/Design
Firm** Pentagram Design **Country** United States

Muzak is a seventy-year-old company with an enormous amount of demographic research, innovation, and design under its belt—and a music collection that is awfully big.

MERIT Product | Service Promotion **Vodafone Design File**

Art Director Katsuhiko Sano **Creative Director** Katsuhiko Sano **Copywriters** Shunichi Oohigashi, Atsushi Tanaka **Designer** Katsuhiko Sano **Account Executive** Masatomo Shiozaki **Producers** Norihiko Takahiro, Shinya Tsukioka **Production Company** Hakuhodo I-Studio Inc. **Programmer** Takeshiro Umetsu **Agency** Hakuhodo I-Studio **Photographer** Ken Matsumura **Sound Design** Takashi Morio **Client** Vodafone k.k. **Country** Japan

"Vodafone Design File" introduces Vodafone's product service and function through a cutting-edge interface in order to present Vodafone's vision of a new style of mobile phone. "Vodafone Design File" creates a distinctive environment by making graphical elements fill the entire screen, along with original sound design and unique interaction. These dynamic elements express a conceptual vision of new Vodafone products.

MERIT Product | Service Promotion
Schmidt & Bender

Art Director Stefan Walz **Creative Director** Achim Jäger **Designer** Stefan Walz **Other** Dorothea Feurer, Brigitte Dingler, Silke Dillmann **Programmer** Oliver Hook **Agency** Jung von Matt AG **Client** Schmidt und Bender GmbH Co. KG **Country** Germany

Schmidt&Bender is a family-owned manufacturer of telescopic sights for hunters and shooters. The quality of the products meets highest demands for precision and durability. Various fixed and moving objects on the website allow one to literally "hunt" down information about the company, its products, and the quality standards of the manufacturer.

MERIT Product | Service Promotion **Starsky & Hutch**

Art Director Richard Foster **Creative Directors** Daniel Federman, Michael Lebowitz
Copywriter Karen Dahlstrom **Designers** Frank Campanella, Dexter Cruz, Christian
Johansson **Sound Design** D. Garrett Nantz **Producer** Karen Dahlstrom **Programmers**
Joshua Hirsch, Christian Stadler, Michael Trezza **Studio/Design Firm** Big Spaceship
Client Warner Brothers **Country** United States

The Starsky and Hutch website was created to promote the
Warner Bros. film, starring Ben Stiller and Owen Wilson. The site
design is heavily influenced by '70s pop culture and iconography.
As in the film, the site parodies the era and the cop show genre.
The site navigation uses typical cop-show phrases such as "The
Goods" and "The Lowdown." In "The Goods" section, users can
find games and downloads that are influenced by '70s fads such
as pinball and T-shirt iron-ons.

MERIT Public Service | Non-Profit | Educational **Website Rijksmuseum Amsterdam**

Art Director Jeroen van Erp **Creative Director** Jeroen van Erp **Designers** Marcel de Jong,
Matthijs Kamstra, Isis Spuibroek, Wim Wepster, Sander Rosenbrand **Technical Director**
Paul Stork **Editor** Peter Gorgels **Producer** Matthijs Klinkert **Production Companies** Fabrique
Design, Q42 **Programmers** Rick Companje, Pim Rijpsma, Kars Veling (Q42) **Agency** Fabrique
Studio/Design Firm Fabrique Design **Client** Rijksmuseum Amsterdam **Country** Netherlands

A sizeable portion of the Rijksmuseum's collection cannot be exhibited, which makes the website
a perfect place for the collection to be broadly accessed. In order to achieve this ambition, the
website has been fully renewed in terms of design, content, and technical infrastructure. The
defining feature is the use of full-screen illustrations of artworks in the collection, which serve as
navigation tools. Another innovation is the creation of interactive presentations for the museum's
exhibitions, including online exhibitions, multimedia stories, timelines, magnifying buttons, and
quizzes. The website offers an integrated range of information. Users need only a single command
to simultaneously search the website, the museum's collection, the web shop, and the library
catalogue. Moreover, the web version of the Rijksmuseum's internal Collection Management System
includes nearly half a million objects. So far, 50,000 objects have been made accessible, and more
than 10,000 are accompanied by an illustration.

Art Director Stefan Walz **Creative Director**
Achim Jäger **Designers** Stefan Walz, Fabian
Bürgy **Other** Oliver Flohrs, Dorothea Feurer,
Brigitte Dingler **Production Company** Jung von
Matt AG **Programmer** Stefanie Welker **Agency**
Jung von Matt AG **Client** Neckar Valley Green
Space Foundation **Country** Germany

The Neckar is a river that flows through one of the most successful economic areas in the world. The "Stiftung Gruenzug
Neckartal" (Neckar Valley Green Space Foundation) has developed sixty projects to bring the Neckar region back to life
and create leisure space for 1.6 million people. To bring the Neckar back, we developed a website that gives people the
opportunity to create, and therefore visualize, their own ideas of the river's future potential.

MERIT Minisite **Silence is Golden**

Art Directors Brian Williams (BBA), Jarrod Riddle (space150) **Creative
Directors** Joe Michaelson (BBA), Billy Jurewicz (space150) **Copywriter**
Tom Lord (BBA) **Designer** Jarrod Riddle (space150) **Directors** Mike
Nelesen (BBA), Riley Kane (space150) **Producers** Lisa Thotland (BBA),
Mark Bennett (BBA), Rebecca Longawa (space150) **Programmer** Marc
Jensen (space150) **Agency** space150 **Studio/Design Firm** space150
Client Best Buy **Country** United States

This sitelet helped catapult Best Buy's in-theater advertising by extending
the humor of the retailer's imaginary movie trailer. With an interactive game,
video clips, and downloadable ringtones, we created a media-rich website
that attracted more than 2.7 million visitors in only three months. Interest
generated through viral marketing and on-screen advertisements made
www.pumpupthemovie.com a huge success.

MERIT Web Application **IntroNetwork System for Max2004**

Creative Director Mark Sylvester **Producer** Kymberlee Weil **Production Company** IntroNetworks, Inc. **Programmers** Grant Skinner (gskinner.com), Phil Chung, Ben Allfree (IntroNetworks, Inc.) **Agency** IntroNetworks, Inc. **Studio/Design Firm** ioResearch **Client** Macromedia **Country** United States

The introNetwork System for Macromedias' MAX2004 Developer Conference is an online gated community used to build relationships between attendees. This rich internet application is built on the Macromedia Flash MX platform. It utilizes a patent-pending method for building an individual profile, turning it into an interesting exercise rather than a tedious chore. Once a profile is completed, the introNetwork Connection Engine matches the user's profile to the entire Community and visually recommends the top 500 attendees that the user might want to contact. The system includes introMailer, a spam-free way of communicating that uses both text and webcam video to create short messages of introduction. Each introNetwork system is customized to reflect the branding of the event, association, or corporation for which it is created. Each of the 120 keywords that are used to describe an individual are selected for their ability to best match the target audience.

MERIT Self-Promotion **RGA Holiday Card**

Creative Director Kris Kiger **Designers** Gui Borchert, Piper Darley, Ernest Rowe, John James, Justin Van Slembrouck **Other** Matt Walsh, Todd Brown **Producer** Emma Johns **Production Company** R/GA **Programmers** Ted Warner, Michael Black, John Jones **Agency** R/GA **Client** R/GA **Country** United States

In keeping with the yuletide feeling of community and sharing, this year's e-card theme encouraged recipients to create and share their own holiday expressions. Staff, colleagues, clients, agency partners, and press were invited to design sculptures based on the red square of the R/GA logo. The intuitive e-card also contained viral functionality: users could email it to friends and post their work of art online at Rga.com, where a gallery of sculptures was displayed. The card received industry praise from MediaPost and CommArt's DesignInteract, which chose our greeting as one of seven featured e-cards in its first unofficial holiday e-card annual.

MERIT Self-Promotion **Homepage Strobelgasse**

Art Director Tomek Luczynski **Creative Director** Tomek Luczynski
Designer Christoph Dertschei **Producer** Ben Knapp **Programmer**
Christoph Dertschei **Agency** Strobelgasse Werbegesellschaft M.B.H.
Client Strobelgasse Werbegesellschaft mbH **Country** Austria

Our main objective was to present our agency, team, and work and to
communicate our business philosophy online. But self-promotion for
an advertising agency is a challenging thing to do: expectations and
competition are high. Therefore, we wanted to create an extraordinary
site: simple, informative, and clear, but still entertaining.

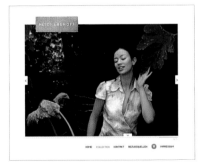

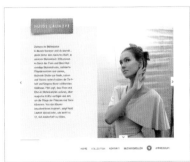

MERIT Self-Promotion **Website Huidi Lauhoff**

379

Creative Director Heike Brockmann **Designer**
Ulrich Pohl **Project Managers** Boris Lakowski,
Henric Uherek **Copyeditor** Patrizia Ribaudo
Production Company Scholz & Volkmer **Flash
Programmer** Oliver Hinrichs **Studio/Design
Firm** Scholz & Volkmer **Client** Huidi Lauhoff
Modedesign **Country** Germany

A website presenting the new autumn/winter
women's collection by the Wiesbaden–based
fashion designer Huidi Lauhoff is reduced and
focused. Each individual garment can be viewed
being worn by a model or observed from all angles
within a 360° viewer. To mark the launch of the
website, the designer has come up with something
really special: the "must-have" shirt, a clever
creation that is only available via the Internet.

MERIT Self-Promotion **Chinese New Year Greeting 2004 (Wishing Tree)**

Art Directors Chan Fai, Jeff Seto, Lam Man Kit **Creative Directors** Adams Chow, Norman Ying **Editor** Wendy Wo **Programmers** Chan Fai, Alex Cheng **Studio/Design Firm** Euro RSCG Partnership HK, Ltd. **Client** Euro RSCG Partnership HK, Ltd. **Country** Hong Kong

The objective was to encourage people to make a wish and be part of the record at the same time. Traditionally, people at wishing trees pray for good fortune in the coming year. We created a simple graphic tree for them to interact with by following their wish step by step to see if it could replicate the wishing tree. For those who are successful, their wish remains part of the wishes left by others.

MERIT Online Magazine | Periodical **Zembla Magazine Website**

Creative Director Vince Frost **Designer** Matthew Willis **Studio/Design Firm** emeryfrost **Client** Simon Finch Rare Books **Country** Australia

(see related work on page 256)

Zembla is a literary magazine that started in London and is now designed in three studios in London, Sydney, and Melbourne. It is graphic design at full volume and completely faithful to the strapline: "fun with words." The website transforms Zembla magazine from print to online in a complementary design form. The composition of the online layout maintains the strong typographic focus that is one of the key elements of the printed magazine. The site is an ongoing adventure that adheres to the same rules as the magazine: "there are no rules." It is updated with each printed issue.

MERIT Banners, Campaign
PlayStation—Fun, Anyone?: Bird, Robogirl, Laugh

Art Director Thorsten Voigt **Creative Director** Michael Kutschinski
Editor Andrea Goebel **Agency** Ogilvy Interactive Worldwide **Client**
Jan Keller **Country** Germany

New characters conquer the Internet: Robogirl, Wobbler, Winner, and
Laughing Mouth. They make the new PlayStation claim "fun, anyone?"
come alive. Each banner ad invites the user to interact with the
characters in a way that corresponds to the specific website.

382

Bird

Minisite

Robogirl

Laugh

MERIT Banners, Campaign
SOS Online Campaign: Signs—Escalator, Men at Work, Walk

Art Director Nathan Hinz **Creative Directors** Kevin Flatt, Todd Riddle **Copywriter** Russ Stark **Designers** Nathan Hinz, Chris Stocksmith **Account Executive** Jill Spitzfaden **Production Artist** Joel Herrmann **Producer** David Annis **Illustrator** Nathan Hinz **Programmers** Chris Stocksmith, Laurie Brown, Tal Tahir, Tony Litner **Agency** Fallon **Client** The Islands Of The Bahamas Ministry Of Tourism **Country** United States

The "Escape From Everyday Life" online campaign was part of an integrated effort that launched in January 2005 and targeted an influential group we call Caribbean Experientials. These people want to do new things, and choose to spend their disposable income on travel. Considered information sources by other travelers, they can play a great role in promoting The Bahamas. The role of the campaign was to drive tourism to The Islands Of The Bahamas by establishing the destination as the escape from the everyday routine. By contrasting the monotony of people's everyday lives with the thrill of escaping to the beauty of The Bahamas, it successfully encouraged travel to The Bahamas. The campaign, called SIGNS, took common elements from everyday life (street signs) and transformed them into some of the exciting experiences available in The Bahamas. The idea of "Escape From Everyday Life" was demonstrated in a simple yet entertaining way.

MERIT Banners, Campaign Subtitles: Bird, Dog, Mouse

Copywriter Miguel Genovese Agency Ogilvy Brazil Country Brazil

 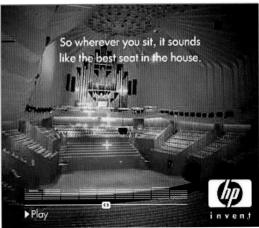

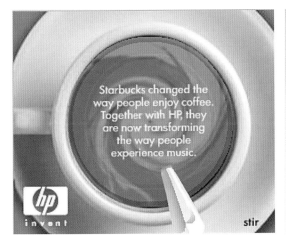 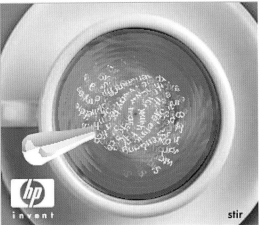

MERIT Campaign Banners **HP Brand Campaign: Sharktale Banner, Sydney Opera House, Starbucks Stir Banner**

Art Directors Yo Umeda, Sean Donahue, Jeff Benjamin **Creative Directors** Steve Simpson, Keith Anderson **Associate Creative Director** Will McGinness **Writers** Aaron Griffiths, Rick Condos, Peter Albores **Account Executives** Chad Bettor, Megan Reinhardt, Justin Young **Producer** Mike Geiger **Production Companies** Natzke Design, Barbarian Group **Agency** Goodby, Silverstein & Partners **Client** Hewlett-Packard Inc. **Country** United States

The HP Brand Banners were designed to integrate and extend the +HP campaign online. They highlight companies that HP partners with, such as Dreamworks, Starbucks, Fender, and Sydney Opera House. We figured interactive banners would intrigue people to check out the sites, and they did.

STUDENT

GOLD Book Design, Public Service | Non-Profit Book **The Senior Library**

Art Director Richard Wilde **Creative Directors** Richard Wilde, Paul Sahre
Designer Paul Sahre **Photo Editor** Paul Sahre **Photographer** Jason
Fulford **Publisher** Advertising/Graphic Design Department of the School
of Visual Arts **School** School of Visual Arts, Office of Paul Sahre **Client**
School of Visual Arts **Country** United States

This publication highlights the work of SVA's Advertising/Graphic Design
seniors of the class of 2003. Students create an extraordinary body of work, but
few are aware of the wide scope and high quality of their work. Whether the
work is conceptually driven or highly personal, the result is a kaleidoscope of
expression—a body of work that signals originality and finely demonstrates what
can be achieved when passion rules.

One idea
stayed
with me:
'good
design is
created
within
parame-
ters.'

Certainly
design has
helped my
illustration
and vice
versa.

Pb: How did you arrive at algorithm or symbols?

saw this guy in black jeans, black boots, black shirt, and he was sitting there reading Nietzsche. So I'm sitting there thinking to myself, 'This guy looks so ridiculous,' and then I think, 'Wait, I read Nietzsche (Fig.73) on the subway too.' I started to think that I didn't want people on the subway to see me reading Nietzsche

anymore. So I started wrapping all of my books in plain white paper.

This was a chance to prove to myself the power of good design.

SVA
students
are not
afraid to
express
them-
selves.

GOLD Title Design **Ratcatcher Movie Title**

Designer Ryan Corey **School** CalArts **Country** United States

The objective of this project was to create film titles conveying complex issues
and themes inherent in the film. The titles had to be both engaging and
informative at the same time and present the information in an interesting way.
Because film titles come before the film, they set the tone and can influence the
way a person views the film, so it is important that they are appropriate.

In Search of Identity

Art Director Nikolai Cornell **Creative Director** Nikolai Cornell **Designer** Nikolai Cornell **Other** Tatiana Parcero, Adriana Parcero **Editor** Nikolai Cornell **Producer** Nikolai Cornell **Programmer** Nikolai Cornell **Agency** madeinLA **Client** Nikolai Cornell **Country** United States

Nikolai Cornell completed "In Search of Identity" as part of his MFA (Media Design) thesis project, "Life-Size," at Art Center College of Design. "Life-Size" is a series of interactive media design installations that explore human-scale interaction, environmental interface, and display systems. The research, experiments, and projects that comprise "Life Size" embed media into environments and enhance both interior and exterior spaces and façades by making them respond to the motion of people moving in and through a space. "In Search of Identity" is an interactive installation that uses a human-scale display system to allow visitors to explore the photographic work of artist Tatiana Parcero on multiple levels of their own choosing. By developing a unique projection technique and by embedding a diverse range of sensors in the physical display, Nikolai Cornell created an innovative way for users to be incorporated into and interact with the artist's work.

SILVER Book Design, Limited Edition, Private Press or Special Format Book
Russian Berlin

Art Directors Eugenia Knaub, Victoria Sarapina **Instructor** Gregor Krisztian **Illustrators** Eugenia Knaub, Victoria Sarapina **Photographers** Eugenia Knaub, Victoria Sarapina **School** University of Applied Sciences Wiesbaden **Country** Germany

"Russian Berlin" presents secular relations between Russia and Germany. It provides a glimpse from the viewpoint of today of well-preserved documents and creates a real document of time. The development of Russian culture in Berlin is in the field of vision. The main purpose of the book is the promotion of dialogue between German and Russian cultures. The texts tell stories about locations in Berlin that testify to the relations between Russia and Germany. The stories of the book are told in numerous pictures, old photos, posters, and drawings. Special care was taken with the typography of German and Russian words. The book is written in German and Russian and has 172 pages with color pictures.

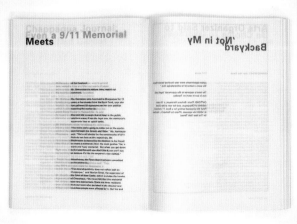

SILVER Book Design, Limited Edition, Private Press or Special Format Book
Oblivion

Art Director Beom Seok Kim **Designer** Beom Seok Kim **School** Yale University
School of Art **Country** United States

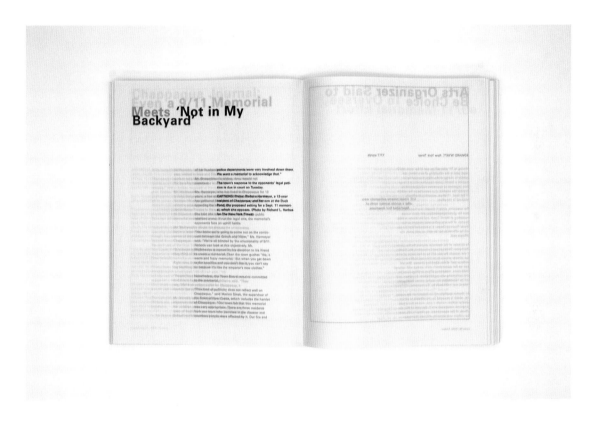

The book, titled "Oblivion," contains seventy-three articles from The New York Times
following the progression of the 9/11 memorial competition. As the focus of the articles
shifts from the tragedy to the logistics of developing the site, the memory of those lost
becomes increasingly obscure. In order to convey this obscurity, the book is designed
with vellum paper. The vellum pages are used to connote the passage of time and
memory. As the reader turns a page, the text from the previous page becomes a visual
element representing time and memory on the current page. This book is my own
memorial to the people lost not only in Manhattan but also in Iraq and Afghanistan.

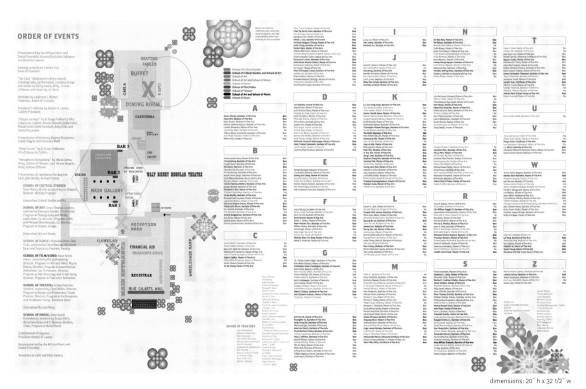

dimensions: 20" h x 32 1/2" w

398

SILVER Postcard, Greeting Card, or Invitation Card
2004 CalArts Graduation Invitation

Designers Penny Pehl, Leon Yan **School** California
Institute of the Arts **Client** California Institute of the
Arts **Country** United States

Using the vernacular language of maps, the CalArts'
graduation program combines familiar and abstract
forms to define the physical space of the ceremony.
The intention was to design a program that was
inextricably tied to the ceremony. The map was created
to be representative of the experience as possible, from
the order of the procession of graduates to the correct
seating arrangement. The piece is printed as a foldout
map, which includes a complete index of all graduating
student names on its reverse side.

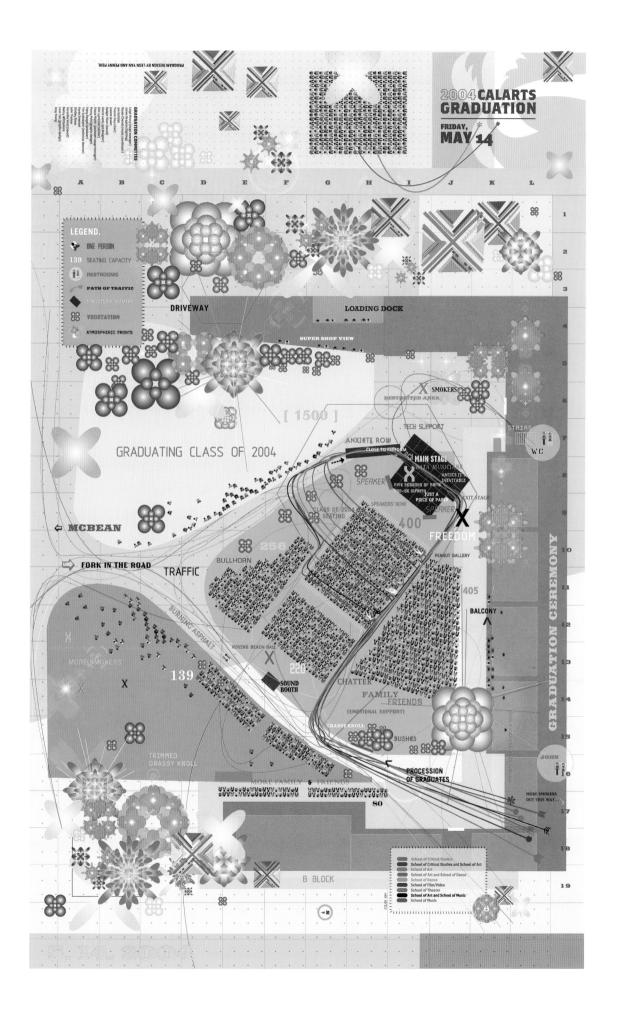

399

SILVER Corporate and Promotional Design, Miscellaneous, Series
Freedom of the Press: Heather Han, I Am Me, Smug Mind Discern

Art Director Heather Han **Designer** Heather Han **Illustrator** Heather Han **School** School of Visual Arts **Country** United States

My ultimate concern regarding Freedom of the Press was to explore the issues of freedom of expression within the medium of graphic design. During my four years of studies at the School of Visual Arts, the constant issue that appeared again and again was the conflict between visual freedom and the clarity that needs to be expressed within one's work. I believe that the guidelines that are often placed on us eliminate some of the rawness that appeals to one on a more emotional level. This project was started when I found the Freedom of the Press paper from the senior show at the ADC, which addresses the issues of limitations within our media. By no means did I develop this work through an intellectual process, nor did I intend to deface the content of its original pages. By simple instinctual method I combined crossed-out words and illustrations in a poetic justice of its own and a meaning of my own. My point was that we are very concerned with speaking universally, yet when we speak to ourselves we can reach others.

On an average weeknight, ███████████ Tonight, ██ Evening ████ and Nightly ██████ tune[d] in ████ mate█ one-quarter ██████ homes in the U.S.; about two-thirds of the American public claim to follow ████████ regularly.

{**MULTIPLE AWARD WINNER**} (see also page 408)

DISTINCTIVE MERIT Branded Content **Game: On**

Art Director Cary Ng **Creative Director** Ethan Vogt **Designer**
Stephanie Caw **Other** Phil McNagny, Rick Sands **Director**
Ethan Vogt **Editor** Eric Kissack **Production Company** Furnace
Media Group **Agency** Euro RSCG **Studio/Design Firm** Furnace
Media Group **Client** Volvo North America **Country** United States

GAME: ON blends live-action with video game graphics to reach a young tech-savvy
audience. Produced for the launch of the Volvo V50, the project won the ProMotion
Pictures contest at NYU for pushing the boundaries of art and commerce. The story
follows an architect who is transported into the realistic 3D world of his favorite video
game and thrust into an unlikely friendship with the game's protagonist.
A new production technique, termed Machinima, was used to create 3D animation in
real-time as players interact in the game. A partnership with Epic Games and Nvidia
made GAME ON the first sponsored Machinima project rendered in high definition video.
The film was released on the Volvo V50 website and has generated ongoing exposure
for the brand at screenings at a new media festival in Europe, a panel discussion at the
Sundance Film Festival, and gaming conferences within the United States.

We want to show the benefit of Mag-Lite in the simplest and most reduced way possible.

DISTINCTIVE MERIT Magazine, Consumer Spread **Mag-Lite "Bright"**

Art Director Tim Zastera **Copywriter** Patrick Herold **School** Miami Ad School
Europe **Client** Mag-Lite **Country** Germany

Designer Catherine Hahm **Photographer** Catherine Hahm **School** California Institute of the Arts **Country** United States

(see related work on page 406)

dimensions: 36" h x 23 1/2" w

"The Gleaners and I" is originally a French documentary made by Agnès Varda. My intention for the poster was to communicate the message that the film contained, and since the film itself was deeply meaningful, I tried to approach it conceptually and through experience. The whole idea of gleaning and gleaners came to me as recycling, re-using things that are left behind for different purposes, and I wanted to show this idea through experimental typography. I liked the idea of finding things for reproduction, so I did a lot of gleaning—just searching and collecting garbage. I wanted to create the title for the poster with found materials and objects. By creating each letter with discarded, found objects (or using garbage itself as letters) and combining them, the title communicated the idea of recycling. It was an interesting solution, because people normally don't see trash as material for letterforms, and these letters have double function of communicating the message of the film and relaying its title.

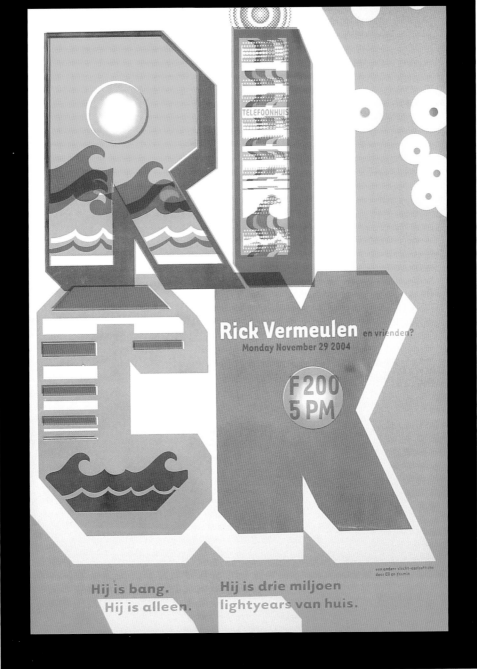

dimensions: 26 1/2" h x 18 1/4" w

DISTINCTIVE MERIT Poster, Promotional
Rick Vermeulen Visiting Artist Poster

Art Directors Eli Carrico, Yasmin Khan **Designers** Eli
Carrico, Yasmin Khan **Other** 3-color silkscreen, hand-
printed **School** California Institute of the Arts **Client**
CalArts School of Art **Country** United States

The poster was designed for a lecture at CalArts by visiting designer Rick
Vermeulen. Rick was coming from the Netherlands to America for one
of his frequent visits to CalArts, and we decided to use the poster as an
opportunity to work in our version of a "Dutch mode." This sensibilty comes
through in the color palette, overprinting, and use of abstract form. The
Dutch text is from "E.T.: The Extraterrestrial" and translates to "He is
afraid, he is alone, he is three million light years from home." (Rick, by the
way, also collects E.T. memorabilia.)

DISTINCTIVE MERIT Title Design **The Gleaners and I**

Creative Director Michael Worthington **Designer** Catherine Hahm
Photographer Catherine Hahm **School** CalArts **Country** United States

(see related work on page 404)

For the title sequence, I used the same approach as I had for the film poster (which is about re-using discard objects for different purposes) but showed a lot more of the process and reproduction in addition to the action of gleaning. Since the film is a documentary, I approached this title sequence in the same manner of filming in freestyle. My major goal was to show the process of gleaning in more depth. To achieve this, I shot the scenes of places where these objects came from. The shots of a hand picking up the letters and putting them down to form the names were shown repeatedly to continue to communicate the idea of recycling. Each time that the letters were put together, they created a different credit name. I wanted to show the hand in interactive action, because I liked the idea of picking up things like the gleaners do in the movie.

Direct Mail

Padded Socks

Lip Clip

Air Guitar Pick

Song Extractor

These wildpostings would be placed in business districts.

REPORT BAD MUSIC
WHEN YOU HEAR IT.

1-800-BAD-SONG

Tell us where and when you heard the
unfortunate music, and we'll do our best
to fix it. All callers will remain anonymous.

MERIT Other, Campaign
Muzak: Direct Mail Kit, Hotline, Card, Receipt, Elevator

Art Director Lauren Weinblatt **Creative Director** Rick Boyko
Copywriter Joel Gryniewski **Planner** Drew Guiteras **School**
VCU Adcenter **Client** Muzak **Country** United States

Muzak has gotten stuck with a bad rap. This campaign is designed
to eliminate the widespread stigma of Muzak as "elevator music,"
while also repositioning the brand to combat new competition
from satellite radio companies. It lays the groundwork for a more
specific campaign to detail Muzak´s services.

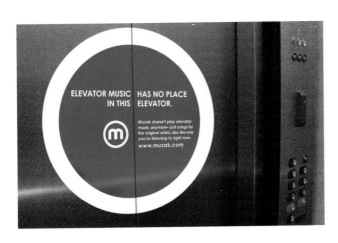

ELEVATOR MUSIC HAS NO PLACE
IN THIS ELEVATOR.

Muzak doesn't play elevator
music anymore— just songs by
the original artists. Like the one
you're listening to right now.
www.muzak.com

These machines would be placed
in restaurants in business districts.

{MULTIPLE AWARD WINNER} (see also page 402)
MERIT Special Effects Game: On

Art Director Cary Ng Creative Director Ethan Vogt Designer Stephanie
Caw Other Phil McNagny, Rick Sands Director Ethan Vogt Editor Eric
Kissack Production Company Furnace Media Group Agency Euro RSCG
Studio/Design Firm Furnace Media Group Client Volvo North America
Country United States

GAME: ON blends live-action with video game graphics to reach a young
tech-savvy audience. Produced for the launch of the Volvo V50, the project
won the ProMotion Pictures contest at New York University for pushing
the boundaries of art and commerce. The story follows an architect who is
transported into the realistic 3-D world of his favorite video game and thrust
into an unlikely friendship with the game's protagonist. A new production
technique, termed Machinima, was used to create 3-D animation in real-time
as players interacted in the game. A partnership with Epic Games and Nvidia
allowed GAME:ON to be the first sponsored Machinima project rendered in
high-definition video. The film was released on the Volvo V50 website, and
has generated ongoing exposure for the brand at screenings at a new media
festival in Europe, a panel discussion at the Sundance Film Festival, and
gaming conferences within the United States.

MERIT Point-of-Purchase, Campaign
Benjamin Moore Paint: 284 Shades of Green, 316 Shades of Blue, 235 Shades of Yellow

Art Directors Jeremy S. Boland, Matt Miller **Copywriters** Jeremy S. Boland, Matt Miller
School University of Colorado, Boulder **Country** United States

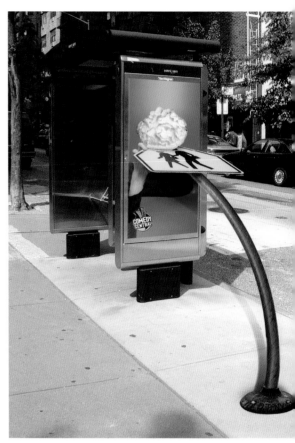

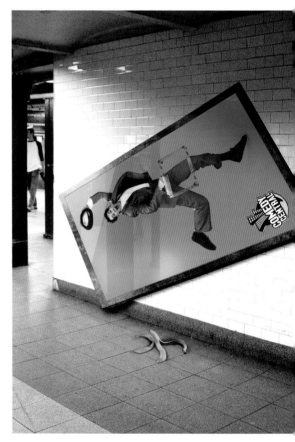

MERIT Posters and Billboards, Transit, Campaign
Comedy Central: Telephone Kiosk, Bus Stop Advertisement, Subway Poster

Art Director Daniel Treichel **Creative Director** Daniel Treichel **Copywriter** Daniel
Treichel **School** School of Visual Arts **Client** Comedy Central **Country** United States

The brief given was simple: just do something funny for Comedy Central. I chose to take cliché
ideas of humor and show them in a new way by manipulating the way that the medium is used.

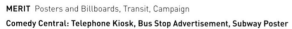

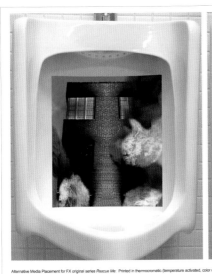

Alternative Media Placement for FX original series *Rescue Me:* Printed in thermocromatic (temperature activated, color changing) ink.

Our objective for this campaign was to attract attention to FX Network's award-winning series in places that were unexpected. We wanted people to interact with the executions and feel like they could "get into" the programs.

Alternative Media Placement for FX original series *nip/tuck:* Placed on mirrors in women's restrooms.

 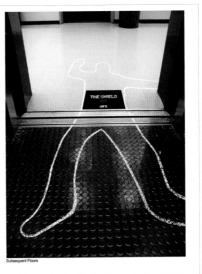

Lobby Subsequent Floors

Alternative Media Placement for FX original series *The Shield:* Found in elevators in busy buildings.

MERIT Collateral Advertising, Guerrilla | Unconventional, Campaign
F/X Network: Rescue Me, Nip/Tuck, The Shield

Art Director Danny Nathan **Creative Director** Sean Thompson **Copywriter** Eric Schwieger **School**
University of Texas at Austin **Country** United States

MERIT Magazine, Trade, Spread | Multipage
Picture Magazine

Designer Anna Ostrovskaya **Instructor** Carin Goldberg
School School of Visual Arts **Country** United States

MERIT Book Jacket **Bibliophilia**

Art Director Milton Glaser **Designer** Megan Oiler **Photographer**
Megan Oiler **School** School of Visual Arts **Country** United States

412

The objective of this assignment was to
design a book jacket for a novella that better
conveyed its content than the existing cover.
Bibliophilia is a story about a librarian whose
age, career, and stern demeanor have robbed
her of the sexuality that she cherished as
a young woman. This solution references
the strong sexual themes that dominate the
novella while also showing the unexpected,
mischievious nature of the main character.

MERIT Magazine, Trade, Spread | Multipage, Series
Picture Magazine: Cover 1, Cover 2, Spread 1: Henri Cartier
Bresson, Spread 2: Lewis Carroll, Spread 3: Lewis Carroll

Art Director Seong Im Yang **Designer** Seong Im Yang **Instructor**
Carin Goldberg **School** School of Visual Arts **Country** United States

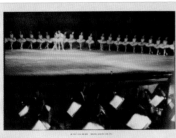

413

"Picture" is an upscale magazine featuring museum quality photography. I
selected three photographers, Henri Cartier Bresson, Lewis Carroll, and
Wolfgang Tillmans, and designed the pages using typography to express the
ideas and sensibilities of each artist. The restraints on the students were that
no photographs could be cropped or have typography placed directly on them.

MERIT Limited Edition, Private Press or Special Format Book
Copy Me! Ein Buch über das Phänomen Kopieren

Designer Edith Lorentz **Illustrator** Edith Lorentz **Photo Editor** Edith Lorentz
School Fachhochschule Mainz **Country** Germany

The phenomenon of copying is an essential condition of each form of life and company. Through a steady exchange among humans, experiences and knowledge are passed on by preserving what exists and by creating variations and changes during the process of copying. This is what makes progress possible. On the basis of scientific and philosophical texts and experimental graphics, I set out to prove this image in my thesis. The spectrum ranges from "hommage à xerographie" to "the museum of copies" to "the selfish gene." On the level of design, creating something new with existing materials, especially with the copying machine, was the main intention. My free-associative graphical slots should sharpen one's eye for the phenomenon. I intend to show that copying is not only pragmatic but also in very sensual.

MERIT Corporate Identity Standards Manual
Graphic Standards Manual for Storm King Art Center

Art Director Se Ra Yoon **Creative Director** Se Ra Yoon **Designer** Se Ra Yoon
Illustrator Se Ra Yoon **Photo Editor** Se Ra Yoon **Photographer** Se Ra Yoon
School Pratt Institute **Client** Storm King Art Center **Country** United States

414

This is a Graphic Standards Manual for Storm King Art Center, a museum that celebrates the relationship between sculpture and nature. I re-designed the logo, stationery, website, posters, symbol signs, invitations, and tickets for the Storm King Art Center. The first visual key of Whole Systems is a triangle, which is a geometric shape and also has a 45°-angle view. The logo was composed using triangles as modular. Why triangles? The name of the Center is from Storm King mountain, and the triangle is a mountain shape and a basic shape of sculptural form. The second visual key of Whole Systems is the sky. The sky is the wall, lighting systems, and ceiling of the Storm King, which means there are no limits in exhibiting works of sculpture there.

MERIT Poster Design, Public Service | Non-Profit | Educational, Series
Fake Flowers 1-3

School Yale School of Art **Country** United States

A poster series explores the perception of information at different physical distances. This phenomenon similar to artificial flowers: they appear real from a distance, but upon closer examination the illusion is revealed.

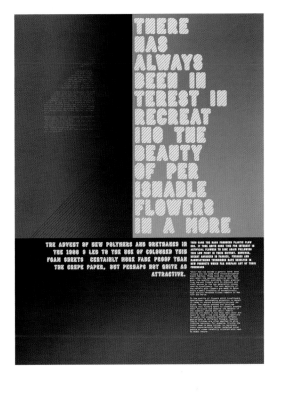

MERIT Poster Design, Public Service | Non-Profit | Educational, Series
And Symbols: Grid, Plus, Ampersand, New Et, New Ands

Art Director Rebecca Alden **Tutor** Paul McNeil **Other** M.A.,
Typo/Graphic Design **School** Tinge Design **Country** United States

416

Based on symbols used in everyday handwriting, I created new characters
to replace "and" in computer-based fonts. One danger of using computer-
based fonts exclusively is it moves us away from the strange little things
that happen when we write by hand. I believe it is important to preserve the
changes that have occurred in our handwriting in recent times. I asked one
hundred people to draw the symbol they use most frequently to replace the
word "and" in writing. In these posters, the magnified and overlaid symbols
show the similarity among the various handwritten "and's." Men's answers
are blue, women's answers are pink. The final outcome of this project
was to create three new symbols for "and" that currently do not exist in
computer-based fonts. These symbols, the connected plus, the new et, and
the loop, are based on Helvetica Neue Regular.

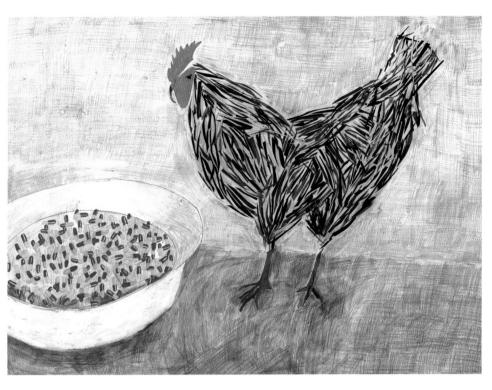

MERIT Illustration, Self-Promotion
Antibiotics in the Food Supply

Art Director Maggie Suisman **Country** United States

"Antibiotics in the Food Supply" was made out of cut paper, magic marker, and colored pencil. It was made to illustrate an article about the dangerous levels of antibiotics we consume in food.

MERIT Hybrid | Art | Experimental **Searchscapes**

Art Director Juliana Sato Yamashita **Other** Kathleen Wilson, David Reinfurt **Programmer** Juliana Sato Yamashita **Country** United States

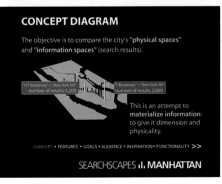

CONCEPT DIAGRAM

The objective is to compare the city's **"physical spaces"** and **"information spaces"** (search results).

This is an attempt to **materialize information:** to give it dimension and physicality.

CONCEPT • FEATURES • GOALS • AUDIENCE • INSPIRATION • FUNCTIONALITY >>

SEARCHSCAPES ıl. MANHATTAN

The intent of "Searchscapes" is to design a tridimensional map of Manhattan using existing data from the web. The objective is to compare representations of the city's "physical spaces" and "information spaces." Taking the metaphor very literally, a specific address is searched on Google (example: "1 Broadway" + "New York, NY"). Such a search will mostly yield results that correspond to this specific location. The total number of text results is parsed and then plotted on a map of the physical space. The height of the building on that location will correspond to the number of results found. More results will correspond to higher "information buildings." This is an attempt to materialize information, to give it dimension and physicality.

417

ADC NOW

{ THE VISION AWARD
{ APPLE COMPUTER – TBWA\CHIAT\DAY

I'VE KNOWN STEVE JOBS SINCE HE WAS 25 YEARS OLD and he started this company with the true intent to change the world. And we've been along for the ride, or at least most of the ride.

When we came to the moment when we were introducing Macintosh, he said, "I WANT ADVERTISING THAT NOBODY'S EVER SEEN BEFORE, I WANT ADVERTISING THAT CHANGES THE WORLD."

But then there were the dark days, the dark years, when Steve left, and we were summarily asked to leave as well. I'm only happy to say that I got a call in 1997 when I was driving home in my car and it was Steve and he said, "Hey, can you come up here? I think I'm gonna try and fix Apple." The goal was to take a company that had been mismanaged and was about to go out of business and breathe some life into it, put it back on a course dedicated to changing everything again.

What "Think Different" did first is basically reestablish Apple's relationship with the consumers who loved it, gave them faith to believe it was going to continue to be a great company, but it also revitalized Apple. The people who worked there again had a passion and something to believe in, that they could be a part of company that could change the world

Unique in the advertising business is to work for a company that actually makes great products. So the challenge, and/or the opportunity for Apple is, how to tell people about something great, something that's going to change how they do things, how they live their life.

The Apple account has been the most exhilarating ride this agency has taken, and we've had some fun ones over the years. It's pretty great for an agency to be around a company that in fact changes the world on a regular basis, and that's what we look forward to in the future.

Thanks for the award.

—Lee Clow

THE ADC BOARD BROKE PRECEDENT THIS YEAR in selecting for the 2005 Vision Award an agency-client team rather than a single company. One half of the team is a unique client with a visionary leader, Steve Jobs, who somehow is able to consistently anticipate what the world needs next and create a unique company culture where talented individuals design products that actually deliver on that leader's vision. The other half is a unique advertising agency, where legendary creative director Lee Clow and his groups have applied their passion and talent to presenting these products and telling the brand's story to the world in ways that consistently take on cultural velocity.

It began a little over two decades ago. As millions of people sat before their television sets, watching a football game and shifting their attention to snacks and conversation, the commercials came on—a kind of tremor. But the tremor was above ground and right there on the TV screen, in the form of a woman charging full-speed, wielding a hammer and preparing to let fly. Once she did, a lot was left shattered: the way people thought about computers, the way they thought about commercials, and, most of all, the way they thought about a company named Apple.

The story of the "1984" commercial is by now well known: how it was inspired by the Orwell novel, how it boldly promised that the Mac would help deliver mankind from the tyranny of machines, how the ad almost did not run at all, then ran once during the Super Bowl and never again, and how it subsequently became part of advertising history, even earning a place in museums. Continuing in subsequent revolutions from the revival of Apple with "Think different." in 1997 to the iPod sensation that began in 2001, Apple and TBWA\Chiat\Day have continued to foster a new way of thinking about brands, and new ways of telling a brand's stories.

Apple is a rare two-time honoree, having received the then-called Management Award in 1988, and one of only two companies to have been twice honored since the award's inception in 1954. Together with TBWA\Chiat\Day, the two companies have been responsible for creating some of the most brilliant—and brilliantly paired—products and advertising to grace the visual landscape over the past two decades.

"My PC wasn't Plug-n-Play.
It was Plug-n-Get-Mad."

apple.com/switch

Yum.

Think different.

Think different.

www.apple.com

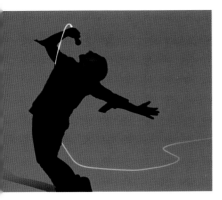

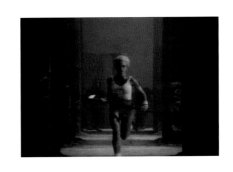

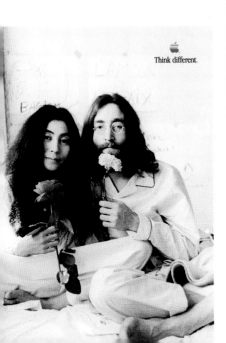

Think different.

iPod

10,000 songs in your pocket. Works with Mac or PC. The new iPod.

iPod

10,000 songs in your pocket. Works with Mac or PC. The new iPod.

{ SEPTEMBER 2004 }

A YEAR IN REVIEW 2004-2005

In addition to the Annual Awards, the ADC offers a variety of programming
throughout the year—speaker events, portfolio reviews, educational workshops
for high school students, exhibitions and parties, breakfast symposia, and a
wide range of "visual fuel."

Our mission is to celebrate and inspire creative excellence and encourage
young people coming into the field. Our mandate is to provide a forum for
creative leaders in Advertising, Graphic Design and Interactive Media, and to
address the growing integration among those industries. Founded in New York in
1920 as the world's first Art Directors Club, the ADC is the premier organization
for visual communications. The ADC is self-funding and not-for-profit.

This timeline offers a glimpse into a year with the ADC. Events and exhibitions
displayed on the top half of each page took place in our own gallery on West 29th
St. in Manhattan. Those below follow our Traveling Exhibitions of the Annual
Awards and Young Guns 4 as they tour the globe.

 ADC NOW

SEPTEMBER 9 – OCTOBER 22, 2004
YOUNG GUNS 4 EXHIBITION

01 02 03 04 05 06 07 08 09 10 11 12 13 14

422

1. OPENING NIGHT ADC YOUNG GUNS 4
2. ADC YOUNG GUNS 4 BOOK COVER
3. AS PART OF YOUNG GUNS 4, HELEN WATERS OF IDANDA.NET MODERATED A PANEL DISCUSSION FEATURING ADC YOUNG GUNS LUKE CHOI, GEOFF GREEN, NATASHA JEN, CARY MURNION, AND JON MILOTTI ABOUT CONTROVERSIAL DESIGN AND GENERATION GAPS.

The ADC kicked off its year with an exhibition, party, and book for the winners of ADC's fourth bi-annual—and first international—competition for creatives under the age of 30. A crowd of over 700 packed the gallery for the party and exhibition preview on September 9.

{ SEPTEMBER 23, 2004
YOUNG GUNS 4 PANEL I: "Is Taste Generational? Is Taste Cultural?

17 18 19 20 21 22 23 24 25 26 27 28 29 30

{ SEPTEMBER 14 – OCTOBER 14, 2004
PARIS —THE 83RD TRAVELING EXHIBITION

The 83rd Traveling Exhibition made its European debut at the Maison de la Publicité, Paris, hosted by the Club des Directeurs Artistiques (French Art Directors Club). The opening was a big hit, as reported by Miranda Salt, Communications Director at BETC Euro RSCG. Salt, a member of the French ADC, is responsible for bringing the 83rd show to France. She said, "The opening night was a big success...over 350 people attended, a record for the French event."

1,2. ANTHONY VAGNONI OF AVAGNONI
MARKETING MODERATED THE SECOND
YOUNG GUNS 4 PANEL DISCUSSION,
FEATURING ADC YOUNG GUNS JOSE
CABALLER, DAVID HEASTY, AND MARK
LAUGHLIN & MICHAEL DYER.
3. ALEX SUH CRITIQUES THE
"ALPHABET" OF FOUND OBJECTS
ASSEMBLED BY THE STUDENTS IN THE
TYPOGRAPHY WORKSHOP

OCTOBER 7, 2004
YOUNG GUNS 4 PANEL II: "Are You Out of Touch? Is Your Industry?"

01 02 03 04 05 06 07 08 09 10 11 12 13 14 15

For the eighth consecutive year, ADC offered Saturday Career Workshops to almost 100 New York City public high school juniors. Thanks to the dedication of the ADC staff and our colleagues at the School Art League, Jane Chermayeff, Renee Darvin, and Naomi Lonergan, we've continued to inspire these talented and motivated students.

Fall workshops were led by Frank Anselmo and Jayson Atienza, Marshall Arisman, Steven Kroninger, Michael Randazzo, and Alex Suh and Boyoung Lee. We also offered our fourth Art College Seminar, where representatives from Cooper Union, the Fashion Institute of Technology, NYC Technical College, Parsons, Pratt, the School of Visual Arts, and the NYU School of the Arts made presentations to students and their parents and teachers. Our second annual Portfolio Review was offered after the seminar, when students met one-on-one with representatives about preparing competitive portfolios for art school applications.

The spring program consisted of workshops led by Gail Anderson, Frank Anselmo and Jayson Atienza, Stephen Kroninger, Diana LaGuardia, Brian Rae, and Alex Suh and Boyoung Lee. (see January 2005)

During the year, we were assisted by volunteers Stephen Brownell, Karen Cohn, Sarah Graham, Kim Grasing, Elisa Halperin, Paul Hughes, Adam Jackson, Alex Kale, Hilla Katki, Nicole Kenney, Dave Mayer, Rick Robertson, Calvin Sun, and Karin Wood. We thank them for their enthusiastic participation in the program.

Many thanks to our benefactor, the Coyne Foundation, whose generous support allows us to expand the program.

–Susan Mayer, Program Director

{ **OCTOBER 15, 2004**
PHOTOGRAPHY PORTFOLIO REVIEW

In the ADC's fifth annual Photography Portfolio Review, one hundred established and emerging photographers were seated with their portfolios for review by area creatives in advertising, publishing, and corporate design.

NOW

ADC

7 18 19 20 21 22 23 24 25 26 27 28 29 30 31

{ **OCTOBER 18 – OCTOBER 25, 2004**
SANTIAGO, CHILE —THE 83RD TRAVELING EXHIBITION

The 83rd Annual Awards Traveling Exhibition was part of the 10th Annual Advertising International Fair in Santiago, Chile, hosted by the Universidad del Pacifico. Director of Publicity for the University, Sebastian Goldsack Trebilock, said, "it is one of the most important events in the professional advertising environment in Chile and includes lectures from notable creative people discussing the latest issues in mass communication."

The Hall of Fame Committee selected an unprecendented nine laureates for 2004. ADC President Robert Greenberg presented awards to educators Edward Tufte (accepted by his colleague Dmitri Krasny) and Muriel Cooper (accepted by her sister, Charlotte Lopoten), and photographer Duane Michals; Board Assistant Secretary/Treasurer Gael Towey presented to illustrators Bruce McCall and Al Hirschfeld (accepted by his widow Louise Hirschfeld), and designer Louise Fili; and Board member and Hall of Fame Selection Committee Chair Rick Boyko presented to advertisers Jerry Andelin and Jay Chiat (accepted by his widow Edwina von Gal), and designer Tibor Kalman (accepted by his widow Maira Kalman). ADC Executive Director Myrna Davis presented the Hall of Fame Scholarship to Zac Kyes.

ADC NOW

{ NOVEMBER 9 – DECEMBER 24, 2004
HALL OF FAME DINNER AND EXHIBITION

01 02 03 04 05 06 07 08 09 10 11 12 13 14 1

{ JULY 1 – NOVEMBER 25, 2004
SHANGHAI, CHINA—SHANGHAI NORMAL UNIVERSITY

ADC Staffers Emily Warren and Scott Ballum participated in the dedication ceremonies of Shanghai Normal University, where the 83rd Traveling Exhibition was hosted. The exhibition was part of the Capital Corporation Image Institution's annual Logo Festival and Design Forum in Shanghai.

17 18 19 20 21 22 23 24 25 26 27 28 29 30

{ DECEMBER 2004 }

THE ADC'S ANNUAL HOLIDAY PARTY BECAME
A BOOK LAUNCH TO CELEBRATE THE EARLY
RELEASE OF ADA 83, THE FIRST TIME THAT
THE ANNUAL HAS BEEN AVAILABLE THE SAME
YEAR AS THE COMPETITION.

ADC NOW

{ **NOVEMBER 9 - DECEMBER 24, 2004**
HALL OF FAME DINNER AND EXHIBITION

01 02 03 04 05 06 07 08 09 10 11 12 13 14 15

{ **DECEMBER 2, 2004**
COOPER HEWITT SPEAKER EVENT
ED BENGUIAT AND HOUSE SPEAKER EVENT

ADC Board of Directors member Red Burns moderated a break-
fast panel discussion, "Sensory Overload: Understanding Infor-
mation." ADC President Robert Greenberg of R/GA, ADC Hall of
Famer Richard Saul Wurman, and Martin Nisenholtz, CEO of New
York Times Digital, joined her to discuss the relationship between
communication design and understanding information.

House Industries threw a party at the ADC to celebrate the launch
of their Ed Benguiat Font Collection, five new typefaces designed
by the ADC 2000 Hall of Famer.

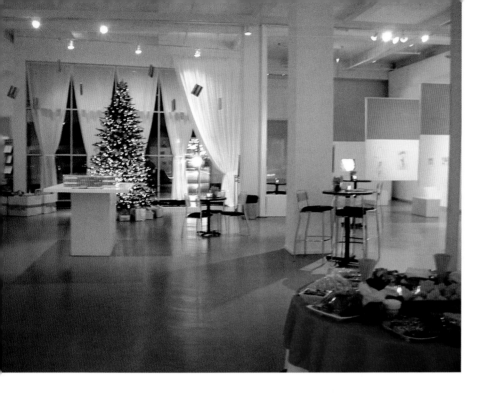

{ **DECEMBER 13, 2004**
ADC MEMBER HOLIDAY PARTY AND BOOK LAUNCH

18 19 20 21 22 23 24 25 26 27 28 29 30 31

{ **DECEMBER 20, 2004 – JANUARY 5, 2005**
GUANGZHOU, CHINA—YG4, GUANGDONG MUSEUM OF ART

The Guangdong Museum of Art in Guangzhou, China,
hosted the Young Guns 4 exhibition in late December.
The show opened to a warm response by visitors.

ADC NOW

01 02 03 04 05 06 07 08 09 10 11 12 13 14 15

THE YOUNG GUNS 4 EXHIBITION AT GUANGDONG
MUSEUM OF ART IN GUANGZHOU, CHINA

1. SATURDAY CAREER WORKSHOPS, SPRING 2005
2. BRIAN REA PRESENTS HIS WORK TO STUDENTS
 DURING HIS EDITORIAL ILLUSTRATION WORKSHOP.
3. AERIAL SHOT OF COLLAGE WORKSHOP
4. ZACHARY HORVATH'S SELF-PORTRAIT IN COLLAGE

7 18 19 20 21 22 23 24 25 26 27 28 29 30 31

JANUARY 21 – JANUARY 29, 2005
HAMBURG, GERMANY—MIAMI AD SCHOOL

The 83rd Traveling Exhibition enjoyed another
well-received stay at the Miami AD School
Europe, Hamburg in January and then made
a short visit to a new agency in that city,
Oysterbay Werbeagentur GmbH, to help it get
off the ground.

{ FEBRUARY 2005 }

GD JUDGING CHAIR EMILY OBERMAN
WELCOMES HER JURY.

FEBRUARY – MARCH 2005
ADC 84TH ANNUAL AWARDS JUDGING SESSIONS

Judging chairs Paul Lavoie (Advertising), Emily Oberman
(Graphic Design), and Kevin Wassong (Interactive) assembled
juries of 66 industry leaders, assisted by 16 student interns, for
three judging weekends in February and March. The 84th Annual
Awards also marked the premiere year for a new category,
Hybrid, for advertising campaigns comprising three or more
media. 383 winners from 23 countries were selected from over
10,000 total entries, with only 19 total Gold medals awarded.

ADC NOW

01 02 03 04 05 06 07 08 09 10 11 12 13

432

FEBRUARY 28 - MARCH 25, 2005
TOKYO, JAPAN—RECRUIT CO., LTD.

Recruit Co., Ltd., Tokyo ran a more
permanent version of the 83rd Annual
Awards Exhibition, which has been
donated to the archives at design schools.

16 17 18 19 20 21 22 23 24 25 26 27 28

FEBRUARY 25 – MARCH 28, 2005
SEATTLE, WASHINGTON—SCHOOL OF VISUAL CONCEPTS.

In Seattle, the 83rd Traveling Exhibition opened
at the School of Visual Concepts in conjunction
with a fundraiser sponsored by AD 2 Seattle for
Peace for the Streets, a homeless youth center.

ABOVE: THE 84TH ANNUAL AWARDS JUDGING PROCESS CONT.

ADC NOW

01 02 03 04 05 06 07 08 09 10 11 12 13 14 15

{ **MARCH 5 – MARCH 23, 2005**
HONG KONG—HONG KONG BAPTIST UNIVERSITY

{ **MARCH 5 – MARCH 23, 2005**
SAO PAULO, BRAZIL—PANAMERICANA ESCOLA DE ARTE E DESIGN

For the seventh consecutive year, Panamericana Escola de Arte e Design, Sao Paulo, hosted our Annual Awards Traveling Exhibition. It is always much anticipated, and has a fabulous turnout.

Hong Kong Baptist University hosted the 83rd Traveling Exhibition in its newly renovated library.

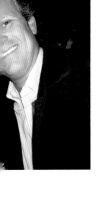

{ **MARCH 21 – APRIL 1, 2005**
SCHOOL OF VISUAL ARTS 3D DESIGN AND GRAPHIC DESIGN EXHIBITION

An annual exhibition of work by seniors at the School of Visual Arts. In addition to advertising and graphic design, this year's show featured a series of redesigned bicycles.

7 18 19 20 21 22 23 24 25 26 27 28 29 30 31

{ **MARCH 23 – MAY 4, 2005**
SAO PAULO, BRAZIL—PANAMERICANA ESCOLA DE ARTE E DESIGN

Panamericana Escola de Arte e Design hosted the YG4 Traveling Exhibition for the first time. It also marks the first time the YG4 has visited South America. ADC's 83rd Traveling Exhibition was held simultaneously.

ADC PAST PRESIDENT BILL OBERLANDER AND
SPECIAL GUESTS DISCUSSED "HOW TO GET
YOUR ACT TOGETHER—A GREAT PORTFOLIO IN
SIX EASY STEPS".

{ APRIL 14, 2005
BILL OBERLANDER SPEAKER EVENT I

ADC NOW

01 02 03 04 05 06 07 08 09 10 11 12 13 14 1

436

WORK OF VEER SCHOLARSHIP WINNER JONATHAN
MCGLOTHIN AND ADC HALL OF FAME SCHOLARSHIP
RECIPIENT KRISTEN DUDLEY, SHOWN LEFT TO RIGHT

The ADC gallery displayed award-winning
professional and student work from Le Club des
Directeurs Artistiques. The opening night party on
April 11 was attended by Remi Babinet, President
and Creative Director, BETC Euro RSCG and
President du Club des Directeurs Artistiques.

APRIL 28, 2005 }
PAPER EXPO

The annual professional event
brought ADC members and friends
together to meet, eat, and collect
the newest samples from paper
companies and printers.

{ APRIL 11 – MAY 13, 2005
FRENCH ADC EXHIBITION

NOW

ADC

17 18 19 20 21 22 23 24 25 26 27 28 29 30

APRIL 26, 2005 }
ADC NATIONAL SCHOLARSHIPS

2005 marked the second year of the ADC National Scholarship Program, which is sponsored by Adobe, Veer, and one by members and families of
the ADC's Hall of Fame. The Hall of Fame scholarship is funded in the names of Hall of Fame legends Roy Grace, Paul Davis, Tibor Kalman, Philip B.
Meggs, Alex Steinweiss, Richard Wilde and Louis Silverstein. Adobe's sponsorship comprises individual scholarships in advertising, graphic design and
illustration, bringing the total number of scholarships awarded to five.

The students were selected from over fifty applicants in the areas of advertising, graphic design and illustration. Each student receives $2,500 toward
their continuing professional development and education. The program is managed by the ADC's Education Coordinator, Isabel Veguilla, in conjunction
with the scholarship committee, whose members include Thomas Mueller, Mary Kay Hartmann and Myrna Davis.

"Helping to train the next generation of visual communicators is a key mission of the Art Directors Club, and we're gratified to be able to award these very
worthy candidates," says Davis. "The work submitted was impressive and exciting, and our winners emerged after a rigorous selection process. We offer
them our congratulations and best wishes for their future endeavors."

In addition to the cash prize, each Adobe scholar will receive full versions of Adobe Creative Suite and After Effects Professional software programs.
Adobe scholarships were presented to Kayu Tai of the College for Creative Studies, Detroit, for excellence in Advertising, Kevin Buth of Portfolio Center,
Atlanta, for excellence in Design, and Wen Hsu-Chen of the Rhode Island School of Design, Providence, for excellence in Illustration.

The Veer scholarship was presented to Jonathan McGlothin of the Herron School of Art and Design, Indianapolis, for excellence in Design. The Hall of
Fame scholarship was presented to Kristin Dudley of Portfolio Center for excellence in Design.

M

{ MAY 2005 }

The top 100 students from Graphic Design and Advertising programs around the country sat with their portfolios for review by the top creative professionals in the field.

ADC NOW

{ MAY 9 – 10, 2005
ADC PORTFOLIO REVIEWS

{ APRIL 11 – MAY 13, 2005
FRENCH ADC EXHIBITION

01 02 03 04 05 06 07 08 09 10 11 12 13 14 15

{ APRIL 12 – MAY 6, 2005
SYDNEY, AUSTRALIA—UNIVERSITY OF TECHNOLOGY, SYDNEY

First-time host University of Technology, Sydney, presented the 83rd Annual Awards traveling exhibition from April to early May. It received a great deal of publicity, including an article in Good Weekend Magazine of The Sydney Morning Herald.

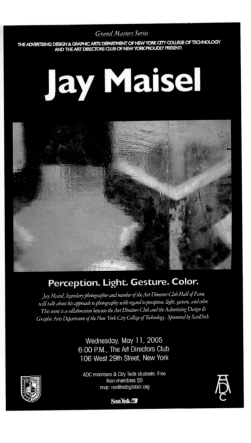

In conjunction with the Department of Advertising and Graphic Design at New York City Tech/CUNY, ADC Hall of Fame photographer Jay Maisel gave a lecture titled "Perception, Light, Gesture, and Color" to a full house of students and members.

The second part of "How to Get Your Act Together," Bill Oberlander was joined by ADC board member Jeroen Bours of Hill Holliday, Neil Powell of Powell, Tom Bagot of Ogilvy, Dean Hacohen of Lowe, and Gib Marquardt of McCann-Erickson to discuss "How to Sell to a Room Full of Clients."

{ **MAY 11, 2005**
JAY MAISEL SPEAKER EVENT

{ **MAY 12, 2005**
BILL OBERLANDER SPEAKER EVENT II

7 18 19 20 21 22 23 24 25 26 27 28 29 30 31

{ **APRIL 15 – MAY 16, 2005**
BELGRADE, SERBIA—NEW MOMENTS/NEW IDEAS COMPANY

May 16th marked the closing of 83rd Annual Awards traveling exhibition in Belgrade, Serbia. First-time host New Moment/New Ideas Company, Belgrade, exhibited the 83rd traveling show during the city's annual cultural fair, "Days of Belgrade," with the exhibition listed as an official venue. Dragan Sakan, owner of New Moment/New Ideas Company, reported that the show received a lot of publicity and was well attended.

{ JUNE 2005 }

THE 84TH AWARDS GALA
The ADC's biggest party celebrates the newest winners in the oldest
competition of its kind. The 84th Annual Awards Gala brought
hundreds of winners, judges, members and press from around the
world to eat, drink, and be merry, and view the best advertising,
graphic design, and interactive work of the year.

} JUNE 2, 2005
ADC 84TH ANNUAL AWARDS GALA

01 02 03 04 05 06 07 08 09 10 11 12 13 14 1

MAY 24 – JUNE 17, 2005
SLOVENIA—NEW MOMENTS/NEW IDEAS COMPANY
Young Guns 4 traveling exhibition }

In May, the New Moments/New Ideas Company hosted the
YG4 Traveling Exhibition. Nastja Mulej, Idea Thinker for
New Moments reported a great turnout for the opening,
with two broadcast stations and four print media were on
hand to report on the festivities.

MAY 27 – JUNE 17, 2005
MUNICH, GERMANY—DESIGN PARCOURS
83rd Annual Awards Traveling Exhibition }

The 83rd Traveling Exhibition was part of the 4th Annual
Design Parcours in Munich, Germany. First-time host, Opium
effect GmbH, Munich, sponsored the exhibition. Gabriele Zuber
of Opium Effect reported a great response to the exhibition.

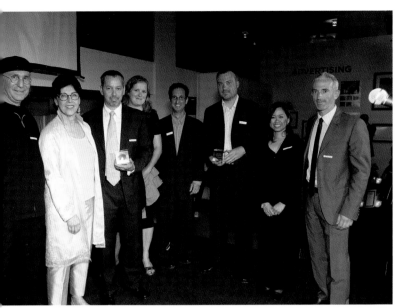

JUNE 2, 2005
ADC VISION AWARD: TBWA\CHIAT\DAY AND APPLE

For the first time ever, the ADC Vision Award was given simultaneously to an agency and client, Apple Computers and TBWA\Chiat\Day. Representatives from both companies attended the 84th Awards Gala to accept the honor and the Manship Medallion.

The ADC Vision Award was established in 1954 to honor companies and individuals in management for commitment to design and understanding its relation to performance, thereby contributing to excellence in communication, education, and social awareness. In 2005 the Board of Directors set a new precedent when it presented the Vision Award to a client and agency simultaneously, in recognition of an extraordinary long-term partnership. The 2005 award was accepted by Hiroki Asai of Apple Computers and James Vincent, Duncan Milner, Eric Grunbaum, and Susan Alinsangan of TBWA\Chiat\Day at the Annual Awards Gala.

Area creatives from the top tiers of advertising, publishing, and corporate design gathered to review the portfolios of forty three established and emerging illustrators.

JUNE 9, 2005
ILLUSTRATION PORTFOLIO REVIEW

17 18 19 20 21 22 23 24 25 26 27 28 29 30

JUNE 1 – JUNE 30, 2005
BANGKOK, THAILAND—BANGKOK UNIVERSITY

The Communication Design Department of Bangkok University hosted the 83rd Traveling Exhibition. This marks the fifth consecutive year that the school has hosted our exhibition. Winyoo Satitvidayanand, Chairperson, says the show is always received very well.

{ JULY 2005 }

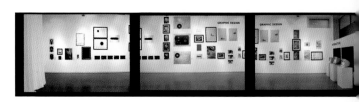

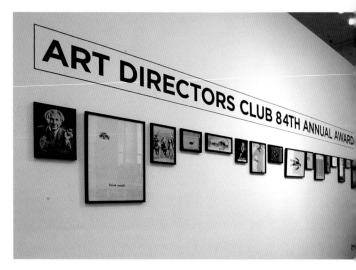

{ JUNE 3 – JULY 29, 2005
ADC 84TH ANNUAL AWARDS EXHIBITION

01 02 03 04 05 06 07 08 09 10 11 12 13 14 15

{ JULY 1 – JULY 15, 2005
ZAGREB, CROATIA—GLIPOTEKA GALLERY

The 82nd Traveling Exhibition opened at Glipoteka Gallery in Zagreb, Croatia, co-hosted by the Association for Promotion of Visual Culture and Visual Communication (VIZUM) and the Croatian Designers Society (HDD). Iva Babaja, President, VIZUM said, "I am happy to report that the opening went exceedingly well. There were a lot of people, and all the comments about the work were great." Like the 81st, the event drew a lot of media: two TV stations, and all of the daily newspapers. After the exhibition closed, it remained in Croatia to be used as a foundation for a national design centre. HDD will exhibit the 83rd exhibition September, 2005.

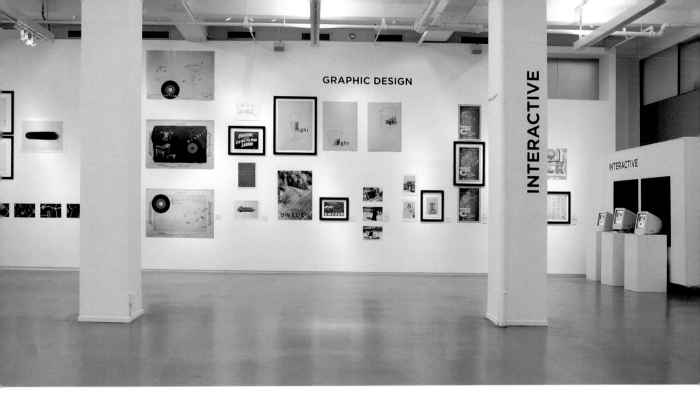

APPENDIX

444

ADC PAST PRESIDENTS

RICHARD J. WALSH, 1920–21
JOSEPH CHAPIN, 1921–22
HEYWORTH CAMPBELL, 1922–23
FRED SUHR, 1923–24
NATHANIEL POUSETTE-DART, 1924–25
WALTER WHITEHEAD, 1925–26
PIERCE JOHNSON, 1926–27
ARTHUR MUNN, 1927–28
STUART CAMPBELL, 1929–30
GUY GAYLER CLARK, 1930–31
EDWARD F. MOLYNEUZ, 1931–33
GORDON C. AYMAR, 1933–34
MEHEMED FEHMY AGHA, 1934–35
JOSEPH PLATT, 1935–36
DEANE UPTEGROVE, 1936–38
WALTER B. GEOGHEGAN, 1938–40
LESTER JAY LOH, 1940–41
LOREN B. STONE, 1941–42
WILLIAM A. ADRIANCE, 1942–43
WILLIAM A. IRWIN, 1943–45
ARTHUR HAWKINS JR., 1945–46
PAUL SMITH, 1946–48
LESTER RONDELL, 1948–50
HARRY O'BRIEN, 1950–51
ROY W. TILLOTSON, 1951–53
JOHN JAMISON, 1953–54*
JULIAN ARCHER, 1954–55
FRANK BAKER, 1955–56
WILLIAM H. BUCKLEY, 1956–57*
WALTER R. GROTZ, 1957–58
GARRETT P. ORR, 1958–60
ROBERT H. BLATTNER, 1960–61
EDWARD B. GRAHAM, 1961–62
BERT W. LITTMAN, 1962–64
ROBERT SHERRICH SMITH, 1964–65
JOHN A. SKIDMORE, 1965–67
JOHN PETER, 1967–69
WIILLIAM P. BROCKMEIER, 1969–71
GEORGE LOIS, 1971–73*
HERBERT LUBALIN, 1973–74
LOUIS DORFSMAN, 1974–75*
EILEEN HEDY SCHULZ, 1975–77*
DAVID DAVIDIAN, 1977–79*
WILLIAM TAUBIN, 1979–81
WALTER KAPRIELIAN, 1981–83*
ANDREW KNER, 1983–85*
EDWARD BRODSKY, 1985–87*
KARL STEINBRENNER, 1987–89
HENRY WOLF, 1989–91
KURT HAIMAN, 1991–93*
ALLAN BEAVER, 1993–95*
CARL FISCHER, 1995–97*
BILL OBERLANDER, 1997–2000*
RICHARD WILDE, 2000–2002*

Advisory Board*

SPECIAL THANKS

JONATHAN RODGERS ALSO SERVED ON THE ADVERTISING JURY IN THE 83RD ANNUAL AWARDS, BUT WAS ACCIDENTALLY OMITTED FROM THE ART DIRECTORS ANNUAL 83. AS A MEMBER OF THE 84TH ADVERTISING JURY, HIS BIO CAN BE FOUND ON PAGE 23 OF THIS BOOK.

HEATHER DOUTT, ACCOUNT MANAGER, TAXI-NY.COM

Contributors	MS. HILDA S. KLYDE MR. SAKOL MONGKOLKASETARIN MR. MARK TUTSSEL
Paper Expo	KODAK

84TH ANNUAL AWARDS

Call for Entries	TAXI-NYC.COM, PAUL LAVOIE (CONCEPT AND DESIGN) MEAD WESTVACO, L.P. THEBAULT (PAPER AND PRINTING)
Gala Invitation	TAXI-NYC.COM, STEPHANIE YUNG AND JANE HOPE (CONCEPT AND DESIGN), TODD HAIMANN AT LITHO-ART (PRINTING), HAMIN LEE PHOTOGRAPHY
Winners' Souvenir Newspaper	TAXI-NYC.COM, STEPHANIE YUNG AND JANE HOPE (CONCEPT AND DESIGN)
Exhibition Design	SCOTT BALLUM
Kiosk and Mini-Site Design	MIKE LEE AND MATT SUNG
84th Annual DVD Design	MATT SUNG AND KAREN HORTON
Event Photographers	RIC KALLAHER AND MONICA STEVENSON
Gala A/V Presentation	JACK MORTON WORLDWIDE
Exhibition Flat Screen Monitor and Digital Cameras	HEWLETT PACKARD
Gala Goodie Bags	SHISEIDO, DYNAMIC GRAPHICS, KIEHL'S, H20 ASSOCIATES, THE CLEAVER COMPANY, YAHOO!, SHOOT
Sponsors	ADOBE, YAHOO!, HEWLETT PACKARD, ONREQUEST IMAGES

CORPORATE MEMBERS

ADOBE SYSTEMS, INC.
AMSHOW + ARCHIVE MAGAZINE
BARTLE BOGLE HEGARTY
CHARLEX
ELIRAN MURPHY GROUP
FRANKFURT KURNIT KLEIN & SELZ
G2 WORLDWIDE
GALE GROUP
GETTY IMAGES
HBO – OFF AIR CREATIVE SERVICES
L.P.THEBAULT COMPANY
MARKS PANETH & SHRON LLP
MARTHA STEWART LIVING OMNIMEDIA
MEADWESTVACO CORPORATION
MERKLEY + PARTNERS

MSN
OGILVY & MATHER BRAND INTEGRATION GROUP
OPIUMEFFECT GMBH
PARADE PUBLICATIONS
PENTAGRAM DESIGN
R/GA
@RADICAL.MEDIA
SAATCHI & SAATCHI
SCHOLZ & VOLKMER INTERMEDIALES DESIGN
SHISEIDO CO., LTD.
ST. MARTIN'S PRESS
TIAA – CREF
TIME WARNER BOOK GROUP
TROLLBACK & COMPANY

ADC MEMBERS

UNITED STATES

ARIZONA
Louie Moses
Neal Olshan
Harold Sosnow

CALIFORNIA
Sean Adams
Amy Armock
Richard Baron
Martha Benari
Patrick Bowyer
Gene Bullard
Arthur Ceria
Mathew Cullen
Allison DeFord
Robert Diebold
Christopher Do
Geoffrey Edwards
Crystal English
Erin Ferree
Tricia Gellman
Ryan Gerber
Renee Gontarski
Debbie Hemela
Joson
Don Kilpatrick III
Micah Laaker
Leon Lazarus
Jim Lesser
David H. MacInnes
Mei-Lu McGonigle
Sakol Mongkolkasetarin
Jacqueline C. Moorby
Noreen Morioka
Minoru Morita
Dan Poynor
Aldo Puicon
Derek Reager
Andy Romano
Tania San Miguel
Randall Scherrer
Christian Seichrist
Rich Silverstein
John Vitro
Scott Weber
Garson Yu

COLORADO
Michael Austin
Michelle Barnes
Ken Fukuda
Thomas Ruzicka
Jonathan Schoenberg
Jing Jing Tsong

CONNECTICUT
Jeff M. Babitz
Bruno E. Brugnatelli
J. Hamilton Davis
Joe Del Sorbo
David Epstein
Megan Ferrell
Kurt Gibson
Bill Gold
Marie Nicole Haniph
Visko Hatfield
Nancy Kent
Amanda Lawrence
Rick Levine
George Lott
Kevin McKeon
Wendell Minor
Yuko Nohara
Wendy O'Connor
Herbert Reinke
Harlow Rockwell
Don Ruther
Susan Scafati
Robert Shea
Eugene M. Smith Jr.
Christine Sniado
Lizabeth Storrs Donnelly
William Strosahl
Briah Uhl
Roy Weinstein
Art Weithas
Megumi Soleh Yamada

DISTRICT OF COLUMBIA
Greg Johnson
Florida
Robert H. Blend
Anthony Chaplinsky Jr.
Ricardo deMontreuil

Donald H. Duffy
Diego Enriquez
Zoe Fedeles
Michael Fenga
Jed Grossman
Craig Hern
Sandy Hollander
Ronnie Lunt
Madeleine Michels
Eugene Milbauer
Jose Molla
William R. Morrison
Onofrio Paccione
Ariel Peeri
Allan A. Philiba
Ernest Pioppo
Henry N. Russell
Pippa Seichrist
Ron Seichrist
Carlos Vazquez
Renetta Welty
Zen Yonkovig

GEROGIA
Jeff Cole
Gauri Deshpande
Ted Fabella
Don Grant
Fernando Guerrero, Jr.
Sam Harrison
Claire Kerby
Henry O. Knoepfler
Melissa Kuperminc
David Levinson
Brad Ramsey
Hank Richardson
Naoya Wada
Rich Wakefield

ILLINOIS
Paul Brourman
Chris Davis
Joe Edakkunnathu
Sally Faust
Steven Liska
Elaine Rodey
Greg Samata
Joe Sciarrotta

Mark Tutssel
David Carter
Daniel E. Stewart

MASSACHUSETTS
Charles S. Adorney
Bob Crozier
Gill Fishman
Jaymes Leavitt
Paula Lerner
Tracy Londergan
Kevin Miller
John Milligan
Smari

MAINE
Wick Beavers
Donald P. Flock

MINNESOTA
Joe Duffy
Jack Griffin
Bill Hillsman
Haley Johnson
Christopher Stoeckel

MONTANA
Tara Adams
Jesse Kuhn
John Verrochi

NORTH CAROLINA
Roymieco Carter
Harry Jacobs
William Seabrook, III
Robert Shaw West

NEW HAMPSHIRE
Edward J. Bennett

NEW JERSEY
Gaylord Adams
Peter Adler
Joe Alesi
Wesley A. Bedrosian
James Bergold
Andrew R. Brenits
Kristi Bridges

Ed Brodsky
EJ Carr
Donna Catanese
Kevin Dorry
Noha Edell
Brian Ganton Jr.
Marlowe Goodson
Suzanne Hader
Bob Hagel
Kurt Haiman
Sammi Han
Douglas Hazlett
Susan Hochbaum
Pai-Cheng Kevin Hou
Edward Ioffreda
Ashwini M. Jambotkar
Paul Jervis
Dennis Koye
Sal Lazzarotti
Gregory B.Leeds
Huy Iu Lim
Richard MacFarlane
Joseph Mann
Brian Matthew McCall
Christine Moh
Susan Newman
John Okladek
Yukako Okudaira
Nina Ovryn
Regine Pedersen
Theodore D. Pettus
Karen Riley
Jamie Rosen
Robert Saks
Don Seitz
Martin Shova
James C. Smith
Robert Steigelman
Bernard Stone
Beau Thebault
Frank A. Vitale
Maria U. Voigt
Allison Winfield
Jenn Winski
Bernie Zlotnick

NEW MEXICO
Michael Gray

NEVADA

Lee Hilands Horswill

NEW YORK

Ruba Abu-Nimah
Lymari Acevedo
Cornelia Adams
Joy Adams
Malcolm Louis Adams
Gennaro Andreozzi
Lora Appleton
Ariel Apte
Lia Aran
Arturo Aranda
Ron Arnold
Philip Attar
Blanca Aulet
Jerome Austria
Kristina Backlund
Ronald Bacsa
Charles H. Baer
Priscilla Baer
Robert Baiocco
Kim Baker
Natalya Balnova
Adam Bank
Giorgio Baravalle
Sarah Barclay
Mimi Bark
Keate Barker
Don Barron
Robert Barthelmes
Dawn Bauer
Mary K. Baumann
Allan Beaver
April Bell
Archie Bell II
Richard Berenson
John Berg
Robert Bergman
Walter L. Bernard
Jennifer Binder
Mat Bisher
Debra Bishop
Christina Black
Erik Blair
R.O. Blechman
Joe Bloch
Barbara Bloemink
Carol Bokuniewicz
Jean Bourges
John Francis Bourke
Jeroen Bours
Harold A. Bowman
Barbara Boyle
Bruce Erik Brauer
Ruth Brody
Christine Bronico
Claire Brown
Janice Brunell
William H. Buckley
Renee Bundi
Sandra Burch
Red Burns
Christian Busch
Chris Byrnes
Stephanie Cabrera
Mark Cacciatore

Jodi Cafritz
Joseph A. Cahill
Nicholas Callaway
Mary Jane Callister
Matt Campbell
Gregg Carlesimo
Thomas Carnase
David Ceradini
Francisco Cervi
Dairo Chamorro
Jack Chen
Mark Chen
Ivan Chermayeff
Deanne Cheuk
Steve Chiarello
David Chomowicz
Richard Christiansen
Peter (Sung) Chun
Shelly Chung
Stanley Church
Charles Churchward
Seymour Chwast
Joseph Cipri
Scott Citron
Andrew Clark
Herbert H. Clark
Thomas F. Clemente
Joann Coates
Fernanda Cohen
Michael Cohen
Peter Cohen
Rhonda Cohen
Jack Cohn
Karen Cohn
Victoria Colby
Alisa Coleman-Ritz
Brian Collins
Andreas Combuechen
Isabella Conenna
Andrew Coppa
Jeffrey Cory
Gary Cosimini
Sheldon Cotler
Susan Cotler-Block
Theodore Coulombe
Niko Courtelis
Robert Cox
Meg Crane
Kathleen Creighton
Gregory Crossley
Ethel R. Cutler
Joele Cuyler
Michelle D'Elia-Smith
Terry Dagrosa
Kyle Daley
Jakob Daschek
David Davidian
Paul Brookhart Davis
Randi B. Davis
Lisa Day
Roland De Fries
Faith E. Deegan
Richard Degni
Venus Dennison
David Deutsch
An Diels
John F. Dignam
Lisa Diller

Roz Dimon
Jeseka Djurkovic
Jason Dodd
Michael Donovan
Louis Dorfsman
Marc Dorian
Kay E. Douglas
Stephen Doyle
James Dunlinson
Virginia Duquette
Julia Durgee
Bernard Eckstein
Peter Edgar
Nina Edwards
Andrew Egan
Nina Eisenman
Stanley Eisenman
Carlos El Asmar
Lise Ellingsen
Judith Ellis
Lori Ende
Lee Epstein
Magnus Erhardt
Shirley Ericson
Rafael Esquer
Felix Estrada
Kathleen Fable
Jose Fernandez
Stan Fine
Nicole Fineman
Blanche Fiorenza
Carl Fischer
Bernadette Fitzpatrick
Emily Flake
Patrick Flood
Marta Florin
Ian Forbes
Tara Ford
Polly Franchini
Cliff Francis
Michael Frankfurt
Stephen Frankfurt
Bill Freeland
Christina Freyss
Ruby Miye Friedland
Stephen Friedson
Michael K. Frith
Janet Froelich
Glen Fruchter
S. Neil Fujita
Angela Fung
Leonard W. Fury
Mindy Gale
Danielle Gallo
Gino Garlanda
Martina Gates
Inga Geciene
Tom Geismar
Steff Geissbuhler
Janet Giampietro
Amanda Giamportone
Justin Gignac
Porter Gillespie
Frank C. Ginsberg
Sara Giovanitti
Bob Giraldi
Donna Glanvill
Milton Glaser

Marc Gobé
Bryan Godwin
Roz Goldfarb
Samuel Gomez
Daniel Gonzalez
Joanne Goodfellow
Jonathan W. Gottlieb
Michael W. Gottlieb
Tony Granger
Geoff Green
Jeff Greenbaum
Robert Greenberg
Lori Zinser Greene
Abe S. Greiss
Harley Griffiths
Olga Grlic
Emily Grote
Raisa Grubshteyn
Lori Habas
Robert Hack
Makiko Hagio
Elisa Halperin
Everett Halvorsen
Lisa Faye Hames
Charles A. Hamilton
India Hammer
Leslie Hammond
Garfield Harry
Stephan M. Hart
Hein Haugland
Luke Hayman
David Heasty
Cheryl Heller
Steven Heller
Randall Hensley
Kristine Ford Herrick
Marcus Hewitt
Samantha Hickey
Carolyn Hinkson-Jenkins
Junko Hino
Stephen Hinton
Andy Hirsch
Charles Ho
Marilyn Hoffner
Scott Holland
Charlie Holtz
Jed Holtzman
Daniel Hort
Michael Hortens
Cara Howe
Roy Hsu
Douglas Huffmyer
Jib Hunt
Manabu Inada
Jonathan Isaacs
Bob Isherwood
Adam Isidore
Caroline D. Jackson
Jan Jacobs
Hal Jannen
Chris Jarrin
Natasha Jen
Patricia Jerina
Graham Johnson
Jamison Jones
Raquella Kagan
Uday Kak
Ric Kallaher

Joanna Kalliches
Jon Kamen
Lauren Kangas
Walter Kaprielian
Peter Karlsson
Adam Kaszycki
Stacey Katzen
Nadra Kabaili
Sean Keepers
Iris Keitel
Casey Kelbaugh
Bridget Kenney
Jo Kennils
Candice Kersh
Kris Kiger
Satohiro Kikutake
Chris Kim
Evelyn Kim
Jean Kim
Ralph Kim-Centra
Nathalie Kirsheh
Susan Kirshenbaum
Judith Klein
Hilda Stanger Klyde
Andrew Kner
Susanna Ko
Eileen Koehler
Kurt Koepfle
Elaini Kokkinos
Sasha Koren
Kati Korpijaakko
Milana Kosovac
Justin Kovics
Rebecca Kuperberg
Rick Kurnit
Mara Kurtz
Anthony La Petri
Mai La Thai
Natalie Lam
Robin Landa
Charlie Langella
David Langley
Lisa LaRochelle
Tom Larson
Jeremy Lasky
Stacy Lavender
Nick Law
Terry Lawler
Mark M. Lawrence
Mark Ledzion
Eun-Jung Lee
Amy Lehfeldt
Jodi LeKacos
Maru León
Mark Levenfus
Keith Levenson
Susan Levin
Stefanie Lieberman
Andreas J.P. Lindstrom
Douglas Lloyd
Rebecca Lloyd
Teddy Lo
Mary-Stuart Logan
George Lois
Monica Lopez
Miriam Lorentzen
Diane Luger
Jason Lynch

Staci MacKenzie
Victoria Maddocks
Samuel Magdoff
Linda Maglionico
Lou Magnani
Jay Maisel
John Mamus
Romy Mann
Jean Marcellino
Sarah Marden
Jack Mariucci
Andrea Marquez
Joel Mason
Russell Maxwell
Susan Mayer
Marce Mayhew
Michael Mazzeo
William McCaffery
Colin McGreal
Sean McQueen
Gabriel Medina
Nancy A. Meher
Ralph Mennemeyer
Parry Merkley
Jeffrey Metzner
Jackie Merri Meyer
Gilda Meza
Douglas Miller
Joan Miller
Lauren J. Miller
Steven A. Miller
Michael Milligan
Jonathan Milott
Michael Miranda
Susan L. Mitchell
Sam Modenstein
Mark Montgomery
Diane Moore Behrens
Janet Morales
Alyssa Morris
Ted Morrison
JoAnn Morton
Deborah Moses
Alexa Mulvihill
Yzabelle Munson
Cary Murnion
Ann Murphy
Brian Murphy
S. Murphy
Wylie H. Nash
Bonnie Natko
Chris Nelson
Robert Newman
Liem Nguyen
Maria A. Nicholas
Mary Ann Nichols
Davide Nicosia
Kari Niles
Joseph Nissen
Barbara J. Norman
Roger Norris
George Noszagh
David November
John O'Callaghan
Kevin O'Callaghan
Christa M. O'Malley
Ellen O'Neill
Bill Oberlander

Janet Odgis
Beverly Okada
Lisa Orange
Jessica Owen-Ward
Bernard S. Owett
Jason Pacheco
Fran Paganucci
Brad Pallas
Chester Pang
Unha Park
Marcel Parrilla
Linda Passante
Chee Pearlman
Stan Pearlman
Brigid Pearson
Margaret Penney
David Perry
Harold A. Perry
Victoria I. Peslak
Christos Peterson
Robert Petrocelli
Daniel Petrucelli
Eric A. Pike
Joseph Piliero
Jane Pirone
Mary Pisarkiewicz
Robert Pliskin
Peter Pobyjpicz
Brian Ponto
Christine Porfert
Monica E. Pozzi
Don Puckey
Tracy Putman
Benita Raphan
Peter Raymond
Rob Realmuto
Samuel Reed
Kendrick Reid
Geoff Reinhard
Joseph Leslie Renaud
Anthony Rhodes
David Rhodes
Lianne Ritchie
Jonathan Rodgers
Roswitha Rodrigues
Gregory Roll
Dianne M. Romano
Gabrielle Rosedale
Charlie Rosner
Peter Ross
Richard J. Ross
Tina Roth
David Baldeosingh Rotstein
Alan Rowe
Mort Rubenstein
Randee Rubin
Anthony Rubino
Jan Sabach
Stewart Sacklow
Hitoshi Sagaseki
Stefan Sagmeister
Yael Sahar
Hideki Sahara
Randy Saitta
Robert Salpeter
James Salser
George Samerjan
Leonard Savage

Nathan Savage
Robert Sawyer
David J. Saylor
Sam Scali
Ernest Scarfone
Wendy Schechter
Nicole Schembeck
Paula Scher
Sandra Scher
Marc Schiller
David Schimmel
Klaus F. Schmidt
Robert V. Schnabel
Michael Schrom
Eileen Hedy Schultz
Scot Schy
Stephen Scoble
Mark Scott
Holly Elizabeth Scull
Arnold Sealey
J.J. Sedelmaier
Leslie Segal
Sheldon Seidler
Tod Seisser
Thomas Seltzer
Young Jun Seo
Matthew Septimus
Ronald Sequeira
Audrey Shachnow
Celine Shields
Karen Silveira
Louis Silverstein
Robert Simmons
Milton Simpson
Leonard Sirowitz
Anne Skopas
Robert Slagle
Jamie Slomski
Richard Smaltz
Carol Lynn Smith
Julia Smith
Sarah Smith
Todd Smith
Virginia Smith
Steve Snider
Dewayne A. Snype
Aniela Sobczyk
Martin Solomon
Russell L. Solomon
Harvey Spears
Allen Spector
Heike Sperber
Peter Stam
Dave Stanley
Mindy Phelps Stanton
Justin Steele
Doug Steinberg
Karl Steinbrenner
Monica Stevenson
Michael Storrings
Lisa Strausfeld
Hilary Strauss Hahn
Peter Strongwater
Snorri Sturluson
Myrna Suarez
Sam Sunshine
Kayoko Suzuki-Lange
Scott Szul

Stephen Szymanski
Barbara Taff
Jeet Tailor
Elizabeth Talerman
Penny Tarrant
Jack G. Tauss
Mark Tekushan
David Ter-Avanesyan
Jonathan Tessler
Winston Thomas
GMD Three
Ken Thurlbeck
Tessa M. Tinney
Jerry Todd
Flamur Tonuzi
Nicholas E. Torello
Steven Toriello
Damian Totman
Gael Towey
Anne Towmey
Victor Trasoff
Jakob Trollback
Linne Tsu
Eiji Tsuda
Joseph P. Tuohy
Roussina Valkova
Jamie Vance
Jill Vegas
Frank Verlizzo
Amy Vernick
Jeanne Viggiano
Jovan Villalba
Meagan Vilsack
Jurek Wajdowicz
Richard Wallace
Helen Wan
Catsua Watanabe
Jessica Weber
Alex Weil
Jeff Weiss
Marty Weiss
Wendy Wen
Miriam White
Andre Wiesmayr
Richard Wilde
Allison Williams
Maurice Williams
Kathleen Wilson
Kevin Wolahan
Jay Michael Wolf
Nelson Wong
Fred Woodward
James Worrell
Nina Wurtzel
Takafumi Yamaguchi
YunSook(Lucy) Yang
Efrat Yardeni
Henry Sene Yee
Rubina Yeh
Ira Yoffe
Frank Young
Caprice Yu
David Zeigerman
Lloyd Ziff
Carol Zimmerman
Alan H. Zwiebel

OHIO

Jennifer Aue
Dave Degers
Stuart deHaan
Meghan LaBonge
Keith Van Norman
Steve Sandstrom

OREGON

Taylor Vignali

PENNSYLVANIA

Robert O. Bach
Kevin Black
Pier Nicola D'Amico
Ed Eckstein
Glenn Groglio
Erin Herbst
David R. Margolis
Anthony M. Musmanno
Arthur Ritter
Bronson Smith
Bonnie Timmons

TENNESSEE

Melcon Tashian

TEXAS

Al Braverman
Veronica Franklin
Chris Hill
Chris Hungate
Florencia Leibaschoff
Sebastian Pallares
Stan Richards
D.J. Stout

VIRGINIA

Rick Boyko
Tim Chumley
Coz Cotzias
Mark Fenske
Jean Govoni
Andrea Groat
John E. Jamison
Dana Johnstone
Charlie Kouns
Paula Pagano
Jackie Silvan
Ashley Sommardahl
Robin Watson

WASHINGTON

Jack Anderson
Greg Lyle-Newton
James D. Nesbitt
Selina Petosa-Boyle
Tracy Wong

WISCONSIN

Julie Kimmell
Melody Kris

ACADEMIC MEMBERS

Miami Ad School
New York City College of
Technology
Portfolio Center

Pratt Institute
School of Visual Arts
Universidad del Pacifico
VCU Adcenter

INTERNATIONAL MEMBERS

AUSTRALIA
Kathryn Dilanchian
Ron Kambourian
Helmut Stenzel
Karel Wöhlnich

AUSTRIA
Tibor Bárci
Mariusz Jan Demner
Lois Lammerhuber
Silvia Lammerhuber
Franz Merlicek
Roland A. Reidinger
Matthias Peter Schweger

BANGLADESH
Shouvik Gupta

BRAZIL
Fabiana Antacli
Samy Jordan Todd

CANADA
Jean-Francois Berube
Twinkle Brygidyr
Rob Carter
Marco Cibola
Claude Dumoulin
Louis Gagnon
Daniel Giles
Jean-Pierre Lacroix
Peter Mitchell
Ric Riordon
Shingo Shimizu
Chal Stiles

CHILE
Manuel Segura Cavia

CHINA
Han JiaYing
Qi Mei
Zheng Si Jin
Min Wang
Lai Wei
Wang Xu
Wang Yuefei

CROATIA
Davor Bruketa
Lina Kovacevic
Moe Minkara

DENMARK
Bent Lomholt

FINLAND
Kari Piippo

FRANCE
Agnes Cruz Sy
Vincent Werbrouck

GERMANY
Heike Brockmann
Thomas Ernsting
Jan Peter Gassel
Harald Haas
Jianping He
Oliver Hesse
Ralf Heuel
Michael Hoinkes
Armin Jochum
Amir Kassaei
Peter Keil
Claus Koch
Dominik Lammer
Olaf Leu
Benjamin Lommel
Friederike Mojen
Ingo Mojen
Lothar Nebl
Gertrud Nolte
Marko Prislin
Stefan Pufe
Alexander Rehm
Andreas Rell
Katja Rickert
Achim Riedel
Sven Hedin Ruhs
Hans Dirk Schellnack
Marc Oliver Schwarz
Stan Skolnik
Beate Steil
Andreas Uebele
Michael Volkmer
Oliver Voss
Harald Wittig
Joerg Zuber

GREECE
Rodanthi Senduka

HONG KONG
Sandy Choi
David Chow
Martin Tin-yau Ko
Fai Desmond Leung

IRELAND
Eoghan Nolan

ISRAEL
Yuval Ziegler
Italy
Titti Fabiani
Gianfranco Moretti
Milka Pogliani

JAPAN
Kan Akita
Takashi Akiyama
Masuteru Aoba
Hiroyuki Aotani
Katsumi Asaba
The-Vinh Bugnon
Norio Fujishiro
Shinsuke Fujiwara
Shigeki Fukushima
Osamu Furumura
Keiko Hirata
Kazunobu Hosoda
Hiromi Inayoshi
Kogo Inoue
Hiroaki Iokawa
Masami Ishibashi
Shoichi Ishida
Keiko Itakura
Yasuyuki Ito
Toshio Iwata
Masaaki Izumiya
Kenzo Izutani
Takeshi Kagawa
Hideyuki Kaneko
Satoji Kashimoto
Mitsuo Katsui
Fumio Kawamoto
Yasuhiko Kida
Shiho Kikuchi
Taisuke Kikuchi
Katsuhiro Kinoshita
Hiromasa Kisso
Takashi Kitazawa
Kunio Kiyomura
Pete Kobayashi
Ryohei Kojima
Mitsuhiko Kotani
Pepii Krakower
Arata Matsumoto
Shin Matsunaga
Iwao Matsuura
Satoshi Minakawa
Keisuke Nagatomo
Hideki Nakajima
William Ng
Katsunori Nishi
Oseko Nobumitsu
Shuichi Nogami
Sadanori Nomura
Yoshimi Oba
Kuniyasu Obata
Toshiyuki Ohashi
Gaku Ohsugi
Yasumichi Oka
Akio Okumura
Toshihiro Onimaru
Hiroshi Saito
Toshiki Saito
Hiroki Sakamoto
Kozo Sasahara
Akira Sato
Naoki Sato
Hidemi Shingai
Norito Shinmura
Zempaku Suzuki
Yutaka Takahama
Masami Takahashi
Shigeru Takeo
Tsuji Takeshi
Masakazu Tanabe
Soji George Tanaka
Yasuo Tanaka
Norio Uejo
Katsunori Watanabe
Masato Watanabe
Yoshiko Watanabe
Yumiko Watanabe
Akihiro H. Yamamoto
Noami Yamamoto
Yoji Yamamoto
Masaru Yokoi
Masayuki Yoshida

KOREA
Bernard Chung
Kwang-Kyu Kim
Kum Jun Park

MALTA
Edwin Ward

MEXICO
Felix Beltran
Vanessa Eckstein
Juan Carlos Hernandez
Camara
Luis Ramirez

NEW ZEALAND
Yu Lu
Guy Pask

NIGERIA
Frederick-Wey Oluseyi

PAKISTAN
Shahud R. Shami

POLAND
Christopher Lempke

PORTUGAL
Eduardo Aires

PUERTO RICO
Juan Carlos López Claudio
Juan Carlos Rodriguez Piz-
zorno

RUSSIA
Leonid Feigin
Dmitry Peryshkov

SERBIA
Dragan Sakan

SINGAPORE
Hal Suzuki
Noboru Tominaga

SLOVAK REPUBLIC
Andrea Bánovská

SLOVENIA
Slavimir Stojanovic

SPAIN
Jaime Beltran

SWEDEN
Ann Kristin Hogberg
Kari Palmqvist
Zeke Tastas

SWITZERLAND
Stephan Bundi
Bilal Dallenbach
Martin Gaberthuel
Igor Masnjak
Andréas Netthoevel
Manfred Oebel
Dominique Anne Schuetz
Pius Walker
Philipp Welti

TAIWAN
Eric Chen

THE NETHERLANDS
Pieter Brattinga

UNITED KINGDOM
Simon Crofts
Harriet Devoy
Jonathan Ellery
Tim Hetherington
Agathe Jacquillat
Domenic Lippa
Alison Mansell
David Mason
Peakash Patel
Harry Pearce
Stephen Rutterford
Anders Schroder
Rob Taylor
Jacob von Dormarus

STUDENT MEMBERS
Aubrey Arago
Mario Ardizzone
Rae Baymiller
Whitney Beemer
Rafi Bernstein
Hannah Birchenough
Miklos Bogar
Austin Callaway
Ivan Cayabyab
Tommy Chan
Lydi Chen
Janine Cicio
Dolores Cortez
Francisco De La Torre-Rocha
Sara Jane Dunaway
Marcelo Ermelindo
Joseph Esposito
Tanya Frank
Paula Andrea Giraldo
Kevin Goff
Julian Gonzalez
Rhea Hanges
Elizabeth Hawke
Cheryl C. Hills
Rob Hoffman
Juri Imamura
Avdhi Jain
Ariele Jerome
Veronica Jones
Charalambos Kannavias
Duksoo Kim
Jacqueline Kim
Lily Kim

Mathis Krier
Minori Kuroishi
Pan Lau
Erin Lawler
Wai Leung
Andrew Lincoln
Giovanna Lopez
Heather Luisi
Marija Miljkovic
Angela Minton
Saphierrina Moellias
John O'Loan
Ewa Orzechowska
Joseph Perno Jr.
Nathan Pickett
Patricia Ramirez
Ribal Rayes
Byron Regej
Kelli Rothenberg
Jaffar Sabet
Christine Santora
Khaled Sawaf
Jenna Smith
Nancy F. Smith
Renée Smith
Omar M. Soto
Vesna Stefanovich
Yoshino Sumiyama
Wei Heng Tang
Jason Tsai
Tamara Umansky
Melissa Utreras
Susanne Vargarden
Mayra Velasco
Ethan Vogt
Mika Watanabe
Mark Whitehead
Ken Wong

INDEX

{ SYMBOLS }

+CRUZ 295, 356, 371
@radical.media 43,
 46, 49
032c Magazine 299
10BAN Studio 328
15 Children 274
180 Amsterdam (180\
 TBWA) 52, 60, 72, 97
2001 Video 42
24+7 154
24th Street Loft 298
2wice Arts Foundation
 304
702design Works, Inc.
 319
740 43

{ A }

Aaron, Michael 48
Achim Lippoth Photo-
 graphy 179, 184
Acme Filmworks 75
Acord, Lance 52, 72,
 135
Adachi, Tsubasa 158
Adams, Shelby Lee 300
Adams, Tom 36, 40, 58
Adbrain Inc. 158
ADC Switzerland 216
adidas 32, 52, 53, 60,
 61, 72, 83, 97, 162,
 167
adidas China 162
adidas International
 52, 72
ADP e.V. / German
 Cancer Aid 282
Advico Young & Rubi-
 cam 161, 216, 305
Ad Seeds Inc. 158
Aftahi, Warren Darius
 203
AIGA NY 290
Air America Radio 245
Aiwa, Inc 371
Akimoto, Yuta 323
Akinyele-Trokey, Sofia
 75, 105, 139
Akkermann, Nico 68
Alarming Pictures 31

Alberdi, Agustín 139
Albertson, Todd 209,
 301
Albores, Peter 352,
 367, 385
Alden, Rebecca 416
Aldhous, Chris 39
Alexander, Joe 156
Allfree, Ben 378
Allsop, Nick 149
AlmapBBDO 103, 157
Alshin, Adam 90, 366
Altoids 130, 202
Amato, Will 371
American Legacy Foun-
 dation 36, 40, 58
American Red Cross 96
Amnesty International
 170
An, Sun 356, 371
Anastasiades, Jon 76
Andeer, Mark 96
Anderson, Charles
 S. 326
Anderson, Keith 352,
 367, 373, 385
Anderson, Matthew 76
Andersson, Nils 169
Ando, Takashi 138
André, Philippe 92
Andréani, Daniel 327
Anggono, Rudi 114, 209
Anheuser-Busch 78,
 106
Annis, David 366, 383
Anselmo, Frank 169,
 174
Anweiler, Dominik 361
Aoki, Chinami 237
Aono, Chihiro 169
Aorta 300
Aota, Mitsuaki 169
Arai, Kenshi 371
Arai, Yuichi 372
Arakawa, Tomohiro
 372
Arce, Alex 345
Archrival 145
Arctic Paper 307
Arkle, Peter 207
Armour, Tony 307
Arnold Worldwide 58
 36, 40, 161

Artimo 254
Art Department 201
Art of Repro 269
Art Printing Co., Ltd.
 237
Asatsu-Dk, Inc. 312
Asayama, Yousuke 208
Astrapak/Syreline 243
Atienza, Jayson 169,
 174
Audi 151
Auel, Tammy 48
Austin, Sean 114, 209
Auten, Rob 64, 85
Avery, Douglas 130
AXYZ 88
ayr creative 274, 317

{ B }

Babble-On Record-
 ing 96
Babcock, Steve 163
Babinet, Rémi 92
Bach, Claudia 123
Bahrmann, Ole 282
Baird, Rob 36, 91
Baldacci, Roger 36
Barbarian Group 385
Barche, Michael 123
Barfoot, Jeff 324
Bargwanna, Nicole 47
Barnes, Derek 94
Barrett, Jamie 71, 140
Barrie, Bob 49, 75, 152
Bartels, Ingmar 34
Barton, Graham 348,
 351
bartradio, inc. 36
Bascule Inc. 355
Bättig, Barbara 265
Battilana, Carlos 371
Baxter, Kirk 60, 97
BBDO Canada 88
BBDO Minneapolis 96
BBDO New York 100,
 101, 102, 142, 143,
 165, 169, 174
BBH 212
Begin, Mary Jane 266
Begon, Emmanuel 210
Beier, Christoph 313
Beier, Heinz 313

Beierarbeit 313
Beith Digital 63, 112,
 146
Bêla, Carlos 342
Beletec, Brian 60
Belknap, Rodger 345
Bell, Dave 342
Bellino, Michael 87
Bellmann 153
Bemfica, Miguel 95
Benjamin, Jeff 385
Bennekers, Bieneke
 254
Bennett, Mark 377
Bennett, Merle 110,
 126
Benoit, Marie-Elaine
 278
Benson, Sam 67
Berger, Thomas 345
Berkmann, Marcel 361
Bernd, Dylan 31
Berthoud, Francois 211
Bertino, Paul 133
Best, Luke 264
Best, Wayne 90, 366
Bester, Jake 110
Best Buy 377
BETC Euro RSCG 92,
 134
Bethge, Beverly 339
Beto, Paulo 342
Bettor, Chad 385
Betz, Andre 105, 139
Bevan, Julian 343
Bharti, Rene 67
Bharucha, Taschi 210
Bic 115
Bichler, Paul 366
Bielefeldt, Christoph
 34
Bierut, Michael 341
Big Fish Filmproduk-
 tion GmbH 141
Big Magazine 298
Big Magazine, Inc. 212
Big Spaceship 359, 376
Bildsten, Bruce 48, 49,
 75, 140
Billy & Hells 154
Bilodeau, Don 292
Birdsall, Derek 286
Birks, Francesca 120

Bisbee, Jackie Kelman
 52, 72
Biscuit Filmworks
 60, 71, 74, 91, 140
Bishop, Deb 211, 212
Bisson, Sebastien 206,
 330
Black, Michael 378
Blaignon, Francois
 100, 101, 102, 143
Blakemore, Betsy 89
Blanchette Press 307
Blechman, Nicholas
 231
Blöck, Helge 174
Blomkamp, Neill 76
Bluhm, Paulette 348,
 351
Blumberg, Tanin 352
Blumenfeld, Luís 342
BMZ und More 190
Boen, Dan 366
Bogusky, Alex 36, 40,
 49, 58, 137
Boku, Masayoshi 355
Boland, Jeremy S. 409
Bomgardner, Robert
 200
Bonjour Paris French
 School 95
Bootlis, Paul 163
Borchardt, Philip 174
Borchert, Gui 378
Borsodi, Bela 201
Borthwick, Mark 300
Bouchet, Jean-Fran-
 çois 164
Boudreau, Judy 120
Bourguignon, André
 368
Boutavant, Marc 211
Boychuk, Tracy 203
Boyko, Rick 407
Bozymowksi, Paul 46
Bradley, Hilary 143
Brady, Kevin 31
Brandt, Michael 202
Brand New School
 64, 85
Branning, Matthew 175
Bremerhavene
 Bürgergemeinschaft
 123

INDEX

Breton, Pete 67, 148
Brett&Tracy 203
Britton, Travis 31
Broadbent, Will 342
Brockenbrough, John 133
Brockmann, Heike 379
Broken Wrist Project 203
Bronstein, Paula 82
Brookes, Sam 371
Brown, Laurie 383
Brown, Todd 378
Brown, Victoria 352
Browns 234, 264, 320
Bruce, Bill 100, 101, 102, 143
Bruce, Tim 307
Brun, Pascal 254
Brunelle, François 206
Bryan, Marion 63, 112
Buchanan, Alan 153
Buckhorn, Dean 48, 140, 152
Buddha Productions 340
Buero Uebele Visuelle Kommunikation 289
Bullock, Richard 52, 72
Burbridge, Richard 298
Bürger, Nadine 156
Burger King 49, 137
Burghart, Manu 300
Bürgy, Fabian 377
Buriez, Thierry 128
Burke, Greg 110, 126
Burnley, Earl 371
Busan Asian Short Film Festival 325
Büsges, Markus 265
Bustabade, Andrea 60, 97
Byrd, Rion 248
Byrne, Mike 93, 94
Byrne, Nathan 89

{ C }

Caballer, Jose 371
Cahan & Associates 259
CalArts 324, 391, 398, 405, 406
Calgary Police Services 118
California Institute of the Arts 398, 404, 405
California Milk Processor Board 74
Callegari, Federico 168
Cama, Felipe 131
Campanella, Frank 376
Campbell, Amy 64
Campdoras, Eric 371
Campion, Emily 225
Canadian Film Centre 148
Canadian Film Centre's Worldwide Short Film Festival 67
Capara, Pablo 109
Cape Town Major Events Co. 243

Cappeletti, Pedro 95, 131
Caputo, Gerard 140
Careborg, Lisa 285, 307, 308
Carmody, Brian 60
Carrico, Eli 405
Carrigan, Andy 153
Carroll, David 207
Carter-Campbell, Jennifer 49
Cartoon Network 342
Carver, Jordan 290
Casaer, Peter 117
Cassar, Doris 100, 101, 102, 143
Caw, Stephanie 402, 408
Cawley, Tim 165
Cehovin, Eduard 335
CG by Cache 299
Challah, Jassin 141
Chambers, Richard 142
Chan, Alvin 322
Channel 4 Television 264
Chapman, Leo 81
Charles S. Anderson Design Company 326
Chelsea Pictures 36
Chen, Szu Ann 371
Cheng, Alex 380
Chester, Ricardo 131
Chia, Grace 371
Chicago Recording Company 78, 106
Chicago Volunteer Legal Services 307
Children's Museum of Pittsburgh, The 248
Chilsen, Liz 298
Cho, Martin 371
Choate, Hyatt 100, 101, 102, 143
Chow, Adams 380
Christensen, Anne 186
Christiansen, Richard 202
Christy, Kevin 203
Chung, Alice 239
Chung, David 36
Chung, Phil 378
Chwalczyk, Marcus 315
Cianfrance, Derek 46
Cianfrone, Bob 36, 137
Cimino, Bill 78
Circus 270
Citi 105, 139
Citroen 76
Cityspace 339
City Mission 126
Claridge, Eric 298
Clarke, Greg 212
Clatter & Din 31
Clayton, Rob and Christian 296
Clément, Bruno 162
Clement, Gary 259
Clement, Rene 206
Cline, John 91
Cline, Peter 52, 72
Cloete, James 297
Clow, Lee 52, 72

Clowater, Michael 136
Clunie, James 165
CMT 136
Coate, Brian 77
Cobblestone Filmproduktion GmbH 68
Cohen, Michèle 134
Cohoon, Jessica 31
Cole & Weber/Red Cell 31
Columbia Pictures/ Sony Pictures Digital 359
Comedy Central 410
Compain-Tissier, Alexandra 231
Companhia Athletica 131
Companje, Rick 376
Company X 67
Condé Nast 201
Condos, Rick 385
Cook, Lee 269
Cooney, Scott 150
Cooper, Kyle 228, 250
Copiz, Stefan 74
Corbis Images 233
Corey, Ryan 391
Cornelius, Todd 194, 205
Cornell, Nikolai 393
Corral, Rodrigo 233
Corwin, Jeff 374
Cossette Media 120
Costa, Joseph 298
Coulter, Jesse 134
Couradjut, Olivier 134
Covenant House Vancouver 173
Covitz, Phil 40, 58
Craigen, Jeremy 127, 142, 149
Crandall, Court 81
Crane, Barbara 298
Cresswell, Alex 120
Crispin Porter + Bogusky 36, 40, 49, 58, 137
Cronenweth, Jeff 60
Cruz, Dexter 359, 376
Cummings, Glen 290
Curran, Fiona 338
Curtis, Hal 93, 94
Cury, Adriana 160
Cutler, Gavin 93
Cuyler, Joele 183, 186
cyan 220, 269
Czeschner, Olaf 368
Czukar, Michelle 55

{ D }

D-BROS 273
D'Orio, Tony 202
D'Rozario, Stuart 49, 75
Dahl, Jennifer 211, 212
Dahlstrom, Karen 359, 376
Daigle, Keith 304
Daily Show With Jon Stewart, The 304
Dallas Society of Visual Commnications, The

324
Dalthorp, James 266
Damen, Birgit 34
Damiani, Michael 132
Damman, David 48
Danglas, Olivier 151
Darfeuille, Martin 155
Dark, Aaron 136
Darley, Piper 378
Darrough, Shannon 364
Davenport, Bill 46
Davidson, Robert 292
Davidson, Tony 371
Davis, Chris 43
Davis, James 55, 67, 98, 136, 137
Davis, Paul 234
Davis, Paul Brookhart 215
Dawson-Hollis, James 49
DDB Berlin 68
DDB Brasil 95, 131
DDB Canada,Vancouver 79
DDB Chicago 78, 106
DDB London 127, 142, 149
DDB PARIS 151
DDB Paris 210
DDD System GmbH 369
Delbourgo, Phil 343
Delfgaauw, Martien 124
Dentsu, Inc. 237, 355, 358, 363, 372
Dentsu, Inc. Kansai 208
Dentsu Communication Institute 237
Dentsu Inc. 158
Dentsu Tec Inc. 158
Derksen, Todd 31
Dertschei, Christoph 379
Designers' Workshop Magazine 314
designhorse 318
Designing Gym Inc. 237
Design Bridge 269
Design Center, Ltd. 335
Dettmann, Katrin 154
Deuchars, Marion 263
DeVito, Sal 144
DeVito/Verdi 144
Dexter Russell Cutlery 165
de Paula Santos, Mateus 342
Dialog im Dunkeln 333
Diamond, Ron 75
Diamond of California 132
Dias, Luiz Gustavo 95
Diaz, Jun 90
Diaz, Pierrette 151, 210
Dick Gerdes Recruiting 156
Dieckert, Kurt Georg 154, 174
Diesel 278, 327, 342
Dietz, Kirsten 316
Digital Domain 52,

60, 72
Digital Palette, Inc. 237
Dillmann, Silke 375
DiMatteo, Kristina 231, 301, 303
Dingler, Brigitte 375, 377
Disentis 189
Dixon, Vincent 128
Doherty, Louise 82, 150
Domeniconi, Robin 298
Domeyer, Michelle 366
Domke, Axel 197
Donahue, Sean 385
Donlon, Linda 40
Donne, Tara 298
Donnelly, Rebecca 211, 212
Donovan, Anthony 257
Dörner, Philipp 34
Douglass, Dave 67, 148
Downtown Partners Chicago 114, 209
DRAFT Co., Ltd. 223, 273
dreamdesign 47
dreamdesign co., ltd. 47
Dreamusic Inc. 274
Driggs, Steve 105, 139
Drummond, Terry 88
Dubois, Eric 310
Dubois, Loic Lima 342
Duchon, Scott 60
Duncan, Rob 374
Duntemann, Matthew P. 225
Duplessis, Arem 180, 209, 231, 301
Du Toit, Gary 146
Dye, Alan 311, 329

{ E }

E. 313
East Japan Marketing & Communications Inc. 84
eBay 71
Economist, The 146
Editora Abril/Veja Magazine 103
Edmiston, Jason 120
Edwards, Geoff 60
Edwards, Simon 348, 351
Ehrke, Linda 81
Eideloth, Kriz 374
Eight and a Half 246
Einhorn, Lee 36
Einhorn, Marc 36, 40, 58
Elie-Meiré, Zec 300
Ellery, Jonathan 234, 264, 320
Ellhof, Jörg-Alexander 34
Elliott, Jim 31
Ellipsis Pictures 31
Emerald Nuts 352
Emery, Garry 294
emeryfrost 256, 257, 294, 306, 381
Engelbrecht, Pete 154

Enric Aguilera Asociados 337
enthusiasm 314
Époxy 310
Epstein, Mitch 298
Eschliman, Dwight 259
ESPN 134, 135, 153
ESPN Sportscenter 134
Essence Communication Partners 202
Esther Haase Photographie 199
Esto 248
Etat, Angelika Synek 190
Eulberg, Megan 31
Euro RSCG 402, 408
Euro RSCG Flagship Ltd. 56
Euro RSCG London 76
Eyeball NYC 343

{ F }

Fabrique Design 376
Fachhochschule Mainz 414
Fad 87
Fai, Chan 380
Fallon 75, 82, 90, 105, 131, 139, 140, 150, 152, 154, 366, 383
Fallon Minneapolis 48, 49
Fan, Yiing 295, 371
Faoro, Paola 270
Faria, André 157
Farrell, Cavan 301, 303
Faur, Diego 139
Favat, Pete 36, 40, 58
Fealy, Jim 89
Featherstone, Guy 371
Federman, Daniel 376
FedEx 88, 142, 157
FedEx/Kinko's 142
Fedyna, Ric 118
Fehling, Ron 148
Fennel, Oliver 189
Ferguson, Sam 98, 136
Fernandez, Roberto 103
Ferro, Francisco 168
Festival St-Ambroise Fringe de Montréal 327
Feurer, Dorothea 375, 377
Fiat 160
Fiebig, Nicole 34
Fiedler, Detlef 220
Final Cut Editorial 97
Finnegan, Annie 40
Finney, Nick 311, 329
Fisher, Emma 294
Fisher, Mark 110
Fisher, Sara 202
Fitton, Nigel 294
Fitzerald, Kevin 342
Fitzgerald, Jim 296
FLAME, Inc. 253, 261, 331
Flatt, Kevin 366, 383
Flintham, Richard 154

Flohrs, Oliver 377
Flores, Lou 147
Fluitt, Cindy 71
Flynn, Bridgette 55
Foam 254
Fogwill, Andy 139
Fok, George 310
Folliott, Josh 120
Fons Hickmann m23 265
Forbis, Amanda 75
Försterling, Stefan 170
Forte, Tim 163
Fortin, Daniel 310
For Office Use Only 364
Foster, Richard 376
Foton Inc. 158
Foulkes, Paul 143
Fox, Nathan 209
Fraggalosch, Grant 173
Francila, Lisa 98
Frankham, David 97
Franklin, James 298
Fraser, Andrew 149
Frazier, Kathryn 298
Frechette, Barry 36, 40
Freeman, Andrew 248
Fritz, Ingo 361
Fritz, Thomas 190
Froelich, Janet 180, 183, 186, 196, 206, 209, 211, 231, 258, 301, 302, 303
Frost, Vince 257, 306, 381
Fruit of the Ground, The 317
Frykholm, Steve 259
Fuchs, Julia 220
Fujii Tamotsu Photography Office 308
Fujimaki, Atsushi 358
Fujimoto, Hideto 321
Fujita, Katsuhisa 167
Fulford, Jason 388
Furnace Media Group 402, 408
Fussenegger, Iris 265
Futaki Interior, Inc. 319

{ G }

Gabler, Rich 374
Gagnon, Louis 206, 330
Gairard, Cedric 52, 72
Galliard, Ilonka 189
Gallus, Simon 265
Garbutt, Chris 175
Garden Museum 309
Gardiner, Daryl 79
Garms, Robin 39
Gaspard, Amanda 67, 148
Gatlin, Jodie 364
Gaul, Nicholas 140
Ge, Fan 162
Geary Theater 114, 209
Gebauer, Esther 300
Geffen Playhouse 215
Geiger, Mike 367, 385
Geizenauer, Greg 96
General Motors South Africa 297
Genovese, Miguel 365,

370, 384
Gent, Martin 39
Gérard-Huet, Jessica 164
Gerber, Heiko 34
Gerbosi, Dave 78, 106
Gericke, Michael 292
Gibbs, Mike 140
Giblin & James 154
Gilbert, Mark 98, 136
Gilden, Bruce 320
Gilmore-Barnes, Catherine 301, 302
Giménez, Christian 109
Gimon, Aureliano 371
Giordano, Lauren 228
Glaser, Milton 412
Glendenning, Jeff 301, 303
Glenmorangie 338
Glue Society, The 49
Goco, Eliezar 146
Goddard, Joe 145
Godin, Hélène 278
Godsall, Tim 67
Goebel, Andrea 382
Gold, Robert 141
Goldberg, Carin 412, 413
Goldman, Paul 85, 89
Golfanlage Kallin Betriebs GmbH 174
Golub, Jennifer 60, 97
Gonda, Masahiko 334
Goodby, Jeff 71, 132
Goodby, Silverstein & Partners 71, 74, 77, 132, 140, 143, 352, 367, 373, 385
good design company co., inc. 277, 323
Gordon, Dick 135
Gorgels, Peter 376
Gorgeous Enterprises 142
Gorman, Jeff 133
Goto, Tetsu 363
Gottbrath, Georg 171
Gotz, Chris 110
Grabarz & Partner Werbeagentur GmbH 124, 198
Graf, Michael 194, 204, 205
Graff, Jason 159, 281
GraficEurope 265
Graf Studios 194, 204, 205
Grampá, Rafael 342
Granger, Tony 159, 281
Granlund, Kimba 364
Granser, Peter 316
Graphiques M/H 278, 327
Graves, Chris 266
Graves, Paul 201
Gray, Andy 298
Green, David Gordon 36
Green, Sheraton 326
Greene, Megan 31
Greenspan, Jeff 159, 281
Greenstein, Keith 147

Gregory, Kenan 373
Greiche, Elise 142
Griffiths, Aaron 373, 385
Grigoroff, Marc X 158
Gross, Avery 172
Gross, Mark 78, 106
Grotrian-Steinweg, Gesine 265
Ground Zero 81
Gryniewski, Joel 407
Guardian, The 149
Gueguen, Philippe 164
Guiteras, Drew 407
Gundzik, Jay 98
Gustafson, Laurie 172
Guy, James 371
GWA 123
Gwee, Wei Ling 32

{ H }

h2o media AG 374
Haan, Noel 130, 202
Haase, Esther 199
Hackley, Billy 311
haefelinger+wagner design 306
Hagmeier, Klaus 156
Hahm, Catherine 404, 406
Hakuhodo, Inc. 119, 288, 315, 333, 334
Hakuhodo I-Studio Inc. 375
Hakuhodo Inc. 169
Haley, Denny 96
Hall, Charles 153
Hall, Graeme 127
Hamasu, Hideki 43
Hamburger, Lawrence 131
Hamburger Bahnhof–Museum Für Gegenwart 220
Hamm, Garrick 338
Hampartsoumian, Arto 295, 356, 371
Hampe, Vera 123
Hampton, Tyler 143
Han, Heather 400
Haneld, Björn 141
Hanes Beefy-T 311
Hannich, Thomas 300
Hansaplast 164
Hansmerten, Catrin 179, 184
Happy Forsman & Bodenfors 285, 307, 308
Harpy Design 215
Harris, Andrew 348, 351
Harris, Nancy 180, 301
Harron, Christine 55
Harry N. Abrams, Inc. 239, 262
Hart, Joseph 259
Hartshorn, Nicole 31
Hashida, Yasuhiro 169
Hashimoto, Shintaro 83
Hassos, Elias 300
Hastings Audio Net-

work 141
Hasui, M. 47
Hatano, Kenichi 237
Hatcher, Chan 49
Hathiramani, Jackie 40, 58
Haufe, Daniela 220
Hauser, Isabelle 117
Haveric, Emir 198
Havey, Amanda 344
Haviv, Ron 153
Haxton, Kim 90
Hayashi, Noriaki 328
Hayashi Design 328
Hayes, Sophie 371
HBO 140, 169, 174
Hearts Oricom 44
Heck, Gabriele 130
Heffels, Guido 282
Heimat 282
Heinzel, Andreas 130, 156
Helgason, Winston 76
Hello Design 371
Hemley, Darcy 298
Henderson, Hayes 311
hendersonbromstead-art 311
Henkel, Mathias 130, 156
Hering, Oliver 374
Herman Miller, Inc. 259
Herndon, John 298
Herold, Patrick 403
Herrmann, Joel 383
Hervé, Alexandre 151, 155, 210
Herzik, Keith 298
Heuel, Ralf 124, 198
Heuter, Karen 342
Hewitt, Fiona 366
Hewlett-Packard Inc. 367, 385
Hewlett Packard 39, 77, 143
He Said She Said 170, 310, 333
Hickmann, Fons 265
Hicks, David 88
Highway 61 49
Higuchi, Tomoko 169
Hildebrand, Christoph 172
Hillman, Mark 339
Hine, Nick 115
Hines, Mark 366
Hinrichs, Oliver 379
Hinz, Nathan 383
Hird, Tony 173
Hirsch, Joshua 359, 376
Hoagland, Christian 40, 58
Hobbs, John 212
Hodge, Carol 31
Hodge, Jack 31
Hodgson, Peter 39
Hodson, Peter 148
Hoedl, Frank 79
Hoffman, Jeremy 304, 309
Hoffmann, Julia 304
Hofgaard, Anders 254
Höfler, Mark 361

Hoinkes, Michael 170, 310, 333
Holden, Eric 92
Holden, Vanessa 298
Holley, Lisa Wagner 215
Hollingsworth, Jovaney 326
Hollister, Bill 40
Holtslag, Jan 166
Homnick, Joshua 371
Hong, Dong-Sik 325
Honigsberg, Hal 77
Honjo, Naoki 277
Hook, Oliver 375
Hooper, Justin 76
Hope, Tim 143
Horn, Jody 352
Horne, Kelsey 118
Hornor, Tim 31
Horowitz, David 89
Hoshi, Tetsuya 355
Hosking, Jim 132
House Foods 169
Howard, Brody 48
Howard, Mike 36
Howell, Saadi 371
Howie, Craig 131
Hsu, Karen 239
Hudson Repro 159, 281
Huger, Guillaume 210
Hughes, James 203, 298
Huidi Lauhoff Modedesign 379
Hultberg, John 200
Hungry Man 134, 142
Hunter Gatherer 344
Hurst, Mark 163
Huxham, Howard 75
Hwang, Mi-Jeong 325
Hwang, Paul 371

{ I }

Icard, Arnaud 371
Ichikawa, Katsuhiro 334
Icke, Russel 94
Ignacio, Lem Jay 371
IKEA 136, 137
Ikebe, Ryuji 246
Ikeda, Bruce D. 295, 356
Immesoete, John 78, 106
Inayoshi, Mai 315
Independent Media, Inc. 140
Inlingua Language Center 172
Inoue, Satoe 308
Intamas, Phunyawee 56
International History Channel 81
IntroNetworks, Inc. 378
Investors Chronicle 329
ioResearch 378
Ishay, Michelle 233
Ishihara, Michiko 158
Ishii, Hiroki 47

Ishikawa, Junya 47
Ishikawa, Yohei 47
Islands Of The Bahamas Ministry Of Tourism, The 383
Itakura, Keiko 208
Italian Glamour 201
Ito, Seiji 334
Iwasaki, Katsuhiko 372
Iwata, Yuki 334
Iyama, Koji 240, 322
iyama design 240, 322

{ J }

Jacobs, Brian 374
Jäger, Achim 375, 377
Jaggy, Alexander 189
Jalabert, Alain 128
Jalal, Ghazia 343
Jalfen, Martin 139
James, John 378
Janetzki, Mark 294
Jans, Markus 300
Japan Snow Project 84
Jaroensuk, Chukiat 56
Jasper 300
Jay, John C. 43, 295, 356, 371
Jean, Billy 210
Jefferson, Michael 298
JeffGoodby 74
Jenkins, Jayanta 43
Jensen, Marc 377
JGF Films 133
Ji, Peng 162
Jiffy Lube 163
Jilka, Mario 369
Jodaf 131
Jofré, Cristián 226
Johansson, Christian 376
Johansson, Ulf 93, 94
John, Margaret 88
Johns, Emma 378
Johnson, Eric 31
Johnson, Michael 270
Johnson, Nate 31
Johnson, Pete 342
Johnson Banks 270
Johnston, Simon 262
Jones, John 378
Jong, Marcel de 376
Jong, Pjotr de 254
Juan, Ana 214
Jucarone, Tom 135
Juenger, Nico 121
Juliano, Jennifer 225
Jünemann, Marcelo 298
Jung von Matt AG 125, 189, 375, 377
Jupiter Drawing Room, The 243
Jurewicz, Billy 377

{ K }

K, Justin 45
K2R 175
Kakehashi, Ikuo 334
Kalil, Diogo 342
Kalleres, Greg 134, 153
Kamen, Jon 46, 49

Kamitani, Taro 47
Kamiya, Shoji 47
Kamstra, Matthijs 376
Kane, Riley 377
Kano, Yuji 158
Kano Shikki Co., Ltd. 318
Kao, Goretti 203
Kasai, Masakatsu 358
Kassaei, Amir 68
Katamura, Fumihito 328
Kato, Hisaki 371
Katsura, Sumiko 43
Katzenstein, Rob 147
Kauffmann, Astrid 34
Kavander, Tim 161
Kawahara, Jean 132
Kearns, Tony 143
Kearse, John 36, 40, 58
Keefe, Damon O' 371
Keeler, Patrick 263
Keister, Paul 36
Keiwa Package 322
Keller, Andrew 49, 137
Keller, Jan 382
Kellogg's 156
Kelly, Paul 137
Ken Woo Photography 118
Keogh, Scott 374
KesselsKramer 342
Kett, Matthew 136
Keyton, Jeffrey 345
Keyzer, Carl De 117
Khair, George 75
Khan, Yasmin 405
Kid's Wear 300
Kids Wear Magazine 179, 184
Kiger, Kris 378
Kilroe, Brett 203
Kim, Beom Seok 397
Kim, Sung-Jae 325
Kim Co., Ltd. 334
Kinast, Teresa 121
Kinze, Carlotta 300
Kirschenhofer, Bertrand 34
Kissack, Eric 402, 408
Kit, Lam Man 380
Kitamura, Keita 358
Kitani, Yusuke 355, 363
Kittel, Andreas 307
Kladivar, Vojko 335
Klein, Ben 47
Klein, Marilyn 47
Klinkert, Matthijs 376
Klohk, Sven 172
Klyce, Ren 52, 60, 72
Knapp, Ben 379
Knapp, Karin 189
Knaub, Eugenia 394
Knittel, Julia 374
KNSK Werbeagentur GmbH 123
Koch, Joerg 299
Kochs, Oliver 374
Kodaira, Masayoshi 253, 261, 331
Koeth, Sascha 226
Koeweiden, Jacques 263, 272
Koeweiden Postma

263, 272, 322
Koide, Wakana 44
Koike, Hiroshi 358
Kojima, Yousuke 237
Kolle Rebbe Werbeagentur GmbH 172
Kondo, Chiharu 321
Koning Eizenberg Architecture 248
Kooij, Bart 68
Kornestedt, Anders 285, 307, 308
Kosel, Tiffany 36
Koshio, Shinsuke 356
Kosolpothisap, Pongsathon 56
Kott, Carolin 141
Kouchi, Sumie 44
Kovacevic, Lina 287
Koyama, Kazuaki 334
Koyama, Nanako 277
Koyama Tofu Co., Ltd. 334
Koza, Dave 134
Krabbendam, Diana 272
Kraft 130, 202
Krallman, Randy 64, 85
Krallmann, Andreas 172
Kreuser, Carla 243
Krieg, Gary 134, 135
Kriss, Evan 301
Krisztian, Gregor 394
Krysa, Danielle 348
Kubo, Satoru 308
Kudelka, Marty 76
Kukuchi, Shojee 356
Kumagai, Jun 274, 317
Kunio, Ogo 371
Kuntz, Tom 90
Kuntz & Maguire 88
Kurigami, Katsushi 47
Kurosawa, Yasunari 323
Kurt, Chris 369
Kurzawski, Thomas 154
Kutschinski, Michael 382
Kysar, Mary 202

{ L }

Lable, Jeff 81
LaBonge, Lilly 133
Lace Sneakers Magazine 315
Lai, David 371
Lai, Jeffrey 290
Lakowski, Boris 379
Lambl, Florian 300
Landrum, Kellis 371
Lasch, Chris 364
Lau, Freda 371
Laurence, Josh 228
Lawley, Rick 140
Lawner, Ron 36, 40, 58
la comunidad 139, 168
Leaney, Angela 225
Lear, Mike 36, 147
Leblanc, Eric 206
Lebowitz, Michael 359,

376
Ledner, Catherine 211
Lee, Matt 149
Leepakpreeda, Wiboon 56
Lees-Rolfe, Michael 110
Lee Dungarees 48
Leigh, Joshua 270
Leine & Roebana 322
Leinfelder, Bernd 374
LeMaitre, Jim 142
Lenz, Melanie 368
Lenz Films 31
Leon, Pedro 356, 371
Leo Burnett 130, 156, 166, 172, 202
Leo Burnett, Frankfurt 130, 156
Leo Burnett Amsterdam 166
Leps, Stephen 55, 136, 137
Leroux, Benoît 162
Lescure, Céline 151
Lester, Shane 356
Leung, Christel 371
Lewin, Adam 159, 281
Liang, Sebastian 162
Lieck, Claus 190
Lillo, Igor Jadue 97
Limpisirisan, Passapol 56
Lind, Alex 74
Linnen, Scott 36
Lippoth, Achim 179, 184, 300
Liric Kaori Sakurai 273
Liric Yayako Uchida 223
Liss, Steve 82
List, Pete 296, 343
Litner, Tony 383
Little More 223
Litzinger, Jan 226
Ljubicic, Boris 332
Lo-V 42
Lobo 342
Loeb, Maury 60
Lofting, Nick 250
Loncraine, Richard 228
Long, Paul 118
Longawa, Rebecca 377
Longley, Nicholla 371
Lony, Pieter 68
Lord, Tom 377
Lorentz, Edith 414
Lowe, Scott 371
Lowercase, Inc. 307
Lu/Mikado 134
Lubars, David 49, 75, 91, 105, 165, 169, 174
Luczynski, Tomek 379
Ludwig, Ross 154
Luppino, Michael 298
Lynn, Elspeth 55, 136, 137
L A N D I A 139

{ M }

M2 Hair Culture 171
Macedo, Cadu 342
Mackall, Kevin 64, 85,

87, 89
MacKellar, Ian 88
MacKenzie, Doug 39
Mackenzie, Ian 142
Mackenzie Cutler 134
Mackler, Jonathan 142
MacLaren McCann
 West 118
Macromedia 378
madeinLA 393
Madill, Alan 88
Mad River Post 135
Mag-Lite 403
MagnaMana 130
Magnum 320
Magnusson, Magnus
 298
Maguire, Mike 90
Maiorino, Chris 169,
 174
Mak, Zarina 90
Makkar, Ash 371
Makowski, Jason 200
Malcolm, Clark 259
Mamero, Sven 197
Manikas, Konstantinos
 121
Mann, Romy 345
Manning, Rudy 371
Manthey, Andreas 282
Marciano, Kymberly
 300
Marcolin, Catherine
 120
Marcondes, Guilherme
 342
Marmo, Rogério 342
Marois, André 278
Marquardsen, Anika
 316
Martha Stewart Living
 Omnimedia 211, 212
Martinez, Eddie 45
Martin Agency, The
 147, 156
Marucci, Jerome 150
Maryon, Dean 52, 72
Masami Design, Ltd.
 314
Mason, Brett 46
Massive Music 141
Mastin, Charles 374
Mastromonaco, John
 137
Masumoto, Shinichi 47
Matadin, Vinoodh 183
Matching Studio 56
Matejczyk, John 105,
 139
Matera, Keif 64, 85
Matsuda, Toshinori 208
Matsue, Taiji 253
Matsumura, Ken 375
Matsushiro, Takako
 363
Matsushita, Tomonori
 208
Matsushita Electric
 Industrial Co., Ltd.
 208
Mauss, Peter 248
Mavrodinova, Velina
 314
Maxmouse, Inc. 363

May, Richard 217
McArthur, Hamish 159,
 281
McBride, Chuck 60, 97
McCann, Jason 348,
 351
McCarthy, Suzanne 40
McClelland, Patrick
 142
McCommon, Mike 132
McCullough, Bill 140
McDaniel, Melodie 153
McDonald, Douglas 374
McDonald, Jock 374
McDonald's 172
McElwaine, David 345
McGill Productions 118
McGinley, Ryan 180
McGinness, Will 367,
 373, 385
McHale Barone 144
McHugh, Peter 52, 72
McKellar, Tyler 74
McMahon, Dan 339
McMann, Kathy 40
McNagny, Phil 402, 408
McNeil, Paul 416
Meadus, Mike 118
Medecins du Monde
 128
Medecins Sans Fron-
 tieres 117
Meier, Raymond 196,
 258
Meiji Seika Kaisha,
 Ltd. 158
Meiré, Mike 300
Mele, Frank 371
Melia, Suzanne 39
Merhige, Elias 140
Merkin, Ari 82, 90, 91,
 150, 152, 366
Merrifield, John 32,
 83, 167
Metatechnik 87
Method 60, 339
Meyer, G. Andrew 130,
 202
Meyer, Garth 200
Meyers, Dave 43
Meyersfeld, Michael
 63, 112
mi2lab 287
Miami Ad School Eu-
 rope 403
Michaelson, Joe 377
Michaud, Sophie 199
Michelson, Barbara
 144
Miller, Abbott 304, 309
Miller, Lorna 264
Miller, Matt 409
Miller, Oliver 130
Milter, Joanna 301
Minami, Haruki 44
MINI Canada 348, 351
Mita, Yoshihiro 44
Mitoh 170, 310, 333
Mitri, Clinton 63, 112
Mitsuhashi, Ryohei 358
Mit Out Sound 52, 72
Miyamoto, Hitoshi 169
Miyata, Satoru 273
Mizukawa, Takeshi 372

Mizuno, Manabu 277,
 323
MJZ 137
Mochinaga, Nobuya
 169
Mochizuki, Kaori 372
Mohrs, Greg 172
Mok, Carl 343
Mollá, Joaquín 168
Mollá, José 139, 168
Moller, Peter 226
Moltedo, Sebastián 109
Mondino, Jean-Baptiste
 186
Montague, Ty 134, 135,
 153
Montessano, Julian 139
Montgomery, John 172
Montreal Jazz Big Band
 330
Moon, Cindy 36
Mooney, Yann 327
Moore, David 130
Moore, Zara 270
Moran, Michael 341
Morimoto, Chie 315
Morimoto, Koji 43
Morio, Takashi 375
Moriya, Koichi 340
Mori Building 47
Moroze, Adam 147
Morton, Rocky 137
Morton Jankel Zander
 90, 137
Mosothoane, Teboho
 126
Mould, Peter 149
Mouly, Françoise 213,
 214
Mountain Dew 100, 101,
 102, 143
Mount Sinai Medical
 Center 144
Mowrer, Sue 31
Moynihan, Anthony 47
Mr. McElwaine 345
Mroueh, Zak 67, 120,
 148
MTV 64, 65, 85, 86, 87,
 89, 345
MTV International 226
MTV Networks 87, 296
MTV On-Air Promos
 64, 85, 87, 89
Muldoon, Tom 100, 101,
 102, 143
Mullen 133
Müller, André 265
Mulloy, Laura 146
Mumbleboy 371
Muniz, Vik 206
Murai, Yasusuke 336
Murasawa, Chihiro 44
Murphy, Tim 257
Murr, Nancy 374
Murro, Noam 60, 71,
 74, 91, 140
Museum of Modern Art,
 The 364
Musicline 369
Muto, Yuichi 274, 317
Muzak 407
Mykolyn, Steve 348,
 351

{ N }

N, The 225
N.G. Inc. 334
Nachtwey, James 152
Nadurata, Josefina 98
Nagai, Hiroaki 334
Nagai, Yuji 318
Naidu, Asheen 63, 112
Nakagawa, Mikiko 47
Nakajima, Hideki 299
Nakajima, Hirofumi
 83, 167
Nakajima, Tomomi 336
Nakajima Design 299
Nakamura, Hiroki 355,
 363, 372
Nakamura, Miki 47
Nakamura, Yugo 358
Nakane, Hiroaki 138
Nakaoka, Minako 273
Nakatsuka, Hiroshi 44
Nantz, D. Garrett 376
Nara, Yositomoto 261,
 331
Narciso, Brenda 31
Nathan, Danny 411
National Federation of
 UNESCO Associa-
 tions in JAPAN 363
National Funds for Dis-
 abled Sporters 166
Natsuka 47
Natzke Design 385
NB: Studio 311, 329
Neary, Jack 88
Nebraska Domestic
 Violence Sexual As-
 sault Coalition 145
Neckar Valley Green
 Space Foundation
 377
Nelesen, Mike 377
Nelson, Sharon 136
Nemoto, Kazuya 84
NET#WORK BBDO 63,
 112, 146, 297
Neubauer, Julia 193
Neue Digitale GmbH
 368
Neuman, Brian 85
Neumann, Wyatt 31
Neves, Virgilio 160
Newbery, Bill 161
newnew films 88
Newton, Marianne 78,
 106
New Yorker, The 213,
 214
New York Times, The
 180, 183, 186, 196,
 206, 209, 211, 231,
 258, 301, 302, 303
New York Times Maga-
 zine, The 180, 183,
 186, 196, 206, 209,
 211, 231, 258, 301,
 302, 303
Ng, Cary 402, 408
Nicholls, Steve 76
Nickelsberg, Mark 49
Nick Digital Networks
 Brand Communica-
 tions 225

Nicol, Jonathan 278
Nicolas, Cedric 60
Niemann, Christoph
 231
Nike 43, 46, 93, 94, 120,
 163, 210
Nike Asia Pacific 43
Nikowitsch, Markus
 374
Nikowitsch, Rob 374
Nishioka, Noritoshi 237
Nista, Naomi 298
Niwa, Hiro 371
Nixdorf, Meike 190
Nixon, Ashley 342
Nobre, Paula 342
Noda, Nagi 138
Noel, Rémi 92
Noguchi Foundation
 309
Nohara, Yasutada 208
Nojiri, Daisaku 315
Nolting, Ralf 124, 198
Nordpol + Hamburg 34,
 141, 361
Norman, John 77, 143
Norsen, Karl 31
North American Coffee
 Partnership 91
North Kingdom 373
Norwell, Jeff 148
Nothdurft, Manuel
 Hernandez y 226
Nowak, Jon 48
NPO Harappa 331
NPO harappa 261
Number Seventeen 245

{ O }

O'Brien, Glenn 245
O'Connor, Tom 81
O'Keefe, Sarah 294
O'Kelly, Mariana 146
O'Leary, Scott 48
O'Neil, Deannie 52, 72
O'Neill, Justin 180
O'Rourke, Ryan 94
Obando, Roger 371
Oberman, Emily 245
Oceanmonsters 371
oco 240
Odaka, Naoko 237
Öding, Katrin 197
Ogilvy 126, 171
Ogilvy & Mather Frank-
 furt 171
Ogilvy Brasil 160
Ogilvy Brazil 365, 370,
 384
Ogilvy Cape Town 110
Ogilvy Interactive
 Worldwide 382
Ogilvy Repro 110, 126
Ohgushi 47
Ohsugi, Gaku 319
Oiler, Megan 412
Oishi, Emiko 237
Oka, Yasumichi 84
Okamura, Masato 340
Okino, Yoshiaki 334
Okkararojkij, Sittichai
 56
Olivieri, Sebastián 109

Olson, Carla 98
Olsson, Mikael 308
Omnific 286
Omnivore, Inc. 239
Onaga, Kumio 84
Onart, Sean 31
One Union Recording 146
Onion, The 147
Onodera, Tsunetoshi 237
Oohigashi, Shunichi 375
Oppmann, Simon 171
Oron, Avi 60, 71, 91
Oshiro, Byron 43
Oshiro, Eiichiro 47
Ostrovskaya, Anna 412
Otto, Mary Jane 71
Outpost Digital 43

{ P }

Pagano, Alexandre 157
Paintura 336
Palmer, Chris 142
Palmer, Rob 71
Palumbo, Vic 94
Panic & Bob 55
Papierfabrik Scheufelen GmbH+Co. KG 316
Paprika Communications 206, 330
Papworth, Kim 371
Paranoid Projects: Tool of North America 77
Parcero, Adriana 393
Parcero, Tatiana 393
Park, Young-Jun 325
Parker, John 147
Park Pictures 52, 72, 135
Parmalat South Africa 110
Parr, Martin 300
Parr, Will 269
Parslow, Ray 306
Parsons School of Design 341
Partizan 100, 101, 102, 132, 143
Parubrub, Richard 133
Passion Pictures 143
Paterson, Ewan 149
Patterson, Ewan 142
Pätzold, Patricia 124, 198
Patzschke, Reinhard 198
Paul Davis Studio 215
Pavesic, Tieneke 43
PBS 140
Pearce, Jon 266
Pearlman, Chee 341
Pearson, Josh 46
Peck, Ryan 48, 105, 139
Pedonti, Carron 36, 40, 58
Pehl, Penny 398
Pelletier, Louis-Thomas 327
Peng, Jack 295, 371
Pentagram 248, 292,

304, 309, 341
Pentagram Design 374
Pepper, Stephen 76
Perarnaud, Edouard 155
Pereira, Roberto 157
Perez, Facundo 139, 168
Perlman, Hank 142
Perlorian Brothers, The 55
Persson, Fredrik 308
Petchsuwan, Suthon 56
Peters, Ruediger 368
Peterson, Barry 60
Petrov, Alexander 75
Petter, Rianne 254
Peugeot Automobiles 92
Pfennighaus, Max 36, 40
Pham, Anh Tuan 364
Phernetton, Ross 96
Phiffer, Dan 371
Philipp und Keuntje 197
Philp, Mick 31
Photonica 311
Phua, Aaron 131
Pictorian 34
Pienaar, Andre 67
Pigagaite, Ramune 300
Pittman, Mikal 202
Piva, André 42
pixelpusher.ca 348, 351
Pohl, Ulrich 379
Police division of Gooi and Vechtstreek 263
Polidor, Eduardo 371
Pollack, Kira 183, 231, 301
Porostocky, Thomas 330
Porter, James 348, 351
Port Authority 292
Postma, Bren 163
Potempa, Olga 171
Potter, Jon 207
Powell 45
Powell, Neil 45
PPBmex Animation 75
Pratt, Leo 139
Pratt Institute 414
Praxis Design 262
Preston, Robin 121
Prevette, Mike 31
Prins, Robert 266
Procter, Kira 120
Proctor, Sundy 93
Prole, Mark 148
Prologue Films 228, 250
Proudfoot, Kevin 134, 135, 153
Publicis Dialog 39
Publicis Frankfurt GmbH 121
Publicis Mojo 163
Publicis Werbeagentur AG 117
Pucion, Aldo 371
Puckett, Tod 74

{ Q }

Q42 376
Quartilho, Marcio 42
Quidu, Noël 117
Quinn, Joanna 75

{ R }

R&D&Co. 207
R/GA 378
Racing Victoria 294
Radziwanowska, Bianca 172
Raedeker, Jochen 316
Ragette, Anita 374
Raimondi, Fred 52, 72
Rainier Brewing Co. 31
Raith, Tom 298
Ralston, Matt 31
Ratcliffe, Jo 338
Rathgeber, Kevin 79
Ray, Gordon 126
Rea, Brian 231
Recom 190
Redtree Productions 40, 58
Reed, Ryan 110, 126
Regan Books 233
Regan Books/Harper-Collins 233
Reginald Pike 55, 98, 136
Reilly, Rob 49
Reinfurt, David 417
Reinhardt, Megan 367, 385
Renault Deutschland 121
Renault Nissan Deutschland AG 34
Renner, Paul 134, 135, 153
Revell 130
Reyher, Levin 156
Reynolds, Josh 77
Rheingold Beer 45
Ribaudo, Patrizia 379
Ribeiro, Rodrigo 160
Riccardo Cartillone Schuheinzelhandels GmbH 141, 361
Richards, Todd 259
RichSilverstein 74
Riddle, Jarrod 377
Riddle, Todd 383
Rijksmuseum Amsterdam 376
Rijpsma, Pim 376
Roberts, Gwyn Vaughan 264
Robinson, Barry 374
Robinson, Jamie 298
Robson, Gayle 79
Rodrigo Corral Design 233
Roe, Chris 78, 106
Roemmelt, Peter 171
Rogers, Josh 45
Rolfe, Dave 49
Romanos, Daniel 109
Rompza, Serge 254
Ropez, Sergio A. 47
Rosen, Jonathon 259
Rosenbrand, Sander 376

Rosenburg, Marc 140
Rosnick, Ted 55
Rosnick Mackinnon Webster 55
Roussou, Eve 175
Rowe, Ernest 378
Royal Mail 286
RSA USA 60
Rühmann, Björn 34, 141, 361
Rühmann, Lars 34, 141
Runge, Clint 145
Russell, Alan 79
Russo, Davi 46
Russoff, Michael 371
Rusznyak, Jack 115
RWE 197
Ryan, Jay 298
Ryan, Kathy 180, 183, 196, 206, 258, 301, 302, 303
RZA 43

{ S }

Saatchi & Saatchi 281
Saatchi & Saatchi New York 159
Sacks, Andy 259
Sader, Mario 342
Sadler, John 295
Sagawa, Fumihiko 363
Sahara, Yasuo 47
Sahre, Paul 388
Saint, Warwick 298
Saito, Kazue 47
Saito, Kei 340
Saito, Keigo 47
Sakaguchi, Shotaro 237
Salazar, Rachel 140
Salvarredi, Juan 109
Samata, Greg 203
Samuel, Rupert 36, 49
Sanches, Luiz 157
Sanders, David 206
Sands, Rick 402, 408
Sankyo Co., Ltd. 372
Sano, Katsuhiko 375
Santana, Jonathan 297
Sarapina, Victoria 394
Sasaki, Keiichi 169
Sato, Sumiko 43, 356, 371
Saturn 373
Scandal Music 78, 106
Schalit, Mike 63, 112, 146, 297
Scheer, Corinna 190
Schenk, Marty 141
Scher, Paula 248, 304
Scherma, Frank 46, 49
Scherma, Tom 36, 40, 58
Scherrer, Melissa 298
Schittny, Burkhard 193
Schlatter, Robert 259
Schlienger, Philippe 200
Schlittenbauer, Robert 374
Schmidt, Christian 190, 197
Schmidt, Stefan 154,

174
Schmidt und Bender GmbH Co. KG 375
Schneider, Don 169, 174
Schneider, Wolfgang 68
Schoenburg, Sophie 103
Scholz & Volkmer 379
School Editing 136
School of Visual Arts 330, 388, 400, 410, 412, 413
Schrager, Victor 212
Schubert, Angela 154
Schubert, Niels 316
Schüler, Christoph 34
Schultchen, Jan C. 123
Schultz, Kim 366
Schumeth, Andrea 348, 351
Schuster, Stephen 250
Schuster, Thies 198
Schuster, Wiebke 34
Schwalenberg, Katja 220
Schwarz, Linda 306
Schwarze, Markus 369
Schweickhardt, Heiko 368
Schwieger, Eric 411
Schwieker, Klaus 123
Scott, Doug 120
Scott, Jake 60
Scott, Jen 31
Scott, Zachary 231
Seah, David 131
Sealy 133
Sebbah, David 196, 206, 211, 258
Seeger, Hans 298
Sega, Nanae 169
Seisser, Tod 159, 281
Sekiguchi, Tadao 47
Selimi, Bejadin 368
Senn, Marty 82
Sensebe, Brian 343
Senstad, Anne Katrine 200
Serpa, Marcello 103
Serpick, Stephanie 298
Setabuth, Asada "Pip" 295
Seto, Jeff 380
Shachter, John 298
Shane, David 134
Shanks, James 309
Shea, Tanner 352
Sheahan, Molly 82
Shembeda, Brian 172
Shen, Rabbit 162
Sheppard, Leonora 190
Sher, Jena 341
Shiina, Yasushi 295
Shimizu, Rokurota 84
Shiozaki, Masatomo 375
Shirai, Keitaro 208
Shiratori, Shintaro 158
Shoaf, Temma 134, 135
Showalter, Kelly 31
Shulteis, Amy Jo 96
Shur, Limore 343
Siakimotu, Gavin 127

Sibley/Peteet Design Dallas 324
Sides, Brandon 40, 58
Siegal, Meghan 36, 40
Siegler, Bonnie 245
Sigg, Stephanie 153
Silbersee Film 34
Silver, Eric 142
Silverstein, Rich 77, 143
Simba Ghost Pops 63, 112
Simmons, John 207
Simon Finch Rare Books 257, 381
Simpson, Garry 115
Simpson, Steve 77, 143, 367, 385
Sinclair, Rob 45
Sinkinson, Topher 202
Skinner, Grant 378
Skoda 154
Skrabal, Philipp 117
Skyback, Johan 294
Slater, Paul 149, 329
smakdesign 315
smartUSA 374
Smb/Dumont 220
Smejia, Jennifer 93
Smith, Bart 36
Smith, Jimmy 43, 46
Smith, Kevin R. 96
Smith, Lisa 234, 264, 320
Smith, Patti 200
Smith, Philipa 94
Smith, Scott 68
Smith & Jones Films 93, 94
Smrczek, Ron 120
Smuggler 60, 97
Smythe, Rupert 142
Snagg, Melanie 98
Snyder, Zach 250
Soh, Calvin 131
Soken Electronics Co., Ltd. 56
Someno, Satoshi 334
Songsri, Nimit 56
Sony 154, 164
Sorrenti, Vanina 300
Soto, Jon 132, 352
Soundscapes 145
Sound Lounge 135
space150 377
Spiegel, Jeff 266
Spiller, Darren 163
Spinadel, Cody 156
Spinatsch, Jules 189
Spin Images 110
Spitzfaden, Jill 383
SpotWelders 52, 72
Sprint PCS 146
Spuibroek, Isis 376
Spy Films 76
St. James, Lee 159, 281
St. John, Todd 344
Stadler, Christian 376
Stanley, Ken 294
Stark, Russ 383
Starkey, Bill 133
Starkman, Aaron 55, 136, 137
Starvoe, Terry 137

Stavoe, Terry 36
Stechschulte, Paul 36
Steele-Perkins, Chris 270
Stefansson, Jon 36
Steger, Peter 130, 156
Steidl Verlag 239, 262
Steiner, Daniel 141
Stevens, Sunshine 31
STIHL 155
Stiller, Mathias 68
Stink 131
Stocksmith, Chris 383
Stoddart, William 199
Stoique&Co. 336
Stoller, Aaron 64, 85
Stone, Holly 75
Stone, Les 152
Stork, Paul 376
Storm King Art Center 414
Stott, Ben 311, 329
Strasberg, Rob 49
Strasser, Sebastian 68
Straumann 117
Streibl, Georg 374
Streigal, Jason 366
strichpunkt 316
Strobelgasse Werbe-gesellschaft M.B.H. 379
Strong, Nick 166
STUDIO4 43
Studio Funk 130
Studio International 332
Suede Magazine 202
Suesstrunk & Jericke 117
Sugahara Glassworks Inc. 240
Sugiura, Yutaka 158
Suisman, Maggie 417
Sunaga, Eiji 319
Sundell, Mike 136
Sung, Angela 161
Sung, Jae-Hyouk 324
super2000 226
Super Cheap Auto 306
Suzuki, Aco 358
Swartz, Dave 36
Sweden Style 277
Swedish Museum of Architecture, The 285, 308
Sweeney, Mark 146
Sylvester, Mark 378
Szymanski Clean Man-agement 310

{ T }

Tabasco 162
Tabery-Weller, Tracy 48
Tada, Keizo 237
Tada, Taku 84
Tahir, Tal 383
Taiyo Printing Co., Ltd. 274, 317
Takada, Tsutomu 208
Takada, Yui 277
Takagi, Hisayuki 358
Takahashi, Go 323

Takahashi, Hiroshi 32
Takahashi, Makoto 334
Takahashi, Masami 314
Takahashi, Shumei 158
Takahashi, Wakana 47
Takahiro, Norihiko 375
Takakusaki, Hirozumi 355, 363
Takasaki, Takuma 158
Takayama, Yasushi 295
Takimoto, Mikiya 246, 261, 315, 331
Talbott, Kate 49, 75
Tamura, Shoichi 355
Tan, Christina 79
Tanaka, Atsushi 375
Tanaka, Hideyuki 84
Tanaka, Kenji 371
Tanaka, Koichiro 358
Tanaka, Ryusuke 315
Tanaka, Tatsuyuki 43
Tani, Sharon 371
Taniguchi, Hiroyuki 84
Tao, Lorraine 55, 136, 137
Taras, Seth 81
Taroux, Philippe 162
Tatarka, Allon 91
TAXI 67, 120, 148, 348, 351
Taylor, Christine 174
Taylor, Mark 137
Taylor, Scott 324
TBWA\G1\Tokyo 169
TBWA\Germany 154, 174
TBWA\Japan 32, 83, 167
TBWA\Paris 115, 128, 162, 164, 175
TBWA\Shanghai 162
TBWA\Vancouver 98
Team, Jodaf 131
Team One 266
Télécréateurs, Les 134
Telefónica 109
Tenorio, Joao 342
Teshima, Masao 295
Tetens, Bettina 190
tha Ltd. 358
THE_GROOP 371
ThereMedia, Inc. 200
Think London 270
Thirache, Sylvain 151, 155, 210
Third Floor Editing 67
This Way, Inc. 308
Thoburn, Elliot 264
Thomas, Iain 243
Thomas, Joanne 243
Thomas, Kevin 105, 139
Thomas Thomas Films 105, 139
Thompson, Sean 371, 411
Thomson, Kevin 31
Thotland, Lisa 377
Three in a Box, Inc. 120
Tikhomiroff, Joao Daniel 131
Tilby, Wendy 75
Time Inc./Real Simple 298
TIME Magazine 82, 152

Tindall, Justin 149
Ting, Tricia 40, 58
Tinge Design 416
Tinson, Charlie 371
Tischner, Dylan 74
Tohokushinsha Film Corporation 84, 358
Tokyoplastic 371
Tokyo Electric Power Company 340
Tokyo FM Broadcasting Co., Ltd. 358
Tokyo Great Visual Inc. 208
Toma, Kenji 259
Tomine, Adrian 213
Ton 317
Tongmyong University of IT 325
Toriyama, Tsuneo 169
Torres, Toni 212
Toshiba Corporation 358
Tourres, Clementine 32
Towey, Gael 211, 212
Towvim, Josh 105
Traenkle, Markus 117
Traktor 100, 101, 102, 143
Transcontinental Litho Acme 206
Trapp, Klaus 130, 156
Trees, Joshua 371
Treichel, Daniel 410
Tresnak, Elena 170
Trewern, Andrew 294
Trezza, Michael 376
Tricot, Rémy 134
Triplett, Gina 45
Triton Films 295
Tscherter, Thomas 306
Tsuchiya, Akane 358
Tsuji, Saori 334
Tsujimoto, Tadashi 32, 167
Tsukioka, Shinya 375
Tucker, Adam 149
Tucker, Nicola 76
Tüffers, Katrin 305
Tugboat 84
Tulinius, Tomas 124
Turnley, Gerard 63
Tuton, Mike 31
Tutssel, Mark 172
TV Asahi CG design room 44
TV Asahi Corpora-tion 44
Twinkle Co., Ltd 323

{ U }

Uchida, Shoji 138
Uchitel, Diego 200
uchu-country, ltd. 138
udru enje za razvoj kulture 287
Uemura, Nick 169
Ueno, Hiroyuki 315
Ueno, Nobuhiko 208
Uffelman, Daisy 373
Uherek, Henric 379
UltRA Graphics 246, 321

Umeda, Yo 352, 385
Umetsu, Takeshiro 375
Unilever 55
unit9.creative.produc-tion 367
United Airlines 49, 75
United Way of the Lower Mainland 79
Universal Pictures 228, 250
University of Applied Sciences Mainz 305
University of Applied Sciences Wiesbaden 394
University of Colorado, Boulder 409
University of Texas at Austin 411
untitled 67, 136, 137

{ V }

Vaillant 190
Valencius, Chris 40
Valente, Erica 42
Valente, Sergio 95
Van, Ludwig 131
Vancouver International Film Festival 98
Vandejong 254
van der Vlies, Gido 166
Van De Lagemaat, Simon 76
van de Weteringe Buys, Rob 105, 139, 140
van Dort, Job 294
Van Dyke, Chris 137
van Erp, Jeroen 376
van Lamsweerde, Inez 183
van Meer, Deen 322
Van Slembrouck, Justin 378
van Zon, Stan 166
Vasarhelyi, Teri 36
VCU Adcenter 407
Vega, Guillermo 109
Veksner, Simon 149
Veling, Kars 376
Vendramin, Daniel 204
Verdin, Jorge 371
Vervroegen, Erik 115, 128, 162, 164, 175
Vescovo, Matt 87
VH1 296, 343, 344
VH1 Latin America 139
Victor Entertainment, Inc. 208
Villains 130
Villiers, Jonathan de 298
Vim 55
Vior, Ricardo 168
Vior, Ricky 139
Virgin Mobile 366
Virgin Mobile USA 90, 150
Vitti, Guido 150
Vivre 138
Vodafone k.k. 375
Voelker, Ulysses 305
Vogel, Francoise 77
Vogt, Ethan 402, 408

Voigt, Patrick 298
Voigt, Thorsten 382
Volkswagen 124, 127, 131, 142, 149, 161
Volkswagen AG 68, 198
Volvo North America 402, 408
von Reis, Christopher 134
Vossen, Juergen 282
Vries, Marcel de 254

{ W }

Wagner, Frank 306
Walker, Micah 154
Walsh, Matt 378
Walz, Stefan 375, 377
Wanda 92
Ward, Philip 234, 264, 320
Warner, Ted 378
Warner Books 304
Warner Brothers 376
Warren, Vinny 68
Warshaw, Jeremy 49
Watanabe, Shinichiro 43
Watanabe, Suguru 208
Watanabe, Yoshie 223, 273
Waterbury, Todd 134, 135, 153
Watson, Dave 148
Watt, Julian 63, 112
Watts, Paul 142
Wauschkuhn, Michaela 34
WDDG 352
Weber, Susanne 172
Ween 366
Wegener, Claudia 193
Weil, Kymberlee 378
Weinblatt, Lauren 407
Weiner, Ann-Katrin 300
Weisband, Phyllis 228
Weiss, Bill 96
Welker, Stefanie 377
Wellard, imothy 47
Wells, Brian 67
Wengelnik, Holger 190
Wenneker, Mark 140
Wepster, Wim 376
Werk, Das 34
Weskamp, Marcos 355
Weymann, Nico 124
Wheatcroft, Mark 329
Wheeler, Brent 98
Whitaker, Jeremiah 31
Whitney Museum of American Art 239, 262
Widegren, James 359
Widmaier, Felix 316
Wieden+Kennedy 43, 46, 93, 94, 134, 135, 153
Wieden+Kennedy London 371
Wieden+Kennedy Tokyo 43, 356
Wieden+Kennedy Tokyo LAB 356
Wieden+Kennedy Tokyo Lab 295
Wieliczko, Christopher 200
Wientzek, Marc 282
Wightman, Jodie 311
Wilde, Richard 388
Wilkes, Justin 46
Wilkes, Stephen 203
Willey, Matt 257
Williams, Brian 377
Williams, Mike 202
Williams Murray Hamm 338
Willis, Matthew 381
Willvonseder, Claudia 121
Wilson, Cameron 327
Wilson, Kathleen 417
Windus, Chaz 371
Winfield, Wayne 144
Winkler, Jean-Claude 190
Winter, Bob 78, 106
Wixom, Rachel 239, 262
Wo, Wendy 380
Wong, Alex 152
Wong, Gwynn 131
Wong, Tony 371
Woods, Janet 55
WOOG 295, 356
Woolcott, Marcus 90, 366
Woollams, Julia 270
Worthington, Michael 406
Wu, Tif 162
Wu, Yi Chun 290
Wundrok, Ellene 298
W Communications 163

{ X }

X-Knowledge Co., Ltd. 253

{ Y }

Yale School of Art 415
Yale University School of Art 397
Yamada, Eiji 246
Yamada, Yukiko 246
Yamanaka, Naoya 138
Yamashita, Juliana Sato 417
Yan, Leon 398
Yang, Seong Im 413
Yasuda, Fukuo 328
Yasuda, Yumiko 274, 317
Ye, Annie 162
Yeo, Yang 131
Ying, Norman 380
Yokoi, Masaru 44
Yoon, Se Ra 414
Young, Justin 385
Young and Rubicam 173
YR Buenos Aires 109
Yu, Brandy 162
Yu, Calvin 98
Yu, Christina 88
Yungblut, Gord 161

Yutani, Katsumi 237

{ Z }

Zai AG 189
Zastera, Tim 403
Zehender, Stephanie 316
Zerban, Frank 226
ZiG 55, 136, 137
Zimmermann, Claus 369
Zumbrunnen, Eric 52, 72
Zuppiger, Mathias 117

INDICES

ADVERTISING AGENCIES AND PRODUCTION STUDIOS

Bascule Inc. 355
Dentsu, Inc. 237
FLAME, Inc. 253, 261
h2o media AG 374
IntroNetworks, Inc. 378
Maxmouse, Inc. 363
mi2lab 287
Natzke Design 385
North Kingdom 373
Q42 376
Scholz & Volkmer 379
TAXI 348, 351
THE_GROOP 371
Time Inc./Real Simple 298
Tohokushinsha Film Corporation 358
WDDG 352
Advertising Agencies and Production Studios
@radical.media 43, 46, 49
180 Amsterdam (180\TBWA) 52, 60, 72, 97
24+7 154
740 43
Acme Filmworks 75
Adbrain Inc. 158
Advico Young & Rubicam 161, 305
Ad Seeds Inc. 158
Alarming Pictures 31
AlmapBBDO 103, 157
Archrival 145
Arnold Worldwide 36, 40, 58, 161
AXYZ 88
Babble-On Recording 96
bartradio, inc. 36
BBDO Canada 88
BBDO Minneapolis 96
BBDO New York 100, 101, 102, 142, 143, 165, 169, 174
Beith Digital 63, 112,

146
BETC Euro RSCG 92, 134
Big Fish Filmproduktion GmbH 141
Biscuit Filmworks 60, 71, 74, 91, 140
Brand New School 64, 85
Chelsea Pictures 36
Chicago Recording Company 78, 106
Clatter & Din 31
Cobblestone Filmproduktion GmbH 68
Cole & Weber/Red Cell 31
Company X 67
Cossette Media 120
Crispin Porter + Bogusky 36, 40, 49, 58, 137
DDB Berlin 68
DDB Brasil 95, 131
DDB Canada,Vancouver 79
DDB Chicago 78, 106
DDB London 127, 142, 149
DDB PARIS 151
DDB Paris 210
Dentsu, Inc. Kansai 208
Dentsu Inc. 158
Dentsu Tec Inc. 158
DeVito/Verdi 144
Digital Domain 52, 60, 72
Downtown Partners Chicago 114
dreamdesign 47
East Japan Marketing & Communications Inc. 84
Ellipsis Pictures 31
Euro RSCG 402, 408
Euro RSCG Flagship Ltd. 56
Euro RSCG London 76
Fallon 75, 82, 90, 105, 131, 139, 140, 150, 152, 154
Fallon Minneapolis

48, 49
Final Cut Editorial 97
Furnace Media Group 402, 408
Goodby, Silverstein & Partners 71, 74, 77, 132, 140, 143
Gorgeous Enterprises 142
Grabarz & Partner Werbeagentur GmbH 124, 198
Ground Zero 81
GWA 123
Hakuhodo, Inc. 119
Hakuhodo Inc. 169
Hearts Oricom 44
He Said She Said 170
Highway 61 49
Hungry Man 134, 142
Independent Media, Inc. 140
JGF Films 133
Jodaf 131
Jung von Matt AG 125
KNSK Werbeagentur GmbH 123
Kolle Rebbe Werbeagentur GmbH 172
la comunidad 139, 168
Lenz Films 31
Leo Burnett 130, 156, 166, 172, 202
Leo Burnett, Frankfurt 130, 156
Leo Burnett Amsterdam 166
Lo-V 42
L A N D I A 139
Mackenzie Cutler 134
MacLaren McCann West 118
madeinLA 393
Mad River Post 135
MagnaMana 130
Martin Agency, The 147, 156
Massive Music 141
Matching Studio 56
McGill Productions 118
McHale Barone 144
Method 60

Mit Out Sound 52, 72
MJZ 137
Morton Jankel Zander 90, 137
MTV 64, 65, 85, 86, 87, 89
MTV Networks 87
MTV On-Air Promos 64, 85, 87, 89
Mullen 133
NET#WORK BBDO 63, 112, 146
newnew films 88
Nordpol + Hamburg 34, 141
Ogilvy 126, 171
Ogilvy & Mather Frankfurt 171
Ogilvy Brasil 160
Ogilvy Cape Town 110
Ogilvy Repro 110, 126
One Union Recording 146
Outpost Digital 43
Panic & Bob 55
Paranoid Projects: Tool of North America 77
Park Pictures 52, 72, 135
Partizan 100, 101, 102, 132, 143
Passion Pictures 143
Philipp und Keuntje 197
Powell 45
PPBmex Animation 75
Publicis Dialog 39
Publicis Frankfurt GmbH 121
Publicis Mojo 163
Publicis Werbeagentur AG 117
Redtree Productions 40, 58
Reginald Pike 55, 98, 136
Rosnick Mackinnon Webster 55
RSA USA 60
Saatchi & Saatchi New York 159
Scandal Music 78, 106
School Editing 136

Silbersee Film 34
Smith & Jones Films 93, 94
Smuggler 60, 97
Soundscapes 145
Sound Lounge 135
Spin Images 110
SpotWelders 52, 72
Spy Films 76
Stink 131
STUDIO4 43
Studio Funk 130
TAXI 67, 120, 148
TBWA\G1\Tokyo 169
TBWA\Germany 154, 174
TBWA\Japan 32, 83, 167
TBWA\Paris 115, 128, 162, 164, 175
TBWA\Shanghai 162
TBWA\Vancouver 98
Third Floor Editing 67
Thomas Thomas Films 105, 139
Tohokushinsha Film Corporation 84
Tokyo Great Visual Inc. 208
Tugboat 84
uchu-country, ltd. 138
untitled 67, 136, 137
Villains 130
Wanda 92
Wieden+Kennedy 43, 46, 93, 94, 134, 135, 153
Wieden+Kennedy Tokyo 43
W Communications 163
Young and Rubicam 173
YR Buenos Aires 109
ZiG 55, 136, 137

CLIENTS

032c Magazine 299
10BAN Studio 328
2001 Video 42
2wice Arts Foundation 304

ADC Switzerland 216
adidas 32, 52, 53, 60,
 61, 72, 83, 97, 162,
 167
adidas China 162
adidas International
 52, 72
ADP e.V./ German
 Cancer Aid 282
AIGA NY 290
Air America Radio 245
Aiwa, Inc 371
Altoids 130, 202
American Legacy Foun-
 dation 36, 40, 58
American Red Cross 96
Amnesty International
 170
Anheuser-Busch 78,
 106
Arctic Paper 307
Art of Repro 269
Audi 151
Best Buy 377
Bic 115
Big Magazine 298
Big Magazine, Inc. 212
Bonjour Paris French
 School 95
Bremerhavener
 Bürgergemeinschaft
 123
Burger King 49, 137
Busan Asian Short Film
 Festival 325
Calgary Police Services
 118
California Milk Proces-
 sor Board 74
Canadian Film Centre
 148
Canadian Film Centre's
 Worldwide Short
 Film Festival 67
Cape Town Major
 Events Co. 243
Cartoon Network 342
CG by Cache 299
Eight and a Half 246
Emerald Nuts 352
ESPN 134, 135, 153
ESPN Sportscenter
 134
FedEx 88, 142, 157
FedEx/Kinko's 142
Festival St-Ambroise
 Fringe de Montréal
 327
Channel 4 Television
 264
Chicago Volunteer Le-
 gal Services 307
Children's Museum of
 Pittsburgh, The 248
Citi 105, 139
Citroen 76
Cityspace 339
City Mission 126
CMT 136
Columbia Pictures/
 Sony Pictures Digital
 359
Comedy Central 410
Companhia Athletica

131
Covenant House Van-
 couver 173
D-BROS 273
Daily Show With Jon
 Stewart, The 304
Dallas Society of Visual
 Commnications, The
 324
Dentsu Communication
 Institute 237
Designers' Workshop
 Magazine 314
Dexter Russell Cutlery
 165
Dialog im Dunkeln 333
Diamond of California
 132
Dick Gerdes Recruit-
 ing 156
Diesel 342
Disentis 189
Dreamusic Inc. 274
eBay 71
Economist, The 146
Editora Abril/Veja
 Magazine 103Italian
 Glamour 201
Fiat 160
Foam 254
Foton Inc. 158
Fruit of the Ground,
 The 317
Fujii Tamotsu Photog-
 raphy Office 308
Futaki Interior, Inc. 319
Garden Museum 309
Geary Theater 114, 209
Geffen Playhouse 215
General Motors South
 Africa 297
Glenmorangie 338
Golfanlage Kallin Be-
 triebs GmbH 174
GraficEurope 265
Guardian, The 149
Hamburger Bahn-
 hof–Museum Für
 Gegenwart 220
Hanes Beefy-T 311
Hansaplast 164
Hastings Audio Net-
 work 141
HBO 140, 169, 174
Hewlett-Packard Inc.
 367, 385
Hewlett Packard 39,
 77, 143
House Foods 169
Hudson Repro 159, 281
Huidi Lauhoff Modede-
 sign 379
IKEA 136, 137
Inlingua Language
 Center 172
International History
 Channel 81
Investors Chronicle
 329
Islands Of The Baha-
 mas Ministry Of
 Tourism, The 383
Japan Snow Project 84
Jiffy Lube 163

K2R 175
Kano Shikki Co., Ltd.
 318
Keiwa Package 322
Kellogg's 156
KesselsKramer 342
Kid's Wear 300
Kids Wear Magazine
 179, 184
Koyama Tofu Co., Ltd.
 334
Kraft 130, 202
Lace Sneakers Maga-
 zine 315
Leine & Roebana 322
Lu/Mikado 134
M2 Hair Culture 171
Macromedia 378
Mag-Lite 403
Magnum 320
Matsushita Electric
 Industrial Co., Ltd.
 208
McDonald's 172
Medecins du Monde
 128
Medecins Sans Fron-
 tieres 117
Meiji Seika Kaisha,
 Ltd. 158
MINI Canada 348, 351
Montreal Jazz Big Band
 330
Mori Building 47
Mountain Dew 100, 101,
 102, 143
Mount Sinai Medical
 Center 144
MTV 64, 87, 89, 345
MTV International 226
Museum of Modern Art,
 The 364
Musicline 369
Muzak 407
N, The 225
National Federation of
 UNESCO Associa-
 tions in JAPAN 363
National Funds for Dis-
 abled Sporters 166
Nebraska Domestic
 Violence Sexual As-
 sault Coalition 145
Neckar Valley Green
 Space Foundation
 377
Nike 43, 46, 93, 94, 120,
 163, 210
Nike Asia Pacific 43
North American Coffee
 Partnership 91
NPO Harappa 331
NPO harappa 261
Onion, The 147
Paintura 336
Papierfabrik Scheufel-
 en GmbH+Co. KG
 316
Parmalat South Africa
 110
PBS 140
Peugeot Automobiles
 92
Photonica 311

Police division of Gooi
 and Vechtstreek 263
Port Authority 292
Racing Victoria 294
Rainier Brewing Co. 31
Renault Deutschland
 121
Renault Nissan
 Deutschland AG 34
Revell 130
Rheingold Beer 45
Riccardo Cartillone
 Schuheinzelhandels
 GmbH 141, 361
Rijksmuseum Amster-
 dam 376
Royal Mail 286
RWE 197
Sankyo Co., Ltd. 372
Saturn 373
Schmidt und Bender
 GmbH Co. KG 375
Sealy 133
Simba Ghost Pops 63,
 112
Simon Finch Rare
 Books 257, 381
Skoda 154
smartUSA 374
Soken Electronics Co.,
 Ltd. 56
Sony 154, 164
Sprint PCS 146
STIHL 155
Storm King Art Center
 414
Sugahara Glassworks
 Inc. 240
Super Cheap Auto 306
Sweden Style 277
Swedish Museum of
 Architecture, The
 285, 308
Szymanski Clean Man-
 agement 310
Tabasco 162
Télécréateurs, Les 134
Telefónica 109
Think London 270
TIME Magazine 82, 152
Tokyo Electric Power
 Company 340
Tokyo FM Broadcasting
 Co., Ltd. 358
Toshiba Corporation
 358
Transcontinental Litho
 Acme 206
TV Asahi Corpora-
 tion 44
Twinkle Co., Ltd 323
udru enje za razvoj
 kulture 287
Unilever 55
United Airlines 49, 75
United Way of the
 Lower Mainland 79
Universal Pictures
 228, 250
Vaillant 190
Vancouver Internation-
 al Film Festival 98
VH1 296, 343, 344
VH1 Latin America 139

Victor Entertainment,
 Inc. 208
Vim 55
Virgin Mobile 366
Virgin Mobile USA 90,
 150
Vivre 138
Vodafone k.k. 375
Volkswagen 124, 127,
 131, 142, 149, 161
Volkswagen AG 68, 198
Volvo North America
 402, 408
Warner Brothers 376
X-Knowledge Co., Ltd.
 253
Zai AG 189

GRAPHIC DESIGN,
PHOTOGRAPHY,
AND ILLUSTRATION
STUDIOS

15 Children 274
24th Street Loft 298
702design Works, Inc.
 319
Achim Lippoth Photog-
 raphy 179, 184
Advico Young & Rubi-
 cam 216
Aorta 300
Art Department 201
Art Printing Co., Ltd.
 237
Asatsu-Dk, Inc. 312
ayr creative 274, 317
BBH 212
Beierarbeit 313
Billy & Hells 154
BMZ und More 190
Brett&Tracy 203
Broken Wrist Project
 203
Browns 234, 264, 320
Buddha Productions
 340
Buero Uebele Visuelle
 Kommunikation 289
Cahan & Associates
 259
Charles S. Anderson
 Design Company
 326
Corbis Images 233
cyan 220, 269
designhorse 318
Designing Gym Inc. 237
Design Bridge 269
Design Center, Ltd. 335
Diesel 278, 327
Digital Palette, Inc. 237
Downtown Partners
 Chicago 209
DRAFT Co., Ltd. 223,
 273
dreamdesign co.,
 ltd. 47
E. 313
emeryfrost 256, 257,
 294, 306
Enric Aguilera Asocia-
 dos 337

enthusiasm 314
Époxy 310
Esther Haase Photog-
raphie 199
Esto 248
Eyeball NYC 343
Fad 87
FLAME, Inc. 331
Fons Hickmann m23
265
good design company
co., inc. 277, 323
Graf Studios 194, 204,
205
Graphiques M/H 278,
327
haefelinger+wagner
design 306
Hakuhodo, Inc. 288,
315, 333, 334
Happy Forsman &
Bodenfors 285, 307,
308
Harpy Design 215
Hayashi Design 328
Heimat 282
hendersonbromstead-
art 311
Herman Miller, Inc. 259
He Said She Said 310,
333
Hunter Gatherer 344
iyama design 240, 322
Johnson Banks 270
Jung von Matt AG 189
Jupiter Drawing Room,
The 243
Ken Woo Photography
118
Koeweiden Postma
263, 272, 322
Lobo 342
Lowercase, Inc. 307
Martha Stewart Living
Omnimedia 211, 212
Masami Design, Ltd.
314
Method 339
Mr. McElwaine 345
MTV Networks 296
N.G. Inc. 334
Nakajima Design 299
NB: Studio 311, 329
NET#WORK BBDO 297
New Yorker, The 213,
214
New York Times Maga-
zine, The 180, 183,
186, 196, 206, 209,
211, 231, 258, 301,
302, 303
Nick Digital Networks
Brand Communica-
tions 225
Number Seventeen 245
oco 240
Ohgushi 47
Omnific 286
Omnivore, Inc. 239
Paprika Communica-
tions 206, 330
Paul Davis Studio 215
Pentagram 248, 292,
304, 309, 341

Praxis Design 262
Prologue Films 228,
250
R&D&Co. 207
Rodrigo Corral Design
233
Saatchi & Saatchi 281
Sibley/Peteet Design
Dallas 324
smakdesign 315
Stoique&Co. 336
strichpunkt 316
Studio International
332
Suede Magazine 202
super2000 226
Team One 266
ThereMedia, Inc. 200
This Way, Inc. 308
Three in a Box, Inc. 120
Ton 317
Tongmyong University
of IT 325
Triton Films 295
TV Asahi CG design
room 44
UltRA Graphics 246,
321
Vandejong 254
Whitney Museum of
American Art 239,
262
Wieden+Kennedy Tokyo
Lab 295
Williams Murray Hamm
338

INTERACTIVE
AGENCIES AND
STUDIOS

Barbarian Group 385
Big Spaceship 359, 376
DDD System GmbH 369
Dentsu, Inc. 355, 358,
363, 372
emeryfrost 381
Fabrique Design 376
Fallon 366, 383
For Office Use Only 364
Goodby, Silverstein &
Partners 352, 367,
373, 385
Hakuhodo I-Studio Inc.
375
Hello Design 371
ioResearch 378
Jung von Matt AG 375,
377
Neue Digitale GmbH
368
Nordpol + Hamburg
361
Oceanmonsters 371
Ogilvy Brazil 365, 370,
384
Ogilvy Interactive
Worldwide 382
Pentagram Design 374
R/GA 378
space150 377
Strobelgasse Werbe-
gesellschaft M.B.H.

379
tha Ltd. 358
unit9.creative.produc-
tion 367
Wieden+Kennedy Lon-
don 371

SCHOOLS AND
UNIVERSITIES

CalArts 324, 391, 398,
405, 406
California Institute of
the Arts 398, 404,
405
Fachhochschule Mainz
414
Miami Ad School Eu-
rope 403
Parsons School of
Design 341
Pratt Institute 414
School of Visual Arts
330, 388, 400, 410,
412, 413
Tinge Design 416
University of Applied
Sciences Mainz 305
University of Applied
Sciences Wiesbaden
394
University of Colorado,
Boulder 409
University of Texas at
Austin 411
VCU Adcenter 407
Yale School of Art 415
Yale University School
of Art 397

Fatto in Italia*

supervisione

ARTLAB

Trimestrale di teoria e pratica della visione, dedicato ai professionisti della progettazione grafica. Dal 2001.
Quarterly magazine, in Italian, providing multi-discipliary updates in the world of graphic design and imagery. Since 2001.
www.artlab.it

*Made in Ita

Step 1. # Step 2.

Repeat as needed.

BREATHE

12 West 21st Street 10th Floor
New York City 212.947.1748

www.breatheediting.com

CCii

the Capital Corporation Image Institution

the Capital Corporation Image Institution

Your brain in China!

Founded in May 1997 in Beijing China, the Capital Corporation Image Institution (CCII), a professional organization in Chinese design field, is mainly dedicated to prompt the international communication among designers as well as the communication between design field and commercial field. Every year, by holding a series of high-level professional competitions, exhibitions, salons, forums, commercial popularizing programs, training items, and publishing, CCII has made a great contribution to Chinese art design field, and also has established steady and friendly cooperation relationship with many international organizations, like ICOGRADA, ADC, AGI, ITC. Nowadays, three major programs held by CCII, the International Logo Biennial Awards, the Creative Industry Annual Awards, and the nationwide traveling exhibition of outstanding international creative works, have become more and more popular with not only the professionals but also the enterprises, not only in China but also in foreign countries.

If you are interested in our competition and exhibition, or want us to do something for you in China, please don't hesitate to visit our website WWW.CCII.COM.CN, or directly contact:

CCII Beijing
No. 2, Wan Hong Xi Jie, Chaoyang District, Beijing, China 100015

Phone	+86 (0)10 8456 7717/7727
Fax	+86 (0)10 6435 5550
Email	bhren@ccii.com.cn

CCII Shanghai
Room 5-102, No. 9, Hong Cao Nan Road, Shanghai, China 200233

Phone	+86 (0)21 6483 3827/5457
Fax	+86 (0)21 6483 5457
Email	euphee.hu@ccii.com.cn

在中国做广告 先读《中闽广告》
Read "China Advertising" firstly
Advertise in China secondly

"China Advertising" which was founded in 1981 is the first domestic special Magazine in advertising. It is published every month, with 160 colored pages and A4 size."China Advertising" was in the charge of China Publishing Group, associated with Oriental Publishing Center, Shanghai YIBAI Group Co., Ltd. and Shanghai Advertising Association.

"China Advertising" creates the column as "Special Topic This Volume", "Man of the Hour","Advertisement Research", "Creation Story", "Brand perspective", "Creation Express" and so on. During its growing progress, China Advertising, deemed as a magazine of authority, practicability and knowledgability, has been highly appreciated by many readers and people from all fields

What's more,"China Advertising" has held many kinds of high-level advertising lectures, trainings,"China Advertising Forum" and so on. "China Advertising Forum" has become one of the top academic activities in China advertising.

Ordered in China: Post Office all over the country (Post Code: 4-408)
Ordered out of China: China International Book Trade Co. (Post Code: MO722)
Address: Room 1805 shenxin Building No. 200 East ninghai Road Shanghai China
OFFICE: 86+021+63552298 Fax: 86+021+63551811 E-mail:china-ad@online.sh.cn

d(x)i

culture & post-design | magazine

d[x]i magazine. The only free-of-charge publication in Spanish devoted to creativity, art and contemporary culture. A reference in the world of design in Spain and Latin America.

Subscriptions:

Subscription is totally free-of-charge. Let us know your address by e-mail:
sub@dximagazine.com

Advertising & Distribution:

For rates and reservations, please contact:
advert@dximagazine.com
Periodicity: 4 issues per year
Language: Spanish
297 x 420 mm, Portrait
ISSN 1577-3175

Contact us:

d[x]i magazine
c/ Maldonado 19, Bajo Dcha.
E46001 Valencia, SPAIN
+34 96 3154215
+34 616 405 429
lex@dximagazine.com
www.dximagazine.com

The best concept ever created has yet to be created.

art directors club

hp

= everything is possible

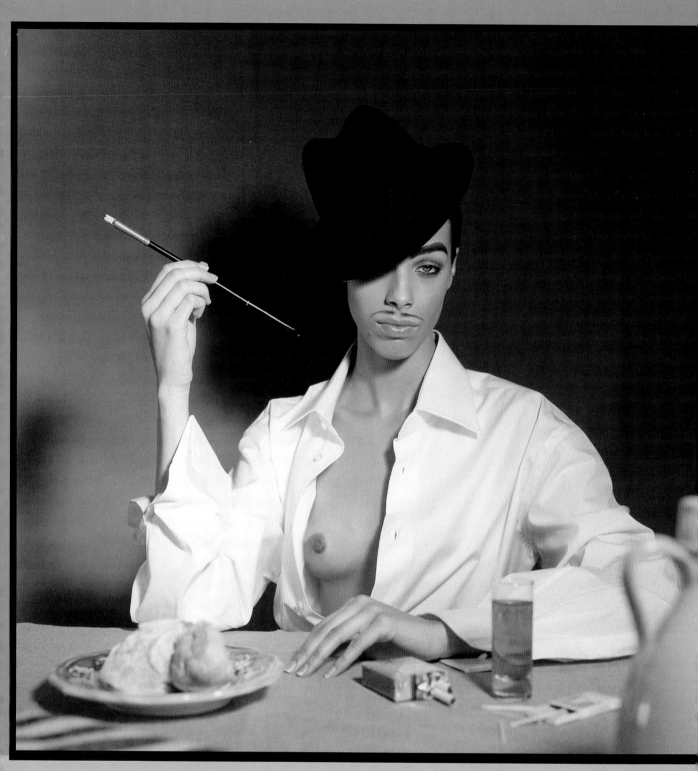

KENTHURLBEC

www.kenthurlbeck.com (t) 212 695 9

A DIVERSE PALETTE
OF SUBJECTS...

LINO Magazine is released quarterly; each issue will
bring you stories on Design, Architecture, Fashion,
Food, Travel, Photography, Art and MixedMedia,
as well as profiles of some exceptionally creative people.

www.linomagazine.com.au

print

DESIGN CULTURE CRITICISM

2005 WINNER NATIONAL MAGAZINE AWARD FOR GENERAL EXCELLENCE

www.printmag.com

TOKION

CREATIVITY NOV

RICHARD PRINCE

GHOSTFACE

*MAURIZIO
CATTELAN*

NIGEL COOKE

LIL JON

*RITA
ACKERMANN*

SA-RA

OS GEMEOS

*FRANCESCO
CLEMENTE*

*ROOTS
MANUVA*

MARIKO MORI

JEFF KOONS

HIGH LOW

www.tokion.com

Lee Clow - TBWA\CHIAT\DAY Campbell-Ewald Wieden+Kennedy Wieden+Kennedy

Wieden+Kennedy Marsteller J. Walter Thompson Leo Burnett

McKinney Dare UK Civic Entertainment Group Deutsch

Your Name Here

WHO'S NEXT?

ALSO AVAILABLE FROM ROTOVISION

Digital Graphics and Animation	Character Design for Mobile Devices
	Game Plan: Great Designs that Changed the Face of Computer Gaming
	Motion Design: Moving Graphics for Television, Music Video, Cinema, and Digital Interface
Digital Video and Audio	Reinventing Music Video
	500 Digital Video Hints, Tips, and Techniques
General Design	Plastics 2
	First Steps in Digital Design
	Digital Illustration: A Masterclass in Creative Image-making
	Experimental EcoDesign: Product, Architecture, Fashion
	The Best Tables, Chairs, Lights: Innovation and Invention in Design Products for the Home
	Designs of the Times: Using Key Movements and Styles for Contemporary Design
Graphic Design	Paper Engineering: 3D Design Techniques for a 2D Material
	Letterpress: The Allure of the Handmade
	Graphiscape: Subways
	What is Graphic Design For?
	What is Typograhy?
	Communicating with Pattern: Stripes
	Communicating with Pattern: Circles
Lifestyle	Bright Ideas: Professional Lighting Solutions for Your Home
	Colormatch for Home Interiors
	Exotic Retreats: Eco Resort Design from Barefoot Sophistication to Luxury Pad
Photography	Digital Photography Workshops: Portraits
	Digital Photography Workshops: Nudes
	500 More Digital Photography Hints, Tips, and Techniques
Stage and Screen	The Science Behind the Fiction: Building Sci-Fi Moviescapes
	The End of Celluloid: Film Futures in the Digital Age
Sales and Editorial Office	Sheridan House
	114 Western Road
	Hove, BN3 1DD
	UK
	Tel: +44 (0)1273 727268
	Fax: +44 (0)1273 727269
	www.rotovision.com